50 Fast Photoshop® 7 Techniques

GREGORY GEORGES

50 FAST PHOTOSHOP® 7 TECHNIQUES

Wiley Publishing, Inc.

50 Fast Photoshop 7 Techniques

Published by
Wiley Publishing, Inc.
909 Third Avenue
New York, NY 10022

`www.wiley.com`

Copyright © 2002 by Wiley Publishing, Inc., Indianapolis, Indiana

Library of Congress Control Number: 2002106031

ISBN: 0-7645-3672-9

Manufactured in the United States of America

10 9 8 7 6 5 4 3 2 1

1K/TR/QX/QS/IN

Published by Wiley Publishing, Inc., Indianapolis, Indiana
Published simultaneously in Canada

For general information on our other products and services or to obtain technical support, please contact our Customer Care Department within the U.S. at 800-762-2974, outside the U.S. at 317-572-3993 or fax 317-572-4002.

Wiley also publishes its books in a variety of electronic formats. Some content that appears in print may not be available in electronic books.

Wiley Publishing, Inc. is a trademark of Wiley Publishing, Inc.

To my wife Linda, for reasons that are too innumerable to list . . .

PREFACE

If you are serious about digital photography; either as a passionate amateur, money-earning professional photographer or artist, or anywhere in between, and you want to edit your photos digitally with Photoshop 7 — this book is for you! It is for you regardless of your experience level with Photoshop 7 or other versions.

Without a doubt, the more you know about Photoshop 7 or an earlier version of Photoshop, the easier these techniques will be to complete. But, if you are new to Photoshop 7, you can complete all of the techniques in the book by carefully following each of the steps and by reading the occasional detailed explanation. By the time you complete all or even most of the 50 techniques, you will have acquired a considerable amount of knowledge about Photoshop 7's most important features and will be well on your way to being able to competently edit your own digital photos.

The premise of this book is that the best way to learn how to use a complex software application like Photoshop 7 is to just use it — to have successful results while working with fun photos, which will make the learning process enjoyable. If the learning process is truly enjoyable, time will fly by, and the hours of effort will result in success. Success will result in more knowledge, which eventually will turn those who work hard to learn Photoshop 7 into competent Photoshop 7 users.

In contrast to those who say Photoshop 7 is too complex for many potential users, I claim inexperienced Photoshop users can create some outstanding results by learning how to use just a few features extremely well. This book includes many techniques that will help you to learn all about some of the more important features and how to use them extremely well to do what you want to do.

ACKNOWLEDGMENTS

Each time I write a new book, I fully recognize the growing number of people that have substantially helped me in one way or another to learn more about the topics that I write about and to write about them in better ways. For this book, special thanks to:

Readers of my books, attendees of my workshops, students, and subscribers to my e-mail group who have contributed to my understanding of what topics need to be included and how they should be presented — an understanding that is essential for writing books that help readers and provide the value they should.

The many contributors of specific techniques and photographs that added considerable "genetic diversity" to this book. These contributors include: Peter Balazsy, Phil Bard, John Brownlow, Michael Chambers, Scott Dingman, Bobbi Doyle-Maher, Lewis Kemper, Tammy Kennedy, Chris Maher Marc McIntyre, Alan Scharf, and Jimmy Williams.

The entire Wiley team, who helped to turn the 50 techniques in my head into a book that I hope will become invaluable to photographers of all skill levels. Key people on the team include: Mike Roney, the Acquisition Editor who acquired this book and the one before it and helped to make them the start of a valuable new book series. Amanda Peterson for her excellent work as Permissions Editor. Marc Pawliger and Dennis Short, technical editors, for making sure each and every technique works as expected. Jerelind Charles for her copy editing.

Carole McClendon — book agent par excellence.

CONTENTS AT A GLANCE

CONTENTS

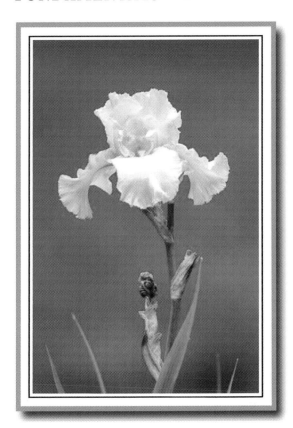

CHAPTER 2: CORRECTING, ENHANCING, AND RESTORING DIGITAL PHOTOS 55

CHAPTER 3: WORKING IN BLACK AND WHITE 111

CHAPTER 4: CREATIVE EXPERIMENTATION 141

TECHNIQUE 20
HAND-PAINTING A BLACK AND WHITE IMAGE 143

TECHNIQUE 21
CREATING A PSEUDOSOLARIZATION 147

TECHNIQUE 22
ADDING A TRADITIONAL DARKROOM TEXTURE SCREEN EFFECT 149

TECHNIQUE 23
FIXING IMAGES WITH A DIGITAL GRADUATED NEUTRAL DENSITY FILTER 153

TECHNIQUE 24
SIMULATING AN INFRARED FILM EFFECT 157

CHAPTER 6: FINE ART TECHNIQUES 187

**CHAPTER 7: USING PLUG-INS
TO ADD IMPACT TO YOUR
PHOTOS 235**

CHAPTER 8: MAKING PHOTOGRAPHIC PRINTS 273

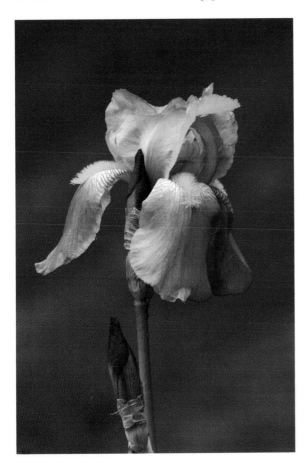

INTRODUCTION

This book, with its 50 step-by-step techniques and 50 sets of "before" and "after" images, has been written to provide you with the knowledge and skills that you need to use Photoshop 7 to edit your own digital photographs. All the techniques are applicable to images created with scanners or with digital cameras. They are for those just beginning to learn more about working in the "new digital darkroom." They are for those who have worked in a traditional darkroom for many years and now want to work digitally as well as for experienced Photoshop users who want to learn more about Photoshop 7 and the digital photo techniques that can be found in this book.

ABOUT BOOT CAMPS AND CHAPTER 1

Many years ago, someone told me that all good things in life that are worth having; require effort — having Photoshop 7 skills is one example of this axiom holding true. Photoshop 7 skills don't always come easy, and so you'll have to work to get them; however, the techniques and the photos you will find in this book should make it a relatively painless process that you should enjoy.

In an effort to help you become successful with the last 44 techniques, the first six techniques in the first chapter have been written as "boot camp" techniques. These techniques will help to get you and your equipment ready to complete the remaining techniques. I highly recommend that you complete all six of the techniques in Chapter 1 before trying any of the other techniques. After you've completed Chapter 1, you may choose to do the other techniques in any order that you want.

A FEW THINGS TO CONSIDER BEFORE BEGINNING THESE TECHNIQUES

Before jumping into the techniques, here are a few additional things to consider first.

Color management is important

If your monitor is not properly calibrated, you will likely not see the results that are expected when you use the techniques and settings suggested in this book. Likewise, if you

have not properly set up your printer, your prints will not turn out to look like the image viewed on your monitor or as intended. Completing Technique 5 and Technique 6 will have you well on your way to working in a color-managed environment.

About the photos on the companion CD-ROM

Having ready-access to the digital photos on the CD-ROM will save you time and make it easier to do each of the techniques. If you have room on your hard drive for these photos, I recommend that you copy the entire "\ps7techniques" folder and sub-folders to your hard drive. Any time that you copy files from a CD-ROM to a hard drive; the files will be tagged with a Read Only attribute. This is not OK, if you want to keep those original files for later use. However, if you want to save your work over those files, you will have to remove the Save Only attribute. To do so in Windows, right-click on a folder or file to get a pop-up menu. Select Properties to get the Properties dialog box, then uncheck the Read Only attribute. You can change attributes for a single image or an entire folder of images and/or folders all at once.

To fit all the photos that are needed for the fifty techniques on the Companion CD-ROM along with a trial version of Photoshop 7, the "after" images have been saved as compressed .jpg image files. To get the best possible prints or to view the best possible images on your screen, you should complete each technique and use the completed images instead of the .jpg versions of the "after" images found on the Companion CD-ROM.

Learn what you need to learn and ignore the rest

Photoshop is — big — way big! It can take years for professionals who work with it all day long, every day, to become proficient with it — and then, there are still many features that they do not know how to use or may not even be aware that they are there! If I had to make a single recommendation about how to quickly learn to successfully use Photoshop 7, it would be to learn all about those few features that you need to use to get your work done — and ignore the rest.

WHAT COMPUTER HARDWARE AND SOFTWARE WILL YOU NEED?

When it comes to digital image editing, the axiom "the more the better" applies. Digital image editing is an activity that can consume lots of disk space, RAM, monitor pixels, and computer processing-cycles. Fortunately, the computer industry has been good to us these past few years as the cost of having power and storage to spare has dropped sharply. Powerful computers with lots of RAM, enormous hard-drives, and quality monitors are getting less and less expensive. At a minimum, you'll need a computer that meets the requirements specified by Adobe for use of Adobe Photoshop 7.

If you use a computer that matches Adobe's minimum requirements, you may find you'll enjoy doing the techniques in this book much more if you have 128MB or more of RAM, and 500MB or more of available disk space. The cost of adding additional RAM or adding an additional hard-drive can be relatively inexpensive in today's competitive computer marketplace. An 80-gigabyte hard-drive sells for under $130 and depending on the type of RAM you need, you can buy 128MB of RAM for as little as $60. If you have a relatively slow processor, adding additional RAM can significantly increase the processing speed and help you to avoid the long waits that can occur when digitally editing images. If you spend much time editing digital photos, you'll find the investment in more RAM to be more than worthwhile.

Besides having a fast computer with enough RAM and hard-drive space, a re-writeable CD-ROM can be one of the most useful (and in my view essential) peripherals for those doing digital image editing. A re-writeable CD-ROM allows you to easily back-up your digital photos, to share them with others, and to make space on your hard-drive. Re-writeable CD-ROM drives can be purchased for under $125. Remember that when you begin to store your digital photo collection on your computer hard drive, it is possible to lose everything if you were to have problems with your hard drive. If you value your digital photos; you need to back them up on to a removable storage device of some type such as a CD-ROM.

The monitor and graphics card you use is also very important to successful and enjoyable image editing. If you primarily work with images that are 1,600 x 1,200 pixels or smaller, you may find it acceptable (or possibly not) to work on a 14" or 15" monitor with 800 x 600 pixels. If you are working on larger images, you'll find that a 17" or larger monitor with at least a 1,024 x 768 pixel workspace to be far more useful. While there are larger monitors than 19" monitors, I have been extremely happy with the 19" monitor that I use. It is big, but not too big, and that is good, as I still have some desk space left. You can also buy graphics boards and use too monitors at once, which is becoming increasingly common. Having two monitors lets you put your images on one screen and all the palettes on the other screen.

For those of you that might want to ask the question: Is it better to use a PC or a MAC? My answer is: The computer that you have or know how to use is the better one. Without a doubt, there are differences between the two platforms, but there aren't any clear-cut reasons why the PC or the MAC is better at doing digital image editing. Therefore, have it your way and enjoy using the computer that you will be most comfortable and successful using — that will be the best one for *your* digital image editing.

NOTES TO MAC USERS

The great news for MAC users is that Adobe has historically offered both PC and MAC versions of all their products. The differences between the PC and MAC version of Photoshop 7 is minimal. The MAC screen-shots will look slightly different from the PC screen-shots shown in this book. Also, the two often-used keys, Alt and Ctrl on a PC's keyboard are known as the Cmd and Options keys on the MAC keyboard. Otherwise, there are only a few significant differences (color management options being one of them) you need to be concerned about. In short, this book is equally useful to PC and MAC users.

CHAPTER 1

PHOTOSHOP 7 FUNDAMENTALS

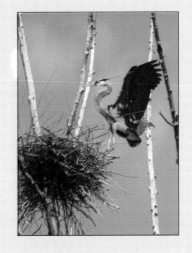

Doing more while doing it better and doing it quicker are the objectives of just about everyone using Photoshop. Photoshop is an extraordinarily powerful application with rich functionality and its complexity and versatility often work against achieving these objectives. The good news: If you know all that is contained in these first six techniques, you'll be able to work efficiently and effectively, which will allow most of your mental resources to be applied to the creative use of Photoshop rather than figuring out how to get done what you want to do.

Even if you are an experienced user of Photoshop, consider carefully reading these first six techniques as there are many practical tips that are invaluable to anyone interested in digital photo editing. You must become the master of your tools, or they can master you and frustration prevails! This chapter is not short, but is an important one worth doing step-by-step, even for those that consider themselves to be Photoshop experts.

CONFIGURING PHOTOSHOP 7

1.1 © 2002 Gregory Georges

1.2 © 2002 Gregory Georges

ABOUT THE IMAGE

Purple Iris Canon EOS D30 digital camera mounted on a tripod, 100mm f/2.8 macro, ISO 100, RAW setting, f/14 @ 1/4, 1440 x 2160, edited and converted to 292 KB .jpg

Photoshop 7 has more than 460 menu items in the main menu. Additionally it has 15 feature-rich tool palettes including the Tools palette with 60 tools; plus it offers a plethora of tool presets, color swatches, actions, blend modes, and much more. Wow, you might think: How am I going to learn all about all that stuff! The fact is if you configure Photoshop 7 properly and you learn to use the tools that you need to use — it really is possible to do all that you'd like to do, without having to learn about everything. This first technique covers all the necessary steps you should take to set up Photoshop 7 — for you and what you want to do.

STEP 1: OPEN FILE

■ Choose **File** ➢ **Open** (**Ctrl+O**). After locating the **\01** folder, double-click it to open it. Click **iris.jpg** and then click **Open** to open the file.

STEP 2: CHOOSE SCREEN RESOLUTION AND COLOR QUALITY SETTINGS

Before you begin configuring Photoshop 7 to best fit your working style, I ought to point out that monitor screen resolution and color quality settings can be changed. If you know about these settings and you know how to use them, then skip to Step 3. Otherwise, this is a step worth carefully reading. I know many competent PC users who were not aware that they can change these settings and were pleased to learn about them — especially those with aging eyes!

■ If you are using Windows, **right-click** anywhere on your desktop where there are no application windows or icons to get a menu. From the menu that appears, select **Properties** to get the **Display Properties** dialog box. Click the **Settings** tab to get a dialog box similar to the one shown in **Figure 1.3**. Toward the bottom left of this dialog box, you see a slider in the **Screen resolution** box. Depending on your display monitor and your graphics board, you have one or more choices of screen resolutions as you move the slider.

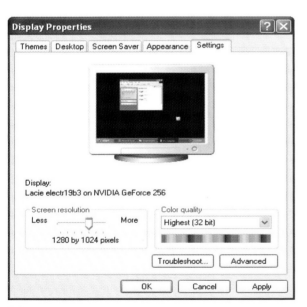

1.3

■ Choosing the best screen resolution setting depends on several factors such as: monitor size, graphics card capabilities, available graphics card RAM, your eyesight, and current work at hand. Most new computers allow you to change screen resolution *on-the-fly,* meaning that you do not have to reboot your PC each time you change screen resolution. If your PC allows on-the-fly changes to your display, then you may want to consider changing often to suit your immediate needs.

At lower screen resolutions, such as 800 x 600 pixels, or 1024 x 768 pixels, everything is relatively large including text, application menus, and application windows, making them easy to see and read. However, the downside is that you have less workspace. This means that you can see less of a large image, or if you have two or more applications open and viewable on your desktop at the same time, you have less room to display the applications. Even more importantly, you see less of the image you are working on if you have lots of tools and palettes open as you work.

■ After you have decided what screen resolution to use, click the slider and drag it to the left or right until you get the setting you want. For most Photoshop work, I like to use the **1280** x **1024** pixels setting when I use a 19-inch or larger monitor.

■ After setting screen resolution, make sure to check the **Color quality** setting — it *must* be set at **24-bits** or higher. Anything less and you have way too few colors to effectively edit digital photos. If your graphics board does not have enough video RAM to display 24-bits of color at a high screen resolution setting, then you may have to choose a lower screen resolution setting to use 24-bit color.

■ After your choice of screen resolution has been selected and you have **24-bit** or higher color quality, click the **OK** button to apply the settings. You then likely see your display flicker as it changes to the new settings. If you get a dialog box saying that

you have to reboot your PC, first save any open documents, and then click **OK** to reboot your PC.

STEP 3: CHECK FOR AND INSTALL UPDATES

One of the many benefits we have in today's Internet-connected world is always having access to up-to-date software. Many of the new products by Adobe, such as Photoshop 7, have a built-in update feature, called Adobe Online Update, which is a terrific feature that you ought to use!

■ First make sure that you have an open connection to the Internet. Then, choose **Help ➢ Updates**. Another dialog box appears before you get the **Adobe Products Update** dialog box shown in **Figure 1.4**. This dialog box may download one or more files. As soon as the **Adobe Product Updates** dialog box appears, it lists all the available updates. You can then check the box for each update that you want to download and install. To learn more about each update, click the update to read a short description in the **Item Description** area in the middle of the dialog box. After you select the updates that you want to install, click **Download** and your software automatically

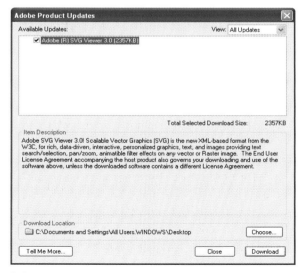

1.4

updates! If there are no updates, or you choose not to install available updates at this time, click **Close**.

Besides manually checking for updates as in Step 3, you can also configure Photoshop 7 to check for updates automatically.

■ Choose **Edit ➢ Preferences ➢ Adobe Online** to get the **Adobe Online Preferences** dialog box shown in **Figure 1.5**. Here you can select how frequently you want Photoshop 7 to check for updates. Click the down arrow in the **Check for updates** box to choose **Once a Day**, **Once a Week**, or **Once a Month**. Click **OK** to apply the settings.

STEP 4: RESTORE PREFERENCES TO THEIR DEFAULT SETTINGS

Adobe engineers have made Photoshop 7 easy to use by making sure that most features have default settings — this means you can just use features and not worry about having to select options each time you use them. The approach they took was to put most of these default settings into several preference files and the Registry, which can be accessed from a series of dialog boxes. We go through each of these dialog boxes in the next step. Before then, I suggest that you first restore your preferences to their default settings.

If you have already set color management settings, or, for that matter any other settings that you do not want to change, then you may want to skip this step and go on to Step 5. Setting all the preferences to their default settings before completing Step 5 simply

1.5

makes it easier for you to end up with the suggested settings.

- If you are using Windows, you can restore the preferences file by pressing and *holding* **Alt**+**Ctrl**+**Shift** immediately after launching Photoshop 7. You will get a dialog box asking if you want to delete the Adobe Photoshop Settings File. Click **Yes** after asked if you would like to delete the settings file.
- If you clicked **Yes**, after Photoshop 7 loads, you will get another dialog box asking if you want to customize your color settings now. Click **No** to continue loading Photoshop 7 as we get to the color settings later in this chapter in Technique 6.

STEP 5: SET PREFERENCES

Photoshop 7 has eight Preferences dialog boxes with lots and lots of changeable options. Not to worry! I am making a bold assumption that you are configuring Photoshop 7 for editing digital photos and that your printer is a consumer-grade digital photo printer. We just cover those options that you are most likely to need to make sure they are set for these purposes. The rest we can just skip over!

While you may not want to make any changes to the preferences file at this time, taking a quick tour through these screens to see what is available can be worth your time. A simple change in one of these settings often makes your work considerably easier and quicker, and in some cases remarkably better.

- Choose **Edit** ➤ **Preferences** ➤ **General** (**Ctrl+K**) to get the **Preferences General** dialog box shown in **Figure 1.6**.

- **Leave History States** set to **20** for now, but it is important that you are aware that this feature can gobble up RAM in huge bytes (or I should say bites!). In Technique 4, you find out more about history states and how it impacts the use of RAM. Now you know where to come to change the setting for number of states should you find your PC is struggling with huge working files.
- Click **Export Clipboard** to uncheck the box. This saves you from having to worry about having a large image in the Clipboard when you change application windows. It also saves RAM. (This may mean other applications won't see what you put on the clipboard in Photoshop.)
- The **Beep When Done** feature is nice to use if you have a slow PC or frequently work with large files. If you find yourself looking at the screen for long periods of time to see when Photoshop 7 has finished a task, turn this feature on. Otherwise, turn it off so that you don't have what to some might be considered an annoying beep. This feature is smart enough to not beep all the time; rather, it just beeps when Photoshop 7 takes a few seconds or more to complete an edit or open a file. I leave it turned on.

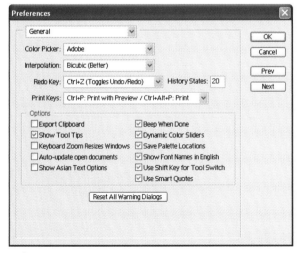

1.6

■ If you have **Save Palette Locations** turned on, each time you close Photoshop 7, then open it again, all palettes will be in the same location they were before closing Photoshop 7. If the option is off, palettes will be displayed in the default layout. This feature may not seem particularly good, but for those who use lots of palettes, having the tools show up where you left off last time is a very nice feature indeed.

■ If you have set the preferences as suggested, your **Preferences** dialog box should now look like the one shown in **Figure 1.6**.

■ Click **Next** to get the **File Handling** dialog box shown in **Figure 1.7**. If you find that you frequently open previously opened files, which you have recently closed, you may want to set the **Recent files list** box to an appropriate number. This setting determines the number of files that appear in a menu when you choose **File ➢ Open Recent**. I use this feature all the time so I set it for ten files.

■ Click **Next** to get the **Displays & Cursors** dialog box shown in **Figure 1.8**. I suggest that you experiment with each of the different cursor styles to decide which ones you most like. The default settings work for me in most cases.

■ Click **Next** to get the displays and **Transparency & Gamut** dialog box shown in **Figure 1.9**. These settings are generally fine just as they are.

1.8

1.7

1.9

■ Click **Next** to get the **Units & Rulers** dialog box shown in **Figure 1.10**. If you work on images for Web pages, you want to set **Rulers** to **pixels**. Should you plan on using guidelines or want to measure images that will be printed, set **Rulers** to **inches**.

While we're on the subject, when you want to use rulers while editing an image, choose View ➢ Rulers (Ctrl+R) to display rulers. To turn off the rulers, choose View ➢ Rulers again.

■ Setting **Print Resolution** to the correct setting for the printer you use most often saves you from having to change the print resolution field each time you create a new document.

■ Click **Next** to get the **Guides, Grid & Slices** dialog box shown in **Figure 1.11**. If you use grids, guidelines, or slices (for Web pages), then this dialog box allows you to determine how they will appear in your document window. For example, if you are laying out images to be printed out as a photo album, guides and grids set in the appropriate intervals and in an easily viewable color can be very useful.

To show a grid in a document window, choose View ➢ Show ➢ Grid. To add guidelines to a

document, you must first make the rulers visible. To display the rulers choose View ➢ Rulers (Ctrl+R). To make a vertical ruler, click inside the ruler along the left side of the document window and drag the ruler into the document where you want it to be placed while watching where it is on the ruler at the top of the document window. For horizontal rulers, do the same except click in the ruler at the top of the document window. Drag it down while viewing the ruler shown at the left side of the document to place the guide where you want it. Should you want to snap precisely on one of the ruler's marks, press and hold Shift while you are dragging the guide. You notice that this causes the guides to snap to the marks shown on the ruler. You can also change the color of the grid so that it may more easily be seen against the colors shown in your image.

■ Click **Next** to get the **Plug-Ins & Scratch Disks** dialog box shown in **Figure 1.12**. Using the correct (or incorrect) settings in this dialog box can dramatically impact the overall performance of your PC when editing images with Photoshop 7.

■ If you have installed plug-ins in a folder other than the default Photoshop 7 compatible plug-in folder and want to use them in Photoshop 7, you

1.10

1.11

can by checking the **Additional Plug-ins Directory** box. This enables you to browse and select one additional folder that contains plug-ins that you want to use. This enables them to appear in the plug-in menu in Photoshop 7 the next time you open Photoshop 7.

■ If you have more than one hard drive, then in the **Scratch Disks** box, set **First** to **the second drive** (usually the D: drive) and set the second to your primary hard drive (usually the C: drive). This lets Photoshop 7 use one drive for the swap file and one for the scratch disk, which prevents Photoshop 7 from clashing with the operating system. You want to set the First scratch disk to the second drive so it will get used by Photoshop first and won't clash with the operating system using it.

One caveat: Be careful not to set the swap file to one partition and the scratch file to another partition on the same hard drive. This makes the hard drive head jump around way too much to efficiently read and write to your image file or files while attempting to maintain the scratch file. You must have two hard drives — not just two different disk partitions if you set one or more disks to different settings. If you have only one hard drive, just use the default settings — first set to Startup, all others to None.

■ Click **Next** to get the **Memory & Image Cache** dialog box.

Cache Levels in the Memory and Image Cache dialog box has to do with how Photoshop 7 saves (or doesn't save) images in RAM to facilitate the display of images on the screen. When Cache Levels is on (that is, it has a value of one or more), Photoshop 7 saves one or more lower resolution versions of the image so that your screen updates more quickly when zooming in or out to see more or less of an image. Besides taking up extra RAM, Cache Levels also takes up some extra scratch disk space as well. If you routinely work on large images and you have sufficient RAM and hard drive space, this feature is indispensable — use it!

So how do you decide on the number of cache levels to use? You need one cache level for each incremental zoom setting you plan on using. You can view the various zoom settings by clicking the Zoom tool in Navigator starting from the one just below 100% to get: 66.67%, 50%, 33.33%, 25%, 16.67%, 12.5%, 8.33%, and so on to numbers that are less than 1%. Obviously, you need a very large image to find much use in zooming to these lower levels, but they are available should you need them. For example, assume that we will zoom to 12.5%. In this case set Cache Levels to 6.

■ If you have lots of RAM and hard drive space relative to the size of images that you typically edit, then set **Cache Levels** to the appropriate number of zoom levels you expect to use.

■ If you don't have much RAM and you normally edit large images, then set **Cache Levels** to **0** and have patience as Photoshop 7 down- or up-samples the images to display.

■ Make sure that the **Use cache for histograms** feature is turned off as it ensures that your histograms are accurate relative to the image file — not the displayed image.

■ While the optimal percentage to use in the **Physical Memory Usage** box is dependent on whether you use a PC or Mac, and which operating system you use, and the amount of RAM you have, you are safe setting it to no more than 80% if you have 128MBs or more of RAM.

■ Click **OK** to close the **Preferences** dialog box. That's it! We covered all eight of the preferences dialog boxes and Photoshop 7 is now configured for you. However, you haven't saved your settings yet. To save them, you must close Photoshop 7, which causes your newly created preferences file to be written to your hard drive. So, close Photoshop 7 *now* to make sure your settings get saved.

STEP 6: RESET TOOLS AND PALETTES

While we are on the topic of resetting *things* to default settings, I would be remiss to not cover the Preset Manager, which allows you to reset libraries of preset: Brushes (Ctrl+1), Swatches (Ctrl+2), Gradients (Ctrl+3), Styles (Ctrl+4), Patterns (Ctrl+5), Contours (Ctrl+6), Custom Shapes (Ctrl+7), and Tools (Ctrl+8).

■ To reset any of the preset libraries, choose **Edit ➤ Preset Manager** to get the **Preset Manager**

dialog box shown in **Figure 1.13**. Click the **Preset Manager** menu button (the tiny triangle just to the right of **Preset Type** box) to get a menu; then select **Reset [the name of the tool]**. You then get a dialog box asking if you want to replace the library to the default library. Click **OK**.

■ After you have reset all the tools you want to reset, click **Done** to close the **Preset Manager**.

STEP 7: ORGANIZE AND CONTROL YOUR PALETTES

The key to working efficiently in a woodworking shop, an artist's studio, or any creative environment including Photoshop 7 — is having an organized workspace — one where every tool can be found easily and yet is not in the way of your getting your work done. Photoshop 7 palettes contain many of the most used features in Photoshop 7, and while their use is essential, they can, if you allow them, take up most of your desktop and block your view of the image that you are editing.

The clever Adobe Photoshop 7 interface designers have, if you can believe it, come up with six different ways to help you manage palettes! Palettes collapse to the size of a dialog box title bar, they can be docked in the palette well, they all can be turned on and off with the Tab key, they can automatically be arranged in either a default or a predefined layout, and they can be grouped and even stacked.

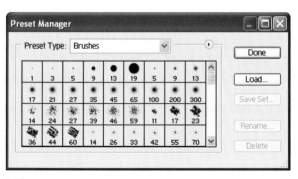

1.13

If you are inclined to either skip or just read the next few steps that show you how to manage palettes, I urge you to grab your mouse and move a few palettes around your desktop. The time and effort you take now to learn about palettes can save you much time and aggravation in the future.

- Once again, open the **iris.jpg** file, if it is not open, so that you have an image displayed.
- Use **Navigator** and the **Info** palettes to practice controlling palettes. If either the **Navigator** or **Info** palettes are not showing, choose **Window** ➢ **Navigator** or **Window** ➢ **Info** to display them.
- To make the **Navigator** palette use as little space as possible without closing it, double-click the **Navigator** tab bar and it collapses to just the **Navigator** tab bar and dialog box, as shown in **Figure 1.14**. To expand it, once again double-click the **Navigator** tab bar and it displays full-size.

If you are using a display setting larger than 800 pixels wide, the Options bar shown just below main menu bar features a palette well for holding palettes such as the Navigator palette.

- To dock the **Navigator** palette in the palette well, click the **Navigator** tab and drag and drop it into the palette well, as shown in **Figure 1.15**. You can remove it by clicking on the **Navigator** tab and dragging and dropping it back onto the workspace.

Alternatively, you can dock palettes by clicking the menu button (the tiny triangle) in the palette and choosing Dock to Palette Well from the menu.

The advantage to docking a palette is that it makes it easy to access — one click and it is accessible. The disadvantage is that any palette that is docked in the palette well closes as soon as any other tool is selected or when clicking an open image. For this reason, docking is excellent for those palettes that you don't need to view when using other tools, such as the Brushes or Color palettes. You click to open them, and then choose the color or brush you want. As soon as you use another tool, they close automatically leaving you with more visible desktop space or image.

- Palettes may also be stacked. To stack the **Navigator** palette with the **Info** palette, click the **Info** tab and drag it onto the **Navigator** tab to get the stacked palette shown in **Figure 1.16**. To separate them, click one of the tabs and then drag and drop the palette back on the desktop.
- Now *group* the **Navigator** with the **Info** palette into a single palette. I do this frequently as I often use the **Navigator** and I am always using the **Info** palette. Click the **Info** tab and drag it slowly to the bottom of the **Navigator** palette. If you drag slowly, you'll see a dark line appear at the bottom

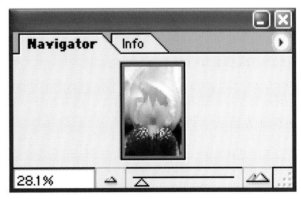

1.16

1.14

1.15

of the **Navigator** palette. Release the mouse button and they are grouped, as shown in **Figure 1.17**.

■ At this point you should have at least two palettes open. I suggest you open up a few more along with the **Tools palette** by selecting **Window** and any palette that does not have a check mark next to it.

■ To hide all these palettes, press **Tab** and they all disappear. Press **Tab** again and they return to the desktop where they were before you first pressed **Tab**. You may notice that this switch also hides the **Options** bar, too. This is a very valuable shortcut that results in a clear workspace.

1.17

■ To hide all but the **Tools** palette and **Options** bar, press Shift+Tab.

That covers four of the six ways to organize palettes that I mentioned earlier. The last two ways are covered in the next step where you discover how to personalize your workspace.

STEP 8: PERSONALIZE YOUR WORKSPACE

As you grow more familiar with Photoshop 7 and you begin to learn how you work most effectively, you're likely to want to personalize your workspace. Photoshop 7 allows you to reset palettes to a default workspace by selecting Windows ➢ Workspace ➢ Reset Palette Locations. Previously in Step 5, you learned how to set Photoshop 7 to open with the palettes in the same location as they were when it was last closed by using Preferences. You can also customize and save your own workspaces and set them up with a simple click of a menu.

Over time, I have learned how I work most efficiently. Sometimes I like to use a 1280 x 1024 screen setting and other times I like to use the 1024 x 768 setting. Depending on the screen resolution that I am using and if I am working on digital photographs or images for Web pages, I like to change my workspace. Every now and then I use a Wacom pen tablet and make digital paintings. At other times, I split my desktop between my word-processor and Photoshop 7 when writing content for books, magazines, or Web pages. In each of these cases, I use different workspaces. You can see the many variations that I use in **Figure 1.18**, which shows the Window ➢ Workspace menu as I have customized it.

My most often-used workspace, shown in **Figure 1.19**, is for a 1280 x 1024 pixel display. As I always seem to have the Navigator open and I frequently use the Info palette, I group them. The History palette is open because I am very much a *trial and error* kind of Photoshop person, so using Snapshots is invaluable. Layers and Channels are stacked as I only need to see one at a time. Finally, I like having the Browser, Brushes, and Color palettes tucked neatly away in the palette well. This lets me get to them in a click and after I select the file, brush, or color I need, the palette closes automatically.

1.18

■ To set up a workspace, arrange the palettes and the **Tools** palette where you want them to be. Then choose **Window** ➤ **Workspace** ➤ **Save Workspace** to get the **Save Workspace** dialog box. Type in the name that you want to show up on the menu and click **Save** — that's it!

Next time you want to use a customized workspace, just choose Window ➤ Workspace and then click your customized setting.

Besides using customized workspace settings, Adobe has created a default setting for you. To use this default setting, choose Window ➤ Workspace ➤ Reset Palette Locations to get a workspace like the one shown in **Figure 1.20**, which is shown in a 1024 x 768 pixel desktop.

I should mention that you may occasionally lose a palette. After you select the Window menu, you see a check mark next to the palette that you want to display, but it is not viewable on your desktop. The reason is that it's been moved off the desktop. This frequently happens when you resize your desktop. To make all the palettes and the Tools palette viewable,

1.19

1.20

choose Window ➢ Workspace ➢ Reset Palette Locations.

STEP 9: SELECT STATUS BAR TYPE

Useful information about the image, the active tool, image processing speeds and efficiency, and so forth may be displayed at the bottom of the Photoshop 7 application window. This information is displayed in the Status bar. If you have the Status bar turned on, you will find it at the very bottom of the Photoshop 7 application window (Windows) as shown in **Figure 1.21**. If you don't see it, choose Window ➢ Status Bar to display it.

■ The **Status** bar can be set to show document sizes, document profile, document dimensions, scratch sizes, efficiency, timing, or current tool. To select the information that you want to display, click the menu button (the triangle icon) in the **Status** bar to get the menu shown in **Figure 1.22**.

I frequently set my Status bar to either Scratch Sizes to keep an eye on how large my images are getting or on Efficiency to see if it starts dropping, meaning I am running low on RAM. If you want to learn more about these settings, consult the Photoshop 7 Help or the printed User Guide.

1.21

1.22

2

CONTROLLING IMAGE WINDOWS

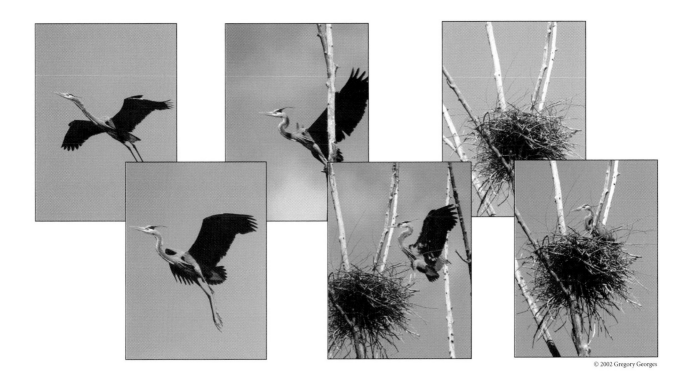

© 2002 Gregory Georges

Great Blue Heron Landing Canon D30 EOS digital camera, 400mm f/4.0 with 2X tele-extender, (six 480 x 640 pixels 900KB .jpg images: cropped & edited)

After reading this technique's title, you may be ready to skip it and head to the next technique. But, I've got a nickel here that says there is something worthwhile in this technique for everyone. Admittedly, I am a stickler for getting everyone to do all of the first six techniques in this chapter. If you do them in a step-by-step fashion, you are almost certain to learn a number of new functions; or, in the least case, you'll practice using the tips enough to make some of them become part of your regular work habits.

The six photos we use for this technique are of a great blue heron flying in to land on a nest built one hundred feet or more up in a dead tree. I have spent hundreds of hours watching these magnificent birds build nests and raise their young. One of the most spectacular events in life that I've seen is a young heron getting brave enough to take its first flight. They stand on a dead branch and look down almost like a small child getting ready to take a dive off a high dive into a pool for the first time. Sometimes they lean forward and they look like they are ready to jump, but at the last moment, they get scared and try to keep from falling. Usually prompted by a sibling in their nest, they finally make the jump and fly off.

STEP 1: OPEN FILES

■ Choose **File** ➢ **Open** (**Ctrl+O**) to display the **Open** dialog box. After locating the **\02** folder, double-click it to open it. Press and hold **Ctrl** and then click **heron1.jpg, heron2.jpg, heron3.jpg, heron4.jpg, heron5.jpg**, and **heron6.jpg** to highlight them. Click **Open** to open all six files in a cascaded stack in the workspace.

STEP 2: SIZE PHOTOSHOP APPLICATION WINDOW

Most application windows can be resized or expanded to occupy the entire desktop and so can the Photoshop 7 application window.

■ To make the Photoshop 7 application window fill the entire screen, double-click the Photoshop 7 application title bar. To return it to its previous size, double-click the application title bar once again.

■ You may achieve the same results by clicking the maximize button in the upper-right corner of the application window. One click and the window expands; click it again and the application window returns to its previous size.

STEP 3: SIZE DOCUMENT WINDOWS

■ Document windows can be resized by clicking the bottom-right corner of the document window; drag and drop to resize the document window as you like. Try resizing one of the heron document windows.

■ You can also work in a *maximized document window* view by double-clicking any document window title bar or by clicking the maximize icon in the upper-right corner of a document window. Click the maximize icon again and the document window returns to its previous size.

■ When in maximized document mode, you can easily change between any open document by choosing **Window** ➢ **Documents** and then selecting the document you want to view. Choose **Window** ➢ **Documents** and you get a menu that lists the name of all six of the open heron image files.

Alternatively, you can press **Ctrl+Tab** to cycle through all the open documents — even when you are in Full Screen mode with no menus.

The maximized document mode is a particularly useful mode when you want to select all of, or part of an image that includes one or more edges, as it allows you to click outside of an image and then drag the selection marquee or crop marquee as you choose. If a document window is not maximized, selecting an image all the way to one or more of its edges is hard.

STEP 4: CHANGE IMAGE ZOOM

■ To resize an image inside of a document window, use the **Navigator** palette, as is shown in **Figure 2.7**. You can increase or decrease the image size by using the slider, or by clicking on the increase or decrease image icons on either side of the slider.

■ Using the **Status** bar can also change image size within a document window. To turn on the **Status**

bar if it isn't already showing, choose **Window** ➢ **Status** bar. At the left end of the **Status** bar is an image magnification setting, as shown in **Figure 2.8**. To change the level of magnification, simply type in the percentage of image size that you want and press **Enter**.

■ To view an image at full-size, type **100%** in the **Status** bar zoom magnification box and then press **Enter** or click the **Navigator** increase or decrease size buttons until you get **100%**, or choose **View** ➢ **Actual Pixels** (**Alt+Ctrl+0**) or double-click the **Zoom** tool in the **Tools** palette to get to **100%**.

■ Sometimes, you want to make an image as large as possible while still showing the entire image. To accomplish this, you can choose **View** ➢ **Fit on Screen** (**Ctrl+0**), or double-click the **Hand** tool in the **Tools** palette.

■ If you select the **Hand** tool (**H**), the **Options** bar will display buttons for **Actual Pixels**, **Fit On Screen**, and **Print Size**, which are handy if they are accessible.

STEP 5: ORGANIZE DOCUMENT WINDOWS

Some projects require that you have more than one image open at a time and consequently, you have so much clutter, your productivity decreases. Photoshop 7 offers a number of ways to help you to organize document windows.

■ Document windows can be tiled by choosing **Window** ➢ **Documents** ➢ **Tile**. This opens up all the windows and sizes them so they all fit on the screen like tiles.

■ Document windows can also be cascaded by choosing **Window** ➢ **Documents** ➢ **Cascade**. When I need to work with two or three or more open images at once, I often tile document windows; then I switch back and forth between a maximized document window view and the tiled view.

■ You may also minimize document windows, which automatically places them in neat rows at the bottom of the Photoshop 7 workspace, as shown in **Figure 2.9**.

2.7

2.9

| 50% | Doc: 900K/900K | ▶ Draw rectangular selection or move selection outline. Use Shift, Alt, and Ctrl for additional options. |

2.8

STEP 6: VIEWING JUST WANT YOU WANT TO VIEW

■ When you have a document window open and the image is scaled at a size that makes it larger than the document window, you can move the image around inside the document window to view the portion of the image that you want. To do so, click inside the **Navigator** palette inside the red *view* box. Drag the red box inside the thumbnail image in the **Navigator** palette until it shows the portion of the image that you want to view.

Alternatively, you can select the **Hand** tool (**H**) in the **Tools** palette, and then click inside a document window to drag the image around within the document window. The best way to select the **Hand** tool is to hold down the **Spacebar**, which selects the **Hand** tool; then it turns the cursor to the **Hand** tool icon. Click in your image and drag it to where you want it. After you release the **Spacebar**, the **Hand** tool automatically reverts back to the previously chosen tool.

■ One other approach to view just what you want to view without having to worry about selecting viewing percentages is to use the **Zoom** tool. While you can click the **Zoom** tool (**Z**) in the **Tools** palette to select the **Zoom** tool, I suggest you get used to selecting the **Zoom** tool by pressing **Ctrl+Spacebar** as this approach allows you to **Zoom** quickly and then automatically return to your previously selected tool. After you select the **Zoom** tool, click and drag a marquee inside the image where you want to view it. After you release the mouse button, the document window shows the selected area centered in the document window — and the **Zoom** tool reverts to the previously selected tool.

■ Occasionally, you may find that you need to methodically examine or edit all of an image at a magnified level. For example, after scanning an image, you may want to check the entire image for marks caused by dust particles and other unwanted things. To do this using keystrokes, press **Page Up** or **Page Down** to have Photoshop 7 scroll the image a little less than a page's worth of pixels up or down. To move right or left when you get to the top or bottom of an image, press **Ctrl+Page Up** or **Ctrl+Page Down**. Use the **Navigator** palette to keep track of where you are in the image. Photoshop 7 also supports using the mouse wheels (the scroll wheels) to zoom in or out.

If the mouse is over a palette, the wheel will scroll the scrollbar for that window. If the mouse is over an image window the wheel will scroll the image. Holding down Alt/Option will zoom the image instead. The Control key means to scroll horizontally instead of vertically. The Shift key means to scroll or zoom by larged increments.

STEP 7: DISPLAYING MULTIPLE VIEWS OF THE SAME IMAGE

There are many reasons why you may want to have more than one document window open at the same time that shows the same image. For example, I am always very picky about having a catch-light in eyes when shooting people, pets, and wildlife. A catch-light is a highlight in an eye; without one an image generally is far less successful than if it had one. To create a catch-light or enhance one, you may need to zoom an image to 200% or more to select and edit the eye. At this zoom level, it is hard to see how your enhancements fit with the overall image. The solution to this problem is to open up a second window.

■ Click **heron2.tif** to make it the active image. Double-click the **Zoom** tool in the **Tools** palette to make sure the image displays at **100%**.

■ Click the **heron2.tif** document title bar and drag the document window to the left of your workspace.

■ To open up a second window showing **heron2.tif**, choose **Window** ➢ **Documents** ➢ **New Window**. Click the document title bar of this

new window and drag it to the right so that you can see the 100% view image on your left. To zoom in on the heron's eye, press **Ctrl+Spacebar** to get the **Zoom** tool. Then click inside the image and drag a marquee around the head of the heron to select the area you want to view.

You now have one window showing the heron at 100% and a second window showing the same image, only it is zoomed in to show the heron's head. You can now make edits in one window and see the results simultaneously in both windows, as shown in **Figure 2.10**. Notice how the other heron photos have been minimized at the bottom of the workspace.

STEP 8: MAXIMIZING VIEWABLE WORKING SPACE

When you open multiple palettes and multiple images, and then consider the space that goes to the Photoshop 7 application window, menu bar, Options bar, Status bar, and window scroll sliders — you don't have much space to view and edit images. But, you have ways where you can see it all!

- To turn off all palettes including the **Tools** palette, the **Status** bar, and the **Options** bar press **Tab** — they are gone! To get them back, press **Tab** again.

- For those picky types who also want to rid their screens of the Photoshop 7 applications window, the application title bar, and menu bar — press **F**. The first time you press **F**, the application window disappears and the active document window expands to fill the screen with the image. Press **F** again and the menu bar goes away.

Press **F** once more and your desktop is restored to its previous state. Pressing **F** allows you to cycle through three modes: **Full Screen View** with menu, **Full Screen View** without menu, and return to previous state.

The other way to switch between these different modes is to use the view controls at the bottom of the **Tools** palette just above the **ImageReady** button, as shown in **Figure 2.11**. The first button is for

2.10

2.11

Standard Screen View, the second for **Full Screen Mode** (with menu bar), and the last is for **Full Screen View** (without menu). While you can use these buttons, I suggest that you learn to use **F** — it is faster and much more convenient than moving a mouse and doing a click. Plus, you can use the **F** key anytime — even when the **Tools** palette is not showing.

I should also point out that when you are in Full Screen Mode, you can still use the Tab key to turn on the Menu bar, the Tools palette, and other palettes. Press Tab again to turn them off. If you want to move around your image, press the spacebar and the Hand cursor will appear allowing you to drag your image around to see what you want. Now you can see why it is so worthwhile to learn a few of the shortcuts that we covered earlier. Having such a clutter-free workspace allows you to concentrate more on your image, which ought to help you be more creative and get better results.

STEP 9: JUMPING BETWEEN PHOTOSHOP AND IMAGEREADY

Photoshop 7 comes with a powerful Web graphics application called ImageReady. If you use digital photos for Web pages, you will want to use the features in ImageReady.

■ To edit the active image in **ImageReady**, click the **Jump to ImageReady** icon (**Ctrl+Shift+M**) at the bottom of the **Tools** palette shown in **Figure 2.11** or choose **File** ➢ **Jump To** ➢ **ImageReady**.
This feature allows you to launch **ImageReady** with the image open. Jumping between applications allows you to easily use the full feature sets of both applications. Images updated in one application can be automatically updated in the other application by setting **Auto-update** in the **Edit** ➢ **Preferences** ➢ **General** dialog box. This preference only applies to when jumping to applications other than ImageReady and Photoshop. The image is always auto-updated between Photoshop 7 and ImageReady 7.

■ As soon as you are in ImageReady and you have completed your tasks, choose **File** ➢ **Exit** to close ImageReady and return to Photoshop 7.

STEP 10: CLOSE DOCUMENT WINDOWS

■ To close a document window, click the **Close Window** icon at the upper-right of the document window, or click a document window that you want to close to make it active, and then choose **File** ➢ **Close** (**Ctrl+W**).

■ To close all the open document windows, (Windows) choose **Window** ➢ **Documents** ➢ **Close All** (**Shift+Ctrl+W**). (If you have edited any of the images, you get a dialog box asking if you want to save changes before closing. If you do, click **Yes**, otherwise click **No**. If you realize that you need to save the edited files under another name or want to cancel the **Close All** command, click **Cancel**.)

You should now have a few tips and techniques in your mind that you will want to use often. While we all find a good tip every now and then that we intend to use, only the diligent souls actually put these tips into everyday use — it is these souls that ultimately become Photoshop 7 experts — the rest merely remain known as users. What are you going to be?

AUTOMATING TASKS

3.1
© 2002 Gregory Georges

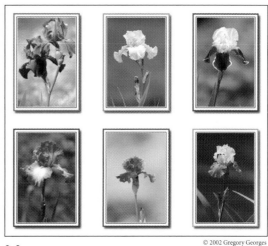

3.2
© 2002 Gregory Georges

Not long after you start using Photoshop 7 to digitally edit photographs, you become aware of the need for a way to automate many tasks that can either be repetitive or boring — or just to get them done as fast as possible. The Photoshop 7 response to this need is a trio of powerful features: Actions, Droplets, and Batch automation.

The process of creating properly sized photos and thumbnails for Web galleries can involve doing the same functions over and over and over and over until you go crazy! For this reason, we use a folder of six photos of an iris to show you how you can get more done, quicker, using the Photoshop 7 trio of go-faster features. Besides just sizing these six photos, we also create an automated frame Action so that they look better on a Web page.

STEP 1: USING A PRE-DEFINED ACTION

Before we create our own action, first use one of the many predefined Actions that come with Photoshop 7. That way, you can understand exactly what you are doing when you get to Step 2. Plus, you'll have an opportunity to see what Actions the inventive folks at Adobe created for you.

■ Choose **File** ➢ **Open** (**Ctrl+O**) to display the **Open** dialog box. Double-click the **\03** folder to open it and then click the **iris1.tif** file to select it. Click **Open** to open the file.

■ If the **Actions** palette is not showing, choose **Window** ➢ **Actions** to display the palette. Click the **Actions** palette menu button (the small tiny triangle in the upper-right corner of the dialog box) and select **Clear All Actions** to start off with an empty palette. Click **OK** when asked: **Delete all the actions?**
Click the **Actions** palette menu button once again. You should see at least six different sets of Actions at the bottom of the menu. At this time, click **Frames.atn** to load the **Actions** palette with actions for creating frames. The **Actions** palette should now look like the one shown in **Figure 3.3**.

■ The **Drop Shadow Frame** is a useful frame to use when creating images for Web galleries, so click the **Drop Shadow Frame** to make it the active action. If you click the triangle to the left of the **Drop Shadow Frame**, the action will open up and you can see each step it will take. At the bottom of the **Actions** palette, you'll find the **Play Selection** icon — it is the triangle icon — click it to run the selected action. Your image should now have a drop shadow as shown in **Figure 3.4**.
If you want to undo the **Action**, choose **File** ➢ **Revert**. You can also use the **Snapshot** feature in the **History** palette, but we skip that approach for now, as Technique 4 covers it.

As you can see, actions are recorded sets of commands and keystrokes that can be played back to repeat an edit process. This automation tool is really powerful, especially when you learn to use some of the other features it offers, too.

STEP 2: CREATING YOUR OWN ACTION

In the last step, we ran a pre-defined action. In this step, we are going to create an action that adds our

3.3

own customized border to an image for use in a Web gallery. Creating such a border manually can require many steps and be rather time-consuming. So, check out how we can automate the entire process to get it done error-free and best of all — quickly.

- Choose **File** ➢ **Open** (**Ctrl+O**) to display the **Open** dialog box. Double-click the **\03** folder to open it and then click the **iris1.tif** file to select it. Click **Open** to open the file.

Our first step is to reduce the size of the image so that when it is framed, it fits within a 640 x 640 pixel square. Next, we add a black line around the photo; then hand-select a color from the image to use for a wider outside frame. Finally, we add a drop shadow by using the pre-defined action that we used in Step 1.

- Set up the **Actions** palette as you did earlier in Step 1. It should show only the **Frames.atn** action set. Click the **Actions** palette menu button and

3.5

3.4

choose **New Set** to get the **New Set** dialog box. In the **Name** box, type in **50 PS 7 Techniques**. Click **OK** to create a new set. You should now see a new action set in the **Actions** palette at the bottom of the palette as shown in **Figure 3.5**.

■ To create a new action for the custom frame, click the **Create New Action** icon at the bottom of the **Actions** palette to get the **New Action** dialog box shown in **Figure 3.6**. Type in **Frame for iris**; then click **Record** to begin recording your steps.

Having done the math, I know the image needs to be 582 pixels tall. Using 582, we can add on the extra space and frames and still end up with an image that fits inside a 640 x 640 pixel square. Or you can use the Fit Image command, which will resize an image so it fits within a given rectangle.

■ Reset color swatches to a black foreground and a white background by clicking the **Reset Swatches** icon (**D**) that is at the bottom of the **Tools** palette next to the foreground and background colors. This sets the background color to white.

■ Choose **Image** ➤ **Size** to get the **Image Size** dialog box shown in **Figure 3.7**. First, make sure a check mark is in the box beside **Constrain Proportions** and then set **Height** to **582 pixels**,

which forces **Width** to change to **388**. Click **OK** to resize the image.

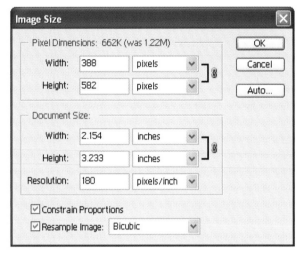

3.7

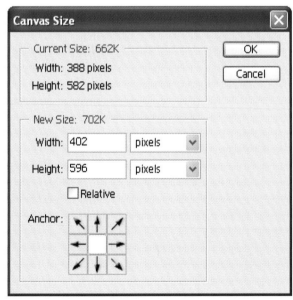

3.8

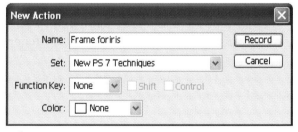

3.6

■ To add a 7-pixel white border around the image, choose **Image** ➢ **Canvas Size** to get the **Canvas Size** dialog box shown in **Figure 3.8**. Set **Width** to **402** (388 + 14) pixels and set **Height** to **596** (582 + 14) pixels; click **OK** to add white canvas.

You can also use the new-to-Photoshop 7.0 **Relative** check box in **Canvas Size**. Click on it and enter **14** pixels (7 × 2) for **Width** and **Height** and you get a 7-pixel border without having to do the math!

■ Choose **Select** ➢ **Select All** (**Ctrl+A**) to select the entire image.

■ Choose **Edit** ➢ **Stroke** to get the **Stroke** dialog box shown in **Figure 3.9**. Set **Width** to **2 pixels** to create a 2-pixel wide black border. Make sure that **Location** is set to **Inside** and then click **OK**. You should now see a 2-pixel black line all around the image.

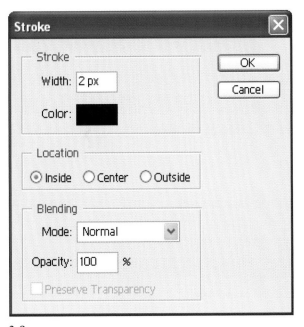

3·9

■ Now we add some more white canvas by again choosing **Image** ➢ **Canvas Size**. Set **Width** to **446 pixels** and **Height** to **640 pixels** to create a 22-pixel wide white border. Make sure to check **Relative**! Click **OK** to create extra canvas.

■ To create the outside border, choose **Select** ➢ **Select All** (**Ctrl+A**). Choose **Edit** ➢ **Stroke**. This time, we don't want to use black for the line; instead, we want to pick a color from the image itself. Click inside the **Color Box** in the **Stroke** dialog box and you get the color picker. Move the **Color Picker** so that you can see the image, and then click inside the image to get the color that you want. Keep clicking until you find something that looks good as a border color. I chose a deep green color that has **R**, **G**, and **B** values of **21**, **85**, and **17**, respectively. Click **OK** on the **Color Picker** dialog box to close it. Then make sure that **Width** is set to **6 pixels** and click **OK** to apply the colored border.

■ Now we add a drop shadow so that it appears to float over a white Web page. We do this by simply adding the **Drop Shadow Frame** action that we used in Step 1 to this action. Scroll up the **Actions** palette until you find the **Drop Shadow Frame** action. Click it to make it the active action, and then click the **Play** button at the bottom of the **Actions** palette. Photoshop 7 then does all the necessary work to create a drop shadow. We have just now added one action to another action.

If you look at the Layers palette, you'll find that it has created a background layer filled with white. If your intention is to use this action to create frames and drop shadows on images that are to go on a Web page that is any color but white, you can modify this action to make the background layer be the same color as your Web page. This enables the image to appear as if it hovers over the page as the image blends seamlessly with the Web page background.

■ Before saving the image, choose **Layer** ➢ **Flatten Image**.

■ To save the image for use on a Web page, choose **File** ➢ **Save for Web** (**Alt+Shift+Ctrl+S**) to get the dialog box shown in **Figure 3.10**. Set **Settings** to **JPEG Medium** and click **Save** to get the **Save Optimized As** dialog box. After naming your file and selecting an appropriate folder (for example, `c:\temp-iris-images`), click **Save** to create a .jpg file.

■ As your action is now complete, turn off the recording function by clicking **Stop Playing/Recording** button, the square icon at the bottom of the **Actions** palette.

Your image should now have a narrow black line plus a wider color outside frame plus a drop shadow like the one shown in **Figure 3.11**. If you want to save your action to your hard drive for future use, click the 50 PS Techniques actions set palette button to highlight it — then, click the Actions palette menu button and choose Save Actions.

STEP 3: DOING THINGS IN BATCHES

If you want, you can now open up one or more images and run the Frame for iris action on each photo individually. The only problem is that it runs without getting any input from you. This means that you have no option to select border colors and every one of your images will have the green frame! Go on — try it. Open up one of the other iris photos and run the action.

Lucky for all of us, you have a feature that allows you to stop any action on any command that uses a

3.10

3.11

dialog box. If you look at the Actions palette shown in **Figure 3.12**, two columns are running down the left side of the dialog box. The first column allows you to turn on or turn off a specific step. The second column indicates whether the step has a dialog box associated with it or not. If it does, it shows a gray box. If you look down the column, you see that there is a gray box next to the Stroke commands. The Stroke command is where we would need to change colors. If you were to click a specific step to make it the active step, you can then click the box to turn on show dialog box. Then, as the script runs, it stops at

that step after opening up the dialog box and waits for your settings before it continued. Pretty cool, 'eh — try it out.

- Look for the second **Stroke** command as the first **Stroke** command creates the thin black line and we want to use a thin black line on all the images. Click the second **Stroke** command to make it active and then inside the box to enable the dialog box function on this command.
- Now open another iris image and run the script again. Remember, you must click the name of the action that you want to run to make it the active action — in this case, the **Frame for iris photos** action. This time, when the script gets to the second **Stroke** command, it opens the **Stroke** dialog box and waits for you to select the color for the stroke. Only after you make any and all changes to the **Stroke** dialog box and click **OK**, will the script continue doing work for you!

Our goal was to create an action and run it on an entire batch of images. As our action has been completed and fully tested, we can now run it on the entire folder of iris images. All we need to do after the script is running is select the right border color for each of the images. Now that's what I call automation!

- One of the peculiar aspects about the **Batch** command is that it does not allow you to create new images in the same folder as the original images or in a folder that is a sub-folder of the

3.12

folder where the original images are stored. So, we first need to create a destination folder to place our new images after the action runs. I suggest that you create a temporary folder on your hard drive such as: **c:\temp-iris-images**.

■ Choose **File ➢ Automate ➢ Batch** to get the **Batch** dialog box shown in **Figure 3.13**. If you have not selected other actions since the beginning of this technique, **Set** should show **50 PS 7 Techniques** and the **Action** should be **Frame for iris**. If not, select them by using the menu boxes.

■ Set **Source** to **Folder** and click **Choose** to choose the source folder containing the six iris photos.

■ If you have set your color management policies to **Ask When Opening**, then you will want to also check **Suppress Color Profile Warnings**. This allows the script to ignore any color profile conflict alerts. These can be set in **Edit ➢ Color Settings**.

■ **Destination** should be set to **Folder**. Click **Choose** to select the temporary folder you set up for this exercise (for example, `c:\temp-iris-images`). Click **Override Action "Save As" Commands** to force the action to write the files to the folder selected in the **Destination** folder. Click **OK** to run the script and choose border colors.

Having seen all those steps flash before your eyes for just six digital photos just imagine how long and how crazy you might be creating the images needed for a Web gallery of around fifty or so photos without the Batch command.

If you want to, you can now go back and edit the `Frames.atn` action and add steps to do add copyright information, overlay a layer that includes a signature, or contact information, or even some basic image correction. Now that you understand how to create and use the Batch command, stop and think for a minute how it can be used to make your Photoshop 7 work easier. Then create the necessary actions and let Photoshop 7 do the work for you.

STEP 4: SAVING AN ACTION AS A DROPLET

A Droplet you might say — now pray tell, exactly what is a Droplet? Well it is the Adobe name for a feature that makes it easy to run an Action. While we can use any action, we can make one that you can use often. If you like to send digital photos as an attachment to e-mail, you'll find this one to be quite handy.

Before creating a Droplet, you must first have an Action. The Action we will create takes any image and reduces it to fit within a 640 x 640 pixel square and then saves it in a compressed .jpg format to a specific folder created especially for digital photos that are to be e-mailed.

■ Choose **File ➢ Open** (**Ctrl+O**) to display the **Open** dialog box. Double-click the **\03** folder to

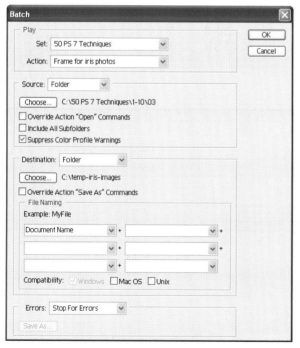

3.13

open it and then click the **iris4.tif** file to select it. Click **Open** to open the file.

■ Create a folder for saving digital photos that you want to e-mail. I suggest using a name like **c:_photos to e-mail**. The underscore makes sure the folder is listed at the top of your directory so that it will be easy to find.

■ Click the **50 PS 7 Techniques** action set to highlight it. Click the **New Action** icon at the bottom of the **Actions** palette to get the **New Action** dialog box. Type in **E-mail photo converter** in the **Name** box and click **Record** to begin recording.

■ Choose **File** ➤ **Automate** to get the **Fit Image** dialog box shown in **Figure 3.14**. Set both **Width** and **Height** to **640 pixels**; then click **OK** to resize the image.

■ Choose **File** ➤ **Save for Web** (**Alt+Ctrl+Shift+S**) to get the **Save for Web** dialog box. Make sure that **Settings** is set to **JPEG Medium** or **JPEG Low** if you want smaller files. Click **Save** to get the **Save Optimized As** dialog box. After locating the folder (for example, **c:_photos to e-mail**) where you want to save your photos, click **Save** to save the file.

■ Click the **Stop Playing/Recording** button at the bottom of the **Actions** palette and your action is complete.

■ To create a **Droplet**, choose **File** ➤ **Automate** ➤ **Create Droplet** to get the **Create Droplet** dialog box shown in **Figure 3.15**. Click **Choose** to get the **Save** dialog box. After locating the folder where

you want to save the files, (for example, **c:_photos to e-mail**), name the file with a name that makes it easy to know what it does, such as **photo converter**, and click **Save** to save the droplet. I suggest saving it to your desktop.

■ Toward the middle of the **Create Droplet** dialog box you find **Destination**; choose **Save and Close**. To avoid having to respond to a color management policies dialog box, make sure you check **Suppress Color Profile Warnings**. Then, click **OK** to create the **Droplet**.

You have now successfully created a droplet. If you saved it to your desktop, you can drag and drop a file from Windows Explorer or other file management program such as a thumbnail application and drop files onto the Photo converter icon — with or without Photoshop 7 being open. When you drag and drop a file onto the icon, Photoshop 7 automatically loads if it is not already open and then converts the

3.14

3.15

file. The file is then saved to your chosen folder ready for you to use as an e-mail attachment.

Droplets may be shared with anyone who has a copy of Photoshop 7 — you just have to make sure that you have not referenced a folder that does not exist on their PC.

So what do you think of these automation tools? The trick to getting things done quickly is learning how to quickly use these automation tools. Then, each time you have a repetitive task — automate it. As I shoot many sporting events like soccer and lacrosse games, I often run a script against a folder of digital photos. Using the Web Gallery feature (we'll cover that later in Technique 48), I can have a Web page uploaded within a few minutes with none of the tedium that would put me off from sharing my photos.

4

CREATIVE EXPERIMENTATION

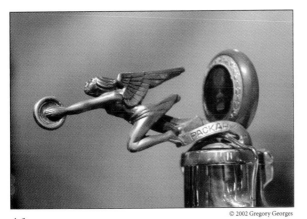

4.1

© 2002 Gregory Georges

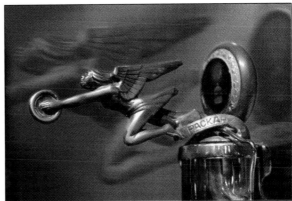

4.2

© 2002 Gregory Georges

Editing digital photos can often be a creative process requiring lots of experimentation. You try a few things. Then you back up one or more steps and try something different. Often that won't be what you want either; so, you want to back up to an even earlier step. Or, maybe you want to just go back and adjust settings. You may even go back and check out earlier steps and decide what you had was just fine, so you quit satisfied with your results. This back and forth process is a way of life for experienced Photoshop users.

I believe so much in creative exploration and the features that are available in Photoshop 7 to facilitate creative exploration, that this entire technique was created to both show you how and to give you practice in the magical Art of Back and Forth. In fact, we cover eight different ways you can undo, step back, change settings, and go forward in your edit process until your image is just the way you want it. Learn to use all these techniques and life with Photoshop 7 will be good.

31

STEP 1: OPEN FILE

■ Choose **File** ➤ **Open** (**Ctrl+O**) to get the **Open** dialog box. Double-click the **\04** folder to open it and then click the **packard-before.tif** file to select it. Click **Open** to open the file.

■ Before beginning any edits, open the **History** palette if it is not already on your desktop by choosing **Window** ➤ **History**. Move it to the right edge of your workspace. As you edit the image, notice how the **History** palette tracks each step.

STEP 2: CREATE NEW LAYERS

Conceptually, I have an idea about what to do to this image. It needs a better background with some kind of texture, richer colors, and I'd like to see the blue cast become more dramatic. My first idea is to create a new background layer and then find a good combination of a blur filter and layer blend mode. I'll warn you though — we are not going there straight away — rather we are going to do a few things to show Photoshop 7's features that help you do some serious creative experimentation. So, start this technique when you have twenty minutes or more and can concentrate — it will be worth the time you invest.

■ If the **Layers** palette is not open, choose **Window** ➤ **Layers**. To create a new layer from the background layer, choose **Layer** ➤ **New** ➤ **Layer from Background** to get the **New Layer** dialog box shown in **Figure 4.3**. Type **textured background** in the **Name** box and click **OK**.

The background layer is different from other layers in many ways — for one, it cannot be scaled without scaling the entire image. Therefore, because we are scaling the image, we use Layer ➤ New ➤ Layer

From Background, which transforms the background layer into an image layer.

■ We need one additional layer, so choose **Layer** ➤ **Duplicate Layer**. After the **Duplicate Layer** dialog box appears, type **ornament** in the **As** box and then click **OK**. You should now have two layers in the **Layers** palette, as shown in **Figure 4.4**.

After creating a duplicate layer, notice that the History palette is keeping a record of each command that you apply to the image. Each of these commands is called a *history state*. You should now have a history state named Make Layer and one named Duplicate Layer, as shown in **Figure 4.5**.

4.3

4.4

STEP 3: EDIT BACKGROUND LAYER

Now begin editing the textured background layer. To do so we first need to hide the ornament layer so that we can view the lower layer.

■ Using the **Layers** palette, click the **Hide Layer** icon (the eye icon) in the left column in the **ornament** layer to hide this layer.

■ Click the **textured background** layer to make it the active layer — it should now be highlighted.

To make the new background, we are going to scale the image, add some blur, adjust saturation, and then add noise.

■ To make it easy to scale the image, reduce the size of the image to **12.5%** by using the **Navigator**. Double-click the **packard-before.tif** document window title bar to maximize it. You should now have a small version of the image in the middle of a large gray workspace.

Choose **Edit** ➢ **Transform** ➢ **Scale** to get a bounding box with nine handles. Press **Shift** and click the upper-left handle and drag it up and to the left. Pressing **Shift** while dragging the bounding

box forces the proportions of the image to remain the same. The goal is to get an image that looks similar to the one shown in **Figure 4.6**. When you let up on the mouse button, you can click again inside the image and drag the image to position it. Depending on the size of your workspace, you may have to **Shift** click the upper-left handle and drag it up and to the left again to scale it properly. Then click and drag inside the image to position it until it looks like **Figure 4.6** — and then press **Enter**.

■ Choose **Filter** ➢ **Blur** ➢ **Radial Blur** to get the **Radial Blur** dialog box shown in **Figure 4.7**. Set **Amount** to **20** by typing in **20** or by sliding the slider until **20** is displayed. Make sure that **Blur Method** is set to **Spin** and that **Quality** is set to **Draft**, and then click **OK** to apply the settings.

■ To blend the two layers, click the **ornament** layer in the **Layers** palette to make it the active layer. Set the **Blend** mode in the **Layers** palette to **Multiply**. You should now see the ornament image overlaid onto the background texture layer.

4.5

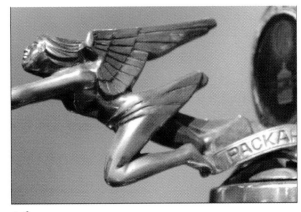

4.6

STEP 4: USING UNDO AND STEP BACKWARD/FORWARD

What do you think of the results? Not quite right for sure. I like the notion of using a blur, but Motion Blur might be a better blur. Also we need to lighten the background image so that the ornament stands out from the background. To do that, we must back up two steps and then apply the Motion Blur filter. There are several ways to go back, but first try using Undo.

■ Choose **Edit** ➤ **Undo Blending Change** (**Ctrl+Z**) and the blend mode is set back to normal. Now we need to go back one more step and undo the **Radial Blur** filter.

If you were to once again choose Edit ➤ Undo (Ctrl+Z), you would find that the menu now reads Edit ➤ Redo Blending Change (Ctrl+Z)! In Photoshop 7, the Undo feature is merely a *last step only* undo-redo feature — it cannot undo more than the last command. If you want to step back more than one step, you have to use another approach.

■ Choose **Edit** ➤ **Redo Blending change** (**Ctrl+Z**) to re-apply the blend mode.
■ This time, we step back two steps by choosing **Edit** ➤ **Step Backward** (**Alt+Ctrl+Z**). Now the blend mode has been undone. Choose **Edit** ➤ **Step Backward** (**Alt+Ctrl+Z**) one more time and the **Radial Blur** is removed. We are now back where we want to be.

STEP 5: USING THE HISTORY PALETTE

If you happened to watch the History palette, you would have noticed that each time you used the Step Backward command in the prior step, the History palette showed that you backed up one history state each time. The steps after the current history state are now grayed out.

Another approach and perhaps the easy way to go back one or more steps is simply to use the History palette.

■ Click the **Free Transform** state in the **History** palette (see **Figure 4.8**) to make it the current state, as it was the last state where we were happy with the results.
■ Now choose **Filter** ➤ **Blur** ➤ **Motion Blur** to get the **Motion Blur** dialog box shown in **Figure 4.9**. Set **Angle** to **– 7 degrees** and **Distance** to **60 pixels**, and then click **OK** to apply the blur.

As soon as the Motion Blur filter was applied, all the states in the History palette past the selected state immediately vanished. Now you have seen how you can move forward and backward in the History palette as you please — checking to see the image as

4·7

4.8

4.9

it was at each step. After you have gone back where you want to be, you can then continue to edit your image, and a new set of history states is created from that point on. Note for the one command that caused the old history to disappear, you have one chance to Undo and go back to that *previous future.*

STEP 6: COMPLETE EDITING OF BACKGROUND IMAGE

Okay, we need to finish editing the background image.

- Make sure that the **textured background** layer is highlighted to indicate it is the active layer. Also, make sure that the **ornament** layer is not visible (that is, the eye icon is not visible in the left column).
- Choose **Image ➢ Adjustments ➢ Hue/Saturation** (**Ctrl+U**) to get the **Hue/Saturation** dialog box shown in **Figure 4.10**. First click the box next to **Colorize** to turn it on. Then set **Hue**, **Saturation**, and **Lightness** to **40**, **20**, and **50** respectively. Click **OK** to apply the settings.

4.10

■ Now add grain by choosing **Filter** ➤ **Noise** ➤ **Add Noise** to get the dialog box shown in **Figure 4.11**. Set **Amount** to **10%**, **Distribution** to **Gaussian**, and turn on **Monochromatic**. Click **OK** to apply the filter.

STEP 7: EDIT ORNAMENT LAYER

Before we edit the *ornament* layer and blend the two layers, we first need to create a layer to edit and later use as when we begin painting color back into the image.

■ Click the **ornament** layer in the **Layers** palette to make it the active layer, and then choose **Layer** ➤ **Duplicate Layer** to get the **Duplicate Layer** dialog box. Type **paint layer** in the **As** box and click **OK**.

Next we blend the bottom two layers, make an adjustment and flatten just those two layers.

■ Click the **Hide Layer** icon in the **paint layer** layer to hide the layer.

■ Click the **ornament** layer to make it the active layer. The **Layers** palette now looks like **Figure 4.12**.

■ In the **Layers** palette, select **Multiply** as the **Blend** mode.

■ Choose **Layer** ➤ **Merge Down** (**Ctrl+E**) to merge the **ornament** layer with the **textured background** layer.

■ Choose **Image** ➤ **Adjustments** ➤ **Hue/Saturation** (**Ctrl+U**) to once again get the **Hue/Saturation** dialog box. Click the **Colorize** box to turn it on. Set **Hue** to **22**, **Saturation** to **8**, and

4.11

4.12

leave **Lightness** set to **0**. Click **OK** to apply the settings.

We now have a monochromatic image where the ornament somewhat stands out against a grainy background, as shown in **Figure 4.13**.

STEP 8: CREATING SNAPSHOTS

Using the **History** palette just as a *multiple undo/redo* feature makes it a valuable feature, but it offers far more capabilities. Next, look at how it can be used for making snapshots. Snapshots are nothing more than temporary copies of your image at a specific history state; however they can be very useful.

If you scroll up to the top of the History palette as shown in **Figure 4.14**, you find a snapshot titled `packard-before.tif`. If you don't see one, then your History palette settings are not set to Automatically Create First Snapshot. To set this option, click the menu button in the upper-right corner of the History palette to get a pop-up menu, and then choose History Options. Click in the box next to Automatically Create First Snapshot and then click OK to apply the settings. The next time you open up an image, it automatically creates this first Snapshot

for you. If you do not have a snapshot now, don't fret as it will not be needed for this technique.

Next we make some adjustments to the *paint layer* layer and make a snapshot that can be used in the next step.

- Click in the **paint layer** to make it the active layer.
- As we want richer colors, choose **Image** ➢ **Adjustments** ➢ **Hue/Saturation** (**Ctrl+U**) to get the **Hue/Saturation** dialog box. Set **Hue** to **0**,

4.13

4.14

Saturation to **40**, and **Lightness** to **0**. Click **OK** to apply the settings.

- Right-click in the last history state (it should be **Hue/Saturation**) in the **History** palette to get a pop-up menu. Choose **New Snapshot** to get the **New Snapshot** dialog box. Type **rich colors** in the **Name** box and click **OK**.

If you scroll to the top of the History palette, you should now see two snapshots, as shown in **Figure 4.15**; one named *rich colors*, which we just created, and one named `packard-before.tif`, which was created when the file was opened.

You may now be wondering what you can do with the snapshot we just created. Snapshots are similar to

4.15

a history state in the History palette, except you can name them, they don't get deleted when you run out of the maximum number of history states set in Preferences, and they show up at the top of the History palette with a thumbnail of the image at that particular state. If you saved a number of snapshots during an editing process, you could then flip through them to find the best one. Plus, you can use a Snapshot with the History Brush tool and the Art History brush as you do in the next step.

STEP 9: USING THE HISTORY BRUSH TOOL

To add some color back into the image, we are going to use the History Brush to paint the ornament back into the image by using the *rich colors* snapshot. Not only does this add some color, it eliminates all the grain that was put into the ornament when we blended layers.

- To select the **rich colors** snapshot for painting purposes, click in the snapshot activation box next to the snapshot at the top of the **History** box, as shown in **Figure 4.16**. Clicking this box sets the history state as the source for the History Brush tool. To see what is shown in the **rich colors** snapshot, click inside the thumbnail. You can now see the rich colors we selected earlier. To compare the saturated version with the original image, click the **packard-before.tif** thumbnail. To go back to the current history state, scroll all the way to the bottom of the **History** palette and click in the last state — it should be **Hue/Saturation**. You should now be viewing a saturated version of the original image.

The source image for painting with the Art History brush is now the *rich colors* snapshot. Next we need to select the layer where we will paint. We could paint directly on the *texture background* layer but this would make it difficult to correct over-painting. If we paint on a transparent layer, these mistakes can be fixed, plus we can have tremendous control over how

the painted layer looks and is blended with the *texture background* layer.

- To make it easy to correct our paint strokes and to give us some extra control over the results, click the **paint layer** in the **Layers** palette to make it the active layer.
- Choose **Select** ➢ **All** (**Ctrl+A**) and then **Edit** ➢ **Clear** to clear the layer to transparency.
- Choose **Select** ➢ **Deselect** (**Ctrl+D**) to remove the selection marquee.

We now have a transparent layer where we can paint the saturated ornament while allowing the *textured background* layer to show where we don't paint with the History Brush tool.

- Select the **History Brush** tool (**Y**) by clicking it in the **Tools** palette.
- Click the **Brush Preset** picker menu button (the second box from the left in the **Options** bar) as shown in **Figure 4.17**. Then select a brush size

from the drop-down palette shown in **Figure 4.18**. I suggest starting off with a soft brush around **45 pixels** in size. As you paint, you may want to change brush settings. Also, make sure the Options bar shows Mode set to Normal, Opacity to 100%, and Flow to 100%.

- I now suggest that you maximize your working space and make it as clutter-free as possible by pressing **F**, **F**, and then **Tab** to hide the palettes.
- To begin painting, press the left mouse button and begin painting inside of the ornament. As you move your cursor, you see that you are painting the saturated ornament onto the background image. If you make a mistake and paint outside of the boundaries of the ornament, you can select **Edit** ➢ **Step Backward** or **Edit** ➢ **Undo,** or you can select the **Background Eraser** tool from the **Tools** palette and touchup anywhere that is needed.

If you click the mouse button often while painting, you can step back a stroke when needed and not have to erase too much of your work. Also, remember that

![History palette]

4.16

4.18

4.17

you can press the Spacebar to get the Hand tool, which allows you to drag your image when you need to view more of it. Plus, you can zoom in to a size that makes it easiest for you to paint accurately. Using these tips, you should find it a real joy to paint on the image that is totally void of all tool palettes, menus, scroll bars, and so forth.

Besides painting with the History Brush tool, you may want to experiment with the Art History Brush tool. This tool is like the History Brush tool, but it paints with a variety of random brushstrokes much like those seen on paintings done by an Impressionist era painter.

STEP 10: USING ADJUSTMENT LAYERS

As we took the time to create a layer specifically to paint on, you can now begin your experimentation with different blend modes and any other filters and commands you want to try. My final bit of editing on this image was to use an adjustment layer and Levels. Like many of the other *go back and do it again* features we have used, Adjustment layers figure prominently in the list of these important features. While there are many advantages to using Adjustment Layers, suffice it to say for now that one of the biggest is that you can go back at any time and change the

settings without causing any picture information data loss.

■ Choose **Layer** ➢ **New Adjustment Layer** ➢ **Levels** to get the **Levels** dialog box. Try setting **Input Levels** to **40**, **1.00**, and **255**; click **OK** to apply the settings. You should now have an

4.19

adjustment level layer in the top of the Layers dialog box, as shown in **Figure 4.19**.

■ If you're not happy with the results, you can go back anytime and make changes to Levels by clicking the thumbnail in the adjustment layer — make your changes and click OK to apply them.

The main advantage to using adjustment layers is that you can go back and change settings that you made earlier rather than apply another Levels command, which would cause more loss of picture information.

After your painting is complete and you adjusted Levels as you want, you should have an image that looks similar to **Figure 4.20**.

STEP 11: USING REVERT

But suppose that after all the work you have done so far in this technique that you just don't like it all! Well then, use the Revert command.

■ Choose **File** ➢ **Revert** to reload the most recently saved version of a file, clearing any edits made since then.

The good news: Revert shows up as a History state, meaning that if you Revert and realize that you should not have written over the file, you can use the History tool to back up and un-Revert!

Admittedly, this was not an easy technique and it was a bit contrived so that you could learn as many ways as possible to jump around in your editing process to get the results you want. While we covered quite a bit in this technique, there is much more you can learn about the topics we just covered.

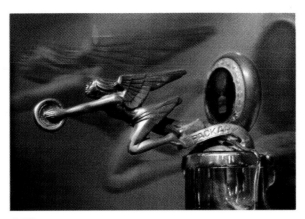

4.20

CALIBRATING YOUR MONITOR

5.1

5.2

ABOUT THE IMAGE

Sample Photos Canon EOS D30 digital camera, mixed lenses and settings, 2400 x 1920 pixels, 670KB .jpg file

I f you have not calibrated your monitor, then you really, truly, for sure ought to do so. While this is just the first of many steps you can take to move into a *fully color managed workflow*, your monitor ought to be calibrated even if you don't want to do much more. Calibrating your monitor is the one thing that needs to be done to ensure that you are reaping the benefits from your investment in equipment, time, and effort. It is straightforward and will take you less than ten minutes at most.

To calibrate your monitor, we use Adobe Gamma, which is a utility that has two important functions. First, it helps you to calibrate or adjust your monitor so that you can see the most accurate colors it is capable of displaying. Secondly, it creates a color profile that is used by Photoshop 7 and your PC's operating system to help display colors correctly. Both of these are very worthwhile functions providing that you take time to do them as well as possible.

43

If you want even more accuracy, then you may want to consider buying additional products that are far more accurate. You can find software only monitor calibration tools, and software/hardware combinations such as the ColorVision LCD/CRT Spyder and either their PhotoCal or OptiCal software.

Depending on your requirements, your hardware, and possibly some luck, you can do a pretty good job of calibrating your monitor with Adobe Gamma. The Adobe Gamma tool can be a particularly useful tool for some people as they seem to have a knack for getting good settings each time. So, try this technique first — then if you aren't happy with your results, do some research on current monitor calibration applications and hardware and try one of them.

STEP 1: GETTING READY TO CALIBRATE YOUR MONITOR

The success you have using Adobe Gamma is extremely dependent on lighting conditions. If you have direct sunlight from a nearby window or are wearing a white or bright colored shirt that is reflecting color or white light onto your monitor, you may as well not take the time to use Adobe Gamma. The best environment to calibrate your monitor and to make critical color adjustments is one with subdued light. As I work in a home office with nearly floor-to-ceiling glass on three of the four walls, I use a hooded monitor; I wear black or dark shirts when working, and I do most critical color correction early in the morning, in late evening, or the dark hours of the night (all Photoshop book authors know these hours all too well). Viewing the Adobe Gamma utility against a medium gray desktop also helps.

■ If you are using Windows, right-click on your desktop and choose **Properties** to get the **Display Properties** dialog box. Click the **Desktop** tab and choose the medium gray color by clicking the

Color box at the bottom right of the dialog box. Click **OK** to apply the setting.

Your monitor should have been on for an hour or more before using Adobe Gamma. Monitor colors take awhile to stabilize after a monitor has been turned on. Also, monitor colors can drift over time. Depending on your monitor and how often it is used, you may want to run Adobe Gamma every few months to ensure that the profiles match its current display characteristics.

STEP 2: OPEN FILE

Before opening Adobe Gamma, I suggest that you open a digital photo in Photoshop 7 to use as a *reality check*. When you get to Step 10, you have an option to switch back and forth between *before* and *after* settings. If you already have a digital photo open, you'll be able to more clearly see if you have improved your settings.

■ Choose **File ➢ Open** (**Ctrl+O**) to get the **Open** dialog box. Double-click the **\05** folder to open it and then click the **sample-photos.jpg** file to select it. Click **Open** to open the file. Double-click the image window title bar to maximize the document window. Then click the bottom-right-hand corner of the Photoshop 7 application window and drag it up to the left to make the application window about one-quarter of the size of your desktop. Then drag the Photoshop 7 application window to the upper-left of your desktop where it is out of the way of the small Adobe Gamma dialog box, which you open in Step 3.

STEP 3: LAUNCH ADOBE GAMMA

Adobe Gamma is a simple utility that can either be completed using a single dialog box or a Wizard that

displays each of the nine steps in nine separate dialog boxes. Either way, the whole process of adjusting your monitor can take less than a few minutes after you do it a few times.

■ As **Adobe Gamma** gets installed in the **Control Panel** during the installation of Photoshop 7, you launch it by double-clicking the **Adobe Gamma** icon after opening the **Control Panel**.

■ After launching Adobe Gamma, you get the dialog box shown in **Figure 5.3**. I suggest that you use the **Step By Step** wizard, which is the default selection. Click **Next** to confirm selection.

STEP 4: NAME NEW PROFILE NAME

While it appears that you are simply naming the new profile that you are creating in this step, in fact, you are selecting the profile that is used as the starting point for your calibrations, too! Therefore, selecting the best profile for your monitor is important, if possible. In theory, it may be possible to select an incorrect profile that simply will not allow you to properly calibrate your monitor. This initial profile is selected differently based upon your operating system and whether you are using a Mac or PC. In many cases, the

initial profile won't be the best choice. Selecting and loading a profile yourself is the best approach.

■ **Figure 5.4** shows the dialog box where you can click the **Load** button to select and load the best profile that is available for your monitor.

STEP 5: ADJUST MONITOR'S CONTRAST AND BRIGHTNESS

■ Click **Next** to display the dialog box shown in **Figure 5.5**. Set your monitor's contrast to the

5.4

5.3

5.5

highest setting — usually **100%**. Then, use the brightness control to make adjustments until the center box is as dark as possible, but not quite black, while keeping the frame white.

STEP 6: SELECT PHOSPHOR TYPE

■ Click **Next** to get the dialog box shown in **Figure 5.6**. Read the documentation you got with your monitor to determine the correct setting to use for **Phosphors** type is best.

If you can't ascertain the kind of phosphor that your monitor has, then look to see if you can see light gray lines running horizontally across your monitor — one approximately ¼ of the way down from the top and one ¼ of the way up from the bottom. If you see these lines, use the Trinitron setting. If you don't have

a Trinitron, odds are good that you will have good results using the P22-EBU setting as these two vendors manufacture the vast majority of monitors and these are the settings for those vendors.

STEP 7: ADJUST RGB GAMMA

■ Click **Next** and uncheck the box next to **View Single Gamma Only**. The dialog box should now have a red, green, and blue box, as shown in **Figure 5.7**, allowing you to adjust each color independently. The goal here is to adjust each of the three sliders so that the center box fades into the patterned frame, thereby removing any color imbalance in the monitor.

While it seems easy, it takes some practice especially with the green, which seems a little more difficult than

5.6

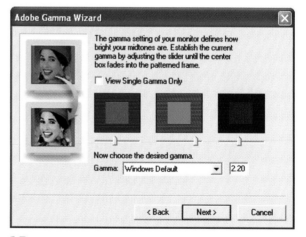

5.7

the other two. If you squint your eyes and turn your head slightly, you should be able to repeatedly set each of the three sliders in the same position each time. Adjusting does take practice, so try it a few times for each color until you have some confidence that you are setting them correctly. If you are way off, you'll know it and you can have another go at it! Sometimes looking away from the screen then back helps, too.

- If you are using Windows, set **Gamma** to **Windows Default** and the value of **2.2** will be displayed. Mac users should choose **Macintosh Default** and use the value of **1.8**.

STEP 8: SELECT HARDWARE WHITE POINT

- Click **Next** to get the dialog box shown in **Figure 5.8**. Adobe Gamma usually sets this setting

correctly itself. If your monitor allows hardware white-point settings (usually accessed via an on-screen menu controlled from buttons at the bottom of the display), then check to see that this setting matches the setting of your monitor.

STEP 9: CHOOSE ADJUSTED WHITE POINT

- Click **Next** to get the dialog box shown in **Figure 5.9**. In most cases, you simply want to leave the **Adjusted White Point Setting** to **Same as Hardware**.

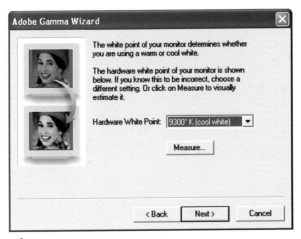

5.8

5.9

STEP 10: COMPARE BEFORE AND AFTER RESULTS

■ Click **Next** to get the dialog box shown in **Figure 5.10**. As you click the **Before** or **After** box, you can see the difference between the settings you had before you began using Adobe Gamma and the settings that you just selected. Should these before and after previews indicate that your

5.10

settings are worse than they were before you began, click **Back** until you get to the settings you need. Keep trying until you have the best settings you can get. Viewing the image you opened in Step 2 can help you to see the differences between *before* and *after* settings.

STEP 11: SAVE NEW PROFILE

■ After you are satisfied with the results, click **Finish** to get the **Save As** dialog box. You then are prompted to type in a name for the profile that you just created. I suggest you use a name that is similar to the original file name you started with, but add your initials and a date. That way, you can recognize that it is a file that you created from a default file, and you can see the date so that you know when you created it.

■ Click **Save** to save the file and close Adobe Gamma.

Your monitor should now be calibrated and you have created a monitor profile.

CONFIGURING BASIC COLOR MANAGEMENT

6.1

6.2

© 2002 Gregory Georges

ABOUT THE IMAGE

Decorative Gourds Canon D30 digital camera, 28-70mm f/2.8, ISO 100, RAW file setting, 2160 x 1440 pixels, converted to a 1.0MB .jpg

When I mention color management to photographers that use Photoshop, they usually have one of two different reactions. One is: What the heck is color management? The other: Oh no — what a nightmare! The fact is color management is truly not a piece of the proverbial *piece of cake* for sure. It is a complete and usually complex workflow that begins with the creation of a digital photo from a scanner or digital camera, then your PC display, and to any output device you use, such as your own photo-quality printer, a high-end printer at a service bureau, or a film recorder.

While you may be happy with your current results, you likely will have even better results if your workflow is color managed. You find some (but not all) of the key steps to correctly setting up your workflow in a fully color-managed environment in Technique 5. This technique and any of the techniques in Chapter 8 are appropriate for your chosen output device.

As the goal of this book is to provide you with 50 practical techniques for digital photos, complete coverage of how to set up color management is out of the scope of this book. However, without covering some of the basics of color management, you won't have the high level of success that I want you to have. So, the lofty goal of this technique is twofold: to give you a basic understanding of color management (while consuming just a few paragraphs) and to help you configure Photoshop 7 so that it is working with you to get the best results, rather than against you (which it can do if the wrong settings are used). While we cover all of the important settings, we avoid too much explanation about why you ought to use the suggested settings and skip some of the settings all together!

Before you begin clicking your mouse button and setting options, a conceptual understanding of color management can help you feel more comfortable with the settings you choose, and later on when you see dialog boxes pop up and ask you about how you want to handle mismatched color profiles.

Color management is a process whereby color maintains a consistent appearance across all the devices you use in your digital photography workflow. In other words, when you shoot a sky-blue sky over a barn-red barn with a digital camera or with a film camera — the sky remains the same sky-blue and the barn remains the same barn-red when you view it on your PC's display or as a final print made by an inkjet printer. That is the obvious intent for everyone for sure. However, the problems come from the many different devices that are used and because you can see colors your monitor cannot display and your printer cannot print.

Digital cameras, scanners, monitors, and output devices like printers all have different ranges of colors they can reproduce — called a color gamut and some have a wider range than others. These differences in color gamut and the need to precisely communicate color between devices cause the need for color management.

The approach used to solve both these problems is to use color profiles to define color gamut, embed these color profiles in image files, and then use a conversion engine to convert between two different profiles from different devices.

Look at a real world example. I use a Polaroid 4000 SprintScan film scanner for scanning slides. I use LaserSoft's SilverFast scanning software to scan and I have it set up to scan files and tag them as Adobe RGB (1988) files. When I open up the file with Photoshop 7, Photoshop 7 first checks to see if it has an embedded profile — which it does. As it is the same profile as my working space in Photoshop 7, no conversion is necessary. Then, Photoshop 7 along with a little help from the Windows XP operating system uses the color profile for my LaCie electron19 Blue III color monitor to display the image correctly. After completing any image editing, I can save the file (again with an embedded profile) or I can print it out to my Epson 1280 printer, which also uses profiles for each specific ink and paper combination that I use.

In that case, everything worked as it should. But now consider what happens when my photographer friend sends me a file he created on his PC. When I open it up, Photoshop 7 realizes that it is tagged as an sRGB file. Because I have set up color management on my PC, it asks me how I want to handle the mismatch in color profiles. After a clicking with an appropriate response, Photoshop 7 can then use its conversion *engine* to convert the file to my Adobe RGB working space or allow me to continue to work on it as it is.

So, the role of Photoshop 7 in setting up color management is a big one. It allows you to edit digital photos based upon the proper display profile, it allows you to convert profiles between different devices if you choose, and it lets you embed color profiles in files that you save.

My hope is that you now understand more about why we did what we did in the last technique when we used Adobe Gamma — we created a fairly accurate color profile for your monitor. Later in this technique

you set options for working space profiles, color management policies, conversion engines, and other stuff! Then in Chapter 8, you'll learn how to make accurate color prints by using color profiles. That in a nutshell (albeit a very tiny one) is color management.

STEP 1: OPEN SAMPLE FILE

If you have an image open when you open the **Color Settings** dialog box, you can use the **Preview** feature later in this technique to see how changes to the working space settings affect the image. If you just want to set the settings without using Preview, skip to Step 2.

- Choose **File** ➢ **Open** (**Ctrl+O/**) to get the **Open** dialog box. Double-click the **/06** folder to open it and then click **gourds.jpg** to select it. Clicks **Open** to open the file.

STEP 2: OPEN COLOR SETTINGS DIALOG BOX

- Choose **Edit** ➢ **Color Settings** (**Shift+Ctrl+K**) to display the **Color Settings** dialog box shown in **Figure 6.3**. If you don't see the bottom portion of the dialog box that includes **Advanced Color Controls**, click **Advanced Mode**. Besides giving you **Advanced Color Controls**, you also get a few more choices in some of the pop-up menus.
- As we are going to create new settings and save them under a new settings name, it doesn't matter what is currently shown in the **Settings** name box.
- Click the **RGB** box in the **Working** spaces section to see the available options. Based upon our earlier assumption that you are primarily editing digital photos and are printing them out on a consumer level printer, such as those made by Canon, Epson, or HP, select **Adobe RGB (1998)**. Notice

after you make a selection, as you move your cursor over the pop-up menu, the **Description** box offers short descriptions of the profile that you selected.

If you chose to open up the sample photo suggested in Step 1, look at it now while clicking the Preview on and off. This shows you the difference between the original setting and the setting that is currently selected. For example, if your original setting was Adobe RGB (1998) and your current setting is sRGB, you can see that the sRGB space is a much narrower color space. If you experimented with these settings, make sure you set the RGB setting back to Adobe RBG (1998).

- As the **CMYK** setting is of no use for our agreed upon purposes, you may leave the setting as it appears.
- If you are using Windows, select **Gray Gamma 2.2** as the setting for Gray. If you're using a Mac, use **Gray Gamma 1.8**. Once again, you can use the **Preview** feature to view the differences between these settings.
- Leave the **Spot** setting to **Dot Gain 20%**.

You have now correctly set up your working space. The next section determines color management policies, in other words, how you want Photoshop 7 to prompt you to handle files that you open up if they have an embedded color profile that does not match your current working space.

- Set **RGB** to **Convert to Working RGB**. There can be a good reason to use the **Preserve Embedded Profiles** too, so if you have an opinion or work flow that gives you a reason to use one over the other — do so.
- While you're not likely to work in the **CMYK** or **Gray** settings, you can leave them as they are.

■ Make sure that the box for **Ask When Opening** is checked in the **Profile Mismatches** area. This sets Photoshop 7 to ask you each time you open up an image file with an embedded profile how you want to handle any mismatch between your current working space and the file's profile.

■ Turn on **Ask When Pasting**. This ensures that you are asked how you want to handle any mismatch between a copied image and the image that you want to paste it into.

Conversion Options is the next area in the Color Settings dialog box. This is where you define how you want Photoshop 7 to convert your images when you have a profile mismatch. In other words, if you open a file with an embedded color profile and it does not match your working space — how should Photoshop 7 convert colors.

■ For the **Engine** setting use **Adobe (ACE)**. This selects the Adobe (ACE) engine as the module that makes the conversions from one color space to another color space.

■ Set **Intent** to **Perceptual**.

■ Leave **Use Black Point Compensation** turned on. This option determines how the darkest image information is handled during a conversion. If this option is off, the darkest neutral colors will get mapped to black, thereby making the overall colors out of balance.

■ Leave **Use Dither (8-bit/channel images)** on as it blends and combines some values in digital photos better than if it is off.

6.3

STEP 3: SAVE COLOR SETTINGS

You are now done and your Color Settings dialog box ought to now have the settings shown in **Figure 6.3**, with the exception that if you are using a Mac, you'll have a Gray Gamma 1.8 setting for Gray in the Working Spaces area.

- To save your **Color Settings**, click **Save** to get the **Save** dialog box. Photoshop 7 automatically opens the color settings folder, which you ought to use as it allows you to easily select your settings file as it will be displayed along with the built-in settings.
- Use a file name that allows you to determine that it is your custom setting and when it was created. For example, I used `gg01-10-02-ps7book.csf` to identify the settings I used for this book. The date lets me see when I created the settings.
- After you click **Save**, you get the **Color Settings Comment** dialog box shown in **Figure 6.4**. This dialog box allows you to add comments to further help you identify the purpose of the color settings file. After adding some descriptive text, click **OK** to save the file.

I grant you that you may have had to take my suggestions with a fair bit of trust. However, these settings will be pretty close to what you ought to have for editing and printing digital photos on consumer level printers. For those of you who want to learn more, I suggest that you consult one of the following resources.

- Ian Lyon's excellent Web site at www.computer-darkroom.com.
- *Photoshop 7 Artistry — Mastering the Digital Image*, by Barry Haynes and Wendy Crumpler.
- *Real World Photoshop 7* by David Blatner and Bruce Fraser.

That's it for the Photoshop 7 boot camp! If you have gone through each of these techniques in step-by-step fashion, you are ready to do any of the other techniques in the book in any order that you choose. Once you complete all of, or even most of, the remaining techniques, you will have the skills needed to survive and even thrive in the exciting new world of digital photography armed with the most powerful image-editing tool on the planet — Photoshop 7!

6.4

CHAPTER 2

CORRECTING, ENHANCING, AND RESTORING DIGITAL PHOTOS

Six of the seven techniques in this chapter are basic techniques that you can use on just about all digital photos. Technique 7 offers a couple of Photoshop 7 actions that help you to quickly edit images, whether it be one image or several folders of images. These actions are as quick and as good as most one-hour photo-processing services, offering editing speed and reasonably good results.

If you want to learn advanced techniques that give you superior results, then Techniques 8 through 10 will show you how to perform much more sophisticated editing, which generally result in far superior images. The next two techniques cover the important topics of removing noise and grain, and sharpening digital images. The final technique shows you a few of the many ways that you can add, edit, or view additional information about your images. Without a good understanding of all of these techniques, your images can be — the best they can be.

QUICK IMAGE CORRECTION

7.1

© 2002 Gregory Georges

7.2

© 2002 Gregory Georges

ABOUT THE IMAGE

Monarch Butterflies Canon EOS D30 digital camera, 300mm f/2.8 IS, ISO 100, Fine image setting, f/7.1 @ 1/160, 2160 x 1440 pixels, 1.1MB .jpg. Butterfly 2: Canon EOS D30, 28-70mm at 28mm, f/18 @ 1/15, ISO 100, RAW CRW format, converted to 9.3MB 8-bit .tif

Many serious photographers have been known to complain about the quality of prints made at one-hour processing labs. While they are quick and inexpensive, they often are not printed as well as they could be. The reason for the poor prints has to do with the limited amount of time that is spent correcting the images and the lack of skill of the processing lab technician. If you are now shooting with a digital camera, you will experience the same conflict between making the best possible images that can take lots of time to process, or take the "quick and dirty" approach to image editing.

This technique offers two customizable Photoshop 7 actions that can help you to quickly edit folders of images so that you can get 4" x 6" prints made, or so that you can make images that are ready to be placed on a Web page. Before I created these actions, I often did not share prints or Web images with those who wanted to enjoy them because it took too much time to *process* them all. Now I can shoot images of a lacrosse or soccer game, run an action on a folder, and have the images uploaded to a Web site in just

minutes. This action also makes it easy to make images that may be e-mailed. Using the second action and an Epson 1280 printer with a roll feeder, it is incredibly easy to make prints of any photos that I want.

If you need *quick and not always perfect* edits, this technique is for you. You might say this is the one-hour film processing technique versus the professional color lab processing technique, which we get to in the next technique.

Unfortunately, Actions which utilize the Stop command cannot be run by choosing the File ➣ Automate ➣ Batch command because the Stop command forces the Batch feature to be halted. Due to this idiosyncrasy, the action you use to automate the processing of digital photos requires that you manually open each photo that you want to edit. Because the new File Browser in Photoshop 7 allows you to view thumbnails of each image, it is a good feature to use to help you keep track of the photos that you plan to edit.

STEP 1: LOAD ACTION SET

On the Companion CD-ROM you find an action set that contains two actions: one for creating Web images and one for creating 4" x 6" 240 dpi prints. After opening this action set, you can select the action you want and run it on as many images as you like.

■ If the **Actions** palette is not showing choose **Window** ➣ **Actions**. To reset the **Actions** palette, click the menu button in the **Actions** palette (the small triangle in a circle icon in the upper-right

7.3

corner) and choose **Clear All Actions** from the pop-up menu. Click **OK** when presented with a dialog box asking if you want to delete all actions.

■ You are now ready to load the **One-Hour Processing** action set. Assuming that you copied files from the Companion CD-ROM as suggested in the Introduction, you can load the **Action** set by clicking the menu button in the **Actions** palette and choosing **Load Actions** to get the **Load** dialog box. After locating the \07 folder, choose the file named **One-Hour Processing.atn**. Click **Load** to load the action set. The **Actions** palette should now look like the one shown in **Figure 7.3** with one action for 640 x 640 Web images and one for 4" x 6" prints.

If you plan on using these Actions often, you may want to copy the One-Hour Processing.atn file to the /Adobe/Photoshop 7.0/presets/Photoshop Actions folder.

STEP 2: OPEN FILE

■ Choose **File** ➣ **Open** (**Ctrl+O**) to display the **Open** dialog box. Double-click the \07 folder to open it and then click the **butterfly-before.jpg** file to select it. Click **Open** to open the file.

■ Double-click the document title bar to maximize the image in the workspace.

STEP 3: RUN 640 X 640 WEB IMAGES ACTION

■ Now run the action for Web images. Click the triangle to the left of the **1-hour processing 640 x 640 Web images** action to open it up. Click the minimize button once in the upper-right corner of the **Actions** palette to open up the **Actions** palette to show all the steps as shown in **Figure 7.4**. You can click the lower-right corner of the **Actions**

palette and drag it out toward the right so that you can view all of the steps.

■ Click the **1-hour processing 640 x 640 Web images** action to make it the active action.

■ Click the **Play Selection** button (the triangle icon) at the bottom of the **Actions** palette to run the action. You then get a message dialog box such as the one shown in **Figure 7.5**. As the image needs to be straightened, click **Stop**. When working with an image that does not need to be straightened, click **Continue**.

You can also put the Actions palette into Button Mode via the Actions palette menu button; then you can just click on the button with action name on it.

STEP 4: STRAIGHTEN IMAGE

Many photos need to be straightened. Buildings or horizons may look tilted, or as is the case with the image of the butterfly, the *specimen photo* needs to be slightly rotated toward the left. The process of straightening an image can be a trial and error process, unless you know about the incredible Measure tool tip, which has been built into our action.

■ Click and hold your cursor on the **Eyedropper** tool in the **Tools** palette until you get a pop-up menu; choose **Measure** tool.

■ Click once in the image just above the center of the butterfly's head and drag down toward the tail of the image as shown in **Figure 7.6**.

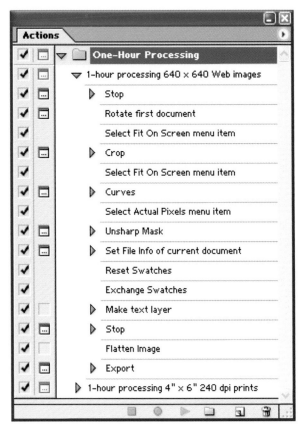

7.4

7.5

7.6

■ Click on the **Play Selection** button at the bottom of the **Actions** palette to continue the action to get the **Rotate Canvas** dialog box shown in **Figure 7.7**. Notice that a value automatically is placed in the **Angle** box and that **CCW** (Counter Clock Wise) is checked. This value is for the degrees of rotation needed to straighten the image. Click **OK** and you have a perfectly straightened image on the first try.

STEP 5: CROP IMAGE

While it is possible to crop an image by using the Rectangular Marquee tool, many more options are available when using the Crop tool. One of the challenges of cropping an image is to show what you want to show while having the correct height and width ratio for your intended output. If you intend to print a folder of images as 4" x 6" prints, you need to crop with a 4 to 6 width-to-height ratio. As this action has been created to make Web images where the longest side is 640 pixels, it will create a 640 x 480 image — a standard Web page image size.

■ The action will automatically place a crop marquee on the image with 640 x 480 proportions.

7.7

■ Click on the handles in the corners of the selection marquee to adjust the selection size. To center the butterfly in the selection marquee, you can click inside the marquee box and drag it to where you want it, as shown in **Figure 7.8**. You can also increase or decrease the size of the selection marquee box by clicking one of the four handles and dragging them until it is sized as you want. For more precise position of the selection marquee box, you can press the **Up**, **Down**, **Right**, and **Left** arrow keys to move the selection marquee box one pixel at a time. To move the box 10 pixels at a time, press and hold the **Shift** key while pressing the arrow keys.

■ After the selection marquee box is as you want it, click the **Commit Current Crop Operation** icon in the **Options** bar. The action will then continue.

STEP 6: CORRECT TONAL LEVELS AND ADJUST COLORS

Adjusting overall tonal range of an image and making color corrections are often two of the most

7.8

time-consuming steps in digitally processing digital photos. With the Photoshop 7 new Auto Color tool, these steps are reduced to a single-click command. However, you ought to be aware, that even though this tool is an improvement over previous *auto* functions, the results can be somewhat less effective than you may want. Certain images can also fool the automatic logic and make it misbehave. It is worth knowing how the underlying mechanism works so you can make the necessary corrections manually if need be.

- After committing the crop selection in the prior step you will automatically be presented with the **Curves** dialog box shown in **Figure 7.9**
- The first time you run this action on an image, check to make sure the initial settings for the **Auto**

Color feature are what they should be. To access these settings, click the **Options** box in the **Curves** dialog box to get the **Auto Color Correction Options** dialog box shown in **Figure 7.10**. For this technique, I suggest that you click **Enhance Per Channel Contrast** in the **Algorithms** area and click the box next to **Snap Neutral Midtones** to turn it on. Click the box next to **Save as Defaults** to place a check mark in that box. Click **OK** to save the settings. The next time you run the action, you can either change these settings if needed or skip opening this dialog box.

- Click **OK** to apply the settings.

7.9

7.10

STEP 7: SIZE IMAGE

The action automatically resizes the image to fit within a 640 x 640 pixel box; in this case, it makes the image 640 x 480 pixels.

STEP 8: SHARPEN IMAGE

After automatically sizing the image, the action sets the image to 100% and opens the Unsharp Mask dialog box shown in **Figure 7.11** so that you can make any adjustments to the image that are needed to sharpen it.

■ I suggest that you set **Amount 150%**, **Radius** to **1.0 pixels**, and **Threshold** to **2 levels**. Click **OK** to sharpen the image.

7.11

STEP 9: ADD METADATA

The latest versions of JPEG, TIFF, PSD, EPS and PDF files all allow a wide-range of information or data (known as metadata) to be added to picture files. Depending on the application, this data can be viewed, added, or modified for a wide variety of uses. For example, if you enter a title, caption, copyright information, credits, or other information to an image file, the Photoshop 7 Web Photo Gallery feature can use this information to create HTML pages that display the metadata.

■ Once again, the action automatically opens the next dialog box — the **File Info** dialog box shown in **Figure 7.12**. It also displays some default values. Type **Eastern Tiger Swallowtail** in the **Title** box and **Papilio Glaucus Linnaeus** (the scientific name of the butterfly) in the **Caption** box. Click in the **Copyright Status** box and choose **Copyrighted Work** from the pop-up menu. Type **Alt+0163** to put a copyright symbol in the **Copyright Notice** box. Then type **2002** and your name to complete the copyright notice. If you want to add a URL, then type the URL in the **Owner URL** box.

7.12

■ Click **OK** to save the information in the image file.

Incidentally, you can view all of the camera settings that I used when I shot the photo by clicking in the **Section** box in the **File Info** dialog box and selecting **EXIF**. Now you know my secret in being able to know exactly what camera, lens, ISO setting, image setting, F-Stop, Exposure time, and so on were used to take each and every digital photo!

STEP 10: ADD COPYRIGHT INFORMATION TO IMAGE

Besides adding copyright information inside the file, you may also want to put your name, or company name, and a copyright date on each image. This action is set up to automatically place *my* name and a copyright on each image automatically.

■ After the action places the copyright information on the image, it will display a dialog box asking if the copyright text needs to be moved on the image. If so, click the **Stop** button to stop the action. To move the copyright notice, click the **Move** tool (**M**) in the **Tools** palette and click the text and drag it until it is where you want it to be.

■ To restart the action, click the **Play Selection** icon at the bottom of the **Actions** palette.

■ If you don't need to move the text, click the **Continue** button.

STEP 11: FLATTEN IMAGE AND SAVE FILE

■ The action automatically flattens the image and then opens up the **File Save for Web** dialog box shown in **Figure 7.13**. Click in the **Settings** box and choose **JPEG Medium**. Click **Save** to get the **Save Optimized As** dialog box. Select the folder where you want to save your image and click **Save**.

■ The action has now completed all the steps and moved the active step highlight back to the beginning so that you are ready to open another image and run the action on another image!

Now try running the 1-Hour 4" x 6" 240 dpi prints action on the `butterfly2.tif` image. This action is very similar to the first action, except it automatically creates images suitable for printing on an inkjet printer. If you have an inkjet printer that has a roll paper option, you can batch process an entire folder of images and then print them out by using a 4" wide roll of inkjet paper. The Epson 1270 and 1280 inkjet printers are excellent printers to use when you want to print a roll of 4" x 6" prints.

You have just run one of the two actions in the One-Hour Processing action set. Just as easily, you could run an action on any image to complete quick image processing to make a 4" x 6" 240 dpi print by simply selecting the other action (1-hour processing 4" x 6" 240 dpi prints) in the action set.

Additionally, you can customize either of the two actions by turning on or off any of the steps in the actions by clicking a box in the left side of a step in the Actions palette. If you want to add steps or modify any of the existing steps, you can click in the action where you want to make changes, click the

7.13

Begin Recording icon at the bottom of the Actions palette, and complete the step you want to add or modify. After you have completed the step, click the Stop Recording button. You may then need to delete the step you replaced. To make changes to settings like those found in the File Info dialog box, double-click the step to open any dialog boxes that the step might include; in this case, you double-click the Set File Info of current document step to get the File Info

dialog box. Type in your changes and click OK. Next time you run the action, you use the new settings.

Finally, I should mention that if you removed or turned off those steps that include the Stop command, you can automatically run one of the actions against an entire folder of images by choosing the File ➤ Automate ➤ Batch command. Using this feature, you don't even have to select, open, save, and close the images.

ADVANCED IMAGE CORRECTION

8.1 © 2002 Gregory Georges

8.2 © 2002 Gregory Georges

ABOUT THE IMAGE

Bald Eagle Canon EOS D30 digital camera, 300mm f/2.8 IS, ISO 800, f/14.0 @ 1/100, 16-bit RAW setting, 1440 x 2160 pixels converted to 18.7MB 16-bit .tif

In the previous technique, you looked at how you can rapidly make corrections to one or more images — with speed of editing being the driving force behind tool selection and editing process. In this technique, we take all steps necessary to make the bald eagle photo look as good as possible regardless of how long it takes. As you may expect, this editing process takes much longer and requires some skill and knowledge about several of the more advanced features of Photoshop 7.

As this is a 16-bits per channel digital photo, my recommendation is that you edit this image once in 8-bits per channel mode and then edit it again (without adjustment layers) in 16-bits per channel mode. You have benefits and drawbacks to both approaches and learning about them is worthwhile if you have the option of using 16-bits per channel images. If you are good with the Photoshop 7 editing tools, you can get a better image when taking advantage of the wider tonal range found in the 16-bits per channel image — but, you must get your settings correct the first time.

STEP 1: OPEN FILE

■ Choose **File** ➢ **Open** (**Ctrl+O**) to display the **Open** dialog box. Double-click the **\08** folder to open it and then click the **eagle-before.tif** file to select it. Click **Open** to open the file.

STEP 2: PERFORM QUICK ASSESSMENT OF IMAGE

If you are serious about making the best possible image from a digital photo, you must have an overall editing strategy, you must use the appropriate tools *correctly*, and you must perform the steps in the proper order. A quick assessment of the original digital photo is the best way to determine your editing strategy.

■ Determine if the image uses 8-bits per channel or more by choosing **Image** ➢ **Mode** to get the menu shown in **Figure 8.3**. Because a check mark is next to **16Bits/Channel**, we know that the image is a 48-bit image (16-bits per each of the red, green, and blue channels).

When performing basic tonal and color corrections, each application of the Levels, Curves, Hue/Saturation, and Color Balance commands further degrades the image (although it may look better). To give users the flexibility of changing the settings for these commands without having to reapply them, which would further degrade the image, Photoshop 7 allows the creation of adjustment layers for each of these commands. At any time during the edit process, you can click an adjustment layer and adjust the settings without further degrading the image. However, these useful adjustment layers cannot be used on images that have more than 8-bits per channel.

So, the good news about the eagle image is that it has 65,536 tonal values per color channel, which results in a higher quality image than a 16-bit per channel image, which has only 256 tonal values per color channel. The bad news is that we cannot use adjustment layers until the mode is changed to 8-bits per channel.

If the goal were to end up with the best possible image, you would apply Levels and Curves to the image first, change mode to 8-bits per channel, and then complete the editing process by using Adjustment layers when possible. Instead, for this example, change the mode to 8-bits per channel to start with and use adjustment layers throughout the

8.3

process so that you have the benefit of being able to tweak the image at any time by using adjustment layers. After you have gained experience with this image, go back and edit it in 16-bit mode and see if you can improve the final results by using the higher bit mode — just make sure you get the settings correct on the first pass and do not apply the commands more than once.

- Choose **Image** ➢ **Mode** ➢ **8Bits/Channel**.
- Choose **Image** ➢ **Adjustments** ➢ **Levels** (**Ctrl+L**) to get the **Levels** dialog box shown in **Figure 8.4**. At a glance you can see that the image lacks values on the right side of the histogram, which indicates the image lacks highlights. Yet, looking at the left side of the histogram, you can see that there are plenty of values in the shadow area; hence, the reason the image looks dark and flat. Next, take a quick look at each of the channels in the **Levels** dialog box by pressing **Ctrl+1**, **Ctrl+2**, and **Ctrl+3**. Alternatively, you can click in the Channel box in the **Levels** dialog box and click each channel from the pop-up menu. As you switch between channels, you'll notice the right ends of each channel histogram ends at a different value. This tells you a colorcast likely needs to be removed.

- Click **Cancel** to close the **Levels** dialog box.
- Take one more look at the image to determine any other important issues that you need to keep in mind while editing. Because of what you learned from **Levels**, you know that the tonal range can be spread out considerably, which helps improve the contrast, but such spreading of the tonal range may cause posterization. The eagle could be improved dramatically if there were more contrast in the dark feathers. Finally, you want to avoid increasing contrast in the white feathers to the point where you get posterization, as they already appear to have some blown-out highlights that are hidden by low contrast level of the image.

With this insight about the image, our editing strategy is:

1. Adjust overall tonal range by using Levels.
2. Remove color cast by using Levels if it remains after using eyedropper tools in Levels.
3. Increase contrast in dark feathers by using a Curves and a layer mask.
4. Adjust color by using Hue/Saturation.
5. Make final adjustments by using previously created adjustment layers.
6. Duplicate image, flatten image, and sharpen image.

STEP 3: FIND DARKEST AND LIGHTEST POINTS

From our work in the prior step, we know that we have a color cast to remove. As the eagle's white feathers is the best place to check for and remove the color cast, place an eyedropper point on one of the feathers. Doing this allows you to continuously monitor the colors (or lack of color) in the white feathers as you do the editing.

- To be precise when doing color corrections, you can do your work by the *numbers* by using the **Color** and **Info** palettes. If they are not showing, choose **Window** ➢ **Color** and **Window** ➢ **Info**. I

8.4

suggest that you slowly drag the **Info** palette by the **Info** tab toward the bottom of the **Color** palette to combine them, as shown in **Figure 8.5**.

■ Choose **View** ➢ **Actual Pixels** (**Alt+Ctrl+0**) to display the image at **100%** so that picking the best white-point is easy. Press the **Spacebar** to get the **Hand** tool. Click and drag the image until the eagle's head is in full view.

■ Click the **Eyedropper** tool (**I**) in the **Tools** palette. Click inside the **Sample Size** box in the **Options** bar and choose **3 by 3 Average** from the pop-up menu, which makes it easier to get a good reading with the eye-dropper tool.

■ Click and drag in the image across the white feathers. As you drag, watch the values in the RGB values in the **Info** palette and the **foreground color** in the **Color** palette. You'll notice that the blue values are usually higher than the red or green values indicating that we have a blue cast to remove.

8.5

■ To set a point, press **Shift** to switch temporarily from the **Eyedropper** tool to the **Color Sampler** tool and click in the image in the lightest area that you can find on the top of the eagle's head, as shown in **Figure 8.6**. Now look at the **Info** palette. You should now see a **#1** point with values for **R**, **G**, and **B**. The point I picked directly above the eagle's eye shows red, green, and blue values of **181**, **204**, and **235** respectively. Since this point is supposed to be white, all the color channel values should be close to equal. Yet there is a **54** point difference between the red and blue values — a definite blue colorcast for sure!

This point gives us a good *white* point to use to monitor colorcasts, but it may not be the brightest white, which we need to set accurate overall white and black points.

■ Choose **View** ➢ **Fit on Screen** (**Ctrl+0**) so that you can see the entire image.

■ To find the lightest point in the image, choose **Image** ➢ **Adjustments** ➢ **Threshold** to get the **Threshold** dialog box shown in **Figure 8.7**. Click the slider and drag it all the way to the right and then slowly bring it back toward the left until you see a small amount of white in the image, as shown in **Figure 8.8**. The **Threshold Level** should be around **195** in the **Threshold** dialog box.

8.6

- Press **Shift** and drag the cursor over the white area at the top of the image while watching the *second* number in the **R**, **G**, and **B** values in the **Info** palette. You'll notice that R, G, and B values

have two numbers; the first, before Threshold, was applied and the second number is the value after Threshold is applied. So, when you have the cursor positioned over a point that shows **255**, **255**, and **255**, press **Shift** and click to set a point. Looking at the bottom of the **Info** palette you now see the values for the **#2** point.

8.7

- Now you must set the darkest point. To find it, click the slider in the **Threshold** dialog box and drag it all the way to the left and then slowly drag it to the right until you only see a small amount of black in the image, as shown in **Figure 8.9**. The **Threshold Level** in the **Threshold** dialog box should be around **10**.

8.8

8.9

■ Press **Shift** and drag the cursor over the largest black area in the image while watching the **R**, **G**, and **B** values in the **Info** palette. When the second numbers following **R**, **G**, and **B** are **0**, **0**, and **0**, click to set a third point. Looking at the bottom of the **Info** palette you now see the values for the **#1**, **#2**, and **#3** points, as shown in **Figure 8.10**.

■ Click **Cancel** to close the **Threshold** box. You should once again see the eagle; only you now ought to see the three points that were just set. Each of them will be numbered.

STEP 4: INCREASE TONAL RANGE

We now have located the lightest (#2) and darkest (#3) points in the image and are ready to increase the tonal range. To do so, we use an adjustment layer that lets us change our settings should we need to at a later time, without further degrading the image.

■ To view the entire image, choose **View** ➤ **Fit on Screen** (**Ctrl+0**). Arrange your combined **Color** and **Info** palette to the side so that you can see the values and colors, but still see the entire image.
■ Choose ➤ **Layer** ➤ **New Adjustment Layer** ➤ **Levels** to get the **New Layer** dialog box. Type **Background Levels** in the **Name** box and click **OK** to get the **Levels** dialog box shown in **Figure 8.11**.
■ Click the **Set White Point** eyedropper, which is the last of the three eyedroppers in the bottom-right corner of the **Levels** dialog box. Click inside the

8.10

8.11

small circle next to the **#2** marker (the lightest point) in the image to increase the tonal range toward the right side. The image now looks remarkably better.

■ Click the **Set Black Point** eyedropper, which is the first of the three eyedroppers in the bottom-right corner of the **Levels** dialog box. Click inside the small circle next to the **#3** marker (the darkest point) in the image to increase the tonal range toward the left side. Once again, you should see a significant improvement in the image.

Before applying the settings, click in the Channel box in the Levels dialog box and select each of the channels to see how the end points were adjusted. After these settings are applied, the tonal range is stretched out to include the full tonal range from pure black to white, which increases the contrast — in this image, quite dramatically.

Now look at the R, G, and B values for point #1 in the Info palette. The values for the point I selected now show 254, 252, and 250. These are quite close indicating that the Levels eyedropper tools did a good job of increasing the tonal range, plus it removed the blue color cast. If there were a signifi-

cant difference in the values for point #1, you would now adjust the appropriate color channels to remove the color cast. The values shown for point #1 are your guide. This process is known as *adjusting colors by the numbers*.

■ Click **OK** to apply the **Levels** adjustment layer. The **Layers** palette should now look like the one shown in **Figure 8.12**. If you look in the **Info** palette, you can now see that the red, green, and blue values are just about equal for all three points, which means that the color cast is now gone.

STEP 5: INCREASE CONTRAST IN DARK FEATHERS

The next challenge is to see if we can increase the contrast in the dark feathers without causing posterization in the white feathers or wreaking havoc with what is now an excellent background. To accomplish this objective, use Curves and a mask layer to protect the entire image from being changed except for the dark feathers area.

■ Choose **Layer** ➢ **New Adjustment Layer** ➢ **Curves** to get the **New Layer** dialog box. Type **Dark Feathers** in the **Name** box; click **OK** to get the **Curves** dialog box.

To increase contrast in the dark feathers area, we need to increase the slope of the Curves line to make the feathers look just as we want them. When making these adjustments, don't be concerned about the rest of the image because we'll mask it out.

8.12

■ Click and drag the cursor all over the image where dark feathers are while watching the point slide up and down in the **Curves** dialog box. You notice that it pretty much stays in the bottom-left corner — therefore this area of the curve needs adjusting.

■ To increase contrast, slope must be increased, so click the line and pull down and to the right. Type **27** and **23** in the **Input** and **Output** box to set the first point.

■ Click the line above the first point to set a second point. Type **63** and **77** in the **Input** and **Output** boxes. The **Curves** dialog box should now look like the one shown in **Figure 8.13**. If you want to make adjustments to these points, you can click either point and use the arrow keys to move them up, down, left, or right one level at a time. As soon as you have the two points set correctly, click **OK** to apply the settings. Incidentally, if you need to reset **Curves**, press **Alt** and the **Cancel** button will change into a **Reset** button; click **Reset** and you are ready to continue adjusting the curve. If you set a point that you no longer want, just click it and drag it off the **Curves** dialog box.

■ Click **OK** to apply **Curves**.

STEP 6: PAINT LAYER MASK

If you watched closely as the points were set in the Curves dialog box, you notice how the white feathers have become horribly posterized. The background does not look as good as it did before, either. But the feathers look awesome! Now we use the best parts of "before" and "now!"

■ Click the **Dark Feathers** layer in the **Layers** palette to make it the active layer. When you create an adjustment layer, you also automatically create a layer mask, which is indicated by the white boxes that are just to the right of the **Levels** and **Curves** layer icons in the **Layers** palette. We now use the layer mask for the **Levels** layer.

■ **Reset Default Foreground and Background Colors** (**D**) by clicking the icon in the **Tools** palette. **Switch Foreground and Background Colors** (**X**) by clicking the icon in the **Tools** palette. Black should now be the foreground color.

■ Click the **Brush** tool (**B**) in the **Tools** palette. Click the **Brush Preset Picker** (the second box from the left in the **Options** box) to get the **Brush** palette shown in **Figure 8.14**. If you get a different palette, click the menu button in the **Brush** palette and choose **Reset Brushes** from the pop-up menu. Click **OK** to replace the current brushes with the default brushes.

■ Click the **Soft Round 300 Pixels** brush.

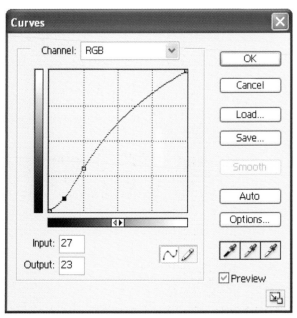

8.13

8.14

- Make sure that the **Options** bar shows **Mode** set to **Normal**, and **Opacity** and **Flow** to **100%**.
- Click and paint over the entire image, except for the dark feathers. As you paint, you are masking out the effects of the **Curves** command and revealing the rest of the image as it was before **Curves** was applied. You now have the best of the dark and white feathers!
- If you decide that you want to remove some of the mask, **Switch Foreground and Background Colors** (**X**) by clicking the icon in the **Tools** palette. White should now be the foreground color and as you paint, you remove the mask.

If you are not sure how much we have improved the image, click the eye icon in the left column of the Dark Feathers layer in the Layers palette to turn the layer on and off. You should see some dramatic improvement in the dark feathers. Just make sure you turn the Dark Feathers layer back on after you finish examining the changes.

STEP 7: ADJUST COLORS

I think the image is looking pretty good, but I'm keen to see if we can improve it with Hue/Saturation. What about you?

- Click the **Background** layer in the **Layers** palette to make it the active layer.

8.15

- Choose **Layer** ➢ **New Adjustment Layer** ➢ **Hue/Saturation** to get the **New Layer** dialog box. Click **OK** to get the **Hue Saturation** dialog box shown in **Figure 8.15**. I'm kind of a deeply saturated image kind of a guy, so I set **Saturation** to **+8**.
- Click **OK** to apply the settings. The **Layers** palette should now look like the one shown in **Figure 8.16**.

STEP 8: MAKE FINAL ADJUSTMENTS

After taking a good look at the image, I decided that everything in the image except the white feathers has a bit more of an orange tone to it than it should have and the overall image is slightly darker than I prefer.

- Double-click the **Levels** icon in the **Background Levels** layer in the **Layers** palette to

8.16

display the **Levels** dialog box. Click and drag the middle slider toward the left until the middle **Input Levels** box shows **1.06**, as shown in **Figure 8.17**. This small change lightens the image slightly.

■ Click in the **Channel** box in the **Levels** dialog box and select **Green** (**Ctrl+2**) to display the **Green** histogram. Click the middle slider and drag

8.17

toward the left until the middle **Input Levels** box shows **1.05**. The orange tone is reduced just a bit and the few greens in the background are now greener, which is okay.

■ Click **OK** to apply the settings.

You now have experienced firsthand the value of adjustment levels. If you want to make further adjustments to the Curves used on the dark feathers, the Hue/Saturation, or Levels used on the background, you can — by simply clicking the appropriate adjustment layer in the Layers palette (**Figure 8.16**) and making your desired changes.

The eagle now looks much more like the eagle I remember sitting on a nest at the North Carolina Raptor Center one cold fall morning. Now all it needs to look like the image shown in **Figure 8.2** is some sharpening. To learn more about sharpening an image, read Technique 12.

If you save this image as a PSD file, all of the layers will be saved and you can at any time make further adjustments to the settings. Or, you can flatten the image and save it in any format that you choose.

INCREASING COLOR SATURATION

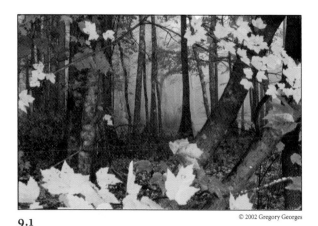

9.1

© 2002 Gregory Georges

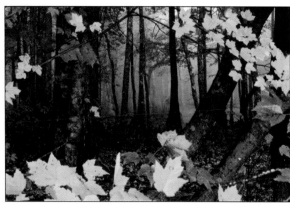

9.2

© 2002 Gregory Georges

Deep in the Forest Canon EOS D30 digital camera, 28-70mm f/2.8 @ 48mm, ISO 100, f/18.0 @ 1/4, Extra Fine RAW setting, 1440 x 2160 pixels converted to 18.7MB 48-bit .tif

Over time, I have learned that when shooting toward a magnificent sunset or sunrise, you should also turn around and shoot behind you, too. While taking early morning sunrise photos of a foggy swamp, I turned around and shot the photo shown in **Figure 9.1**. When I looked at the LCD on my digital camera, I was astounded to see the contrast between the rich bright orange and yellow leaves and the deep blues and greens of the forest.

In this technique we look at how you can *exaggerate* the colors and make an even more color saturated *rich, mossy, foggy, deep inside the forest* image — one that looks like it would be the perfect place to find a unicorn! To achieve our objectives, we use a combination of the Multiply blend mode, Curves, and Hue/Saturation.

STEP 1: OPEN FILE

■ Choose **File ➢ Open** (**Ctrl+O**) to display the **Open** dialog box. Double-click the **\09** folder to open it and then click the **forest-before.tif** file to select it. Click **Open** to open the file.

■ Choose **View ➢ Fit on Screen** (**Ctrl+0**) so that you can see the entire image.

STEP 2: IMPROVE TONAL RANGE

Once again, we have the advantage of working with a 48-bit image. But this time, unlike what we did in the last technique, we take full advantage of the extra picture information and make the initial tonal corrections before changing to 24-bit mode (8-bits per color channel).

■ Choose **Image ➢ Adjustments ➢ Levels** (**Ctrl+L**) Quickly take a look at the **Red**, **Green**, and **Blue** histograms by clicking the **Channel** box and selecting each channel to see if it is optimized to show the best tonal range. You notice that some of the tail ends in some channels are lacking data, indicating that the tonal range can be improved. A good example of such a channel is the **Green** channel histogram, as shown in **Figure 9.3**.

9.3

■ Click in the **Channel** box and select **Red**. While pressing **Alt**, slide the left slider in toward the middle until you just begin to clip some of the shadow data, as shown in **Figure 9.4**. When the first **Input Levels** box shows **25**, you have clipped just about all the shadow data that you want to clip.

■ While pressing **Alt**, slide the right slider in toward the middle until you just begin to clip some of the highlight data. The third **Input Levels** box should be at about **250** and the **Levels** dialog box should look like the one shown in **Figure 9.5**.

Moving the left or black-point slider in toward the middle makes all those tones lower and to the left black. With a setting of 25, all tones between 0 and 25 now become pure black, which makes all the tones

9.4

9.5

between 26 and 255 stretched between 0 and 255. The result of this stretching is an increased tonal range or image contrast. The same holds true for sliding the right or white-point slider, except in this case you are setting the tones to the right of the slider to white and further stretching the remaining points between 0 and the value you set. After doing this to all three channels, you have an image that has black darks and pure white whites.

- Click in the **Channel** box in the **Levels** dialog box and select **Green** (**Ctrl+2**). While pressing **Alt**, slide the left slider in toward the middle until you just begin to clip some of the shadow data. When the first **Input Levels** box shows **18**, you clipped just about all the shadow data that you want to clip.
- While pressing **Alt**, slide the right slider in toward the middle until you just begin to clip some of the highlight data. When the third **Input Levels** box shows **236**, you clipped just about all the highlight data that you want to clip.
- Click in the **Channel** box in the **Levels** dialog box and select **Blue** (**Ctrl+3**).
- While pressing **Alt**, slide the left slider in toward the middle until you just begin to clip some of the shadow data. When the first **Input Levels** box shows **5**, you clipped just about all the shadow data that you want to clip.
- While pressing **Alt**, slide the right slider in toward the middle until you just begin to clip some of the highlight data. When the third **Input Levels** box shows **239**, you clipped just about all the highlight data that you want to clip.
- Click **OK** to apply the **Levels** settings.

The image looks much better with the wider tonal range. Now darken and increase the color saturation to create a *deep inside the forest* look. To do this, we are going to need to increase color saturation. If you are thinking that we can do that with Levels and Hue/Saturation, you are thinking correctly; but we are going to use an adjustment layer to give us more control. Plus, because we want to make some pretty

severe changes in the blue and green colors, we first select the orange and yellow leaves to make sure they don't get bathed in an unwanted color.

- As none of the color selection commands we will be using are available when editing an image in 48-bit mode, we have to change modes to select the leaves. Also, we can't use adjustment layers in 48-bit mode either so choose **Image ➤ Mode ➤ 8 Bits/Channel**.

As you change from a 48-bit image to a 24-bit image, the size of your image decreases by 50%. This image file decreased from 17.8MBs to 8.9MBs. You can see these changes either by setting the Status Bar to show Document Sizes, or you can choose Image ➤ Size to read the file sizes.

STEP 3: SELECT YELLOW AND ORANGE LEAVES

- Choose **Select ➤ Color Range** to get the **Color Range** dialog box shown in **Figure 9.6**. Click in the **Select** box and choose **Sampled Colors**.
- Slide the **Fuzziness** slider all the way to the right to **200**.

9.6

■ Click and move your cursor over the largest yellow leaf in the middle of the bottom of the image to select the yellow leaves. As you move around in the leaf, watch the **Color Range** pre-view window to see where you get the best leaf selection and then click **OK** to get a selection marquee.

■ Choose **Select** ➢ **Save Selection** to get the **Save Selection** dialog box shown in **Figure 9.7**. Type **leaves** in the **Name** box and then click **OK** to save your selection, as you will need it later.

STEP 4: DARKEN IMAGE AND INCREASE COLOR SATURATION

At this point, we want to darken the image and increase color saturation. While you are correct in thinking that we can do this with Levels or Curves and Hue/Saturation, we use a technique that gives us more control over the changes we make.

■ As we want to make adjustments to the entire image except the selected areas, choose **Select** ➢ **Inverse** (**Shift+Ctrl+I**) to invert the selection.

■ Choose **Layer** ➢ **New Adjustment Layer** ➢ **Curves** to get the **New Layer** dialog box shown in **Figure 9.8**. Click in the **Mode** box to select **Multiply** and then click **OK** to get the **Curves**

dialog box. The image is considerably darker, but closer to what we want.

Setting Mode to Multiply builds density in the image, which results in a much darker image. The mathematics behind the Multiply blend mode is simple. It takes corresponding pixels from each image and multiplies them by each other and then divides the results by 255. Such math always results in every point being darker than either source — in this case, both sources are the same image and they are *multiplied* together.

■ We have now lost all detail in the tree on the left one-third of the image, so drag you cursor around that area and watch the corresponding point slide up and down the **Curves** window. You'll notice that we need to lighten and maybe increase contrast in the bottom one-third of the image. Click once on the line to set a point and drag it down toward the bottom. When **Input** is about **29** and **Output** is **32**, we can once again see detail in the bark. To increase contrast in this area, click the line in the **Curves** dialog box again and set another point. Drag this point up and to the left or type **64** and **114** in the **Input** and **Output** boxes.

■ In making this curve, we have also brightened the blue area more than desired, so set one more point. Click the top part of the line in the **Curves** dialog box and pull the top down and to the right until **Input** is **156** and **Output** is **219**. The **Curves** dialog box now looks like the one shown in **Figure 9.9**.

We now have the overall richness of color that we want — well, almost. How about if we try to make

9.7

9.8

the blue mist brighter and more misty? In particular, see if we can make the blue in the left side of the image more pronounced.

■ Click in the **Channel** box in the **Curves** dialog box and select **Blue** (**Ctrl+3**).

■ Drag your cursor over the lighter blue mist areas as you watch where the corresponding points occur in the line in the **Curves** dialog box. You'll notice that the points are in the top one-third of the line, so that is where you need to make the adjustments. Click once in the line and drag it up to make the blue brighter. A good setting for this point is **179** and **195** for **Input** and **Output** respectively. The **Curves** dialog box now looks like the one shown in **Figure 9.10**.

■ To further increase the richness of the colors and to bring out the green colors, click the **Channel** box in the **Curves** dialog box and select **Green**. Set one point at **62** and **82** for **Input** and **Output** respectively. The **Curves** dialog box looks like the one shown in **Figure 9.11**.

■ Click **OK** to apply the curves.

9.10

9.9

9.11

As you saved the selection of the leaves and as you used an adjustment layer for the all of the Curves settings, you can go back at any time and make small changes to fine tune the image without suffering from any needless image degradation.

STEP 5: ADJUST COLORS OF LEAVES

The image is looking pretty good now. Don't you think so? You have not yet even touched Hue/Saturation and you have a very dark, rich-colored image thanks to the Multiply blend mode. Being one of the curious types, I now want to see if we can do anything to further improve the image with Hue/Saturation. First, see what we can do with the leaves.

- As you saved the selection that you made earlier for the leaves, you can now reapply it by choosing **Select** ➢ **Load Selection** to get the **Load Selection** dialog box shown in **Figure 9.12**. Click in the **Channel** box and select **leaves** and then click **OK** to apply the selection.
- So that we can later make changes to the settings, use another adjustment layer by choosing **Layer** ➢ **New Adjustment Layer** ➢ **Hue/Saturation**. Click **OK** in the **New Layer** dialog box to get the **Hue/Saturation** dialog box.

- Slide the **Hue** slider left to **−11** to make the leaves more orange. Also reduce the **Saturation** to a **−10** setting as well. Click **OK** to apply the settings.

STEP 6: ADJUST BACKGROUND COLORS

- Load the leaves selection by choosing **Select** ➢ **Load Selection** to get the **Load Selection** dialog box. Click in the **Channel** box and select **leaves**. Click in the box next to **Invert** to invert the selection and then click **OK** to apply the selection. This selects everything but the leaves that you selected earlier.
- To create one more adjustment layer choose **Layer** ➢ **New Adjustment Layer** ➢ **Hue/Saturation**. Click **OK** in the **New Layer** dialog box to get the **Hue/Saturation** dialog box.
- Slide the **Hue** slider left to **+8** to make the blue a little bluer. Increase **Saturation** to a **+10** setting. Click **OK** to apply the settings.

At this point, your Layers palette should look like the one shown in **Figure 9.13**. You have a background layer, a Curves adjustment layer for the entire image except the leaves, and two Hue/Saturation adjustment layers, one for the leaves and one for everything but

9.12

9.13

the leaves. You can now go back and double-click any of these adjustment layers and modify the settings. Because you also saved the selection for the bright orange foreground leaves, you can select the leaves, or everything but the leaves, so that you can make further adjustments. This is an excellent example of the power of adjustment layers and saved selections.

I suggest that you now save your image with all the Alpha Channels and Layers intact by choosing File ➤ Save As (Shift+Ctrl+S) to get the Save As dialog box shown in **Figure 9.14**. Click in the Format box and select Photoshop (*.PSD) Photoshop (*.psd, *.pdd). Make sure check marks are on for the Alpha Channels and Layers boxes in the Save Options box at the bottom of the Save As dialog box. After selecting an appropriate folder and entering the file name, click Save to save your file. Saving your file allows you to go back at any time and make changes as you desire.

The image now looks very different than the one you started with. It may not yet have a unicorn, but other techniques in this book can surely help you insert one if you are lucky enough to get a photo of one.

9.14

RESTORING AN OLD PHOTO

10.1

© 2002 Gregory Georges

10.2

© 2002 Gregory Georges

Sometimes, the goal is not to fix a digital image taken with a digital camera or from a scanned slide or negative, but to restore an old damaged photographic print. Besides usually being faded, many old prints can have tears, crinkles, or even missing parts. They can be discolored or have stains, blotches, spots, chunks, and many other undesirables.

When looking for a challenging photo for this technique, a friend gladly provided me with one with *all* the previously mentioned undesirables. But, that is okay, as Photoshop has always been the tool of choice for restoring images such as this one. With Photoshop 7's new specialized tools for photographic restoration, you'll learn that restoring this image is simply a piece of the proverbial cake. This is a fun image to work with, and it is old — so old in fact, that the photo was taken way back when they believed that you should not smile when having your portrait made!

STEP 1: STRAIGHTEN AND CROP IMAGE

This photo has been mounted onto a piece of thin leather. So, the first challenge is straighten the image and to crop the image to just the photo.

- Choose **File** ➤ **Open** (**Ctrl+O**) to display the **Open** dialog box. Double-click the **\10** folder to open it and then click the grandfather-before.tif file to select it; Click **Open** to open the file.

- To straighten the image, click and hold on the **Eyedropper** tool icon in the **Tools** palette to get a pop-up menu; select **Measure** tool. Click on the image in the upper-left corner of the photo and drag a line down to the bottom-left corner of the photo while keeping the line parallel to the edge of the photo.

- Choose **Image** ➤ **Rotate Canvas** ➤ **Arbitrary** to get the **Rotate Canvas** dialog box. You will notice that there is a value in the **Angle** box. This is the amount of rotation that Photoshop 7 has determined is needed to straighten the image. Click **OK** and the image will be straightened.

- Now click on the **Crop** tool (**C**) in the **Tools** palette. If there are values in the **Width**, **Height**, or **Resolution** boxes in the **Options** bar, click **Clear**. Click just inside the upper-left corner of the edge of the photo and drag the marquee down and to the right to the corner of the photo to select the entire photo. To save time editing the edges of the photo, click on a selection handle to move the selection marquee if needed to avoid selecting any dark edge or part of the leather the photo has been mounted on. Press **Enter** to crop the image. Your image should now look like the one shown in **Figure 10.3**.

10.3

10.4

STEP 2: REPAIR LONG VERTICAL FOLD LINE

The upper-right corner needs to be created, so you'll have to create more paper to fill in the missing parts! Before we begin that task though, it is best to first fix the areas around the missing corner so that we may clone in the missing corner.

- One tool that you can use to fix the vertical fold line is the new **Patch** tool, which you can select by clicking on and holding the **Healing Brush** tool in the **Tools** palette. After getting a pop-up menu, choose **Patch** tool.
- Click and drag a selection marquee around part of the fold line as shown in **Figure 10.4**. Click inside the selection marquee and carefully drag it to the left where there is a very similar part of paper. When you let go of the mouse button, the fold will be gone! Do this several more times until you have fixed most of the fold down to the man's shoulder.
- There is one more tiny fold line that runs horizontally just under the missing corner. Use the **Patch** tool to fix it too. When you have finished, remove any selection marquee by choosing **Select ➢ Deselect (Ctrl+D)**.

STEP 3: REPLACE THE TORN CORNER

- Now that we have some reasonably good paper near the missing corner, we can use it as a clone source to fill in the missing corner. Click on the **Clone Stamp tool** (**S**) in the **Tools** palette. Click in the **Brush Preset Picker** box in the **Options** bar to get the **Brush** palette shown in **Figure 10.5**. If the palette looks different, click on the menu button in the upper-right corner of the **Brush** palette to get a pop-up menu; choose **Reset Brushes**. Click on the **Soft Round 100 Pixels** brush.
- Before you can begin cloning in the missing corner you must first set the clone source by pressing **Alt** and then clicking once in the image where you want to set the source image. I suggest

that you click to the left of the missing corner and then click the same distance down from the top to begin cloning. Click often and reset your clone source so that you don't end up with two parts of the paper that have exactly the same stain!

STEP 4: USE CLONE STAMP TOOL TO FIX BEARD AND FOLD IN COAT

Using the Clone Stamp tool and a smaller brush size, clone the beard without ink over the beard where there are ink lines until all of the ink lines are gone. While you have the Clone Stamp tool selected, carefully select your clone source and clone out the rest of the vertical fold in the right shoulder. If you set your clone source carefully, you can perfectly match the shadow lines caused by the fold in the man's coat. You will get the best results by clicking often and rarely dragging the Clone Stamp tool.

STEP 5: REMOVE RED INK SPOTS

Use the Clone Stamp tool to remove the red ink spots next to the left edge of the photo and on the white shirt next to his tie.

10.5

STEP 6: REMOVE ALL THE SPOTS AND PERFORATIONS ON THE IMAGE

Now is the time to gather all of your patience and remove the spots and perforations on the image with the wonderful new-to-Photoshop 7 Healing Brush tool! This useful tool automatically *heals* an area by matching the lighting and shading of the *to be healed area* to the texture of the source pixels — a far better approach than using the Clone Stamp tool.

■ Click on the **Healing Brush** tool (**J**) in the **Tools** palette. Using a variety of **Brush** sizes, you can now select different source points and click to "heal" all the spots on the image. Because the **Healing Brush** tool does not match the source lighting, you can select the best part of the image to use as the source texture, then heal other areas and not have the healed areas look lighter or darker than they should!

STEP 7: MINIMIZE STAINING

The bottom part of the man has obviously been vignetted during the exposure process; however, I think that part of that same area has either been stained or lightened more than when it was first printed. We also need to fix the lighter areas that have been stained or faded in the rest of the image as well.

■ To darken the light areas, you need to selective increase image density. To do that, duplicate the layer by choosing **Layer ➤ Duplicate Layer**; click **OK** to duplicate the layer.
■ Click in the **Blend Mode** box in the **Layers** palette and select **Multiply**. The idea is to set **Opacity** at a level that creates the darkest background color that is needed to cover the stain. Set **Opacity** in the **Layers** dialog box to **65%**.
■ Choose **Layer ➤ Add Layer Mask ➤ Hide All** to hide the entire dark layer. You can now paint on the **Layer** mask and gently build up the density level wherever it is needed.

■ Select the **Brush** tool (**B**) by clicking on it in the **Tools** palette. Click in the **Brush Picker Palette** in the **Options** bar and select the **Soft Round 200 Pixels** brush. Set **Opacity** in the **Options** bar to **10%**. Make sure that the foreground color is **White**.
■ You can now begin painting on the image to remove the lighter stained areas. If you paint too much and part of the image gets too dark, you can switch to **Black** and paint the mask so that you lighten the image again. Click often and gradually build up the color. It is best to work in full-screen mode by pressing **F**, **F**, and then **Tab**. Remember you can move the image around with the **Hand** tool by pressing and holding the **Space** bar to get the **Hand** tool.

10.6

■ Notice that it is also possible to paint some of the image density back into the bottom part of the coat. Once you have completed painting the mask, you may find that you will need to use the **Healing Brush** tool to fix any spots that have now become more pronounced.

■ When you are happy with the results, choose **Layer ➢ Flatten Image**.

STEP 8: MAKE FINAL TONAL ADJUSTMENTS

Using Levels or Curves you can make minor adjustments to the tonal range to get an image that looks similar to the one shown in **Figure 10.6**.

When faced with a restoration job like this one, the more time and patience you have, the better job you can do. Photoshop 7 offers so many wonderfully useful tools; you can just about fix any image! Try these tools on one of your old images or restore one for a client or friend. They'll believe that you can perform magic.

Admittedly, this one technique shows only a small part of what you can do to restore an old image — there is so much that can be done that someone could write an entire book on how to use Photoshop just to restore images. If you plan on doing lots of restoration work, I highly recommend that you purchase Katrin Eismann's *Photoshop Restoration and Retouching* book to get a whole book full of restoration and retouching tips and techniques.

REMOVING NOISE OR GRAIN

11.1

© 2002 Lauren Georges

11.2

© 2002 Lauren Georges

Great Horned Owl Canon EOS D30 digital camera, 300mm f/2.8 IS, ISO 800, f/3.2 @ 1/125, 16-bit RAW setting, 1440 x 2160 pixels converted to 9.3MB 8-bit .tif, iCorrect and Levels have been applied

When using a film camera, most photographers choose the slowest film speed (ISO speed) that can be used to correctly capture their subjects. The reason for this is that slower speed films result in less grain. This is one of the reasons why so many professional photographers prefer slide films, such as Fuji's Velvia (ISO 50) or Provia (ISO 100), instead of the faster speed films, such as ISO 400 or 800 films. Unfortunately, the electronics in digital cameras also suffer from having the same tradeoff between slow ISO speeds and a low level of grain, or fast ISO speeds and loads of grain, which is usually referred to as digital camera *noise*.

Furthermore, the process of digitizing analog film by using a scanner also produces digital noise. Therefore, just about any time you edit digital photos, you are likely to have some level of grain or noise. Besides the fact that most photographers usually want to minimize the dreaded grain or noise,

as it is not in the original scene, an even more compelling reason to minimize it is most digital photos need some sharpening and digital sharpening, usually makes the grain even more pronounced.

While I'd like to tell you that you are about to learn a technique that will remove all of the noise or grain from any image, I am sad to say that removing those nasty little dots can be somewhat challenging if not outright impossible. The problem comes from trying to digitally soften or smooth out the noise or grain without losing important detail in an image. Images without fine detail make it easy to remove grain, while other images that have grain and important fine detail, such as the feather in the owl in **Figure 11.1**, make it much more difficult. Some images have few important fine details and so the softening of the grain does not noticeably soften the image.

Many approaches are taken to minimize grain and noise — you notice that I said *minimize*, because removing it completely is fairly hard. Favorite Photoshop 7 filters for removing grain include blur filters, such as Gaussian Blur, Despeckle, Dust & Scratches, and Median. Some digital photographers who have a severe dislike for grain and noise use two or more of these filters in a specific order, making custom adjustments to each filter's settings as they are applied. Besides using one or more of these filters on the entire image, you can also apply them to one or more of the channels depending upon the characteristics of each channel. Other experts offer valid reasons for changing from RGB to Lab mode to apply filters to remove noise or grain.

Finally, you have actions or plug-ins designed specifically to remove grain and noise from digital photos. Two of the more sophisticated and widely used plug-ins are Grain Surgery (www.visinf. com) and Quantum Mechanic Pro (www.camerabits. com), both of which I sometimes use when faced with especially difficult noise problems in an image. Fred Miranda (www.fredmiranda.com) has created a

set of Photoshop actions for removing grain and banding problems from several specific digital cameras when using specific ISO settings. Noise Reduction Pro is another useful plug-in offered by The Image Factory (www.theimaging fatory.com).

Okay, okay, you are probably saying; get on with removing the grain in the owl image! Before deciding on how to remove the grain, first take a quick look at the image to help determine the best grain minimizing approach to take.

STEP 1: OPEN FILE

- Choose **File** ➢ **Open** (**Ctrl+O**) to display the **Open** dialog box. Double-click the **\11** folder to open it and then click the **owl-before.tif** file to select it. Click **Open** to open the file.
- Choose **View** ➢ **Actual Pixels** (**Ctrl+Alt+0**). Press the **Spacebar** to get the **Hand** tool and

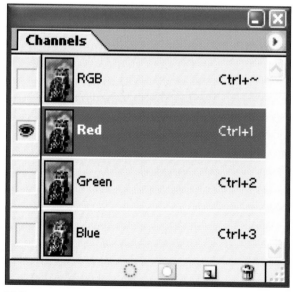

11.3

drag the image so that you can see the grain in the upper-left corner of the image. All those little colored specs are noise that we want to minimize.

Compare this noise to the noise in the iris images shown in Techniques 1 and 3, which were shot using ISO 100 instead of ISO 800. This comparison shows the value of using low ISO speeds.

STEP 2: CHECK EACH CHANNEL FOR NOISE

The first item to do is to check each of the channels to find out where the noise might be and to see if we can minimize it by lightly applying filters on one or two channels.

■ If the **Channels** palette is not currently displayed, choose **Window ➤ Channels** to display the **Channels** palette. Click the **Red** channel (**Ctrl+1**) in the **Channels** palette to view the **Red** channel. Your **Channels** palette should look like the one shown in **Figure 11.3** and the document window should now have a black and white image of the owl, such as the one shown in **Figure 11.4**. Considerable noise is in this channel.

■ Click the **Green** channel (**Ctrl+2**) in the **Channels** palette to get a black and white image, such as the one shown in **Figure 11.5**. Remarkably less grain is here, which is good.

■ Click the **Blue** channel (**Ctrl+3**) in the **Channels** palette to get a black and white image,

11.4

11.5

such as the one shown in **Figure 11.6**. As can usually be expected, you find the most grain in the **Blue** channel. I'm not optimistic about being able to remove much grain from any of these channels as the owl itself has so much important detail in the edges of the feathers — minimizing grain can necessarily mean loss of important detail, too.

■ Click the **RGB** channel in the **Channels** palette to once again make the **RGB** channel visible. The **Channels** palette should now look like the one in **Figure 11.7**.

With some images, you find that you can use a small amount of Gaussian Blur or other *blur filter* on one or two channels to remove a substantial part of the unwanted grain. But, this is not true for this image. Consequently, we have to come up with another

strategy. For this image, we are mostly concerned about removing the noise from the background, not the owl itself. So, duplicate the background layer; blur the background to remove noise, and then create a layer mask that allows the grain-free background layer to show thorough.

11.7

11.6

11.8

STEP 3: CREATE NEW LAYER FOR THE OWL

- Choose **Layer ➢ Duplicate Layer** to get the **Duplicate Layer** dialog box. Type **Owl** in the **As** box and then click **OK** to create a new layer. The **Layers Palette** should now look like the one shown in **Figure 11.8**.

STEP 4: BLUR BACKGROUND LAYER

- Click the **Background** layer in the **Layers** palette to make it the active layer. Click the eye icon in the **Owl** layer to turn that layer off.
- Choose **Filter ➢ Blur ➢ Gaussian Blur** to get the dialog box shown in **Figure 11.9**. Click inside the preview box in the **Gaussian Blur** dialog box

11.9

and drag the image until you can see the owl's left ear.

- Slide the **Radius** slider all the way to the left and then move it as far as you can move it toward the right until the noise just begins to disappear. At **1** and **2 Pixels**, the dots of noise become blotches; at **2.5 Pixels** it is a nice soft blur as we would find if the photo were taken using an ISO 100 setting; but it is not too different from the rest of the image. Notice how much of the detail is lost in the feathers in the owl's ear even at a 2.5 pixels setting.
- Click **OK** to apply the **Gaussian Blur**.

The reason that I have chosen the Gaussian Blur filter is because of the very fine control it allows. Unlike some of the other filters, it allows you to work in tenths of a pixel. Also, you may have noticed that the 2.5 Pixels setting was considerably short of making the background as smooth as the backgrounds in photos taken using an ISO 100 setting. The reason for this conservative setting is that too much of a smooth background would look inconsistent with the part of the image that features an owl.

STEP 5: PAINT LAYER MASK TO REVEAL BACKGROUND

- Click the **Owl** layer in the **Layers** palette to make it the active layer and you now see the grain come back into the image.
- Choose **Layer ➢ Add Layer Mask ➢ Hide All** to create a new layer mask in the **Owl** layer.
- **Reset Default Foreground and Background Colors** (**D**) by clicking the icon in the **Tools** palette. **White** should now be the foreground color.
- Click the **Brush** tool (**B**) in the **Tools** palette. Click the **Brush Preset Picker** (the second box

from the left in the **Options** box) to get the **Brush** palette shown in **Figure 11.10**. If you get a different palette, click the menu button in the **Brush** palette and choose **Reset Brushes** from the pop-up menu. Click **OK** to replace the current brushes with the default brushes.

- Click the **Soft Round 300 Pixels** brush.
- Make sure that the **Options** bar shows **Mode** set to **Normal** and **Opacity** and **Flow** set to **100%**.
- Click and carefully begin painting over the owl. As you paint, you are painting out the effects of the **Gaussian Blur** command and revealing the rest of the image as it was before **Gaussian Blur** was applied, which results in a sharp owl and a grain-less background.
- You need to change the brush to **Soft Round 35 Pixels** so that you can paint back all of the feathers around the owl's ear.
- If you decide that you want to add back some blurred image, click the **Switch Foreground and Background Colors** (**X**) icon in the **Tools** palette.

11.10

Black should now be the foreground color and as you paint, you paint the blurred layer back into the image.

- Do not flatten the image until you save it as a PSD file with layers, as you are likely to want to make further modifications to the mask after you examine the effects of the **Unsharp Mask**. The first time I masked the owl, I did not do it carefully enough and found that I had sharpened grain around the edge of parts of the owl — a wholly unacceptable bit of masking! Having saved the file, it was simple to go back and fix the mask.

If you find that there is too much grain in the owl's feathers when applying the Unsharp Mask to sharpen the image, you may want to try adjusting Opacity in the Options bar. As you lower the Opacity setting, you begin to get a mix of the soft layer that was blurred and the sharper Owl layer. Using the Layer mask, you can get an optimal level of grain removal for all parts of the image.

Figure 11.2 shows the results of varying the Opacity level while painting the mask and after applying the Unsharp Mask. The midtones value was also adjusted a small amount by using Levels to darken the image.

This approach to removing noise worked well for this image. Other images may demand an entirely different approach. But you now know which *blur* filters to consider, how to check each channel, and how to use a mask layer to apply different levels of grain removal to an image. After some experimentation, you will be able to find a good approach for specific digital cameras or scanners, and for the level of grain due to specific ISO settings or film speeds. I also suggest that you visit this book's companion Web page to get a clickable list of vendors offering tools to remove grain and noise. Most vendors offer trial versions of their software so that you can see how well they will work on your images.

SHARPENING DIGITAL PHOTOS

12.1

© 2002 Gregory Georges

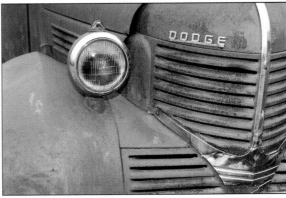

12.2

© 2002 Gregory Georges

ABOUT THE IMAGE

Ancient & Rusty Dodge
Canon EOS 1v, 28-70mm at
28mm f/2.8, f/16.0 @ 1/100,
Kodak Supra 100, 2400 x
1608 pixel 11.6MB .tif,
scanned with Polaroid Sprint-
Scan 4000 and VueScan

N early all digital images need to be sharpened — period. Well, I better qualify that somewhat. Those images that you intend to be sharp — need to be sharpened as soft edges are just one of the characteristics of digitized photos no matter whether they have been created with a scanner or with a digital camera.

The rusty Dodge photo shown in **Figure 12.1** was chosen for this technique because most sharpening techniques suffer from a tradeoff between sharper edges (on edges that ought to be sharpened) and getting undesirable effects, such as enhanced grain, halos, excessively pronounced textures, and other unwanted effects. This rusty Dodge image has a variety of edges, plus lots of different kinds of textures that are useful for learning about the Unsharp Mask filter, the key tool for making images look sharper.

While this technique isn't particularly exciting, it is an essential one to make your photos look as good as they can. For this reason in this technique you learn three different approaches to sharpening images, and you get more information on the *hows* and *whys* than any other technique in the book. The three different approaches that are covered are:

- Using Unsharp Mask on the entire image
- Sharpening only one or two channels instead of the entire image
- Using filters to select only the edges, and then sharpen only the edges

I should point out that the best way to get sharp images is to use a high-quality scanner to scan a sharp negative, slide, or photo or to shoot a sharp image with a high-quality digital camera — then you usually still need to sharpen the image digitally. Although it would be nice, I am sad to report you have no way to sharpen an out-of-focus digital photo. In fact, when using the following sharpening techniques, you'll quickly realize that we are not really *sharpening* them. Instead, we are creating the illusion that they are sharp by digitally emphasizing *edges* in the image by making one side of an edge lighter and the other side darker.

As you soon discover, the illusion effect we use to make an image appear sharp is resolution dependent. This means that you should not apply sharpening effects to an image until you know what your final output will be. A sharpened high-resolution image won't have the optimal amount of sharpening if it is down-sized to be used as a low-resolution image on a Web page or vice-versa. Consequently, sharpening ought to be one of the last steps in your workflow. One other reason to leave sharpening as one of the last steps in your workflow is because the *sharpening effect* will likely be removed or damaged, if you first sharpen your image and then use a variety of other commands and filters.

USING UNSHARP MASK ON THE ENTIRE IMAGE

STEP 1: OPEN FILE

- **File** ➢ **Open** (**Ctrl+O**) to display the **Open** dialog box. Double-click the **\12** folder to open it and then click the **dodge-before.tif** file to select it. Click **Open** to open the file.

A few minor adjustments have already been made to this image using Levels to enhance the image so that this technique can be devoted to sharpening — a most important topic for photographers.

STEP 2: DUPLICATE LAYER

Before taking any steps to sharpen an image, first duplicate the layer. Not only does this duplicate layer make it easy for you to switch between *before sharpening* and *after sharpening* images so that you can view the differences, but it also allows the option of *painting* back in some of the original image, or using a mask or selection to limit what is or isn't sharpened. Additionally, you can blend the background layer with the sharpened layer by using one or more of the blend modes to further improve the sharpness of the image.

JOHN BROWNLOW

Besides being an excellent photographer, John Brownlow is a significant contributor and discussion leader of useful Internet-based content on a variety of important photographic and imaging topics. He is the founder and moderator of the highly active and useful Street Photography (650+ members), Digital Silver (850+ members), and Big Neg

- Choose **Layer ➤ Duplicate Layer** to get the **Duplicate Layer** dialog box. Type **sharpened** in the **As** box and then click **OK**.

STEP 3: SET UP IMAGE VIEW

Any time you use the Unsharp Mask, view your image at 100% to get an accurate view of the effects.

- Choose **View ➤ Actual Pixels** (**Alt+Ctrl+0**).
- Press the **Spacebar** to get the **Hand** tool and click and drag the image until you can see the Dodge logo, the rusty grill, and part of the left headlight if you have sufficient desktop. These are the key areas to watch as you apply effects.

STEP 4: APPLY UNSHARP MASK

Now we get to this seemingly misnamed filter — the Unsharp mask. If you are one who has not ever used the Unsharp Mask — because you always want to sharpen an image when you select the Sharpen menu, not un-sharpen your image — you are not the first to not use the most valuable tool for *sharpening* images! The name comes from a pre-digital darkroom technique where a blurry version of the contact negative was layered with the original contact negative. The result of combining these two "layers" was a pronounced edge contrast, making the image appear to be sharper. As the Unsharp Mask works in the same way, it is appropriately named and it is the best tool for the job — period!

- Choose **Filter ➤ Sharpen ➤ Unsharp Mask** to get the **Unsharp Mask** dialog box shown in **Figure 12.3**. The Unsharp Mask has the following three settings:
- **Amount:** This control determines how much the contrast increases in percentage terms ranging from 0% to 500%. This setting might also be considered as the *intensity* or *effect strength* setting.
- **Radius:** Measured in pixels, Radius determines how wide the *sharpening effect* is. You can choose a setting between 0 pixels and 250 pixels and even in parts of a pixel, which is important when you are using values under 5 pixels, which you do most of the time.
- **Threshold:** This control lets you set the starting point for when sharpening occurs. You can choose from 0 to 255 levels difference between two touching shades. When Threshold is set to 0, everything gets sharpened. When Threshold is set to 255, nothing gets sharpened. Using the optimal Threshold setting, you can usually prevent grain, scanner noise, or important image texture from being sharpened.

(150+ members) e-mail groups. As a member of his groups I have often benefited from his posts, enjoyed his humor, and continue to value his image sharpening actions. As a full-time screen-writer and director, it amazes me that John always finds time to take photographs and actively share his passion for photography with those who join his groups or visit his Web site at www.pinkheadedbug.com.

The Unsharp Mask is actually creating a halo effect around edges. It creates a lighter shade on one side of what it thinks is an edge, and a darker shade on the other side, thereby creating the illusion of a sharp edge. Amount determines how bright the halo is, Radius determines how wide the halo is, and Threshold is the minimum shade difference required before a halo is created.

A good approach for getting optimal settings when working with high-resolution images is to set Amount to 175%, Radius to 2, and Threshold to 0. Most images require an Amount setting in the range of 150% to 200%. Generally, Radius values are less than 2.0 and each tenth of a pixel can be significant.

Setting Threshold to 0 means that every edge gets sharpened and for now that is okay as it is the easiest setting to adjust after the other two settings are determined. The tricky part is determining the right combination of Amount and Radius.

- Set **Amount** to **175%**, **Radius** to **2**, and **Threshold** to **0**.
- Depending on the image, it may be better to define the edges with a narrower but brighter halo. Other images may look better with a wider, but less bright halo. See what you think looks best for this one by sliding the **Amount** to **200%** or more and lower **Radius** to around **1.5** to **1.8**. These settings make the rust chips look amazingly real, almost as if they are going to flake off your screen and into your keyboard.
- As you change settings, click the **Preview** box in the **Unsharp Mask** dialog box to view the image with and without the sharpening effect. Also, click inside the **Preview** box to get the **Hand** tool. Click and drag the image around to view areas where you want to make sure the settings work.
- As soon as you have a good combination of settings for **Amount** and **Radius**, look around the image for an area where there is fine texture, such as on the smooth part of the fender. You can now slowly slide the **Threshold** slider toward the right

12.3

12.4

until you remove the unwanted sharpening effect on the smoother areas.

- For this image, I set **Amount** to **180%**, **Radius** to **1.8**, and **Threshold** to **4**.
- Click **OK** to apply the settings.
- Because you did all the sharpening in the **sharpened** layer, you can now click the **Hide Layer** icon (the eye icon) in the left column of the **Layers** palette to view the difference between the original image and the sharpened image.
- If you want to reduce the effects, choose **Edit** ➢ **Fade Unsharp Mask** (**Shift+Ctrl+F**) to get the **Fade** dialog box shown in **Figure 12.4**. As you slide the **Opacity** slider toward the left, the sharpen effects fade. Besides using **Normal**, you should also try using the **Luminosity** blend mode.
- Click **Cancel** to cancel the **Fade** settings.

At this point, the rusty old Dodge image looks much better than it did before the Unsharp Mask was applied. In this example, we have applied the Unsharp Mask to the entire image. Occasionally, you may work on an image where you don't want the entire image to be sharpened. Using the Quick Mask,

12.5

layer mask, or a selection tool of your choice, you can easily select and remove or even change the opacity of the sharpened layer, leaving the unsharpened layer below as part of the viewable image.

Now that you have a good understanding of how to use the Unsharp Mask, here are two other approaches to sharpening an image.

SHARPENING INDIVIDUAL CHANNELS

Some lower-end scanners and digital cameras produce enough noise that it becomes difficult to sharpen an image without also sharpening and accentuating the unwanted noise, too. There are also images where it is hard to differentiate between important image texture or detail and the *edges* that you want to sharpen. In these and other cases, you want to take a look at each of the color channels to see if you can find one that holds most of the edges that you want to sharpen, but not much of the unnecessary detail. Typically, the lightest channel is the one that you want to sharpen, as it is also the one with the least amount of noise.

STEP 1: OPEN FILE AND DUPLICATE LAYER

- Choose **File** ➢ **Open** (**Ctrl+O**) to display the **Open** dialog box. Double-click the **\12** folder to open it and then click the **dodge-before.tif** file again to select it. Click **Open** to open the file.
- Choose **Layer** ➢ **Duplicate Layer** to get the **Duplicate Layer** dialog box. Type **Sharpened** in the **As** box and then click **OK**.

STEP 2: EXAMINE THE RED, BLUE, AND GREEN CHANNELS

- Your **Channels** palette should look like the one shown in **Figure 12.5**. If the **Channels** palette is not visible, choose **Window** ➢ **Channels**.

■ Click the **Red** channel (**Ctrl+1**), then the **Green** channel (**Ctrl+2**), and the **Blue** channel (**Ctrl+3**) to view each channel. **Figures 12.6**, **Figure 12.7**, and **Figure 12.8** show each of the channels.

STEP 3: APPLY UNSHARP MASK

■ As the **Red** channel is the lightest channel, sharpen it as it has the least amount of detail that you don't want to sharpen.

■ Click the eye icon in the left column of the **RGB** channel so that you can see the effects of your settings in full color, but make sure to leave the **Red** channel as the active channel. The **Channels** palette should now look like the one shown in **Figure 12.9**.

■ Choose **View** ➢ **Actual Pixels** (**Alt+Ctrl+0**).

■ Press the **Spacebar** to get the **Hand** tool and click and drag the image until you can see the

12.6

12.8

12.7

12.9

Dodge logo, the rusty grill, and part of the left headlight if you have sufficient desktop. These are the key areas to watch as you apply effects.

■ Make sure the **Red** channel is highlighted and then choose **Filter ➤ Sharpen ➤ Unsharp Mask** to get the **Unsharp Mask** dialog box.

■ Set **Amount** to **225%**, **Radius** to **2.0**, and **Threshold** to **0**. This time, you can use a slightly higher setting for **Amount**, and you can use **0** for **Threshold** as the **Red** channel does not show all the detail that we saw earlier.

Some images have two channels that you need to sharpen. If so, beware that applying different settings can cause some rather unusual things to happen. My suggestion is to use the same settings if you are going to sharpen two channels. If you switch between the layers using the eye icon in the Layers palette, you will notice that sharpening just the red channel has caused a noticeable increase in red around some of the more defined edges — especially on the grill.

You can also have multiple views of the same document visible at once — one with only an individual channel visible and the other with the composite so you can see the effect changing one channel has on the entire image. Choose **Window ➤ Documents ➤ New Window**.

USING FILTERS TO SELECT EDGES ONLY, AND THEN SHARPEN ONLY THE EDGES

As is true with many facets in life, the best way is often the most difficult or longest way. This axiom is true for sharpening images as well — that is if it weren't for John Brownlow! The longer way, and in most cases, the best way to sharpen an image is to first select all the edges that ought to be sharpened and then sharpen only those areas. While there are quite a few steps and many different approaches for this technique, John Brownlow has made it easy for all of us. He has created two action sets that automate several different sharpen techniques.

So, rather than go through all the steps, we just load John's actions, select one, and try it out.

STEP 1: OPEN FILE AND DUPLICATE LAYER

■ Choose **File ➤ Open** (Ctrl+O) to display the **Open** dialog box. Double-click the **/12** folder to open it and then click the **dodge-before.tif** file again to select it. Click **Open** to open the file.

■ Choose **Layer ➤ Duplicate Layer** to get the **Duplicate Layer** dialog box. Type **Unsharpened** in the **As** box and then click **OK**. This extra layer makes it easy for you to view *before* and *after* images.

■ Click in the **Background** layer to make it the active layer. Click the **eye icon** to hide the **Unsharpened** layer.

STEP 2: COPY ACTIONS INTO PHOTOSHOP FOLDER

■ As John's actions are so useful, I recommend that you copy them into the appropriate Photoshop folder so that you can easily access them any time you need to sharpen an image. Assuming you copied files from the companion CD-ROM as suggested in the Introduction, you find them in the **\12** folder. The names of the action files are: **Deadman's Custom Sharpen.atn** and **Deadman'sSharpeners.atn**. Copy both of these files into the following Photoshop 7 folder: **C:\Program Files\Adobe\Photoshop 7.0\ Presets\Photoshop Actions**

STEP 3: LOAD ACTIONS

■ To load the actions, click the menu button in the **Actions** palette. If the **Actions** palette is on your desktop, choose **Window ➤ Actions**. After

clicking the menu button, you get a pop-up menu such as the one shown in **Figure 12.10**. If you copied the actions correctly, both of them are listed in the bottom part of the menu. Click **Deadman's Custom Sharpen.atn** to load it.

■ Click the **Deadman's Custom Sharpen** action set once to open it. Click the **Deadman's Custom Sharpen! Action** to open the action. The **Actions** palette should now look like the one shown in **Figure 12.11**.

STEP 4: RUN ACTION

■ Before running the action, choose **View ➢ Actual Pixels** (**Ctrl+Alt+0**) so that you can see the results of the action on the full-size image.
■ Press the **Spacebar** to get the **Hand** tool. Click and drag so that you can see the Dodge logo and the front grill.

12.10

12.11

■ To run the action, click the **Play Selection** icon at the bottom of the **Actions** palette. The action is well written with pop-up dialog boxes that make suggestions on the settings you should use. After making all the suggested settings, you have a sharpened image — it is that easy.

The image shown in **Figure 12.2** is the result of applying *Deadman's Super Sharpen* action.

I suggest that you load the Deadman's Sharpeners.atn set as well. It includes four additional sharpening actions. My favorite for most images is the "Deadman's Super Sharpen" action. If you duplicate the background layer each time you try an action, or if you create a Snapshot in the History palette, you can easily compare the results of different actions and different settings. Experimenting with these actions and finding one that you can use on all of your digital images is well worth your time.

As sharpening is such an important topic for digital photographers, I suggest that you consult the following additional resources if you want to learn more about the topic.

The Web page, www.luminous-landscape.com/smart_sharp.htm, on Michael Reichmann's Luminous Landscape Web site features "A Smart Sharpening Tutorial" written by John Brownlow.

Real World Photoshop 7 — Industrial-Strength Production Techniques, by David Blatner and Bruce Fraser (Peachpit Press), has devoted an entire chapter to the topic of sharpening. If you are serious about Photoshop, this is a must-have book for this and many other reasons.

ADDING INFORMATION
TO A DIGITAL PHOTO

13.1

13.2

ABOUT THE IMAGE

Sunset in Silk Hope Canon EOS D30 digital camera, 28-70mm f/2.8 at 33mm, f/8.0 @ 1/15, ISO 100, Fine image setting, 1440 x 2160 pixel 1.2MB .jpg

A picture is worth a thousand words. However, a picture with metadata, security features, a color profile, notes, sound recordings, and other information is worth even more than just a picture! Photoshop 7 offers a number of significant features to help you share your digital photos with others whom you choose, in the manner in which you choose, and with valuable information that you want to pass on or keep for yourself. In this technique, we look at how you can view, add, and edit information that can be attached to your digital photos. Plus, we look at how you can share your digital photos in a secure manner by using PDF files.

Photoshop 7 offers several ways to add, edit, or view a variety of information types that can be attached to an image. We look at File Info, the Image Browser, how you can add notes or sound recordings to an image, and we look at some of the options that you have when you save a file. Finally, we take a brief look at some of the possibilities available to you when you save your images in a PDF document.

STEP 1: OPEN FILE

■ Choose **File** ➢ **Open** (**Ctrl+O**) to display the **Open** dialog box. Double-click the **\13** folder to open it and then click the **sunset-before.jpg** file to select it. Click **Open** to open the file.

STEP 2: VIEW, ADD, AND EDIT METADATA BY USING FILE INFO

The *Digital Still Camera Image File Format Standard*, known as EXIF (Exchangeable Image File Format) was created as a standard for sharing information along with digital images. Most new digital cameras write EXIF data into each digital photo file. Important information, such as the date and time the picture was taken, resolution, ISO speed rating, f/stop, compression, and exposure time are generally provided. Some of the newer digital cameras even allow you to store voice annotations to the files according to EXIF specifications.

To learn more about the EXIF data provided by a specific digital camera, read the camera's documentation. If you are interested in learning more about the EXIF specification, visit `www.exif.org`.

■ Choose **File** ➢ **File Info** to get the **File Info** dialog box shown in **Figure 13.3**. You can now add any information that you feel is useful.

■ The **Filename**, **Caption**, **Credits**, **Title**, and **Copyright** fields are particularly useful if you are using one of the Web page formats such as **Vertical Slide Show 2** when using **Web Photo Gallery**. If you have values in these fields, you have the option of having these fields be automatically placed on a Web page when **Web Photo Gallery** creates Web pages — a huge timesaving feature!

■ Click in the **Copyright Status** box to select **Copyrighted Work**. Turning this feature on makes the copyright symbol show in some application's title bar to make it easy to be aware that the image is copyrighted.

■ To insert a copyright notice in the **Copyright Notice** box, press **Alt+0169** to make the copyright symbol and then type a year and your name.

■ Click the **Section** box in the **File Info** dialog box and select **Keywords** (**Ctrl+2**) to get the dialog box shown in **Figure 13.4**. Many of these keywords can be accessed by third-party image management applications.

13.3

13.4

■ Click the **Section** box in the **File Info** dialog box and select **Categories** (**Ctrl+3**) to get the dialog box shown in **Figure 13.5**.

■ Click the **Section** box in the **File Info** dialog box and select **Origin** (**Ctrl+4**) to get the dialog box shown in **Figure 13.6**.

Photoshop 7 supports the image information sharing standards of the Newspaper Association of America (NAA) and the International Press Telecommunications Council (IPTC). This standard includes entries for captions, keywords, categories, credits, and origins. In Windows, you can add file information to files saved in Photoshop, TIFF, JPEG, EPS, and PDF formats. In Mac OS, you can add file information to files in any format.

If you are not a press photographer, you may be asking yourself why you should care about all these standards. The answer may be that you don't and ought not to care! However, you can still put this information storage feature to tremendous use.

■ Click the **Section** box in the **File Info** dialog box and select **EXIF** (**Ctrl+5**) to get the dialog box shown in **Figure 13.7**. Scrolling down you can learn all kinds of details about the photo. It was

taken with a Canon EOS D30 camera on March 12, 2002, fifty seconds after 9:31PM! The ISO speed rating was set to 100. The focal length was 33mm — an odd focal length, so it must have been a zoom lens (which is true as a 28-70mm zoom was used). The aperture was set at f/8.0 and the shutter speed was set to $\frac{1}{15}$th of a second.

13.6

13.5

13.7

■ Click **OK** to close the **File Info** dialog box. When you save the file, all the information that you enter is saved in the image file.

STEP 3: VIEWING INFORMATION BY USING THE FILE BROWSER

Besides viewing picture information in the File Info dialog boxes, you can also view EXIF data by using the File Browser.

■ To view the **File Browser**, choose **Window ➤ File Browser**. It should look similar to the one shown in **Figure 13.8**. The menu button in the **File Browser** and the status bar offer you a lot of selectable options for determining what information you show and how it is presented. More EXIF data is shown in the **File Browser** than in the **File Info** dialog box. **Figure 13.9** shows all of the EXIF data for the sunset image.

13.8

Filename	sunset-before.JPG
Date Created	3/5/2002 09:02:38 AM
Date Modified	10/1/2001 06:58:18 PM
Image Format	JPEG
Width	2160
Height	1440
Color Mode	RGB
File Size	1.11M
Make	Canon
Model	Canon EOS D30
Orientation	Normal
X Resolution	180.0
Y Resolution	180.0
Resolution Unit	Inches
Date Time	2001:10:01 18:58:19
yCbCr Positioning	Centered
Exposure Time	1/15 sec
F-Stop	16.0
ISO Speed Ratings	100
ExifVersion	0210
Date Time Original	2001:10:01 18:58:19
Date Time Digitized	2001:10:01 18:58:19
Components Configuration	Unknown
Compressed Bits Per Pixel	3.0
Shutter Speed	1/15 sec
Aperture Value	8.0
Exposure Bias Value	0.0
Max Aperture Value	3.0
Subject Distance	0.0 m
Metering Mode	Pattern
Flash	Did not fire.
Focal Length	33.0 mm
FlashPix Version	0100
Color Space	sRGB
Pixel X Dimension	2160
Pixel Y Dimension	1440
Focal Plane X Resolution	2421.525
Focal Plane Y Resolution	2420.168
Focal Plane Resolution Unit	Inches
Sensing Method	One-chip color area sensor
File Source	DSC

13.9

STEP 4: ADDING NOTES AND AUDIO ANNOTATIONS

Photoshop 7 offers two valuable features that make it easy to communicate additional non-picture information with others or to just make notes for your own use.

- To add a note to the image, click the **Notes** tool (**N**) in the **Tools** palette. Click anywhere in the image to create a *sticky note*. You can now type your comments in this note. These notes can be moved, collapsed, and deleted at any time.
- If you have a microphone connected to your computer, you can also record a voice annotation by clicking the **Notes** tool in the **Tools** palette; wait for the pop-up menu and select the **Audio Annotation** tool. To make a voice recording, click the image to get the **Audio Annotation** dialog box. Click the **Start** button and begin speaking in the microphone. When you are done, click **Stop** to place an icon in the image indicating there is a voice message that can be played back. **Figure 13.10** shows several notes and voice annotations that have been placed on the image.

STEP 5: USING THE SAVE AS AND SAVE COMMANDS

When considering the *extras* that can be added to a digital image, it would be wrong not to consider Channels, Layers, Annotations, Spot Colors, and ICC Profiles.

- Choose **File** ➢ **File Save As** to get the **Save As** dialog box shown in **Figure 13.11**. Here you notice a few check boxes that may be checked or unchecked to determine if a certain type of information is to be added to the file after it is saved. Click **Cancel** to close the dialog box without saving the file.

STEP 6: SAVING A FILE IN A PDF DOCUMENT

Adobe PDF documents have become the de facto standard for sharing documents across most hardware platforms and operating systems. They can be

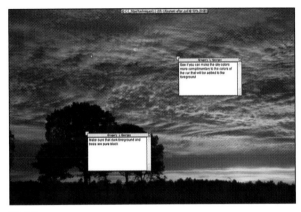

13.10

13.11

small compressed files that are easy to e-mail or download from a Web page, or they can be huge files that contain images and all the information needed in a pre-press environment. As it is a feature available to you in Photoshop 7, you ought to take a brief look at how PDF documents can be used.

■ To save a digital image in a PDF document, choose **File ➢ Save As** (**Shift+Ctrl+S**) to get the **Save As** dialog box. Click in the **Format** box to get a pop-up menu; click **Photoshop PDF .pdf**. Click **Save** to get the **PDF Options** dialog box shown in **Figure 13.12**.

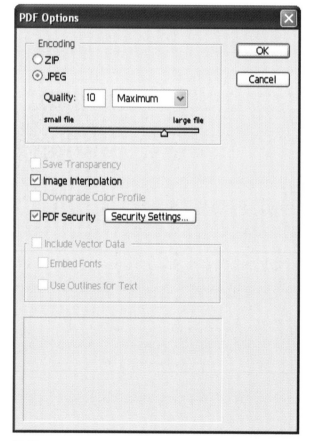

13.12

Besides having the option of choosing **JPEG** quality levels, you can also select from a few very useful security options. Click the box next to **PDF Security** and then click the **Security Settings** button to get the **PDF Security** dialog box shown in **Figure 13.13**. Here you can determine if and how passwords are to be used, plus you have the option of determining if the image may be printed, changed, copied, extracted, or if comments and form fields may be added or changed.

As there are entire books written on the topic of creating and using Adobe PDF documents, I'm going to leave this topic to them. Just be aware that Photoshop 7 allows you to have considerable control over any digital image that you want to share with others.

That concludes this quick tour of the features of Photoshop 7 that allow you to make an image be worth more than a picture! Creative application of these features can be very helpful to you to get more done — quicker and better.

13.13

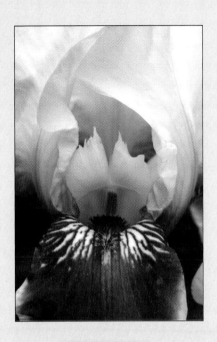

CHAPTER **3**

WORKING IN BLACK AND WHITE

There is resurgent interest in black and white photography, with many good reasons for the renewed interest. You'll increasingly find more of it in art galleries and museums that display photographic works of art. Fantastic new ink sets for inkjet printers are becoming available that produce excellent prints. Traditional photographers are learning digital photography, which allows far more control over their images than they ever had in the darkroom. Those shooting with digital cameras are looking to do new things with their color images. If you enjoy black and white photography, you'll enjoy this chapter.

The first two techniques show you how to convert color images into black and white images with more control than was ever possible with all the clever techniques and different grades of paper that were used in the darkroom. The next three techniques demonstrate how master photographer and printer Phil Bard produces his wonderful black and white prints. The last technique shows how Jimmy Williams, the award-winning commercial photographer, is able to mimic some of his in-camera stylistic techniques with Photoshop 7. Thanks to both Phil and Jimmy, you can learn these techniques by working on some of their wonderful original image files.

CONVERTING A COLOR PHOTO TO B&W I

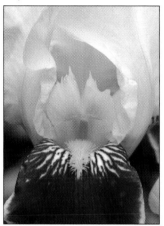

14.1 © 2002 Gregory Georges

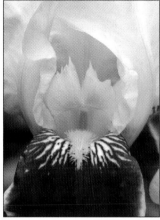

14.2 © 2002 Gregory Georges

ABOUT THE IMAGE

Purple Iris Canon digital camera D30 EOS mounted on a tripod, 100mm macro, f/2.8 ISO 100, RAW setting, ¹/₄ @ f/14, 1440 x 2160 pixels, edited and converted to 9.3MB .tif

If you shoot black and white film — you have a black and white photo. If you shoot with color film, or use a digital camera and shoot in color mode — you can have either color or excellent black and white images! In fact, you have so much more control over how your black and white images turn out when converting digitally with Photoshop 7, that you may decide it is not worth shooting black and white film ever again.

You have at least eight basic approaches and many variations to convert a color image into a black and white image using Photoshop 7. They are:

1. Convert image to black and white by converting image to a grayscale image by using **Image ➢ Mode ➢ Grayscale**. This is the easy way, but usually produces the least desirable results.

2. Desaturate by using **Image ➢ Adjustments ➢ Desaturate** (**Shift+Ctrl+U**). Alternatively, you can use **Image ➢ Adjustments ➢ Hue/Saturation** (**Ctrl+U**) and slide the **Saturation** slider all the way to the left to a value of **0**. This approach is similar to the first approach in terms of control and results.

3. Use **Image ➢ Mode ➢ Lab Color** and use the **Lightness** channel as the black and white image. This approach is easy, straightforward, and can produce excellent results depending on the colors and tones of the original image. We'll use this technique on an image of an iris a little later in this technique.

4. Choose one of the three channels (Red, Green, or Blue) to use as the black and white image. Often times, one of these three channels will be just what you want. At other times, you'll want parts of each of the three channels — mixed. This approach is similar to shooting on black and white film through a color filter and it can lead to some unexpected and yet pleasing results.

5. Use **Image ➤ Adjustments ➤ Channel Mixer** and create your own mix of two or more of the channels. This approach gives you the most control and we look at it in detail in Technique 15.

6. Create new images comprised of two or more channels; then mix these layers using **Opacity**.

7. Select two or more channels; then combine them using **Calculations**.

8. Use a third party Photoshop 7 compatible plug-in, such as **Convert to B&W Pro**, which has been designed specifically to convert color images into black and white images. Whenever I convert color images to black and white, I almost always use Convert to B&W Pro as it gives you so much control over how the image looks. You read more about this plug-in in Technique 38.

14.3

In this technique, you use Lab Color mode and the Lightness channel to create a black and white image.

STEP 1: OPEN FILE

■ Choose **File ➤ Open** (**Ctrl+O**) to display the **Open** dialog box. Double-click the **/14** folder to open it and then click the **iris-before.tif** file to select it. Click **Open** to open the file.

STEP 2: CONVERT TO LAB COLOR

■ Choose **Image ➤ Mode ➤ Lab Color** to convert from **RGB** to **Lab Color** mode. Lab Mode is constructed according to how color actually exists and how our eyes perceive it — a magenta-green relationship, a yellow-blue relationship, and a lightness (or black-white) relationship.

■ Open the **Channels** palette if it is not already open by choosing **Window ➤ Channels**. The **Channels** palette should now look like the one shown in **Figure 14.3**. Notice that there is a **Lightness** channel — this channel represents how bright a color is and so it is an ideal channel to use alone for a black and white image.

STEP 3: CONVERT TO GRAYSCALE

■ Choose **Image ➤ Mode ➤ Grayscale**. If the warning box "**Discard color information?**" appears, click **OK** to convert the image to a grayscale by using the **Lightness** channel. Your image should now look like the one shown in **Figure 14.2**.

■ If you need an RGB image, convert it back to RGB by choosing **Image ➤ Mode ➤ RGB**.

After completing this technique, try Technique 15 and Technique 38; compare the results of each of these approaches to determine their suitability for your images.

CONVERTING A COLOR PHOTO TO B&W II

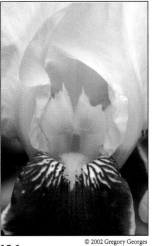

15.1

© 2002 Gregory Georges

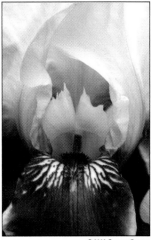

15.2

© 2002 Gregory Georges

In this technique, you use the Channel Mixer to create a custom mix choosing from each of the three channels to convert the color image into a black and white image. While this technique offers much more control than Technique 14, it can be time-consuming to try various combinations and permutations. If you frequently convert color images to black and white images, this approach should be compared with Technique 14 and Technique 38.

STEP 1: OPEN FILE

■ Choose **File** ➤ **Open** (**Ctrl+O**) to display the **Open** dialog box. Double-click the **/15** folder to open it and then click the **iris-before.tif** file to select it. Click **Open** to open the file.

STEP 2: EXAMINE EACH CHANNEL

■ Choose **Window** ➤ **Channels** to display the **Channels** palette if it is not already displayed. The **Channels** palette should look like the one

115

15.3

shown in **Figure 15.3**. Click the **Red** channel (**Ctrl+1**) in the **Channels** palette to view the red channel. Then click the **Green** (**Ctrl+2**) and **Blue** (**Ctrl+3**) channels to view them. **Figure 15.4** to **Figure 15.6** show each of these three channels. Note that you can tell what channel or channels are being viewed at any time by looking at the document title bar.

Each of these three different channels shows an entirely different black and white version of the colored iris. Looking at these, you can now begin to understand how much control you will have over how your final image will look — that is if you learn how to mix the channels properly.

Incidentally, I should make the point that if you like one of these versions, you are already done. Just click and drag the two channels that you don't want to use onto the trash icon at the bottom of the Channels palette. You are then left with a grayscale image.

15.4

15.5

STEP 3: USE CHANNEL MIXER TO MIX CHANNELS

I like the image found in the blue channel; it is a good high-contrast image that shows the detail in all parts of the flower. However, I like parts of the green channel as it shows in more detail in the background. So for simplicity's sake and to match my preferences (yours will undoubtedly be different), combine just the blue and green channels and not use any of the red channel.

- Click the **RGB** channel in the **Channels** palette to highlight all channels.
- Choose **Image** ➢ **Adjustments** ➢ **Channel Mixer** to get the **Channel Mixer** dialog box shown in **Figure 15.7**. Click in the box next to **Preview** (if it is not already checked) to turn **Preview** on. Click in the box next to **Monochrome**.
- As we don't want to use any of the **Red** channel, type **0** in the **%** box in the **Channel Mixer** dialog box. Because the **Blue** channel offered provides

most of the desired details, slide the **Blue** slider to **80%**. To avoid some strange effects, all three channels ought to total **100%**. Therefore, slide the **Green** channel slider until it reads **20%**. Click **OK** and your image should look like the one shown in **Figure 15.2**.

- If you don't like these results, choose **Edit** ➢ **Step Backwards** (**Alt+Ctrl+Z**), then try again until you get your desired results.

The differences between this mixed-channel version and just the blue channel version are subtle, but we have accomplished what we wanted. Using Channel Mixer you have incredible control over your image — more so than you would ever have in the darkroom or when shooting black and white film and using assorted color filters. The problem with using the Channel Mixer is that it is difficult to compare various mixes. If you are serious about black and white photography, I suggest that you consider using the Convert to B&W Pro plug-in, which Technique 38 covers.

15.6

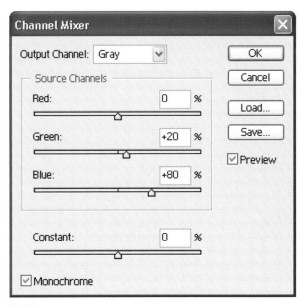

15.7

BURNING AND DODGING WITH MASKS

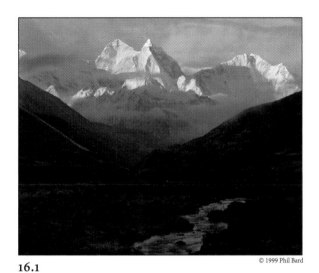

16.1

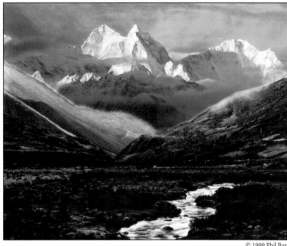

16.2

ABOUT THE IMAGE

Kangtega and Thameserku from Pheriche Everest Region Canham 4x5 field camera mounted on tripod, 210mm lens with light red filter, TMax 100, scanned with a Heidelberg Tango drum scanner at 2,400 dpi , 100MB grayscale file was down-sampled to a 2400 x 1920 pixel, 4.4MB grayscale .tif

I n the darkroom, black and white printers alter contrast and dodge and burn (lighten and darken) to improve their prints. The adjustment layers in Photoshop 7 now make these techniques possible digitally with much more precision, control, and the flexibility to go back and make changes. Rather than making a permanent change to the image's pixel information, adjustment layers are modifiable at any time after they are created. In this technique, you discover how Phil Bard, a master photographer and printer, uses adjustment layers to enhance his photo of Kangtega in Nepal.

STEP 1: OPEN FILE

■ Choose **File ➢ Open** (**Ctrl+O**) to display the **Open** dialog box. Double-click the **\17** folder to open it and then click the **kangtega-before. tif** file to select it. Click **Open** to open the file.

The image file `kangtega-before.tif` is a low-resolution version of the file that Phil uses to print this image. Using a 4x5 camera and a high-quality scanner, he generally works with images around 8,000 x 10,000 pixels or larger. You might now begin to wonder what kind of a computer he uses to work on images this large. In the next technique, you find out his trick for being able to edit large images quickly.

STEP 2: DUPLICATE LAYER

■ Choose **Layer** ➢ **Duplicate Layer** to get the **Duplicate Layer** dialog box; click **OK** to create the layer.

Having a duplicate layer makes it possible to perform Transform functions and to view the changes from the original by simply turning the layer on and off from the Layers palette. You can accomplish sort of the same thing by using the snapshot created when the file was opened, which will not increase the document size as duplicating layers will.

STEP 3: ADJUST SHADOWED FOREGROUND

In this and the next two steps, different adjustments are made to the shadowed foreground, sky, and snowy peaks.

■ To select the shadowed foreground areas, click the **Lasso** tool (**L**) in the **Tools** palette.

■ Using the **Lasso** tool, click the mountains and drag around them to create a selection like the one shown in **Figure 16.3**. Selecting the shadowed foreground precisely is not important, as we will next soften the selection.

16.3

16.4

Phil Bard is a master black and white photographer and printer with over 30 years of darkroom experience. While he still shoots mostly with large format film cameras and black and white film, he is a leader in developing and using a digital

PHIL BARD

workflow that produces some of the most outstanding black and white digital prints that can be found anywhere. His silver gelatin and digital fine prints are collected in both private and corporate collections internationally. His Web site, `www.philbard.com`, offers four

- Choose **Select** ➢ **Feather** (**Alt+Ctrl+D**) to get the **Feather Selection** dialog box shown in **Figure 16.4**. Type **30** in the **Feather Radius** box and click **OK**.
- To view the actual feathered selection, click the **Quick Mask** mode (**Q**) button at the bottom of the **Tools** palette. You can make any necessary adjustments to the selected area by using the **Brush** tool (**B**). Again, don't worry about the selection line between the two mountain ranges; just fix the shadowed foreground area if it is needed. Click the **Standard Mask** mode (**Q**) button at the bottom of the **Tools** palette to turn off the mask.
- Choose **Layer** ➢ **New Adjustment Layer** ➢ **Levels** to get the **New Layer** dialog box shown in **Figure 16.5**. Type **shadowed foreground** in the **Name** box and click **OK** to get the **Levels** dialog box shown in **Figure 16.6**.
 Set the **Input Levels** boxes to **0**, **.83**, and **105**. Click **OK** to lighten and add some highlights to the foreground. Since you had an active selection when you chose **New Adjustment Layer**, the selection automatically was used to create the mask for the adjustment layer to determine which parts of the image are affected by the layer.
- Your **Layers** palette should now look like the one shown in **Figure 16.7**.

Because the feathered selection that was used to create an adjustment layer causes a slight *glowing* effect just above the foreground range, it needs to be removed. The great news is removing the glow is easy to do because an adjustment layer was used.

- Click the **Brush** tool (**B**) in the **Tools** palette. Click the **Brush Preset Picker** in the **Options** bar to get the **Brush** palette shown in **Figure 16.8**. Click the **Soft Round 65 Pixels** brush. If the **Brush**

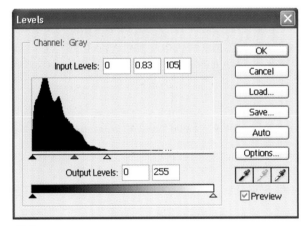

16.6

16.5

palette does not look like the one in **Figure 16.8**, click the menu button in the upper-right corner of the **Brush** palette to get a pop-up menu. Choose **Reset Brushes**; then click **OK**.

In the **Options** bar, set **Mode** to **Normal**, **Opacity** to **20%**, and **Flow** to **100%**.

Set **Foreground** color to **Black** by typing **D**; then press **X** to set the **Foreground** color to **Black**.

You can now carefully brush over the white halo above the lower mountain range to remove the halo

16.7

16.8

effect caused by the feathered selection. You may notice that the painting darkens the image. This is because you are now painting on the mask, affecting the area it covers and, correspondingly, the area that the adjustment layer influences in the image below. If you overdo the painting, select white as the foreground color, and the Brush tool erases the mask. Should you want to change the Levels settings that were used, you can at any time by clicking the levels adjustment layer in the Layers palette and change settings.

- Now add some contrast control to the same foreground area. Click the **Shadowed foreground** layer in the **Layers** palette to make it the active layer.
- Choose **Select** ➢ **Load Selection** to get the **Load Selection** dialog box. Click **OK** to reload the previous selection. The selection marquee now reappears indicating that the unmasked area is once again selected.
- Choose **Layer** ➢ **New Adjustment Layer** ➢ **Curves** and click **OK** to get the **Curves** dialog box which controls the new layer that was just created. Set points on the **Curve**, as shown in **Figure 16.9**.

16.9

To display a ten by ten grid instead of the normal four by four grid, press **Alt** while clicking in the curve box. You can now set each of the points by clicking the curve and dragging them to where they should be. Or, you can click to set a point and type in the **Input** and **Output** values for each of the three points, which are: **32** and **22**, **56** and **55**, and **80** and **86**. Click **OK** to apply the settings.

With this curve, you are expanding the mid-tone contrast while slightly compressing the highlights and shadows. As before, the effect is governed by a mask, which is resident to the layer and was created from the loaded selection of the previous layer. You now have separate Levels and Curves controls for the same foreground region, allowing you to do extremely precise fine-tuning at any time.

- To darken the thin strip of light-toned gravel on the left hillside, use the **Brush** tool set to **black** to add mask density to the **Curves 1** layer, which flattens out the gravel tonalities nicely.

STEP 4: ADJUST SNOWY PEAKS AND SKY

Now you are ready to work on the remaining portions of the image, the snowy peaks and the sky. Because you want to work in the areas not governed by the first two adjustment layers, you load that one first and invert it.

16.10

- With the **Curves 1** layer in the **Layers** palette highlighted, choose **Select** ➤ **Load Selection** to get the **Load Selection** dialog box. Make sure to check the **Invert** box and then click **OK**.
A marquee appears around the peaks and sky, and if you retouched the light gravel area, you notice it is selected as well. Deselect the gravel area if you retouched it by selecting the **Lasso** tool (**L**). Press **Alt** and draw a marquee around the selected gravel area.
- Choose **Layer** ➤ **New Adjustment Layer** ➤ **Levels** to get the **New Layer** dialog box. Click **OK** to get the **Levels** dialog box. Set the **Input Levels** to **4**, **1.14**, and **240**. The **Levels** dialog box should now look like the one shown in **Figure 16.10**. Click **OK** to apply the settings. This produces better contrast and lightens the area a little.
- Choose **Select** ➤ **Load Selection** and click **OK** to reselect the peaks and the sky.
- Choose **Layers** ➤ **New Adjustment Layer** ➤ **Curves** and click **OK** to get the **Curves** dialog box. Set three points on the curve, as shown in **Figure 16.11**.

16.11

If you find it easier to type the values in, the three points are: **22** and **15**, **46** and **51**, and **65** and **84**.

Click **OK** and take a look at your work so far. If the last layer mask is causing the tops of the foreground hills to look too dark, add some mask density there with the **Brush** tool. Also feel free to make changes to the other adjustment layers you have created so far, although you're not quite finished yet.

STEP 5: DARKEN SKY

- To darken the sky slightly, click the **Curves 2** layer in the **Layers** palette to make it the active layer. Using the **Lasso** tool (**L**), carefully draw a selection marquee, as shown in **Figure 16.12**. On the left side of the image, drop down into the cloud a small amount. Make sure you select the entire sky, extending all the way to the top of the image.
- Choose **Select** ➢ **Feather** (**Alt+Ctrl+D**) to get the **Feather** dialog box. In the **Feather Radius** box, type **10**, and then click **OK**.
- Choose **Layer** ➢ **New Adjustment Layer** ➢ **Levels** to get the **New Layer** dialog box, as shown in Figure **16.13**. Click **OK** to get the **Levels** dialog box. Set **Input Levels** to **0**, **.73**, and **255**. The sky

now darkens slightly adding drama to the peaks, which is balanced to the rest of the image.

One further refinement you can make is a **Levels** adjustment layer for the stream in the foreground. In order to place this layer just above the **Levels 1** and **Curves 1** layer, highlight the **Curves 1** layer, and then draw a marquee around the stream and create the new adjustment layer. The only histogram change needed is to drag the center pointer to the left a bit, thereby lightening the water. Remember that you may go back and make changes to any of these layers at any time, or turn any or all of them off if so desired.

When employing this technique on your own images, keep in mind that the layers add together from the bottom up to create changes in the rendering of the tonal range. For the best efficiency, try to avoid overlapping layers of the same type. This is especially true if one layer darkens image pixels and the other lightens. Also, when working with lower resolution scans that have areas of even graduation (open skies, smooth services), avoid making radical changes to the histogram and curves layers that affect these areas, or posterization of the values may result. This technique is applicable to color images as well, and with a little practice you will quickly be achieving professional results in all of your photographs.

16.12

16.13

USING SCALING MASKS TO SPEED UP EDITS

17.1

© 1998 Phil Bard

17.2

© 1998 Phil Bard

ABOUT THE IMAGE

Birches Along the Kevo River KB Canham 4x5 field camera mounted on tripod, 120mm lens with red filter, Kodak TMax 100, $^1/_2$ @ f/22, scanned (wet) on a ScanView drum scanner yielding 100MB grayscale file, down-sampled to 2400 x 1920 pixel 4.4MB grayscale .tif

Large image files, multiple layers, slow computer processors, minimal RAM, or extensive edits can all make the editing process painfully slow and time-consuming. If you employ the use of adjustment layers for making changes (as was done in Technique 16), this technique by Phil Bard can be an incredible timesaver. This is especially true if you work on files that start off as 100MB or larger files and grow to 300MB or more after six or eight layers are added, as is the norm for Phil.

In this technique, you use a relatively low-resolution image of one of Phil's photographs that he took of birch trees along the Kevo River in Lapland, Finland. Even though this small 4.4MB grayscale file is not likely to test your patience or stress your PC, it will illustrate the technique, which can be used with any image size.

STEP 1: OPEN FILE

■ Choose **File** ➢ **Open** (**Ctrl+O**) to display the **Open** dialog box. Double-click the **\17** folder to open it and then click the **birches-before.tif** file to select it. Click **Open** to open the file.

STEP 2: REDUCE IMAGE SIZE AND SAVE FILE

■ Choose **Image** ➢ **Image Size** to get the **Image Size** dialog box shown in **Figure 17.3**. Make sure that **Constrain Proportions** and **Resample Image** are both checked and that **Resample Image** is set to **Bicubic**. In the **Pixel Dimensions** area, change **Width** from **2400** to **500**. Notice that the image size went down from **4.39MB** to **195Kb**. Click **OK** to resize the image.

An important step at this point — save the file. If you do not save the file, you won't able to scale it and apply the masks to the original image after editing is complete.

■ Choose **File** ➢ **Save As** (**Shift+Ctrl+S**) to get the **Save As** dialog box. Type **small-birch** in the **File Name** box. Click in the **Format** box and select

Photoshop (**.psd**) as the file type. Then click **Save** to save the file.

STEP 3: INCREASE CONTRAST IN THE WATER PART OF THE IMAGE

■ To select the area containing water, click the **Lasso** tool (**L**) in the **Tools** palette. Click in the image and drag the selection marquee around the water, as shown in **Figure 17.4**.
■ To feather the selection, choose **Select** ➢ **Feather** (**Alt+Ctrl+D**) to get the **Feather** dialog box. Type **20** into the **Feather Radius** box and click **OK**.
■ Next you must create an adjustment layer for this selection only. To do so, choose **Layer** ➢ **New Adjustment Layer** ➢ **Curves** to get the **New Layer** dialog box. Click **OK** to get the **Curves** dialog box.
■ Click the bottom part of the line in the **Curves** dialog box to set a point. Type **27** and **18** in the **Input** and **Output** boxes respectively to adjust the point. Click the upper part of the line to set a second

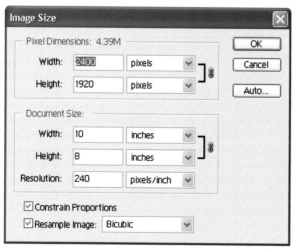

17.3

17.4

point and then type **75** and **82** in the **Input** and **Output** boxes respectively. The **Curves** dialog box should now look like the one shown in **Figure 17.5**. Click **OK** to apply the settings and increase the level of contrast in the water.

STEP 4: INCREASE CONTRAST IN TREE AREA

■ To select the part of the image that was not previously selected, choose **Select** ➢ **Load Selection** to get the **Load Selection** dialog box shown in **Figure 17.6**. Click in the box next to **Invert** to place a check mark and to invert the previous selection. Click **OK**. As the previous selection was feathered, there is no reason to feather it now.

■ Choose **Layer** ➢ **New Adjustment Layer** ➢ **Curves** to get the **New Layer** dialog box. Click **OK** to get the **Curves** dialog box.

Once again the slope needs to be increased, but it needs more slope than last time so, set two points

on the curve at: **31, 18** and **72, 81**. Click **OK** to apply the settings.

STEP 5: LIGHTEN THE BIRCH TREES

To lighten the birch trees, first select them and then make one last adjustment layer.

■ Using the **Lasso** tool, click in the image and select the birch trees only, as shown in **Figure 17.7**.

17.6

17.7

17.5

- To feather the selection, choose **Select** ➤ **Feather** (**Alt+Ctrl+D**) to get the **Feather** dialog box. Type **30** into the **Feather Radius** box and click **OK**.

- Choose **Layer** ➤ **New Adjustment Layer** ➤ **Levels** to get the **New Layer** dialog box. Click **OK** to get the **Levels** dialog box. Drag the **White Point** slider toward the left until it just begins to touch the points on the histogram, as shown in **Figure 17.8**. If you were to move the slider any further you would burn out the highlights in the trees. Click **OK** to apply the settings and create a new layer.

STEP 6: INCREASE IMAGE SIZE AND APPLY MASKS TO ORIGINAL IMAGE

In the last step, you finished all of the edits that are to be done to the smaller image. Now, the objective is to scale the masks back up to the size of the original image, and then transfer them to the original image along with the edits. In doing this, you only have to wait one time to have all the edits applied at once — to the larger image.

- Make the **Layers** palette big enough so that you can see all of the layers.

- Click the topmost layer to highlight it, if it is not already highlighted. Then click the **Link** box next to each of the two next layers below the top layer. The **Layers** palette should now look like the one shown in **Figure 17.9**. Do not link the background!

- Click the **Menu** button in the upper-corner of the **Layers** palette to get a pop-up menu. Choose **New Set From Linked** to get the **New Set From Linked** dialog box. Type **masks** in the **Name** box and then click **OK**. If you click the small triangle to the left of the **masks** folder icon that you just created in the Layers palette, the folder will open to show all of the masks you just created. The **Layers** palette should now look like the one shown in **Figure 17.10**.

- Now reopen the original **birches-before.tif** image. Choose **Image** ➤ **Size** to get the exact pixel dimensions if you forgot them. You find that it shows a **Width** of **2400** pixels and a **Height** of **1920** pixels. Click **Cancel** to close the dialog box.

17.8

17.9

■ Click the **small-birch.psd** image to make it the active image. Choose **Image** ➤ **Size** to get the **Image Size** dialog box. Type **2400** in the **Width** box and if the **Constrain Proportions** box is checked, Photoshop 7 will automatically place **1920** in the **Height** box in the **Pixel Dimensions** area. Click **OK**. Photoshop 7 now increases the image size; but, more importantly, it also increases the size of the masks to be the exact same size as the original image.

■ Rearrange and size both images so that you can see both of them in your workspace. Then, click the **small-birch.psd** image to make sure it is the active image.

■ While holding the **Shift** key, drag the **masks** folder icon from the **Layers** palette onto the original **birch-before.tif** image. You must press and hold **Shift** while dragging the **Set 1** folder to perfectly align the masks from the small **small-birch.psd** image to the large **birch-before.tif** image.

You have now applied the masks from the smaller image to the larger original image. All your edits should now be present in the birch-before.tif image and it should now look like the one shown in **Figure 17.2**. You can continue to work in the large scale image if it needs further editing. Or, you can once again scale it down and transfer it up again; however, be careful not to duplicate layers if you do this.

While working with this small sample image probably has not pushed the limits of your hardware or your patience, one day you may have to edit a large image, and for that this technique is a real timesaver. You should avoid downsizing your working image

too far, however, as there is a point at which the masks will show some loss of shape, particularly if you have one that closely follows a shape and it is not feathered. Dropping to ½ or ⅓ of the pixel dimensions is usually safe enough. You could always use this method for the simple *area* masks first, and then create any precision masks in the full size image after the other ones are transferred to it, thereby still saving you considerable time.

To learn more about Phil Bard and his work, read his profile at the end of Technique 16.

17.10

ISOLATING AND EXTRACTING DETAIL USING VALUES

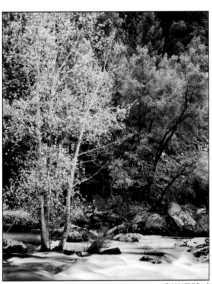

18.1

© 1986 Phil Bard

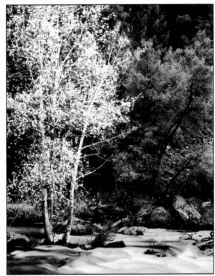

18.2

© 1986 Phil Bard

Cottonwood on the Merced River in Spring Linhof Monorail camera mounted on a tripod, 210mm lens with yellow filter, Kodak PlusX, 10 seconds @ f/16, scanned (wet) on a ScanView drum scanner yielding 100MB file, down-sampled to 2400 x 1920 pixels, 4.4MB grayscale. tif

Phil Bard shot the photo shown in **Figure 18.1** in 1986 in Yosemite Valley, California. This image is the result of several contrast manipulations of the original scan, and is basically "finished" except for the fact that, to Phil, the foreground tree details lack sufficient brightness. He wanted it to stand out a little more from the darker background. Selecting the general area of the tree and performing a Levels or Curves adjustment would be one way to achieve this, but that would also lighten mid-tone areas of the background somewhat as well. Instead, he chose a more surgical approach, one that affects only the tree. In this technique, you discover how Phil was able to *extract* the tree based on its *value*. In other words, a specific range of tones is selected based on their location in the histogram.

The Photoshop 7 masking and adjustment layer features have many applications, one of the less obvious being the ability to extract image information with respect to value. This is a useful technique for mimicking a darkroom technique called *bleaching*, in which highlights are lightened without significant effect to the mid-tones and shadows.

STEP 1: OPEN FILE

■ Choose **File** ➢ **Open** (**Ctrl+O**) to display the **Open** dialog box. Double-click the **/18** folder to open it and then click the **cottonwood-before.tif** file to select it. Click **Open** to open the file.

STEP 2: SELECT LIGHTEST PARTS OF THE IMAGE BY VALUE

■ If the **Channels** palette is not visible, choose **Window** ➢ **Channels**. In the **Channels** palette, click the **Load Channel as Selection** button (the left-most button), located at the bottom of the **Channels** palette. This creates a graduated selection of the entire image based on value, with the lightest details being most selected (least masked) and the darkest, least selected (most masked).

If you want to use this technique on RGB or CMYK images, you will need to select the channel or channels you want to load as the selection. In the case of the image used in this technique, the image is a grayscale image and there is only a single channel to load.

■ Click the **Quick Mask Mode** button (**Q**) in the **Tools** palette, which will create a mask from the selection. Your image should now look like the one shown in **Figure 18.3**.

■ Hide the **Gray** channel by clicking the eye icon (to switch it off) in the **Gray** layer in the **Channels** palette so that you can better view the mask. Notice that the mask is now thinnest (lightest) over the highlight areas. Remember that you are looking at a black and white mask, not the black and white image.

To get an even clearer view of the mask's gradation, increase the image to **100%** by choosing **View** ➢

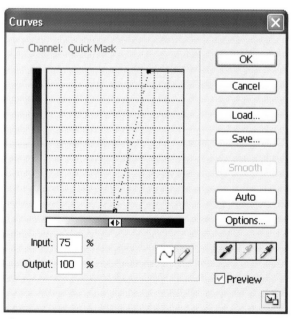

18.3

18.4

Actual Pixels (**Ctrl+Alt+0**). Choose **View** ➢ **Fit on Screen** (**Ctrl+0**) to fit the image on the screen.

STEP 3: REDUCE SELECTION TO JUST THE COTTONWOOD TREE

■ Because we want to further reduce the selection so that we can make changes only to the Cottonwood tree, edit the mask further. Click the **Quick Mask** channel in the **Channels** palette to select it if it is not already highlighted.

■ Choose **Image** ➢ **Adjustments** ➢ **Curves** (**Ctrl+M**) to get the **Curves** dialog box.

■ In the **Curves** dialog box, drag the curve into the shape illustrated in **Figure 18.4**.
To make the **Curves** dialog box show a 10 by 10 grid instead of a 4 by 4 grid, press **Alt** while clicking inside the curve box.
Set the lower end-point so that the **Input** and **Output** values are **50%** and **0%** respectively.

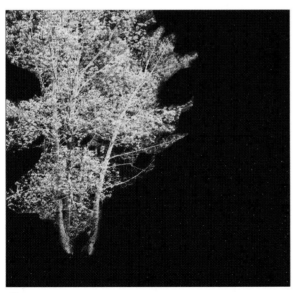

18.5

Set the upper end-point so that the **Input** and **Output** values are **75%** and **100%** respectively. Click **OK** to apply the settings.

This Curves adjustment increases the density of the mask in the highlight areas, while eliminating the shadow and some of the mid-tones, which helps to isolate the tree itself. This is a crucial adjustment that must be done to make this technique work.

■ Click the **Lasso** tool to draw a selection around the Cottonwood tree on the left of the image as carefully as you can, excluding the water and rocks where possible. Absolute precision is not necessary, but make sure you include all of the tree branches.

■ Choose **Select** ➢ **Inverse** (**Shift+Ctrl+I**). Make sure that the background color is set to black. This is very important! Press the **Delete** key. This eliminates the non-tree areas from the mask. Your image should now look similar to the one shown in **Figure 18.5**.

■ Choose **Select** ➢ **Deselect** (**Ctrl+D**) to remove the selection marquee.

■ Click the **Eraser** tool (**E**) in the tool palette. In the **Options** bar, set **Mode** to **Brush**, **Opacity** to **100%**, and **Flow** to **100%**. Using the **Eraser** tool, erase any of the detail you want, while leaving only the tree. This means that you should be erasing areas where there are large amounts of black. Be careful not to use too large a brush and erase important detail. To do this, you may want to vary the size of the **Eraser** tool from **35** pixels to **100** pixels by clicking the **Brush Preset Picker** on the **Options** bar.

■ Now we are ready to apply the mask. In the **Channels** palette, click the **Gray** layer and then click the **Standard Mode** in the **Tools** palette. Notice that a marquee appears indicating that the mask has now become a selection.

■ Choose **Layer** ➢ **New Adjustment Layer** ➢ **Curves** to get the **New Layer** dialog box. Click **OK** to get the **Curves** dialog box. Click the curve in the **Curves** dialog box to set a point at **34** and **24.** Click the curve again to set a second point at **80** and **85**. The **Curves** dialog box should now look like the one shown in **Figure 18.6.**

18.6

Click **OK** to apply the settings. This curve increases the contrast of the layer, which makes the Cottonwood tree stand out from the other trees, as shown in **Figure 18.2**.

If you uncheck and recheck the eye icon in the Curves 1 layer in the Layers palette, you can view the results of this new adjustment layer. Of importance is the fact that any changes made to this curve apply only to the tree, which has been *extracted*, so to speak. Remember that, because this is an adjustment layer, you can always go back and edit its effect. And because the mask you just made resides in this layer, you are able to load it as a selection and add more adjustment layers if you want.

This useful technique is applicable in many ways beyond what we have explored here. By inverting the color of the mask (during editing in Quick Mask mode), it can be used to select shadow areas and therefore increase or decrease their local contrast. Another approach you may want to try to get a similar effect is to duplicate the background to a new layer, then set the blend mode of the new layer to a lightening mode and use the Blend If sliders. This would create the same results; however, it would not be limited to just a masked area.

To learn more about Phil Bard and his work read his profile at the end of Technique 16.

SELECTIVE FOCUSING

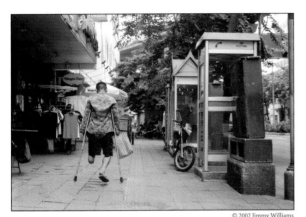

19.1

© 2002 Jimmy Williams

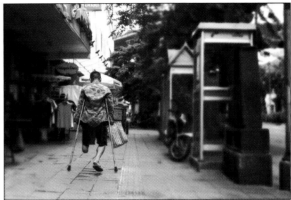

19.2

© 2002 Jimmy Williams

W hen I first looked at Jimmy Williams's portfolio, I was struck by how he was able to transform rather ordinary subjects into absolutely captivating images. Even more surprising to me was how these images were then turned into high-profile ads or commercial images for his many prestigious clients. Part of his early success was due to his creation and mastery of in-camera techniques.

With the onset of digital imaging and Photoshop, Jimmy has now become proficient in mimicking those techniques digitally. He can now choose between in-camera techniques or just shoot the shots and accomplish the same thing digitally with Photoshop. In this technique we'll look at how he used Photoshop to create a selective blur that a few years ago, could only have been done with a camera using swings and tilts.

As you will see in this technique, Photoshop allows much more control over the selective focus technique allowing him to have greater accuracy for placement and quantity of blur, and he can even be more selective about which parts go out of focus, even to the extent of not following the rules of optics should he decide to do so. This digital approach allows him to make such decisions after shooting when he can think with less distraction and evaluate the small nuisances as well as his emotional reaction to the effect.

STEP 1: OPEN FILE

■ Choose **File** ➤ **Open** (**Ctrl+O**) to display the **Open** dialog box. Double-click the **\19** folder to open it and then click the **boy-before.jpg** file to select it. Click **Open** to open the file.

■ Choose **Image** ➤ **Mode** and you notice that this image is **CMYK color** as this is the mode that Jimmy uses because almost all of his work is printed on a press. Click in the image to close the menu.

STEP 2: CREATE BLUR-LAYER

■ Choose **Layer** ➤ **Duplicate Layer** to get the **Duplicate Layer** dialog box shown in **Figure 19.3**. Type **blur layer** in the **As** box and click **OK**.

■ Choose **Filter** ➤ **Blur** ➤ **Gaussian Blur** to get the **Gaussian Blur** dialog box shown in

19.3

Figure 19.4. Using the slider, set the **Radius** to **7.0** pixels. Click **OK** to blur the image.

STEP 3: CREATE MASK LAYER TO FOCUS ATTENTION ON THE BOY

■ Choose **Layer** ➤ **Add Layer Mask** ➤ **Reveal All** to create a mask to be used to create focus on

19.4

JIMMY WILLIAMS

For more than two decades, Raleigh, North Carolina–based Jimmy Williams has captured unforgettable images, winning him a coveted spot on *Adweek's Southeast Creative All-Star* team. He has been recognized in nearly every creative show and publication in the advertising

the boy. Alternatively, click the **Add Layer Mask** button at the bottom of the **Layers** palette. The **Layers** palette should now look like the one shown in **Figure 19.5**.

- Click the **Brush** tool (**B**) in the **Tools** palette.
- Click the **Brush Preset Picker** in the **Options** bar and select the **Soft Round 300 Pixels** brush. If you cannot find the brush, click the menu button in the upper-right corner of the **Brush Preset Picker** and select **Reset Brushes**; then click **OK**.
- Make sure that the **Options** bar shows **Mode** as **Normal**. Set **Opacity** to **100%** and **Flow** to **20%**.
- Click the **Default Foreground and Background Colors** (**D**) button in the **Tools**

19.5

palette. Then click the **Switch Foreground and Background Colors** (**X**) button in the **Tools** palette to set black as the foreground color.

Painting on the layer mask with black masks out the blurred layer thereby allowing the sharp layer from below to show through. The objective is to slowly build up a smooth gradation so that the boy on crutches is in focus while the rest of the image is blurred.

- Using the **Brush** tool, paint vertical strokes where the boy is standing. Because **Flow** is set to **20%**, you have to click and paint several strokes to make a pure black mask so that the boy is totally in focus. Then, paint a few strokes on either side to make a smooth graduation between the blurred and focused parts of the image.

Be aware that no matter what Flow setting you use, you can never get more opaque than your Opacity setting. Flow controls how quickly the paint builds up to the Opacity value. Hence, if you want to paint 100% opaque black, Opacity must be set to 100%.

- If you paint too much in an area, you can set the foreground color to **White** (**X**) and erase the mask. Should you be unhappy with your masking altogether, you can choose **Select All** (**Ctrl+A**) and then **Edit** ➢ **Cut** (**Ctrl+X**) and start again.

industry, including *Communications Arts*, *The One Show*, *The Art Director's Club*, *Print*, *Graphis*, and the *Addy's* where he has won Best of Show honors. While still shooting with film, he has developed a digital workflow that allows him to provide exceptional digital images or prints to his clients to meet their specific requirements. Jimmy may be reached by telephone at (919) 832-5971.

- To view the mask, click in the **Make Visible** column to turn on the eye icon on the **blur layer Mask** channel in the **Channels** palette, which should look like the one shown in **Figure 19.6**. The mask should look similar to the one shown in **Figure 19.7**. Click the eye icon in the **blur layer Mask** channel in the **Channels** palette once again, to turn off the mask. You can now continue painting on the mask if needed.

19.6

19.7

STEP 4: DARKEN RIGHT SIDE OF IMAGE

- Choose **Layer** ➤ **New Adjustment Layer** ➤ **Curves** to get the **New Layer** dialog box. Type **darken right side** in the **Name** box; click **OK** to get the **Curves** dialog box. Click in the center of the line in the **Curves** palette and drag it until **Input** and **Output** show **45%** and **54%** respectively. Click **OK** to darken the image.
- Once again use the **Soft Round 300 Pixels** brush and paint vertical strokes starting at the left edge of the image to lighten the left side. Vary **Flow** from **100%** to **20%** to make a slight gradation between the boy on crutches and the buildings just to his right. Your mask should look similar to the one shown in **Figure 19.8**. If you have turned on the mask, turn it off before continuing to the next step.

STEP 5: CHANGE HUE/SATURATION

- Click the **darken right side** layer in the **Layers** palette to make it the active layer.
- Choose **Layer** ➤ **New Adjustment Layer** ➤ **Hue/Saturation** to get the **New Layer** dialog box. Type **hue/saturation** in the **Name** box; click **OK** to get the **Hue/Saturation** dialog box shown in **Figure 19.9**. First click in the box next to **Colorize**, and then set **Hue** to **15**, **Saturation** to **25**, and **Lightness** to **1**. Click **OK** to apply the settings.

19.8

STEP 6: CREATE FINAL CURVES ADJUSTMENT LAYER

■ Choose **Layer** ➢ **New Adjustment Layer** ➢ **Curves** to get the **New Layer** dialog box. Type **overall color** in the **Name** box; click **OK** to get the **Curves** dialog box.

■ You now set three points and adjust each endpoint, as shown in **Figure 19.10**. Drag the upper end-point toward the left; Type **95** and **100** in the **Input** and **Output** boxes.

Drag the lower end-point toward the right. Type **7** and **0** in the **Input** and **Output** boxes.

Click the curve to set a point. Type **20** and **24** in the **Input** and **Output** boxes.

Click the curve to set a point. Type **39** and **57** in the **Input** and **Output** boxes.

Click to set one last point. Type **69** and **80** in the **Input** and **Output** boxes. The curve should now look like the one shown in **Figure 19.10**. Click **OK** to apply the settings.

The Layers palette should now look like the one shown in **Figure 19.11**. Because of the extensive use of adjustment layers, you can go back at any time and fine-tune the settings and masks until the image is exactly as you want it.

19.10

19.9

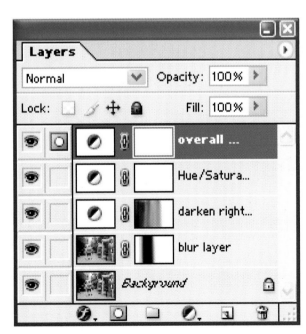

19.11

CHAPTER 4

CREATIVE EXPERIMENTATION

Many classic photographic effects can be reproduced or simulated by using new digital tools, such as Photoshop 7. With good techniques, the intent of the original classic photographic effects can be taken even further and doing them digitally often allows more variations, or control over the effect. In this chapter, you find out how to digitally hand-color a black and white image without all the mess and fuss of using photographic paints. Technique 21 shows how you can create a pseduosolarization — you may have to read it to learn what it is. Next, you discover how to apply digital texture screen effects to a digital image, such as the screen effects that were used by William Mortensen in the 1920s and 30s. If you did not use a graduated neutral density filter when it was needed when you shot a photograph, you learn a digital technique that may still be able to improve your image. Technique 24 shows how to digitally simulate an infrared film effect, and the last technique shows how you can tone a black and white image.

HAND-PAINTING A BLACK AND WHITE IMAGE

20.1

20.2

ABOUT THE IMAGE

Hope Linhof 4 x 5 Super Technika V with Polaroid back, Schneider 150mm f.5.6, f/11 @ 1/30, Polaroid print was scanned with an Isomet 455 scanner, image has been reduced to 1635 x 2400 pixels, 11.2MB .tif

The image of the girl in the window shown in **Figure 20.1** is just one of many wonderful black and white photos that Scott Dingman has taken. As Scott often uses freelance graphic artist Tammy Kennedy to edit his images, I asked her to provide a technique and tips for digitally hand-painting Scott's image of Hope.

I really like traditional hand-painted black and white photographs that have been painted with traditional photographic paints. However, painting with these traditional paints is time-consuming. Even the smallest mistakes can often not be corrected. Painting a photograph is a major job and lots of workspace is required. You have no way to make multiple copies without having to hand-paint each one. Color palettes are limited and I hate to wait for the paints to dry. Using this technique and tips by Tammy Kennedy, all those *negatives* are gone! The results of using this technique can be fantastic — try it on this image and then on one of your own.

STEP 1: OPEN FILE

■ Choose **File ➤ Open** (**Ctrl+O**) to display the **Open** dialog box. Double-click the **\20** folder to open it and then click the **hope-before.tif** file to select it. Click **Open** to open the file.

STEP 2: LIGHTEN IMAGE

■ To enable subtle hand-tinted colors to be more visible, lighten the image by choosing **Layer ➤ New Adjustment Layer ➤ Curves** to get the **New Layer Dialog** box. Type **lighten background** in the **Name** box and click **OK** to get the **Curves** dialog box.
Click the curve to set a point with **Input** and **Output** values of **50** and **68** respectively, as shown in **Figure 20.3**. Click **OK** to create the adjustment layer.

20.3

STEP 3: CREATE LAYERS FOR EACH COLOR AND PAINT COLORS

The best approach for creating a hand-painted image is to create a separate layer for each color you use. Set

SCOTT DINGMAN

Scott Dingman is an advertising photographer who specializes in photographing people both on location and in the studio. A graduate of Rochester Institute of Technology, Scott has a BFA in commercial photographic illustration and an exceptional talent for discovering the personality of his subjects and portraying

it in unique ways in a photograph. He has a growing list of prestigious clients that include: Blue Cross-Blue, Fast Company, Progress Energy, Duke University, Eastman-Kodak, Ericsson, Interpath Communication, Nortel, Siemens, Sprint, and Vector Group. Scott's Web page is www. scottdingman.com.

the Blend mode in the Layers palette for each color Layer to Color. **Figure 20.4** shows how Tammy creates folders and uses colors in the Layers palette to help her keep track of the paint colors and any adjustment layers that are added to the color layers.

The advantage to this approach is that everything is reversible! You can easily delete a layer, clear a layer, or add an adjustment layer to change color or increase saturation. If you paint with a soft brush with Opacity set to 10-15%, you can gradually build up the colors and they will look smoother than if you used a higher Opacity setting. If an entire layer of color is too dark, you can easily scale it back by reducing the Opacity of the layer in the Layers palette.

Should you have a question about what color to use, open up a similar color photograph and use the Eyedropper tool to select important colors, such as skin and eyes; then paint those colors in the working image.

The best hand-painted photos are usually painted with subtle colors. One of the mistakes usually made by those just beginning to hand-paint images is to use colors that are too bold. So go easy on the colors and take your time and paint with a low Opacity setting. Your results will look much more professional.

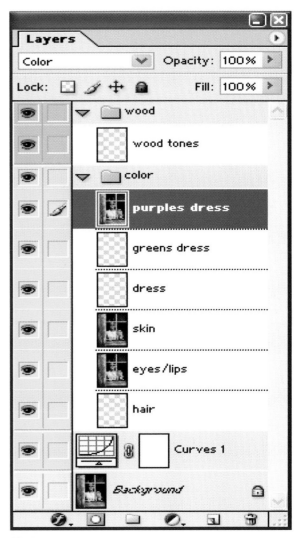

20.4

TAMMY KENNEDY

Tammy Kennedy, The Retouching Fairy Godmother, is a freelance graphic artist who specializes in photo editing. Besides working directly for clients, she has become the photo-retouching expert of choice for many photographers who need some editing magic performed on their images. As she is a highly organized expert in working with layers, her work may be easily adjusted at any time throughout the design process. Tammy uses a dual processor Mac G4 with a 21" monitor and a pen tablet. Tammy may be contacted by e-mail at photogodmom@ nc.rr.com or by telephone at (919) 662-9387.

CREATING A "PSEUDOSOLARIZATION"

21.1

21.2

ABOUT THE IMAGE

Rusty Truck Canon EOS 1v, 28-70mm f/2.8, Kodak Supra 400, F/16 @ 1/125, negative scanned with a Polaroid SprintScan4000, 2400 x 1617 pixels, 11.7MB .tif

Yeah right, you say — a *pseudosolarization* — just what is that and do I really want to create one? There are chemical solarizations, and solarizations that can be created in darkrooms during exposure, and then some that can only be created in theory. The exposure necessary to produce true solarization is in the range of 1,000 to 10,000 times that necessary to produce total black in the negative, which is rather difficult to create — that is unless you are using Photoshop 7 and can take a little detour around the true definition.

As I am more the creative type than the technical type and the notion of swapping some or all of the colors sounds cool, consider this an official *classic photographic effect*, which means that it fits nicely in this chapter. (In reality, I just really enjoy messing around with Curves and wanted it covered in this book as it can produce some really cool effects.) These effects look even better when you create an entire portfolio of *pseudosolarizations*! Try this technique on a few of your images — you'll probably like them. If not, just consider this technique a break from all the seriousness in the other 49 techniques.

147

STEP 1: OPEN FILE

■ Choose **File** ➢ **Open** (**Ctrl+O**) to display the **Open** dialog box. Double-click the **\21** folder to open it and then click the **rusty-truck-before.tif** file to select it. Click **Open** to open the file.

STEP 2: ADJUST LEVELS

■ Choose **Layer** ➢ **New Adjustment Layer** ➢ **Levels** to get the **New Layer** dialog box. Click **OK** to get the **Levels** dialog box shown in **Figure 21.3**. Drag the black slider to the right until **Input Levels** read **18**, **1.0**, and **255**.

STEP 3: ADJUST CURVES

■ Choose **Layer** ➢ **New Adjustment Layer** ➢ **Curves** to get the **New Layer** dialog box. Click **OK** to get the **Curves** dialog box. Begin setting and moving points around on the curve to make the curve look like it is a long rope being whipped up and down. Generally, you want to keep the two end-points where they are. I set points on the **Curve**, as those shown in **Figure 21.4** to get the image shown in **Figure 21.2**. There are infinite varieties — experiment and see what you can create. Try two, three, and four sets of loops.

■ When you get an image you like, consider creating a new adjustment layer for **Hue/Saturation**. **Figure 21.5** shows the results of applying **Hue/Saturation** with the settings **+101**, **−15**, and **0** to the image shown in **Figure 21.2**.

Believe it or not — this technique should be tried on a variety of different kinds of images as the results are unpredictable and they can be quite good. Okay — enough of this fun diversion and the art of creating *pseudosolarizations*.

21.4

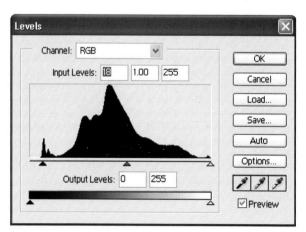

21.3

21.5

ADDING A TRADITIONAL DARKROOM TEXTURE SCREEN EFFECT

22.1 © 2002 Peter Balazsky

22.2 © 2002 Peter Balazsky

ABOUT THE IMAGE

Lady in Light

Nikon 8008s film camera mounted on tripod, 105 mm f/2.8, Fuji Sensia-RH slide film, ISO 400, f15.6, image from Kodak Photo-CD, 2048 x 3077 pixels reduced to 1920 x 2400 pixels, 13.8MB .tif

I learned about the wonderful photography and unique techniques of William Mortensen from Alan Scharf's postings to an e-mail group that we both belong to. As a long-time photographer and darkroom printer, as well as one who is interested in the history of photography, Alan has created his own digital Steeline texture screens to get results similar to those of William Mortensen and his texture screens, which William used extensively in the 1920s and '30s.

A texture screen is a film that is used in the darkroom. The screen has a texture printed on it and it is placed over the photographic paper or sandwiched with the negative during exposure. The use of these texture screens enables photographs to take on the characteristics of an etching, canvas, charcoal, pastel, or fresco.

As there is limited space in this book to cover the techniques or the work of William Mortensen, I highly recommend that you search the Internet for Web pages about him or that you attempt to find one of his long-out-of-print books. One of William's students is still creating texture screens as he created them. You can learn more about these screens and purchase one if you'd like from the Web site www.texturefects.com.

149

STEP 1: OPEN FILE

As William Mortensen's photographs frequently featured women (often nude) in rich brown-tones, with lots of grain, we use a wonderful photograph taken by photographer Peter Balazsy to try out the Steeline texture contributed by Alan Scharf.

- Choose **File** ➢ **Open** (**Ctrl+O**) to display the **Open** dialog box. Double-click the **\22** folder to open it and then click the **lady-in-light-before.tif** file to select it. Click **Open** to open the file.

STEP 2: CREATE DIGITAL TEXTURE SCREEN

Digital texture screens can be created by photographing appropriate textures, manually creating them on paper and then scanning them, or creating them digitally. Alan Scharf found that Andromeda's EtchTone Filter (www.andromeda.com), a Photoshop plug-in, works beautifully for creating certain types of screens. After some experimentation, he found that different images require different screen line frequency (spacing) and line thickness. Using the EtchTone Filter, he created the sample screen found on the Companion CD-ROM, which you use in this technique.

- Choose **File** ➢ **Open** (**Ctrl+O**) to display the **Open** dialog box. Double-click the **\22** folder to open it and then click **scharf-steeline1.tif** file to select it. Click **Open** to open the file.

Using this screen full-size is important. After the screen is applied to an image, the image should not be re-sized or saved as a JPEG as it causes deterioration of the screen effect.

STEP 3: APPLY DIGITAL SCREEN TEXTURE EFFECT

- To apply Alan's texture effect, click the **scharf-steeline1.tif** image to make it the active image; then press **Shift** and click the thumbnail image in **Background** layer in the **Layers** palette; then drag and drop the image onto the **lady-in-light-before.tif** image.
- To blend the screen with the image, click in the **Blend** mode box in the **Layers** palette and select **Multiply**. You can try other **Blend** modes as well. In particular, the **Darken** mode can work well. Additionally, you can reduce the **Opacity** level in the **Layers** palette. For this image, I used **Multiply**

PETER BALAZSY

Peter Balazsy is recognized as one of the most accomplished photographers in the art of the Polaroid photo-image transfer technique. Peter currently divides his professional life, working as both a portrait photographer and artist, as well as heading up a small computer consulting company where digital-image-manipulation provides yet another creative outlet for his artistry. Increasingly, Peter is working with new digital tools, including Photoshop, to create exciting new photographic art. About half of Peter's works are female nudes and portraits while the other half are cityscapes and still lifes that present his unique artistic-style. You can read more about Peter and his work on his Web site at www.pbpix.com.

as the **Blend** mode and set **Opacity** to **40%**, as shown in the **Layers** palette in **Figure 22.3**.

STEP 4: FINE-TUNE EFFECT

This technique has many variations. Besides reducing Opacity, you can create a layer mask and mask out parts of the screens where there are either important details (for example, eyes) or where highlights occur, such as those on the back of the lady in the photo used for this technique. **Figure 22.2** shows the results of carefully painting with a 300-pixel brush at 10% Opacity to remove the texture screen effects on the lady's back and in the brightest part of the light.

After you try this technique, consider creating your own screens textures and experiment with them on black and white photos as well as color photos. Thanks to Alan Scharf, this technique is a great start to what may well become a widely-practiced technique for those working in the new digital darkroom — thanks, Alan. Also, thanks to Peter for his perfect photograph for this technique! If you would like to contact Alan Scharf, he may be reached via e-mail at `ascharf@sk.sympatico.ca`. If you are interested in getting a set of his Steeline texture filters, send him an e-mail and ask him about them — he is continually experimenting and is creating a nice collection of them.

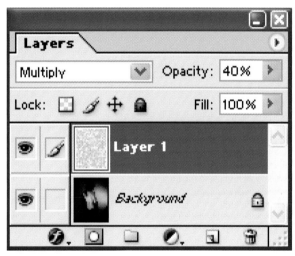

22.3

FIXING IMAGES WITH A DIGITAL GRADUATED NEUTRAL DENSITY FILTER

23.1

© 2002 Lewis Kemper

23.2

© 2002 Lewis Kemper

Most photographers have experienced the challenge of capturing the tonal range found outdoors with a camera when it exceeds the tonal range of the digital image sensor or film. A good example of this problem occurs when shooting a sunset scene with reflections in water, as shown in **Figure 23.1**. One way of overcoming this *too wide* tonal range is to use a graduated neutral density filter when shooting the scene. There are various types of graduated neutral density filters, which can be glass, plastic, or gel, and they are available in one, two, three, and more stops. The purpose of these filters is to compress the tonal range or contrast range of a scene into a range that will fit within the limitations of the camera that is being used to take the photo.

Many times though, photos are taken without the benefits of a graduated neutral density filter. In those cases, you *may* be able to partially rescue the image by using this useful digital graduated neutral density filter technique suggested by Lewis Kemper. Unlike the camera-based filter, this digital

technique allows you to more selectively define what gets lightened and darkened, rather than just applying a straight graduated neutral density tone to the photograph.

STEP 1: OPEN FILE

■ Choose **File ➢ Open** (**Ctrl+O**) to display the **Open** dialog box. Double-click the **\23** folder to open it and then click the **mt-ansel-adams-before.tif** file to select it. Click **Open** to open the file. A quick look at the photograph and you notice that the sky is too bright (it is over-exposed) and the foreground is too dark (under-exposed).

STEP 2: CREATE AN ADJUSTMENT LAYER AND SET BLEND MODE

■ As the intent is to use the **Multiply** blend mode to darken the bright sky and distant mountain range, an adjustment layer is needed. To create one, choose **Layer ➢ New Adjustment Layer ➢ Curves** to get the **Layer** dialog box. Click **OK** to get the **Curves** dialog box. Click **OK** to create the layer as no adjustment to the curve is needed for now. The **Layers** dialog box now looks like the one shown in **Figure 23.3**.

When creating the adjustment layer, Levels, Curves, Hue/Saturation, or any other type of adjustment

layer can be selected. Creating an adjustment layer allows a blend mode to be set and it automatically creates a mask, which is needed in Step 3.

■ Click in the **Blend Mode** box in the **Layers** palette and choose **Multiply** from the pop-up menu. The entire image looks much darker now as the **Multiply** blend mode has the same effect as stacking two slides together on a light box — they build up density and the image gets darker.

If the intent were to bring out the details in the darker part of the image, then the Blend Mode should be set to Screen, which has the same effect as increasing the exposure to lighten the image.

23.3

LEWIS KEMPER

Since 1980, Lewis Kemper has been working as a freelance photographer. Since he received a BA in Fine Art Photography from George Washington University, Lewis has not only created a phenomenal portfolio of photographs,

but he is also a prolific writer who has written several books, published many magazine articles, and is currently a contributing editor to *Outdoor Photographer* and *PC Photo* magazines. His photographs have been shown or collected nationally in galleries and museums,

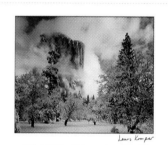

STEP 3: CREATE GRADUATED DENSITY MASK

■ To create the effects of a graduated density filter, click the **Gradient** tool (**G**) in the **Tools** palette. To select a gradient, click in the **Gradient Picker** in the **Options** bar to get the **Gradient** palette shown in **Figure 23.4**. If the palette does not look like the one shown in **Figure 23.4**, click the menu button in the **Gradient** palette and select **Reset Gradients**; click **OK** when asked **Replace current gradients with the default gradients?**
Click the **Black, White** gradient, which is the third gradient from the left on the top row.

■ To lighten the bottom part of the image, press **Shift** and click in the image about half way up the image and drag the cursor all the way to the top of the image. Pressing **Shift** makes the gradient run perfectly straight up the image. The image looks much better now as the gradient acts as a mask to the second layer — the blacker the mask, the more the second layer is hidden and the lighter the image is. Conversely, the lighter the mask is, the more the second layer is allowed to darken the image.

STEP 4: FINE-TUNE MASK

Now here is the advantage of this technique over using a graduated neutral density filter when shooting. After the initial gradient has been drawn in Step 3, you can now retouch the image by using the Brush tool set to a low Opacity of around 10% and painting the mask to lighten the trees and make the transition look more realistic. Using a real filter in the field would make the treetops darker than the bottoms, so this method is a definite advantage over the conventional method. After some painting on the mask, your image should look similar to the one shown in **Figure 23.2**.

This outlines the steps you can take to improve this image. You can now continue working on it as you would any other image and adjust it further as you like.

As an alternative to shooting a single photo and making the best of it by using this useful technique, you should also consider taking two different exposures of a scene; one exposed for the highlights, and one exposed for the shadows — then use Technique 28.

23.4

such as The Cornell Museum, The Frederick S. Wight Gallery, The Baltimore Museum of Art, The Princeton Gallery of Fine Art, The Popular Photography Gallery, The Ansel Adams Gallery, Photographer's Gallery, and The Yosemite Valley Visitor Center. Lewis teaches Photoshop classes for Palm Beach Photographic Centre, Santa Fe Workshops, and Hoot Hollow Institute. He also runs a custom print service using his digital skills to create fine art prints for photographers. To learn more about Lewis' work and the services he offers, visit his Web page at `www.lewiskemper.com`.

SIMULATING AN INFRARED FILM EFFECT

24.1 © 2002 Gregory Georges

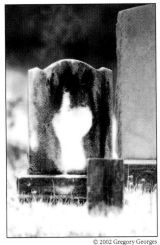

24.2 © 2002 Gregory Georges

When it came to creating a Photoshop 7 technique to simulate an infrared film effect, I knew that I could get a great one from Chris Maher. Chris has been very involved in all aspects of infrared photography. He and his business partner Larry Berman have gone so far as to tear apart and modify digital cameras so that they can shoot color infrared photos. If you enjoy infrared photography and you now use a digital camera, you must make a visit to their Web page at www.infrareddreams.com.

If you want to avoid tearing apart your digital camera and modifying it (as I do), then you'll enjoy Chris' technique, which allows you to simulate an infrared film photo by using any color digital image and editing it with Photoshop 7. As many of my favorite infrared photos (those that were taken by others) have been taken in graveyards, I looked through my photo collection and found a blank gravestone to use for this technique.

STEP 1: OPEN FILE

- Choose **File** ➢ **Open** (Ctrl+O) to display the **Open** dialog box. Double-click the **\24** folder to open it and then click the **gravestone-before.jpg** file to select it. Click **Open** to open the file.

STEP 2: CORRECT SKY

One of the characteristics of infrared photos is that bright skies become velvet black. This particular image does not have sky, so no work is to be done. However, if you are working on an image of your own that has a bright sky, select the sky area with the Magic Wand tool (W) and feather it a small amount so that it blends in with the surrounding areas. Set the Foreground color to near black (R: 35, G: 35, and B: 35) and the Background color to medium gray (R: 150, G: 150, and B: 150). Select the Gradient tool and use it to paint the gradient in a natural way according to how the sky looks.

STEP 3: LIGHTEN GREEN FOLIAGE

- To give the green foliage the characteristic whiteness that leaves refracting infrared would

show, choose **Image** ➢ **Adjustments** ➢ **Channel Mixer** to get the **Channel Mixer** dialog box. Click the **Monochrome** box at the bottom of the dialog box. Set the **Green** channel to **+200** by dragging the **Green** slider all the way to the right. To keep the tonal range looking correct, you need to make all the numbers add up to **100%**. As a good point to start, Chris recommends setting **Red** to **–50%** and **Blue** to **–50%**, as shown in **Figure 24.3**. These starting points look pretty good, so leave them as they are. Click **OK** to apply the settings.

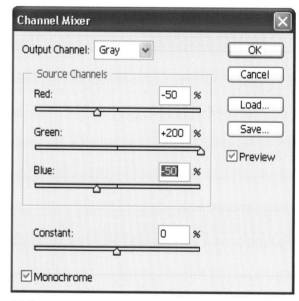

24.3

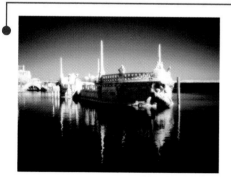

CHRIS MAHER

Chris Maher graduated from Rochester Institute of Technology with a Bachelor's Degree in Photographic Illustration and later received a Masters Degree in Visual Communications from Southern Illinois University. After working at Eastman Kodak for a few years, Chris began touring the U.S., earning a living for the next 15 years by selling his original photographic prints at juried art shows. Besides co-authoring articles for *eDigital*

STEP 4: ENHANCE THE DYNAMIC RANGE

- To enhance the dynamic range, choose **Image ➢ Adjustments ➢ Auto Levels** (**Shift+Ctrl+L**).

STEP 5: ADD GLOW

- To finish the effect, the image needs a glow to give it the look of a real infrared photograph. Because the filter you are using to create the glow requires that the **Background** color is set to **White**, set the **Background** color to **White** in the **Tool** palette, if it is not already **White** by pressing **D**. Choose **Filter ➢ Distort ➢ Diffuse Glow** to get the **Diffuse Glow** dialog box shown in **Figure 24.4**. Infrared film is pretty grainy, so set **Graininess** to **6**. Set **Glow Amount** to **4** and **Clear Amount** to about **15**. Click **OK** to apply the settings and your image looks like the one shown in **Figure 24.2** — a real infrared-looking photo!

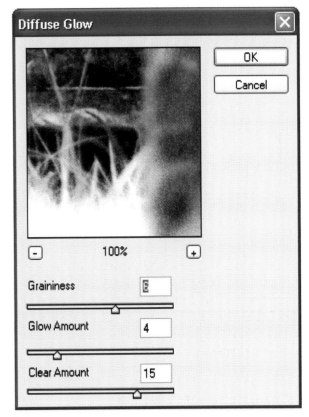

24.4

Photo and *Shutterbug* magazines with his business partner, Larry Berman, they both continue to create and sell their photographs at juried art shows across the country and create Web sites for other artists. Their Web site at www.bermangraphics.com contains a tremendous amount of useful information and a multitude of photo galleries, including several featuring infrared photography.

CREATING A TONED IMAGE

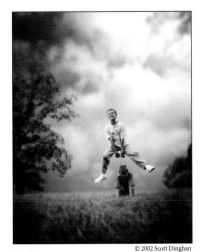

25.1 © 2002 Scott Dinghan

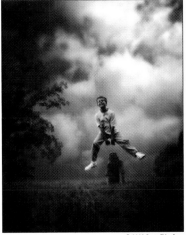

25.2 © 2002 Scott Dinghan

Boys Playing Leapfrog Contax 645 AS, 120mm Macro f/4.0, Kodak Plus-X, 4 different images have been digitally combined, film was scanned with an Isomet 455 scanner, image reduced to 1920 x 2400 pixels, 13.2MB .tif

Figure 25.2 shows a second example of Scott Dingman's photography, which has been digitally altered with Photoshop by Tammy Kennedy, a digital imaging freelancer. To learn more about Scott and Tammy read their profiles, which are at the end of Technique 20. This image showing two boys playing leapfrog was made from four separate images; one of the boys, one for the sky, and one for each of the trees or bushes on either side of the image.

When viewing this image and others in Scott's portfolio, you become aware of a very distinct and captivating style. He is excellent at capturing his subject's personality and presenting it in a photograph. Most of his images have been shot or digitally edited to draw the viewer in toward the subject. To create consistency between many of his black and white photos in his portfolio, he tones them with his own customized duotone. In this technique, you read how Scott tones many of his black and white portfolio images.

STEP 1: OPEN FILE

■ Choose **File ➣ Open** (**Ctrl+O**) to display the **Open** dialog box. Double-click the **\25** folder to open it and then click **leapfrog-before.tif** to select it. Click **Open** to open the file.

STEP 2: CONVERT TO DUOTONE

■ As you cannot directly convert an RGB image into a Duotone, choose **Image ➣ Mode ➣ Grayscale**. Then choose **Image ➣ Mode ➣ Duotone** to get the **Duotone Options** dialog box, which should look similar to the one shown in **Figure 25.3**. Click in the **Type** box and select **Duotone**.

■ To select the first color, click the color sample box for **Ink 1** to get the **Color Picker** dialog box shown in **Figure 25.4**. To set **black** as the first color, type **0** in the boxes next to **R**, **G**, and **B**; alternatively, you can click in the **Color Picker** box and drag the selection marker all the way to the extreme bottom-right or bottom-left — then the values of **R**, **G**, and **B** are all set to **0**. Click **OK** to set the color and return to the **Duotone Options** dialog box.

■ Click in the **Color Sample** box for **Ink 2** to get the **Custom Colors** dialog box. If you get the **Color Picker** dialog box instead, click the **Custom** button to get the **Custom Colors** dialog box shown in **Figure 25.5**.

25.3

25.4

Click in **Book** and select **Pantone solid coated**, which Scott has chosen for his portfolio prints. The color you want is **Pantone 728 C**, so type **7** to view the colors starting with a **7**. Scroll down until you see **Pantone 728 C**; click it to select it. Click **OK** to select the color and return to the **Duotones Options** box.

■ To create more contrast and darker brown colors, Scott modified the **Duotone Curves** for both of the selected colors. Click in the **Curves** box for **Ink 1** to get the **Duotone Curve** dialog box shown in **Figure 25.6**. Type **50** in the **30** box and then click **OK** to return to the **Duotones Options** dialog box. Do the same for the **Pantone 728 C** color; click in the **Curves** box for **Ink 2** to once again get the **Duotone Curve** dialog box. Type **70** in the **50**

box and click **OK** to return to the **Duotone Options** dialog box. Click **OK** to apply the **Duotone**.

■ To convert the image back to an RGB file, choose **Image** ➢ **Mode** ➢ **RGB Colors**. The image now looks like the one shown in **Figure 25.2**.

You have many issues to consider when using duotones, especially when manually adjusting duotone inks, which is a complex science. That is one of the reasons that Adobe provides so many preset curves for duotones, tritones, and quadtones settings. If you want to learn more about creating and using duotones, I highly recommend *Professional Photoshop 7 — The Classic Guide to Color Correction*, by Dan Margulis.

25.5

25.6

5

COMBINING PHOTOS IN MONTAGES, COLLAGES, AND COMPOSITES

This chapter is on combining images. First, we look at how to use the Photoshop 7 Extract feature to remove an object from a background image. After this task is complete, you have a photo object on a transparent background that is ready to be dragged and dropped onto any other image. Next is a fun technique that shows several different approaches to creating a photomontage. The end result of these techniques is a cool-looking building comprised of many parts of many old buildings — it is not a very inviting place — but it surely is amusing to look at. Then, we cover one of the most useful techniques in the entire book — a way to combine two bracketed photos into a single image with dynamic range that is much wider than can be captured with a digital or film camera. The last technique offers a collage mask and a technique that can be used to create a traditional photo collage. The photo collage is especially useful for Web pages.

26

CREATING PHOTO OBJECTS

26.1
© 2002 Gregory Georges

26.2
© 2002 Gregory Georges

R emoving part of one image and using it in another image is one of the more exciting possibilities made possible by using an image editor such as Photoshop 7. Creating photo objects may be done with one or more Photoshop 7 tools, such as Rectangular Marquee, Magnetic Lasso, Color Range, and so on, and the results of these tools can be improved when they are used on layers or even channels. However, in this technique, you will learn how to use the powerful Photoshop 7 Extract tool.

The objective is to remove the California brown pelican from his seaside view on top of a rocky overlook so that he may be placed in another image. The results of the work in this technique will be a transparent layer containing only the pelican, which may be dragged and dropped onto another image.

STEP 1: OPEN FILE

■ Choose **File ➢ Open** (**Ctrl+O**) to display the **Open** dialog box. Double-click the **\26** folder to open it and then click the **pelican-before.tif** file to select it. Click **Open** to open the file.

STEP 2: DUPLICATE LAYER

Before beginning the extract process, first duplicating the layer is wise so that you have the option of correcting parts of the image and so that you can easily compare your extracted image with the original.

- Choose **Layer** ➢ **Duplicate Layer**.

STEP 3: SELECT EXTRACT TOOL

The Extract tool has a number of user selectable settings that allow you to precisely select objects.

- Choose **Filter** ➢ **Extract** (**Alt+Ctrl+X**) to get the **Extract** dialog box shown in **Figure 26.3**.

STEP 4: DRAW AROUND PELICAN

The Extract tool is simple to use; you draw around the edge of the object that you want to remove, and then fill the interior of the object with paint and Extract removes all the background leaving just the object.

- Click the **Edge Highlighter** tool (**B**).
- In the **Tool Options** box on the right side of the **Extract** dialog box, you find a box next to **Smart Highlighting**; click in it to turn on **Smart Highlighting**, which helps you find strong edges.
- Carefully trace around the pelican with the **Edge Highlighter** tool. When needed, you can click the **Zoom** tool (**Z**) to increase the size of the image. To reduce the image size, press **Alt** while clicking the image with the **Zoom** tool.

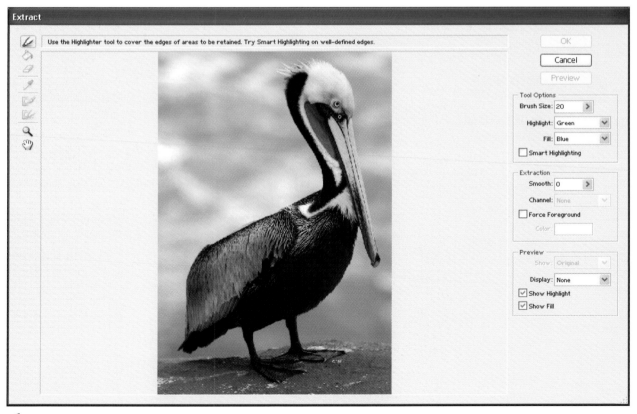

26.3

■ If the **Edge Highlighter** tool's paint color blends in with the image, select another color by clicking the box next to **Highlight** and select a color that offers more contrast with the background.

■ When using the **Edge Highlighter** you can change the size of the brush by typing a new size in the **Brush Size** box or by clicking in the **Brush Size** box and dragging the slider to choose a new brush size. As you are using the **Edge Highlighter** to straddle the edge of the targeted elements, you may sometimes find that a larger brush makes this task easier. Use a small brush for hard edges and a large brush for softer edges.

■ To move the image around in the workspace, use the **Hand** tool (**H**).

■ If you make a mistake while painting with the **Edge Highlighter** tool, click the **Eraser** tool (**E**) and erase the misplaced highlighting.

■ When the entire pelican has been selected, click the **Fill** tool (**G**) and click inside the pelican. The image should now look like the one shown in **Figure 26.4**.

■ If you decide that you want to start over, press **Alt** and the **Cancel** button will turn into a **Reset** button; click the **Reset** button and you will be back where you started.

STEP 5: VIEW PREVIEW

■ To view the extracted pelican, click **Preview** and the **Extract** dialog box now looks similar to the one shown in **Figure 26.5**. If you want to see

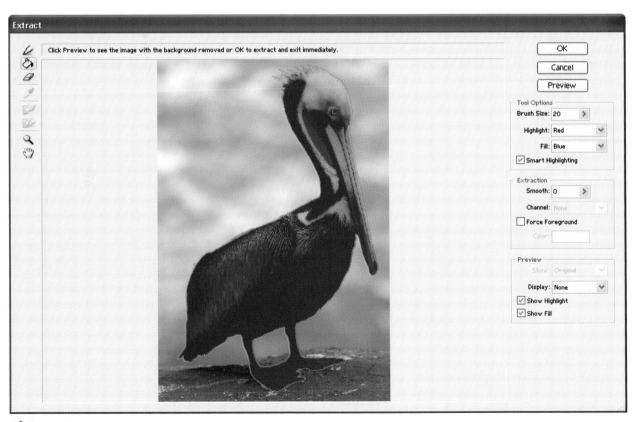

26.4

the pelican against a different background, click **Display** in the **Preview** area and select your choice of matte colors.

■ If you need to make corrections to the extraction, you can now use the **Cleanup** tool (**C**) or the **Edge Touchup** tool (**T**). Drag the appropriate tool to erase or to make pixels visible.

■ After the extraction is the way you want, click **OK** and the extraction is placed on the top layer in the Photoshop 7 workspace.

■ Key features of the pelican are the soft light-colored feathers on his head. If you click the eye icon on the **Background** layer on and off, you can see that some of those all-important feathers have been clipped! To put them back on, you can very carefully paint them back by using the **Clone Stamp** tool set to the **Background** layer and by painting on the extracted layer.

You now have an extracted pelican (or in the graphic arts field a pelican photo object). To place the pelican in another image, simply drag and drop the extracted layer onto another image. You can then position it, size it, and edit as you like. Just for fun, **Figure 26.2** shows the pelican placed on a swing — it was a simple drag and drop task. A small part of the nearest rope had to be cut and pasted as a new layer so that it could be put in front of the pelican, but that was easily done by using the Magnetic Lasso tool. Where do you want to put the pelican today?

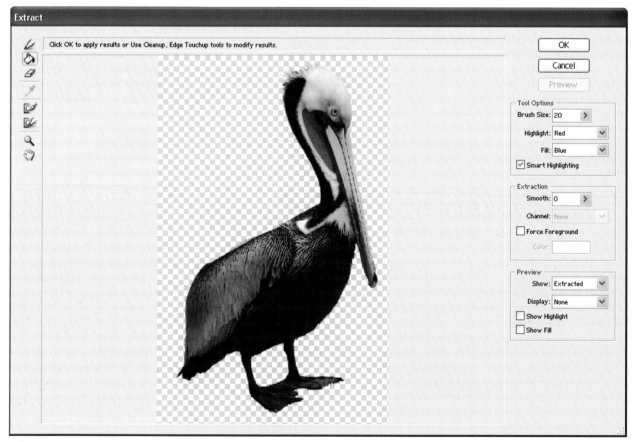

MAKING A PHOTOMONTAGE

27.1

© 2002 Gregory Georges

27.2

© 2002 Gregory Georges

As the title of the image suggests — we are going to create a home fit for a gargoyle by combining up to 17 different images of parts of old buildings. To do this, we use an underlying layer with some color and texture and the Luminosity blend mode to get a unifying effect that will help us avoid some heavy-duty color adjustments. We then look at a few ways to "merge" the images. From there, you are on your own. If you create an award-winning home that looks like it would suit an up-scale gargoyle, please create a small `.jpg` (one that fits in a 640 x 640 area) and e-mail it to me at `ggeorges@reallyusefulpage.com`. Good submissions will be put on display on this book's companion Web page at: `www.reallyusefulpage.com\50ps7\gargoyle-home.htm`. You'll get credit for the creation and — who knows, you may even get an offer or two to buy the home!

STEP 1: OPEN AND SCALE BACKGROUND IMAGE

■ Choose **File** ➢ **Open** (**Ctrl+O**) to display the **Open** dialog box. Double-click the **\27** folder to open it and then click the **background.jpg** file to select it. Click **Open** to open the file.

If you have a relatively fast computer and 128MBs or more of RAM, I suggest that you double the size of the background image and use each of the other files at full-size. Otherwise, you may want to keep the background image at its original size and reduce each of the image files that you use by 50% by using Image ➢ Size.

STEP 2: ADD IMAGE

■ Choose **File** ➢ **Open** (**Ctrl+O**) to display the **Open** dialog box. Double-click the **/27** folder to open it and then click **image2.jpg** (a door image) to select it. Click **Open** to open the file.

■ Arrange your workspace so that you can view the background image, plus **image2.jpg** or whatever image you have just opened. Click the **Move** tool (**V**) in the **Tools** palette. Click the **image2.jpg** image and then drag and drop it onto the background image to make it a new layer in the background image file. Alternatively, you can click the **Background** layer in the layer palette while the **image2.jpg** is the active image and drag and drop it onto the **background.jpg** image to create a new layer.

■ After an image is loaded as a layer on the **background.jpg** image, you can close it to conserve on memory.

STEP 3: USE BLEND MODE TO UNIFY COLOR AND TEXTURE

If you look at the 17 images that are available in folder **\27**, you will find that they are quite different in terms of color, focus, texture, and tonal range. To avoid having to make a multitude of adjustments on each image so that they can all be combined to look like they are part of the same building, a blend mode will be used to pick up color and texture from the `background.jpg` image.

■ To blend **image2.jpg** with the **background.jpg** image so that it picks up the color of the background.jpg image, click in **Blend** mode box in the **Layers** palette to get a pop-up menu; choose **Luminosity** as the blend mode.

Using the Move tool, you can click the **image2.jpg** layer and drag it around on the background image. Notice how it picks up the underlying color and textures. Place **image2.jpg** where you want it before going on to the next step.

STEP 4: POSITION AND SIZE IMAGE

One of the challenges in creating a successful image from the 17 images is to position, size, and *blend* each of the images into a building that looks — well, like a building and not 17 images pasted together in a haphazard fashion.

■ To position each image, use the **Move** tool.

■ To size an image choose **Edit** ➢ **Transform** ➢ **Scale**, or **Edit** ➢ **Free Transform** (**Ctrl + T**); then, click one of the handles found on the selection marquee and drag the image to size or scale it as you desire. If you want to keep the width to height proportions the same, press **Shift** before dragging the selection marquee. On the **Edit** ➢ **Transform** menu, you find other useful transformation options, such as **Rotate**, **Skew**, **Distort**, **Perspective**, and so on.

Each time you have an image where you think you want it, go back to Step 2 and add another image until you have added them all, or as many as you want. After the images are approximately sized and placed where you want them, you can begin blending them.

STEP 5: USE "BLEND" TECHNIQUE

As the goal of this technique is to create a photomontage by combining digital photos into a single image, some parts of the images either have to be cut out (using Cut) or hidden from view, by using a mask. While Cut can be used to selectively remove (permanently) parts of an image — it is a destructive command — that is, it tosses out or destroys the part of the image that is cut so that you cannot get it back later if you want it. For this reason, I suggest that you create a layer mask for each of the images that you bring in as a layer. Layer masks allow you to mask and then later unmask them should you change your mind about what parts of an image are to be visible.

■ To create a layer mask, click the chosen layer in the **Layers** palette to make it the active layer. Choose **Layer ➤ Add Layer Mask ➤ Reveal All**. This creates a layer mask icon on the layer in the **Layers** palette. **Figure 27.3** shows the **Layers** palette after an adjustment layer was added to the first layer.

27.3

After you create a layer mask, you can click it to make it active; then paint on it with the **Paint** brush by using **black** to hide parts of the image. If you want to add back part of the image, just paint it back by using the **Paint** brush and using **white**. When painting a layer mask, you can vary the **Opacity** level in the **Options** bar to get fine control over smooth blends, as shown in **Figure 27.4**. Notice how the door has been blended into the underlying rusty metal — you no longer realize that it was previously a square image. Later if you need to paint back some of the door image, just change the foreground color to white and paint the mask back to once again reveal the image. If you had used **Cut**, the portion of the image that you cut would be gone for good.

■ To make one layer lie on top of another layer, click a layer in the **Layers** palette and drag and drop the layer where you want it to be. To avoid having to select each layer by clicking it in the **Layers** palette, click in the box next to **Auto Select Layer** in the **Options** bar when the **Move** tool is selected. This enables the **Move** tool to select a layer based upon the image that you click. **Figure 27.5** shows the results of dragging the door layer in the Layer palette up one layer. Compare this image with that of **Figure 27.4**. You can see how effective a combination of the blend techniques can be — the two images now look like they were taken as a single photo.

27.4

■ Another way to blend an image with the one next to it is to use the **Clone Stamp** tool (**S**). After selecting the tool, click an image to set the source image; then click where you want to paint the source image and begin painting. You can change the brush size to suit the cloning requirements. **Figure 27.6** shows the results of using the **Clone Stamp** (**S**) tool to paint the image on the right across the door image.

To summarize: You can "blend" images by adjusting the layer order by painting on a layer mask to hide part of an image or by using the Clone Stamp tool to paint part of one image onto another part of the image. When you vary the Opacity level as you paint on a layer mask or with the Clone Stamp tool, you can get even smoother "blends" of images.

STEP 6: MAKE ADJUSTMENTS TO LAYERS

After all the images are added, sized, positioned, and blended, you may find that one or two of the images looks too dark or too light. As you might suspect, I recommend that you create an adjustment layer to make the necessary changes while allowing you to go back at any time to fine-tune the settings. You can use Levels or Curves. **Figure 27.7** shows the Layers palette after 11 images were added, plus one Adjustment Levels layer for Layer 2.

STEP 7: FLATTEN IMAGE AND MAKE A FEW FINAL ADJUSTMENTS

■ When you are happy with the image, save it as a **.psd** file with the **Layers** box checked so that you can go back and make further changes to the layers if you choose. Then, choose **Layer ➢ Flatten** image.

■ You can now treat this newly created image as an original photo. Create adjustment layers for **Levels**, **Curves**, **and Hue/Saturation**; use the **Unsharp Mask** to sharpen the image or make changes to the color by using one of the many color adjustment tools of Photoshop 7. **Figure 27.2** shows the results of increasing contrast and slightly adjusting colors by using Hues/Saturation. I confess that I got carried away with this image and did about a half-dozen different prints. Try making a few of your own and do experiment with the Hue/Saturation adjustment layer as the Blend mode does some really cool stuff with the rusty background layer. Don't let this funky image of a home fit for a gargoyle make you think this technique is not particularly useful — as it is. You can use this same approach to create a photomontage of sporting

27.5

27.6

events, family events, or just about any combination of images that you want to add to one image. It does take some patience and time as making a flawless montage is not easy, but the technique is!

27.7

COMBINING BRACKETED PHOTOS

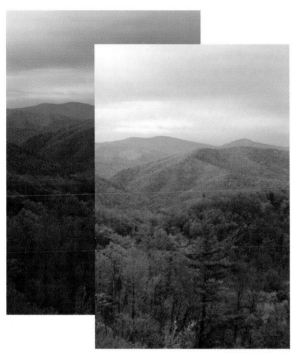

28.1
© 2002 Gregory Georges

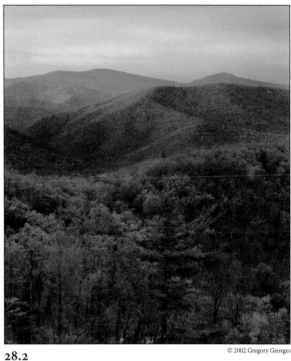

28.2
© 2002 Gregory Georges

ABOUT THE IMAGE

Shenandoah National Forest After Sunset Canon EOS D30 digital camera, 28-70mm f/2.8 at 34mm, ISO 100, RAW image quality, f/2.8 @ 1/10 and f/4.0 @ 1/10, 2160 x 1440 pixels, images have been converted from 16-bit to 8-bit .tif

Just looking at these photos makes me cold. When getting out of the car to take them, I seriously questioned whether I *really* wanted to take photos that much. The temperature dropped about 30-degrees in an hour — it was around 18 degrees F with a 40-mph wind blowing the light rain up the side of the mountain directly into my face and the camera lens. By the time I got the camera set up on a tripod and took two shots, my face and hands were numb. A quick look at the images shown in **Figure 28.1** gives you an idea of the challenge — to blend the best parts of the bracketed images together to give good detail in the light areas and good detail in the shadows.

Admittedly, I did not take the best possible photos in this case. Given a more relaxed shooting environment, I would have used the camera's spot-metering capability and metered the sky and then the foreground, while taking a photo in each case. Instead, I set up the camera very quickly — took one shot — changed from f/2.8 to f/4.0, took a second shot, and jumped back into the car!

177

After you complete this technique, my bet is you'll find that shooting bracketed photos and combining them by using this technique will yield better results than if you were to take the time to use a graduated neutral density filter. As you will see, this technique does not force you into positioning a perfectly gradated filter over an image of a scene where life is not so perfect, and, where the dynamic range of the subject exceeds the dynamic range of your digital camera's imaging chip or the film in your film camera. Try this technique on the images supplied on the companion CD-ROM — then try it on some of your own.

STEP 1: OPEN FILES

■ Choose **File ➢ Open (Ctrl+O)** to display the **Open** dialog box. Double-click the **\28** folder to open it. Press **Ctrl** and click **sunset1-before.tif** and **sunset2.tif** to highlight both files; then, click **Open** to open both files.

28.3

STEP 2: COMBINE BOTH FILES INTO ONE IMAGE

■ To place the lighter of the two images on top, click once in the **sunset1-before.tif** image to make it the active image. Press the **Shift** key while clicking the **Background** layer in the **Layers** palette; then, drag the layer onto the top of the **sunset2. before.tif** image. The **Layers** palette should now show a **Background** layer and a **Layer 1**.
■ Choose **View ➢ Fit on Screen (Ctrl+0)** to maximize the image.

STEP 3: CREATE LAYER MASK

Next you combine the two images by using a layer mask.

■ Click **Layer 1** in the **Layers** palette if it is not highlighted.
■ Choose **Layer ➢ Add Layer Mask ➢ Reveal All**. Looking at the **Layers** palette now, you notice that there is a layer mask thumbnail just to the right of the **Layer 1** thumbnail (see **Figure 28.3**); click it to make it the active layer.
■ Set **black** as the foreground color by clicking the **Default Foreground and Background colors** (**D**) icon at the bottom of the **Tools** palette and then press **X**.
■ Click the **Brush** tool (**B**) in the **Tools** palette. Click the **Brush Preset Picker** in the **Options** bar to get the **Brush** palette shown in **Figure 28.4**. If you get a different palette, click the menu button at the upper-right corner of the **Brush** palette and choose **Reset Brushes** from the pop-up menu. Select the **Soft Round 200 Pixels** brush.
■ Click in the **Opacity** box in the **Options** bar to get a slider; set **Opacity** to **10%** and **flow** to **100%**.

STEP 4: PAINT ON THE LAYER MASK TO REVEAL THE LOWER LAYER

In the prior step, a layer mask was created, a brush was selected, and Opacity was set to 10%. As the layer

mask is painted with black, it allows the lower layer to show through. If you paint with white, it will once again hide the lower layer. To get the best results, try painting with Opacity set to 10%, which makes your painting be a 10% gray. Using this setting, you can more carefully build up the mask to show precisely what you want. Each time you click, you increase the buildup of the mask by 10%. Painting an image like this one is vastly easier, more fun, and more accurate if you have a pen tablet like one of the Wacom tablets.

■ Begin carefully painting the sky with the **Brush** tool until you have increased the image density to match the foreground. I suggest that you vary the size of the brush and that you increase the image to **100%** when painting the edges between the sky and the distant mountain range, especially when painting the edge between the middle mountain range and the foreground trees. Later when you make further adjustments to the image, your careful painting eliminates the need to go back and try again. Yes, there is a corollary to this — don't paint carefully and you'll have to paint again! After some painting, your image should look similar to the one shown in **Figure 28.5**.

If you change your Brush to a Soft Round 65 or Soft Round 100 Pixel brush, you can increase contrast in the mountains in the middle of the image by painting only on the denser green areas. You could never do this with a split neutral density filter!

28.4

28.5

STEP 5: CREATE ADJUSTMENT LAYERS AND MAKE FINAL ADJUSTMENTS TO THE IMAGE

After you blend the images as you want, you can begin making the same kinds of image adjustments that were covered in Chapter 2 — only make sure that you use adjustment layers for each of the adjustments! Doing this allows you to go back and modify the settings; plus, because we used a layer mask to blend the two images, you can also go back and fix any part of the mask that you don't like — all without causing any irretrievable loss of picture data!

■ Click the **Layer 1** thumbnail (the left thumbnail on **Layer 1**) — not the **Layer 1 mask** thumbnail (the right thumbnail). There is a big difference between these two thumbnails!

■ Choose **Layer ➢ New Adjustment Layer ➢ Levels** to get the **New Layer** dialog box; click **OK** to get the **Levels** dialog box. Using the **RGB** channel, slide the left slider toward the right until **Input Levels** shows **10**, **1.00**, and **255**, as shown in **Figure 28.6**.

Click the **Black Point Eyedropper** and click once in the darkest tree trunk you can find in the foreground to set the black point to pure black. This helps to increase image contrast. Click **OK** to apply the setting.

■ Click once again on the **Layer 1** thumbnail (the left thumbnail on **Layer 1**) — not the **Layer 1 mask** thumbnail (the right thumbnail).

Once again, I make the point that it is important that you click the correct thumbnail. As we want to add another adjustment layer to the image — not the Levels adjustment layer, you must select Layer 1 — not another layer — not the layer mask!

■ Choose **Layer ➢ New Adjustment Layer ➢ Curves** to get the **New Layer** dialog box; click **OK** to get the **Curves** dialog box. Click in the image in the foreground and drag around the foreground while watching where the point moves up and down the curve in the **Curves** dialog box. This indicates the part of the curve where the slope must be increased to increase contrast in rich-colored foreground trees.

Try setting one point at **54** and **47**, and a second point at **91** and **91**. Setting these two points greatly improves the foreground tree area. The curve now looks like the one shown in **Figure 28.7**.

28.6

28.7

If you want to perform a similar adjustment to the sky to increase the contrast of the sky, once again drag your cursor over the sky to see what area of the curve needs to have the slope increased, which increases contrast. I liked the results of setting two points at **202** and **200** and another one at **226** and **230**.
Click **OK** to apply the settings.

■ Click one last time on the **Layer 1** thumbnail (the left thumbnail on **Layer 1**) — not the **Layer 1 mask** thumbnail (the right thumbnail). By now, you should understand how you add adjustment layers and how they work with a layer mask.

Even though the image now shows some rich fall colors, they looked much richer and brighter before the wind and rain began. So, just because we can — increase color saturation a tiny bit to make those orange colors pop out off the screen and later off the print.

■ Choose **Layer** ➢ **New Adjustment Layer** ➢ **Hue/Saturation** to get the **New Layer** dialog box; click **OK** to get the **Hue/Saturation** dialog box shown in **Figure 28.8**. Using the **Master** channel in the **Edit** box, slide the **Saturation** slider to **+12**. As you move the slider, watch carefully to see how the red and orange trees begin to glow — stop before

you overdo it. Click **OK** to apply the settings. Your image now looks like the one shown in **Figure 28.2**.

At this point, the Layers palette should look like the one shown in **Figure 28.9**. The significant point here: By clicking on any one of the layers — you can go back and change any of the settings and you can even modify the layer mask, which determines how the two original images blend together. You can also click the eye icon in any of the layers to turn a layer on and off to see the effect — try it.

As these few steps fully illustrate this approach to capturing the full dynamic range found in real life settings, we end this technique here. However, be aware that many other changes can still be done to this image — some of the other techniques in this book can be used on this image to further improve it such as sharpening.

28.8

28.9

USING A MASK TO CREATE A COLLAGE

29.1 © 2002 Gregory Georges

29.2 © 2002 Gregory Georges

Many art stores, frame shops, and photo stores offer pre-cut collage matte boards, which make it easy to display multiple photos on a single matte board. This technique shows you how to create a digital collage that allows you to easily slip digital images behind a collage mask so that it looks just like the pre-cut matte boards. The benefit of this approach is that you can create a collage mask once, and then use it each time you need to display new photos.

Figure 29.2 shows how a collage mask is used to display eleven lacrosse action photos of the week on a Web page. This pre-defined collage mask may be found on the Companion CD-ROM. If you want to create a collage to print (you need more resolution), or if you want to design your own, follow the instructions in Step 1. Otherwise, skip to Step 2 and use the pre-defined mask.

STEP 1: CREATE COLLAGE MASK

Figure 29.3 shows the layout of the collage you can find on the Companion CD-ROM. It was easily created in just minutes by using the Photoshop 7 rulers and guidelines. Technique 1, Step 1 shows how to set up the rulers and how to use guidelines to create layouts such as this one.

The steps for creating the collage mask are as follows:

1. Create a new image. As this particular collage mask was created for a Web page, it was sized at 800 x 600 pixels.

2. Duplicate the **Background** so that digital photos can slide beneath the collage mask layer (top layer) and above the **Background**.

3. Set rulers to pixels by using **Edit ➢ Preferences ➢ Units & Rulers** as discussed in Technique 1.

4. Drag guidelines from the rulers and drop them where guidelines are needed for locating the masks. To learn more about using guidelines, see Technique 1.

5. Using the **Rectangular Marquee** and **Elliptical Marquee** tools, select each area to be masked (on the top layer) and fill them with black by using **Edit ➢ Fill**.

6. After all the *openings* have been filled with black, select them all with **Select ➢ Color Range** or with the **Magic Wand** tool. To *cut* them out, load the **Frames.atn** actions into the **Actions** palette and then run the **Cutout (selection)** action. To learn how to use actions, see Technique 3.

That's it — your collage mask is now ready for photos to be placed beneath each opening.

STEP 2: INSERT DIGITAL PHOTOS

■ If you did not create your own collage mask in Step 1, choose **File ➢ Open** (**Ctrl+O**) to display the **Open** dialog box. Double-click the **\29** folder to open it and then click the **collage-mask.psd** file to select it. Click **Open** to open the file. You should now have an image that looks like the one shown in **Figure 29.4** and the **Layers** palette should look like the one shown in **Figure 29.5**.

29.3

29.4

Eleven lacrosse images can be found in the \29 folder. The original full-size digital action photos were cropped, edited, resized, and then sharpened so that they would fit inside the masked openings. They were then saved as .jpg files by using the Photoshop 7 Save for Web feature.

- To open all 11 images at once, choose **File ➢ Open (Ctrl+O)** to display the **Open** dialog box. Double-click the **/29** folder to open it. Press and hold **Ctrl**; then click each file named **image1.jpg** through **image11.jpg** to select them all. Click **Open** to open all the files into the Photoshop 7 workspace.
- Click **Background** layer in the **Layers** palette to make it the active layer.
- Click the **Move** tool (**V**) in the **Tools** palette.
- To insert the first photo, click **image1.jpg** to make it the active image and drag it onto the **collage-mask.psd** image. Using the **Move** tool, click and drag the image so that it shows through the center elliptical opening.
- Using the **Move** tool, continue clicking each image and dragging it onto the **collage-mask.psd**

image until all images have been correctly positioned. After you place all of the images, the **Layers** palette shows the **Background** layer, the **openings layer**, and 11 image layers.

Depending on how you select and position the images, you may find that one or more images overlap another image. If this occurs, make sure Auto Select Layer is turned on by clicking in the box next to it in the Options bar. Then, click the overlapping image by using the Move tool to select it. Click the Lasso tool; then click and draw a selection marquee around the part of the image that you want to remove. Choose Edit ➢ Cut (Ctrl+X) to cut the overlapping part of the image. Alternatively, you can create a layer mask and paint out the part of the image that you do not want to show. Or, you can drag and drop layers in the Layers palette so that the order of the images eliminates the overlapped image problem.

STEP 3: FLATTEN IMAGE AND SAVE AS A NEW FILE

- Choose **Layer ➢ Flatten Image**.
- To minimize image size, click the **Square Marquee** tool and drag a selection marquee around all the images. Choose **Image ➢ Crop** to crop the image.
- To save as an optimized **.jpg** file to be used on a Web page, choose **File ➢ Save For Web** (**Alt+Shift+Ctrl+S**) to get the **Save For Web** dialog box. Select the **JPEG Medium** setting and click **Save**. Name the file and save it in an appropriate folder.

The image is now a mere 52KBs and is ready to be placed on a Web page. **Figure 29.2** shows how the image looks in an Internet browser after an HTML editor has been used to add a title. If you had to create such an image, each week, for weekly action photos, you would simply need to open the collage mask and drag and drop images — it is that easy.

29.5

CHAPTER 6

FINE ART TECHNIQUES

This chapter is for photographers who either have always wanted to be a painter or who have painted and now want to learn how to use Photoshop to transform digital photographs into graphic art or fine art prints. This chapter is also for graphic and fine artists that want to effectively use their traditional media skills in the new digital paint studio. Of all the chapters in this book, this is the chapter that shows off the awesome power Photoshop 7 has for transforming digital photographs into art of an entirely different type.

The techniques in this chapter cover how to create line drawings, rough marker sketches, pen and ink sketches with a watercolor wash, fine art images with filters, and more. While one technique is for those with traditional painting skills, the others may be used by just about anyone with a few digital photos. While I would consider this to be a fun chapter, some of the techniques are rather long and they can be time consuming.

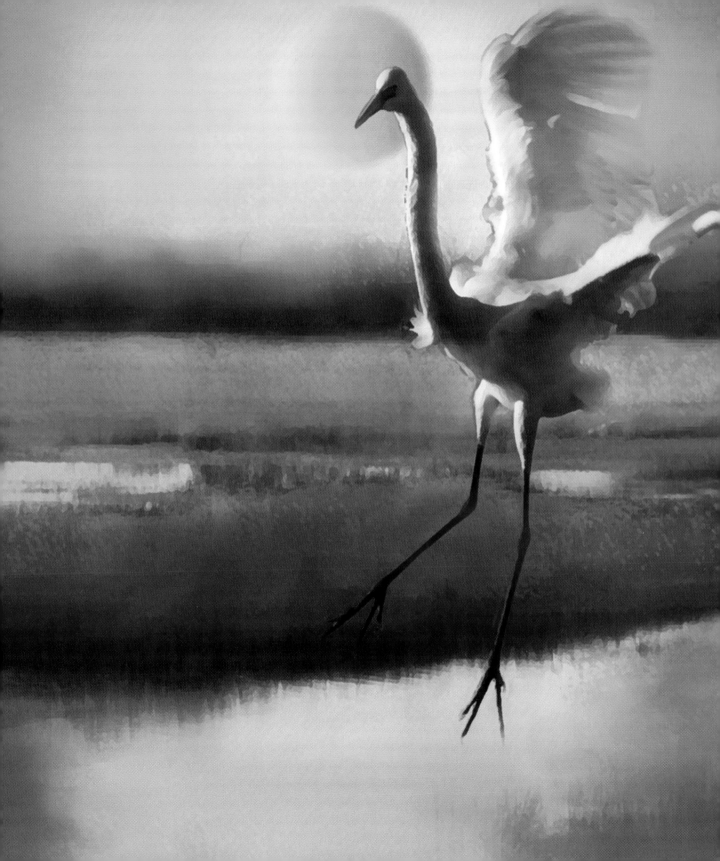

TOTAL COLOR TRANSFORMATION

30.1

© 2002 Gregory Georges

30.2

© 2002 Gregory Georges

Figure 30.1 shows a digital photo that was created by digitally stitching together five photos that were taken with a digital camera on a tripod. Each photo was overlapped about one-third and then combined into a single image by using Enroute PowerStitch software, which is no longer available. You can achieve the same digital stitching effect by using the Photomerge feature in Adobe Photoshop Elements. Shot in the early afternoon, the bright blue color of the sky dominates the image. Our objective for this image is not insignificant — to turn the image into an after-dusk image with a rich orange sunset color and a magical tree just to add a bit intrigue.

STEP 1: OPEN FILE

- Choose **File** ➤ **Open** (**Ctrl+O**) to display the **Open** dialog box. Double-click the**30** folder to open it and then click the **farm-before.tif** file to select it. Click **Open** to open the file.

STEP 2: CREATE MIRRORED TREE

The objective of this step is to select a portion of the image between the middle of two trees, copy it, and paste it back into the image. Then, flip it horizontally and slide it to the right so that part of the image is mirrored.

- Click the **Rectangular Marquee** tool (**M**) in **Tools** palette. In the **Options** bar, set **Feather** to **0** pixels and **Style** to **Normal**.
- Double-click the document Window title bar to maximize it. Using a maximized window makes it easier to select an image all the way to the edges.
- Choose **View** ➤ **Fit on Screen** (**Ctrl+0**) to make the image as large as it can be by using one of the standard enlargement factors and yet have all of it be visible.
- Click the **Rectangular Marquee** tool just below the image and in line with the middle of the largest tree; drag the marquee up toward the left until the left side of the marquee is in the middle of another tree, as shown in **Figure 30.3**.

- Choose **Layer** ➤ **New** ➤ **Layer via Copy** (**Ctrl+J**) to copy the selection and paste it back into the image as a layer.
- Choose **Edit** ➤ **Transform** ➤ **Flip Horizontal** to flip the pasted layer horizontally.
- Click the **Move** tool (**V**) in the **Tools** palette. Press **Shift** and click inside the pasted portion of the image and move it toward the right until the two middles of the big tree mirror, as shown in **Figure 30.4**. Pressing **Shift** will help you to keep the image aligned vertically with the **Background**.
- To make final adjustments to the location of the pasted layer, click the **Zoom** tool (**Z**). Click once and drag the **Zoom** selection marquee around the largest tree so that it fills up the desktop.
- Once again, click the **Move** tool (**V**) in the **Tools** palette. Now press the **Right Arrow** or **Left Arrow** keys to move the pasted layer 1 pixel at a time. If you press **Shift** and one of the arrow keys, the layer will move 10 pixels at a time. Keep making adjustments until the tree is perfectly symmetrical.
- After the layer is accurately positioned, choose **Layer** ➤ **Flatten Image** to flatten the layer.

STEP 3: CROP IMAGE

If you look toward the right side of the image, you will find a part of the image that no longer fits with the rest of the image. The break occurs where there is

30.3

30.4

a break in the white fence. The image to the right of the break in the fence needs to be cropped out.

- Click the **Crop** tool (**C**) in **Tools** palette. In the **Options** bar, delete any values in the **Width** and **Height** boxes by clicking **Clear** in the **Options** bar.
- Double-click the document window title bar to maximize it if it is not already maximized.
- Choose **View** ➤ **Fit on Screen** (**Ctrl+0**) to make the image as large as it can be and yet have all of it be visible.
- Using the **Crop** tool, click just outside the upper-left side of the image; then drag the marquee down and to the right until you have all of the image selected up to the end of the white fence on the right side.
- Press **Enter** to crop the image.

If you have enough RAM, I suggest that you now create a snapshot as this is a key state in this technique. To create a snapshot, click the menu button in the History palette to get a pop-up menu. Choose New Snapshot to get the New Snapshot dialog box. Type mirrored tree in the Name box and then click OK. You also can click the Create New Snapshot icon at the bottom of the History palette, but creating a

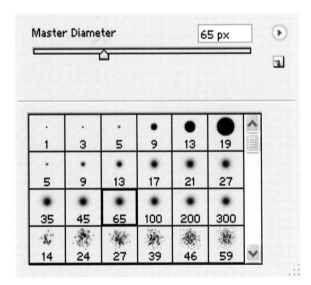

30.5

new snapshot this way does not allow you to name the snapshot while creating it. One other alternative is to press Alt while clicking the New Snapshot button and you will be prompted for a name. Pressing Alt when choosing a command or clicking a button usually means *show a dialog box if you normally wouldn't or don't show a dialog box if you normally would.*

STEP 4: REDUCE THE APPEARANCE OF SYMMETRY

While I like the magical-looking tree, I do not like the fact that everything around the tree also looks *mirrored*. So mess up the symmetry a bit so that only the tree appears to have been touched by magic when it was a mere seed in the woods.

- Click the **Clone Stamp** tool (**S**) in the **Tools** palette.
- In the **Clone Stamp** tool **Options** box, make sure **Mode** is set to **Normal**, **Opacity** to **100%**, and **Flow** to **100%**.
- Click the **Brush Preset Picker**, which is the second box from the left on the **Options** bar to get the brush palette shown in **Figure 30.5**.
- If the **Brush Preset Picker** does not look the same as the one in **Figure 30.5**, you may need to either reset the brushes or change layout. To reset the picker, click the menu button in the upper-right corner of the **Brush Preset Picker** palette to get a pop-menu. Choose **Reset Brushes** and click **OK** when asked: **Replace current brushes with the default brushes?**
- To change the layout of the **Brush Preset Picker**, click the menu button and choose **Small Thumbnail** from the pop-up menu.
- Click the **Soft Round 65 Pixels** brush to select it.
- To help make your cloning work as easy and accurate as possible, choose **View** ➤ **Actual Pixels** (**Alt+Ctrl+0**), and then press **F**, **F**, and **Tab**. You now have an uncluttered screen full of the image at 100%.
- Press the **Spacebar** to get the **Hand** tool; then drag the image so that the largest tree and the two silos are in the middle of the screen. You are now ready to begin painting with the **Clone Stamp** tool.

- First paint the white fence all the way across the gap beneath the large symmetrical tree. When you press **Alt**, you get a new cursor, which sets the source of the clone brush. With this cursor, click once on the bottom rung of the fence on the second fence post to the right of the two silos — this sets the clone source.
- To begin cloning, press the left mouse button after aligning the center of the **Clone Stamp** tool cursor on the bottom rung at a post where you want to begin cloning. Drag the cursor to paint in the fence.
 When needed, reset the clone source by pressing **Alt** and then paint in more fence until the entire fence looks correct.
- The brown silo on the right really ought to go as well. Once again, find some good source branches and clone them until the silo is no longer there. I suggest that you also get rid of one of the little outbuildings that are on either side of the symmetrical tree. As you eliminate the symmetry in everything around the single large symmetrical tree, your image begins to look more realistic — that is with the exception of the single magical tree — and that is just what we want.

As you paint with the Clone Stamp tool, you may want to select a different brush size or maybe even one with a hard edge. To do so, simply click the Brush Preset Picker box and select a new brush. There is some art to cloning. Carefully consider where and how often you set your source. When painting, click often and change to an appropriate brush to get the best results and to avoid having to re-clone large areas should you clone where you don't want to clone. Using many short strokes instead of a few long ones also helps to cover your tracks as well.

- Press **Tab** and **F** to return to normal view again. Double-click the document window to maximize it; then choose **View** ➤ **Fit on Screen** (Ctrl+0).

Now is a good time to take a Snapshot should you have sufficient RAM. Alternatively, you can save your

file as a temporary file with a file name, such as "farm-before-mirrored."

Before you begin changing the colors in the image, create a duplicate layer as it may be needed later. How do I know this? Well I do, because I have experimented enough to know that some really cool things can happen when you use some of the blend modes to darken images. After you complete this technique, you'll find yourself keeping a few extra layers around just in case too!

- Choose **Layer** ➤ **Duplicate Layer** to get the **Duplicate Layer** dialog box. Click **OK** to create a duplicate layer.

STEP 5: CHANGE BLUE SKY TO A DARK ORANGE SUNSET COLOR

The process of changing colors as much as we are attempting is fraught with difficulties. As you go on, you see that you have some strange color casts to remove.

- Choose **Image** ➤ **Apply Image** to get the **Apply Image** dialog box shown in **Figure 30.6**. Click in the **Blending** box to get a pop-up menu; choose **Multiply** and then click **OK** to blend the layer with itself.
- Choose **Image** ➤ **Adjustments** ➤ **Hue/Saturation** (Ctrl+U) to get the **Hue/Saturation** dialog box shown in **Figure 30.7**.
- Set **Hue** to +165, **Saturation** to 30, and **Lightness** to –15. Click **OK** to apply the settings. Now the challenge is to remove the greens, cyans, and blues that are in the field and trees.
- Choose **Image** ➤ **Adjustments** ➤ **Hue/Saturation** to get the **Hue/Saturation** dialog box.
- Click in the **Edit** box to get a pop-up menu; choose **Greens**.
- Set **Hue** to 0, **Saturation** to –100, and leave **Lightness** set to 0.
- Click in the **Edit** box to get a pop-up menu; choose **Cyans**.
- Set **Hue** to 0, **Saturation** to –100, and leave **Lightness** set to 0.

- Click in the **Edit** box to get a pop-up menu; choose **Blues**.
- Set **Hue** to **0**, **Saturation** to **–60**, and leave **Lightness** set to **0**.
- Click **OK** to apply the settings.

The objective now is to darken the image and to add some contrast to the sky so that it looks like there is an orange glow caused by the sun setting below the far off horizon. To do this, we use the Soft Light blend mode, which compares to image and selects values from both images based upon the lightest values.

- Make sure that **Background copy** layer is highlighted in the **Layers** palette.
- Choose **Image** ➢ **Apply Image** to get the **Apply Image** dialog box shown in **Figure 30.8**.
- Click in the **Layer** box and choose **Background** from the pop-up menu.
- Click in the **Channel** box to get a pop-up menu; choose **Red**.
- Click in the **Blending** box to get a pop-up menu; choose **Soft Light**.
- Leave **Opacity** set to **100%** and click **OK** to apply the blend.

STEP 6: MAKE FINAL COLOR AND TONAL CHANGES

You can improve the image easily by increasing image contrast using levels.

- Choose **Image** ➢ **Adjustments** ➢ **Levels** to get the **Levels** dialog box. Set **Input** levels to **10**, **.88**, and **236**. Click **OK** to apply the settings.

If the orange color is not exactly as you want it, you further fine-tune the colors by using the Hue/Saturation command once again. As for me, I've done enough to be happy with this image as it is. I should mention that while this heavily saturated red image looks good on a PC screen, it is a true challenge to get it to print correctly on consumer level inkjet printers. It can be done, but, you may have to do some tweaking of your printer's controls to get a print as you want it.

30.7

30.6

30.8

USING FILTERS TO CREATE FINE ART PRINTS

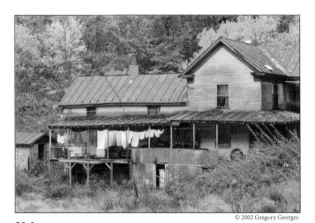

31.1

© 2002 Gregory Georges

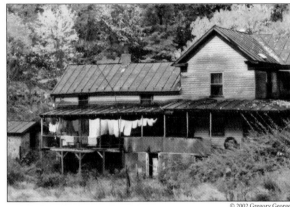

31.2

© 2002 Gregory Georges

The photo of the country farmhouse shown in **Figure 31.1** was taken in Virginia on a freezing, rainy day. One of the neighbors told me some local folklore about the house. The story is that the house contains some rather significant distillery capabilities. The color of the laundry is a coded message that tells what is brewing and invites friends to drop-in for a drink. I don't know if the story is true, but I wouldn't knock on the door to ask!

Anyone who takes photographs knows that you can try as hard as possible to take great photos with each click of the exposure button. Yet, later you find out that you didn't get the shot you had hoped to have. One of the exciting things about using a digital image editor such as Photoshop 7 is that you can often fix those not *quite right* photos. Or even more — you can apply a half-dozen filters and end up with a good print you are pleased to have made. This technique shows how a few commonly used filters can be combined to end up with an image that makes a pretty good print.

STEP 1: OPEN FILE

- Choose **File** ➢ **Open** (Ctrl+O) to display the **Open** dialog box. Double-click the **/31** folder to open it and then click the **cabin-before.jpg** file to select it. Click **Open** to open the file.

One tip for getting the better effects when using some of the filters in the Filter menu is to use a filter on one layer and blend it with a second layer, which may or may not have been edited. As we intend to do this later in this technique, we need to create a second layer now.

31.3

- Choose **Layer** ➢ **Duplicate Layer** to get the **Duplicate Layer** dialog box. Click **OK** to create a layer we can later use to apply a blend mode to increase density and soften the effects of a couple of filters.

STEP 2: SOFTEN IMAGE

To dramatically change the character of this digital photo, we are going to apply a few filters to soften the edges and add depth to shadows.

- First increasing the image to 100% before applying filters so that you can clearly see the effects that you will get is generally a good rule.

31.4

You can zoom to **100%** by double-clicking the **Zoom** tool in the **Tools** palette, or you can choose **View** ➤ **Actual Pixels** (**Alt+Ctrl+0**).

■ Press the **Spacebar** to get the **Hand** tool; then click the image and drag it up toward the right until you can see the red shirt on the laundry line. Also, look at the brown grass in the bottom-left corner of the image. As you apply effects to the image, check both of these areas to make sure the effects are what you want.

■ Choose **Filter** ➤ **Blur** ➤ **Smart Blur** to get the **Smart Blur** dialog box shown in **Figure 31.3**. When you move your cursor over the preview image in the **Smart Blur** dialog box, the cursor changes into the **Grab** tool icon. Click and drag the image around until the red shirt on the laundry line shows in the middle of the preview box.

■ In the **Smart Blur** dialog box, set **Quality** to **High** and **Mode** to **Normal**. Try using a **Threshold** setting of **25.0** and then begin sliding the **Radius** slider until you get the results you like. I found a **Radius** setting of **3.0** to be just about right. Click **OK** to apply the blur.

■ Choose **Filter** ➤ **Artistic** ➤ **Poster Edges** to get the **Poster Edges** dialog box shown in **Figure 31.4**. Once again, click inside the preview box and drag the image around until you can see the red shirt on the laundry line and then look at an area where there are leaves. Experiment with different settings to make sure there are enough dark edges, but not too many. Try setting **Edge Thickness**, **Edge Intensity**, and **Posterization** to **1**, **1**, and **6** respectively. Click **OK** to apply the effect.

STEP 3: DARKEN THE IMAGE

One way to darken an image without getting a posterization effect like you can get when using Levels is to duplicate a layer and then blend it with itself by using the Multiply blend mode. However, rather than taking the effort it takes to duplicate a layer, blend it and then flatten it again — the Apply Image command does it all in a single step with less consumption of your time and your PC's memory resources.

■ To darken the image, you blend the two layers in the **Layers** palette that now look like the one shown in **Figure 31.5**. Click the **Blend** mode box to get a pop-up menu. Choose **Multiply** and set **Opacity** to **65%**.

■ Flatten the image by choosing **Layer** ➤ **Flatten Image**.

STEP 4: MAKE FINAL COLOR AND TONE ADJUSTMENTS

Now increase color saturation and try to add some "punch" to the image to make the cabin stand out from the background.

■ As we are not particularly concerned about posterization in this image (having used the **Poster Edges** effect), choose **Image** ➤ **Adjustments** ➤ **Auto Color** (**Shift+Ctrl+B**) to improve the tonal range of each of the three color channels (red, green, and blue).

31.5

■ Choose **Image** ➢ **Adjustments** ➢ **Hue/ Saturation** (**Ctrl+U**) to get the **Hue/Saturation** dialog box shown in **Figure 31.6**. Set **Hue** to **0**, **Saturation** to **25**, and **Lightness** to **0**. Click **OK** to apply the settings.

■ The image now needs some punch, so increase contrast and brightness. Choose **Image** ➢ **Adjustments** ➢ **Curves** to get the **Curves** dialog box.

■ Click once in the top half of the line to set a point. In the **Input** box, type **158** and in the **Output** box type **168**.

■ Click in the top half of the line to set a second point. In the **Input** box, type **100** and in the **Output** box, type **83**.

■ The **Curves** dialog box now looks like the one shown in **Figure 31.7**.

■ Click **OK** to apply the settings.

■ Choose **Layer** ➢ **Duplicate Layer** to get the **Duplicate Layer** dialog box; click **ok**. Choose **Filter** ➢ **Blur** ➢ **Gaussian Blur**. Set **Radius**

to **4.0** and click **ok**. Click in the **Blend Mode** box in the Layers palette and select Luminosity as the blend mode. Set **Opacity** to **40%**. Select **Layer** ➢ **Flatten Image**.

That completes this image and this technique — that is unless you are inclined to do some more tweaking. If changing colors is your objective, I suggest you try Hue/Saturation. Using the Hue/Saturation command you can make global changes to the colors by using the Master channel as we just did, or you can click in the Edit box and select Reds, Yellows, Greens, Cyans, Blues, or Magentas to adjust each color independently. If you make a few adjustments and you want to start all over, press Alt and the Cancel button changes to Reset. Click Reset to reset all the settings.

31.7

31.6

TECHNIQUE 32

COLORING A DIGITAL SKETCH

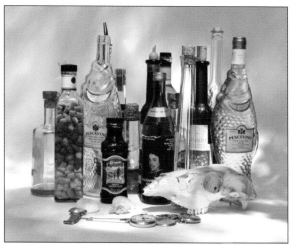

32.1

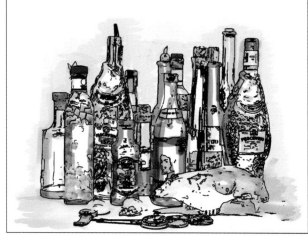

32.2

ABOUT THE IMAGE

Olive Oil Bottles Canon D30 digital camera, 28-70mm f/2.8, ISO 100, Extrafine RAW setting, f/16 @ 1/40; original 2160 x 1440 pixel image edited, cropped, and up-sampled 2x to a 2400 x 1920 pixel 8-bit, 13.8MB .tif

As a line drawing is generally the first of a progression of steps taken to create most artwork, it seems reasonable to spend a few pages of this book on several different techniques for creating line drawings. A line drawing created from a digital photograph can be used for many purposes. As most inkjet printers can print on fine art paper, it is possible to print a line drawing on fine art paper and use it to begin a traditional media painting. Digital photos turned into line drawings can also be used as the starting sketch for a digital painting. Line drawings can also be incorporated into other digital techniques, as shown in Technique 33, where a digital photograph is turned into a very elegant *pen and ink* sketch with a watercolor wash.

As the line drawing is so important for both traditional media and for digital art, we look at three different approaches to create line drawings. These three approaches not only help ensure that you can get a successful line drawing from most digital photos, but they also allow you to vary the style of the lines in your digital drawings.

While it is possible to make line drawings from a grayscale digital photo by applying a single filter, the five-step process outlined here may obtain far superior results. This process is the basis for the three line drawing techniques that follow — the only significant difference is that each of the three different techniques uses a different *find edge* filter — either the **Find Edges**, or **Poster Edges**, or **Smart Blur** filters.

1. *Covert image into a grayscale* image by choosing **Image** ➤ **Mode** ➤ **Grayscale** or by choosing **Image** ➤ **Adjustments** ➤ **Desaturate** (**Shift**+ **Ctrl**+**U**) and then setting **Saturation** to **−100**. While these are the easy ways to convert a color image into a grayscale image, you can also perform this conversion by using Technique 14, 15, or 38 to get more control over the shades of gray.

2. *Pre-process the image* to get optimal results from the filter that is to be applied to find edges. As most of the edge-finding filters work on contrast, you can often get much better effects by adjusting contrast either by choosing **Image** ➤ **Adjustments** ➤ **Brightness/Contrast**, **Image** ➤ **Adjustments** ➤ **Levels**, or **Image** ➤ **Adjustments** ➤ **Curves**. Some images will have so much texture that it is difficult to differentiate the texture edges from the important edges. In this case, you may be able to reduce some of the texture by experimenting with either the **Gaussian Blur** or **Median** filters. You may have to experiment with both filters and several different settings until you get the results that you want.

3. *Apply an edge-finding filter* that creates lines. While you have many filters to use to find edges, we use the **Find Edges**, **Smart Blur**, and **Poster Edges** filters. I generally get the best results with the little-known **Edges Only** feature in the **Smart Blur** filter. Having said that — you still ought to try the other two filters as they can produce good results and possibly exactly the effects that you want.

4. *Adjust the resulting line drawing* to improve contrast and remove undesirable effects. Depending on the image and the results of the prior three steps, you may have some work to do to clean up your line drawing. The results you want can help you decide what is needed. You may often use the **Levels** or **Brightness/Contrast** filters to increase the darkness of the lines and remove unwanted artifacts. The **Eraser** tool may be used to remove *spots*. Large areas containing spots may be selected by using one of the many selection tools and then deleted all at once.

5. *Apply one or more filters to add character to the lines.* After you have lines where you want them — and no additional spots, dots, or other unwanted artifacts — you can use one or more filters to add character to the lines. My favorite character-adding filters are the **Poster Edges** and **Dark Stroke** filters. There are other filters, but these can add lots of character to your lines — try them. If you don't get what you want after applying them once, apply them more than once or use a combination of them.

By now, unless you are like me and you appreciate a quality line drawing made with lines that have lots of character, you're probably thinking I'm a bit over the top on this one! Nevertheless, read on, as these line creation techniques can be exceedingly useful as they can be the basis for some outstanding work such as you see later in this chapter. We first use the Find Edges and Poster Edges filters. Then, we use the Smart Blur filter and digitally paint the resulting ink sketch.

FIND EDGES FILTER APPROACH TO CREATING A LINE DRAWING

The Find Edges filter is possibly the most commonly used filter used to create line drawings, but the filter results in lines made with shades of gray. The reason for this is that Find Edges makes low-contrast areas white, medium-contrast areas gray, and high-contrast areas become black. It also turns hard edges into thin lines and soft edges into fat lines. The result is a line drawing that is very different from the thin lines that we get by using the Smart Blur filter. It can, however,

transform some digital photos into some pretty cool line drawings.

STEP 1: OPEN FILE AND REMOVE COLOR

■ Choose **File** ➢ **Open** (**Ctrl+O**) to display the **Open** dialog box. Double-click the **\32** folder to open it and then click the **bottles-before.tif** file to select it. Click **Open** to open the file.

■ Choose **Image** ➢ **Mode** ➢ **Grayscale**. Click **OK** to remove the color from the image and turn it into a grayscale image where color can no longer be added.

After a quick look at the Histogram for this image, I decided not to experiment with the Brightness/Contrast and Levels filters. Some preprocessing may improve the ability of the Find Edges filter to find edges and get your desired effects. We look more carefully at this when we get to the Smart Blur technique.

STEP 2: FIND EDGES AND CREATE LINES

■ Choose **Filter** ➢ **Stylize** ➢ **Find Edges** to apply the Find Edges filter.

After applying the Find Edges filter you have a good line drawing, except it has lines that are made of three shades of grays — not just black lines. You can see the results in the drawing shown in **Figure 32.3**.

STEP 3: REMOVE SOME LINES AND MAKE THE REST BLACK

■ Choose **Image** ➢ **Adjustments** ➢ **Threshold** to get the **Threshold** dialog box shown in **Figure 32.4**. Set the **Threshold Level** to **175** and then click **OK** to apply the setting.

STEP 4: CLEAN UP THE DRAWING

■ Click the **Eraser** (**E**) tool in the **Tools** palette and drag the cursor over the few stray marks that ought not be there.

The final line drawing is shown in **Figure 32.5**.

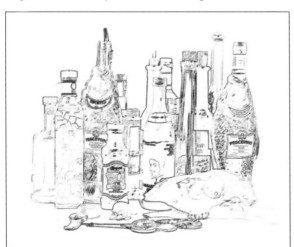

32.3

32.4

32.5

POSTER EDGES FILTER APPROACH TO CREATING A LINE DRAWING

The Poster Edges filter reduces the number of colors (or shades of gray) in an image according to your chosen settings. Besides drawing lines between contrasting edges, it also shades areas, which means it does not directly create a line drawing. You can use these shaded areas to create solid black areas, which can result in what may look more like a line drawing with black ink shades. This filter does require some experimentation to get good results.

STEP 1: OPEN FILE AND REMOVE COLOR

■ Choose **File** ➢ **Open** (**Ctrl+O**) to display the **Open** dialog box. Double-click the **\32** folder to open it and then click the **bottles-before.tif** file to select it. Click **Open** to open the file.

32.6

■ Choose **Image** ➢ **Adjustments** ➢ **Desaturate** (**Shift+Ctrl+U**) to remove the color from the image.

STEP 2: ADJUST LEVELS

■ Choose **Image** ➢ **Adjustments** ➢ **Levels** (**Ctrl+L**) to get the **Levels** dialog box. Set **Input Levels** to **15**, **1.70**, and **220** and then click **OK** to apply the settings.

STEP 3: FIND EDGES AND CREATE LINES

■ Choose **Filter** ➢ **Artistic** ➢ **Poster Edges** to get the **Poster Edges** filter dialog box shown in **Figure 32.6**. Set **Edge Thickness**, **Edge Intensity**, and **Posterization** to **1**, **10**, and **6** respectively. Click **OK** to apply the filter.

STEP 4: REDUCE SHADES OF GRAYS AND SOME LINES

After applying the **Poster Edges** filter, you begin to see a semblance of a line drawing! Now we need to remove some of the shades of gray and some lines.

■ Choose **Image** ➢ **Adjustments** ➢ **Posterize** to get the **Posterize** filter dialog box shown in **Figure 32.7**. Set **Levels** to **2** and then click **OK** to apply the filter. These settings result in only black and white with no shades of gray.

STEP 5: REMOVE SOME LINES AND MAKE THE REST BLACK

You are just about done; you need to remove some lines and all the unnecessary background must go.

32.7

■ Click the **Eraser** tool (**E**) in the **Tools** palette to select the **Eraser** tool. Click in the **Options** box to select the **Hard Round 19 Pixels** brush. Carefully erase a path of the unwanted dots all around the outside edge of the objects.

■ Click the **Lasso** tool (**L**) in the **Tools** palette to select the **Lasso** selection tool.

■ Click and drag the selection marquee around the objects where you just erased a path.

■ After the selection is complete, choose **Select** ➢ **Inverse** (**Shift+Ctrl+I**) to invert the selection.

■ Choose **Edit** ➢ **Cut** (**Ctrl+X**) to delete all of the remaining unwanted dots in the background.

You can see the results of this technique in **Figure 32.8**.

SMART BLUR FILTER APPROACH TO CREATING A LINE DRAWING

Due to Smart Blur's Radius and Threshold settings and its ability to make very fine lines, this filter has become my favorite for creating line drawings. After you have lines where you want them, you can use several other filters to change the character of the lines.

STEP 1: OPEN FILE AND REMOVE COLOR

■ Choose **File** ➢ **Open** (**Ctrl+O**) to display the **Open** dialog box. Double-click the **/32** folder to

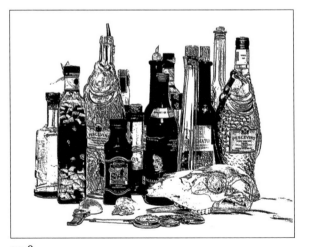

32.8

open it and then click the **bottles-before.tif** file to select it. Click **Open** to open the file.

■ Choose **Image** ➢ **Adjustments** ➢ **Desaturate** (**Shift+Ctrl+U**) to remove the color from the image.

We can use the **Brightness/Contrast** or **Levels** filters to adjust the contrast in the image; however, use it as it is. This image is an especially good one to use to create a line drawing, as it requires little work to get excellent results.

STEP 2: FIND EDGES AND CREATE LINES

■ Choose **Filter** ➢ **Blur** ➢ **Smart Blur** to get the **Smart Blur** filter dialog box shown in **Figure 32.9**. Set **Quality** to **High** and **Mode** to **Edge Only**.

32.9

■ The preview box in the **Smart Blur** dialog box shows white lines on a black background. Click the preview window and drag and drop it around until you find an area on a bottle where you want to make sure you have the right level of detail. Begin sliding the **Radius** and **Threshold** sliders around until you get enough detail in the image — but not too much. After you have a setting that works, drag and drop it around the rest of the image until you have the right level of detail in all parts of the image.

■ Try using a **Radius** setting of **5.0** and a **Threshold** setting of **20.0**. Click **OK** to apply the settings.

Using 5.0 and 20.0 as the settings for Radius and Threshold produces a line drawing with as few lines as is needed to outline the bottles and some of the ingredients. Increasing the Threshold setting increases the number of lines and adds increasing detail to the drawing. Depending on the desired effects, a higher setting can create an even more visually interesting line drawing — more of a *sketchy sketch* than a mere line drawing.

■ Invert the white lines on a black background image by choosing **Image** ➢ **Adjustments** ➢ **Invert** (**Ctrl+I**).

After applying the Smart Blur filter, you have an excellent line drawing, as shown in **Figure 32.10**. This drawing has very fine lines and can be used as a sketch to begin a painting or other kind of artwork.

STEP 3: INCREASE THE WIDTH OF THE LINES

■ To make the lines darker and wider, choose **Filter** ➢ **Artistic** ➢ **Poster Edges** to get the **Poster Edges** dialog box shown in **Figure 32.11**. Set **Edge Thickness**, **Edge Intensity**, and **Posterization** to **10**, **0**, and **0** and click **OK** to apply the settings.

The results of applying the Poster Edges filter are shown in **Figure 32.12**. If you want even thicker and bolder lines, apply the Poster Edges filter once or twice more.

32.11

32.10

■ Make the lines even bolder so that they look like they were created with a marker. Choose **Filter ➢ Brush Strokes ➢ Dark Strokes** to get the **Dark Strokes** dialog box shown in **Figure 32.13**. Try using a setting of **5**, **6**, and **2** for **Balance**, **Black Intensity**, and **White Intensity** respectively, which results in the image shown in **Figure 32.14**.

■ Now save your image to your hard-drive as you use this drawing a little later in the technique. Save it as **bottles-rough-sketch.tif**.

■ Close the file.

If you don't get the results you want from any of these *find edges* filters, I suggest you investigate the possibilities of the Trace Contour, High Pass, and Glowing Edges filters.

Okay — enough of these line drawing techniques. Now we can use the rough sketch that we just created and digitally hand paint it to add some color.

COLORING THE ROUGH MARKER SKETCH

So far in this technique you have looked at three different ways to create black and white line, or ink drawings from photographs. You also looked at a number of ways to modify the character of those

32.13

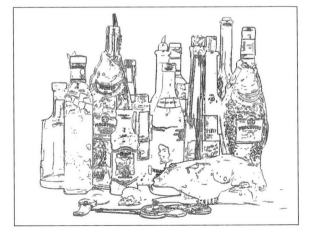

32.12

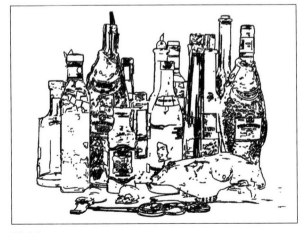

32.14

lines and have converted one of them into a marker-like sketch. Now you are going to paint in color on the dark stroke sketch you just created.

While it is not difficult to set up this painting technique, it must be done correctly and you need to have a good understanding of why there are three layers and what some of the more important blend modes can or cannot do. Finally, you need to understand how to paint with brushes and with the History Brush tool. After you understand the underlying concepts, you should be able to create thousands of different kinds of images. Varying pen strokes, image sources, textures, blend modes, and other variables can allow you to produce effects to meet your most conservative to most wild tastes!

STEP 1: OPEN FILES

■ Choose **File** ➢ **Open** (**Ctrl+O**) to display the **Open** dialog box. Double-click the **\32** folder to open it and then click the **bottles-before.tif** file to select it. Click **Open** to open the file.

■ If the **bottles-dark-strokes.tif** file that you just created is not already open, then open it from the folder where you saved it.

STEP 2: CREATE A PAINTING LAYER

■ Click the **bottles-before.tif** image to make it the active document if it isn't already.

■ Choose **Layer** ➢ **New** ➢ **Layer** (**Shift+Ctrl+N**) to get the **New Layer** dialog box. Type **Paint Layer** in the **Name** box and click **OK** to create a new transparent layer for painting.

■ To copy the rough sketch into the **bottles-before.tif** document, click the **bottles-dark-strokes.tif** document to make it the active document. Then click in the **Background** layer thumbnail in the **Layers** palette while pressing **Shift** and drag it on to the **bottles-before.tif** document. Pressing the **Shift** key makes the layers align perfectly.

■ The **Layers** palette now looks like the one shown in **Figure 32.15**.

32.15

32.16

- Now close the **bottles-dark-strokes.tif** as it is no longer needed.
- Click the **Paint Layer** layer in the **Layers** palette to make it the active layer.
- Choose **Edit** ➤ **Fill** to get the **Fill** dialog box shown in **Figure 32.16**. Click the **Use** box and select **White**. Set **Mode** to **Normal** and set **Opacity** to **100%**. Click **OK** to fill the layer.
- Now click the **Hide Layer** icon in the left column of the **Layer 1** layer in the **Layers** palette to hide the rough sketch.

If at any point, you want to paint on the Paint Layer layer while being able to view the original image below, first hide the rough sketch layer and then click the Fill box in the Layers palette to get a slider. Slowly slide the slider to the left until you can see the underlying image. At about 80% you can see the image below well enough to paint directly on this layer to make a painting. However, we won't be painting, in this manner in this technique. Instead, we use the History Brush tool and paint directly from a snapshot. We also have a sketch to guide our painting, so being able to view the underlying image is not a requirement in this case. Make sure to slide the Fill slider back to 100%.

STEP 3: SET UP HISTORY BRUSH TOOL

Before you can begin painting, you must select the History Brush tool, pick an appropriate brush size and style, select a suitable blend mode and opacity level, and set the source history state. After you accomplish this, you can begin painting on the paint layer. As the paint layer is below the sketch layer, the paint won't interfere with the rough sketch.

- Click the **History Brush** tool (**Y**) in the **Tools** palette.
- Click the **Brush Preset Picker** in the **Options** bar, which is the second brush box from the left, as shown in **Figure 32.17**. Click the menu button to get a pop-up menu. Choose **Reset Brushes** and click **OK** to get the default set of brushes. For this technique I find that the **Small List** view (see **Figure 32.18**) is a better view than one of the thumbnail views as the full descriptive name is helpful for getting an appropriate brush. To change to the **Small List** view, after clicking the **Brush Preset Picker** box, click the menu button to get a pop-up menu and choose **Small List**.

32.18

32.17

■ If the **History** palette is not already visible, choose **Window** ➢ **History**. Scroll to the top of the **History** palette and you should see a snapshot named **bottles-before.tif**, as shown in **Figure 32.19**. As this is the only snapshot, the **History Brush** automatically sets this snapshot to be the source image for painting. If there were more than one snapshot, you would click in the box to the left of the thumbnail image to set this chosen snapshot to be the source for the **History Brush** tool.

32.19

32.20

If a snapshot is not in the **History** palette, your **Preferences** setting is not set to automatically create a snapshot when opening a file. To create a snapshot, make sure that the **Background** layer in the **Layers** palette is highlighted and that the top two layers are hidden. To hide those layers, click the eye icon if it is displayed in the left column of each layer to hide the layer. Click the menu icon in the **History** palette to get the pop-up menu; choose **New Snap Shot** to create a new snap shot.

■ To start painting, use the **Watercolor Loaded Flat Tip** brush. Click the **Brush Preset Picker** in the **Options** bar to get the **History Brush** menu palette, which is shown in **Figure 32.20**. Scroll toward the bottom of the palette and click **Watercolor Loaded Wet Flat Tip** brush.

This is an excellent brush to use for this technique as it allows wet-on-wet painting — that is, you can see the paint build up, plus you can see where it overlaps. The looseness of this brush matches the looseness of the rough sketch you created earlier.

■ Because we are cloning from a photograph and because we want to build up layers, set **Opacity** to **34%** in the **Options** bar. Set Mode to **Normal** and set **Flow** to **100%**.

STEP 4: BEGIN PAINTING

■ You could begin painting now, but you would not be able to see the rough sketch, so you do not know where to paint! To view the sketch too, click **Layer 1** in the **Layers** palette to make it the active layer. Click in the **Mode** box and choose **Multiply** from the pop-up menu.

■ You must now click the **Paint Layer** layer in the **Layers** box to reset it as the active layer. If you do not, you will paint over the rough sketch and depending on your brush settings, you could ruin the sketch.

■ Finally, you can begin painting! If you have a Wacom pen tablet, this is a perfect time to use it. Begin painting long brushstrokes down the edges of

the bottles. Paint in the label areas and in the caps of the bottles. To make the painting look consistent with the loose pen and ink sketch, brush roughly and let some of the paint flow outside the bottles.

■ After you have a light layer of paint on the image, you can darken some of the areas in several ways. You can change the blend mode, or you can change **Opacity** in the **Options** bar.

■ Besides painting directly from the digital photo in the bottom layer, you can also change to the **Brush tool** (**B**) and paint with a color found in the sketch by clicking a chosen color in the image with the **Eye Dropper** tool. As there is not much color on the surface where the bottles are sitting, select a couple of gray or tan colors with the **Eye Dropper** tool and paint the horizontal surface with one of the large watercolor brushes using these two colors.

■ To add a bit more character to the sketch, use colors similar to those that you used on the surface below the bottles and paint horizontal and vertical lines with the brush tool around the tops of the bottles.

As your painting develops, try varying the Flow and Opacity settings. Also, try changing to one of the other blend modes, such as: Soft Light, Hard Light, and Darken. Other brushes worth considering include: Oil Medium Flow, Oil Pastel Large, and Charcoal Large Smear.

My two-minute sketch is shown in **Figure 32.21**.

There are many, many other things you can do to this image. After you paint all that you want to paint in the paint layer, you can apply a texture by choosing Filter ➤ Texture ➤ Texturizer to the Paint Layer layer. You can paint on the sketch layer and mix colors directly with the black markers. Running various filters on the background layer and then blending that layer with the other layers can create some interesting effects. Likewise, you can apply filters and change colors of the paint layer by using tools, such as Hue/Saturation, Levels, Curves, and Color Balance. You can even invert the sketch layer to get an image such as the one shown in **Figure 32.22**. The possibilities are almost limitless. Try a few different approaches and then use one of your own photos. Pick a line drawing technique that you like and create some cool prints in just a few minutes using your own photos!

The next technique is similar to this technique in many ways, except you use the colors from the original photo and use filters to make the painting instead of using the Brush or History Brush tools. After completing both techniques, you may find combinations of the two techniques that work well, too.

32.21

32.22

CREATING A "PEN AND INK" SKETCH WITH A WATERCOLOR WASH

33.1

© 2002 Gregory Georges

33.2

© 2002 Gregory Georges

ABOUT THE IMAGE

Flowering Urn Nikon 950 digital camera, Fine Image Quality setting, original 1200 x 1600 pixel image cropped and converted to a 1152 x 1600 pixel, 5.8MB .tif file

O f all the different art media there is, I particularly like watercolors with their often-blurry edges and transparent colors. Very loose *pen and ink* sketches with loosely defined shapes and lines with lots of character can also hold my interest. I think the looseness of these two types of artwork is what appeals to me. They can be suggestive and yet leave enough undefined to allow your imagination to fill in the remaining parts, quite like reading a book versus seeing a movie made from the same story.

The photograph in **Figure 33.1** shows an urn that I found on the front porch of a fancy home in Charleston, South Carolina. You might not think that it is possible to turn this digital photograph into a fine-art quality print on watercolor paper, but it is — try it. This is one of the many images in this book that just doesn't show well printed in the book compared to what it looks like printed full-size on quality textured fine-art paper with a photo-quality inkjet printer — it really does look quite good.

This technique shows how to transform a digital photo into a watercolor-like image and a pen and ink sketch, then how the two can be combined to become a pen and ink sketch with a watercolor wash. Because it really is two techniques in one, it is a long technique. However, it is well worth trying on the urn image, and then on one or more of your own photos. I think you will like the results.

STEP 1: OPEN FILE

- Choose **File** ➢ **Open** (**Ctrl+O**) to display the **Open** dialog box. Double-click the **\33** folder to open it and then click the **urn-before.tif** file to select it. Click **Open** to open the file.

STEP 2: DUPLICATE LAYER

- As both a watercolor painting and a pen and ink sketch are needed, you need two layers. Duplicate the background layer by choosing **Layer** ➢ **Duplicate Layer**. When the **Duplicate Layer** dialog box appears, type in **pen-ink** to name the image, as shown in **Figure 33.3**, and then click **OK**.

STEP 3: TRANSFORM ONE LAYER INTO A WATERCOLOR PAINTING

Photoshop 7 does have a watercolor filter, but in most cases, I find that it makes the images too dark with too many odd-looking brush strokes. Therefore, we use another approach.

33.3

- Click the **Background** layer in the **Layers** palette to make it the active image.
- Click the **Hide Layer** icon in the left column in the **pen-ink** layer to hide the top layer. The **Layers** palette should now look like the one shown in **Figure 33.4**.
- Choose **Filter** ➢ **Artistic** ➢ **Dry Brush** to get the **Dry Brush** dialog box. Click in the preview window and drag the image around until you can see a few flowers. Begin experimenting with the settings for **Brush Size**, **Brush Detail**, and **Texture**. I used **2**, **8**, and **1**, as shown in **Figure 33.5**. Click **OK** to apply the settings.

To soften the brush strokes and make them look more like a watercolor wash, use a blur filter.

- Choose **Filter** ➢ **Blur** ➢ **Smart Blur** to get the **Smart Blur** dialog box shown in **Figure 33.6**. Try using a **Radius** of **10** and a **Threshold** of **50**. Also, make sure you have **Quality** set to **High**, and that **Mode** is set to **Normal**, before clicking **OK** to apply the settings.

For this particular image, these few steps produce a realistic-looking watercolor. After using many images and trying many different techniques to create watercolor paintings, I've concluded there are

33.4

many variables and settings for each of many different techniques; what works on one image, may work poorly on another. In general, these steps work well on images that are about 1600 x 1200 pixels in size and have been taken with a digital camera.

On larger files, and when photographs have been scanned with a flat-bed scanner or negatives or slides have been scanned with a film scanner, the same techniques work well if you first apply a light Gaussian Blur to the image. The larger the files, the better this technique seems to work provided that the image is a good-quality image with minimal grain. Sometimes, you may also find that an image can be made to look more like a watercolor painting if you apply some of these filters more than once. Experimentation is the key to getting what you want.

3.5

STEP 4: TRANSFORM SECOND LAYER INTO A "PEN AND INK" SKETCH

The next step is to turn the *pen-ink* layer into a pen and ink sketch. While most Photoshop experts use and recommend the Find Edges filter to make line drawings, I usually get much better results with a hidden option in the Smart Blur filter. The results as you'll see can be quite outstanding.

- Click the **pen-ink** layer to make it the active image.
- Choose **Image ➢ Adjustments ➢ Desaturate** (**Shift+Ctrl+U**) to remove all color.

3.6

■ Choose **Filter** ➤ **Blur** ➤ **Smart Blur** to once again get the **Smart Blur**. This time, set **Quality** to **High** and **Mode** to **Edge Only**.

Finding settings that show the vertical lines on the columns while not adding too many lines around the flowers is important. To do this, click in the preview box inside the Smart Blur dialog box and drag the preview image until you see the column.

■ Try setting **Radius** to 25 and **Threshold** to 35. Click **OK** to apply the settings. Have patience as the **Smart Blur** filter can take some time to process.

33.7

■ You may be surprised to see what now looks like white lines on a black ink scratchboard, but this is okay — choose **Image** ➤ **Adjustments** ➤ **Invert** (**Ctrl+I**) and you see black lines on a white background sketch, as shown in **Figure 33.7**.

STEP 5: BLEND LAYERS

At this point, you have learned two techniques and you have two entirely different images made from the same digital photo — a watercolor-like image and a pen and ink sketch. We now want to combine these two layers.

■ Click the **pen-ink** layer to make it the active layer.

■ Using the **Layers** palette, click the pop-up menu and choose **Multiply**. Leave **Opacity** set to **100%**. The **Layers** dialog box should now look like **Figure 33.8**.

33.8

STEP 6: MAKE FINAL COLOR ADJUSTMENTS AND ADD YOUR SIGNATURE

Now is the time to make a few creative color adjustments.

■ To lighten the image, use an adjustment layer so that you can go back and make changes if desired. Choose **Layer ➤ New Adjustment Layer ➤ Levels** to get the **New Layer** dialog box. Click **OK** to display the **Levels** dialog box. Set **Input Levels** to 5, 1.50, and 170, as shown in **Figure 33.9**. Click **OK** to apply the settings.

The final step is to adjust the colors, as you'd like them. As you have both Photoshop 7 and an artistic license to create as you'd like to create, try making the image turquoise, purple, and green with yellow flowers, as shown in **Figure 33.2**!

■ Once again, to allow us the opportunity to go back and change our settings, use another adjustment layer to make changes to the colors. Choose **Layer ➤ New Adjustment Layer ➤ Hue/Saturation** to get the **Hue/Saturation** dialog box. Set **Hue**, **Saturation**, and **Lightness** to 120, 20, and 0, as shown in **Figure 33.10**.

33.9

As we used adjustment layers, you can now go back and double-click the Levels 1 or Hue/Saturation layers and make changes to the settings until you get the results that you want. You may also try using some of the other color commands, such as Color Balance or even Replace Colors if you want to replace the yellow flowers with another color.

Also, don't forget to add your signature — it adds a nice touch to your painting. If you want, you could also hand paint more of the flowers yellow. Some of them seem to be lacking a bit of color on the left side of the image. A good tool for painting the flowers is one of the watercolor brushes. You also may want to put a soft edge on the image by using a soft eraser on both the ink layer and the painted layer. Save your file and it is ready to be printed.

While this image looks reasonably good on a computer screen, it *really* does look exceptional when printed on a fine-art watercolor paper with a photo-quality inkjet printer. I used an Epson 2000P printer and the Epson Watercolor Paper – Radiant White — the print is excellent and archival. Printing on quality fine-art paper is essential to getting a print that you'll be proud to frame.

33.10

CREATING A DIGITAL PAINTING

dmittedly, the phrase *digital painting* in the title of this technique evokes different meanings to different people. There are those who think a digital painting is a lesser *art form* than a natural media painting. Others consider a digital painting to be some kind of high-tech painting that lacks the soul that can be found in fine art painted by fine artists — instead of *computer* artists. For me, a good digital painting can be just one more kind of painting, and it can truly be considered to be fine art. A digital painting can be as different as a watercolor painting is from an oil painting, and in no way need it be considered as a *lesser* fine art than other media. A well-done digital painting can have the soul found in so many other types of fine art paintings, as you find in this work done by painter Bobbi Doyle-Maher.

In this technique, you look at how you can transform two digital photos into a *fine art* digital painting that has soul! While many digital paintings are created by carefully placing digital brush strokes on an image by using an image-editing program, this one is done by using mostly large digital brushes

217

ABOUT THE IMAGE

Egret Landing at Sunset
Egret photo: Canon EOS D30 digital camera, ISO 100, Fine image setting, 300mm f/2.8 with 2X tele-extender, f/9 @ 1/320, 1440 x 2160 pixels, .7MB .jpg. Marsh photo: Pentax Spotmatic F, 55mm, Kodachrome, scanned with Nikon Coolscan IV, 2222 × 1667 pixels, 11.1MB .tif

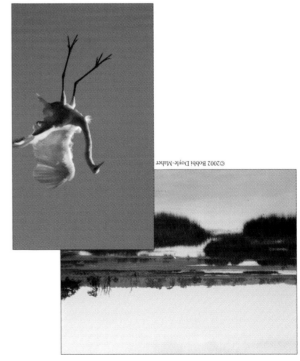

34.1

© 2002 Gregory Georges

© 2002 Bobbi Doyle-Maher

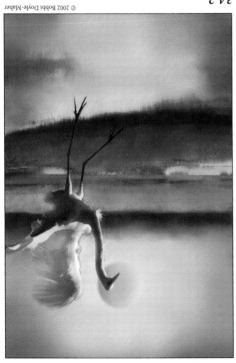

34.2

© 2002 Bobbi Doyle-Maher

with soft edges and blend modes. It is a technique that you can successfully use on all kinds of digital photos to make outstanding prints on fine art papers.

While this technique is an inspiring technique for everyone, you need a moderate amount of traditional *painting* skills to match the painting done by Bobbi. You also need from two to four hours to complete the painting — it took Bobbi about three hours. Even if you don't have painting skills, you may want to quickly complete this technique as it can be used in much simpler ways for good results, too. If you are a painter, you'll love this technique and my bet is that after you complete this painting, you'll be ready to begin exploring all the wonderful new brushes in Photoshop 7 and do some *brush-stroke* painting.

While it is possible to complete this technique and to use this approach with other digital photos, without having a pen tablet, using one makes your painting more painterly, accurate, and fun. Several companies make pen tablets. Wacom (www.wacom.com) makes some of the best ones.

Before you begin this technique, if you have a photo-quality printer, print the final image file to use as a reference image while doing the technique. The file, egret-after.tif, can be found in the \34 folder. If you do not have a color printer, you may want to open the image file anyway and choose Image ➤ Image Size to reduce it to a small reference image that you can keep open in Photoshop 7, or you can use **Figure 34.3** for reference.

STEP 1: OPEN FILE

- Choose File ➤ **Open** (Ctrl+O) to display the **Open** dialog box. Double-click the **\34** folder to open it and then while pressing **Ctrl**, click the **marsh-before.tif** and **egret-before.tif** files to select them. Click **Open** to open both files at once.

STEP 2: COMBINE IMAGES

- Click the **Move** tool (**V**) in the **Tools** palette.
- Click inside the **egret-before.tif** image and drag it onto the **marsh-before.tif** image to place it as a new layer in the **marsh-before.tif** file.
- Double-click the **Layer 1** label in the **Layers** palette and then type **egret** to name the layer.
- Click the **egret-before** image to make it the active image and then close it by clicking the **Close** icon in the upper-right corner of the document window, as we no longer need it.
- Double-click the **marsh-before.tif** document window title bar to maximize it.

STEP 3: RESIZE EGRET LAYER

- The **Layers** palette should now look like the one shown in **Figure 34.4**. Double-click inside the **Opacity** box inside the **Layers** palette and type **40** to lower the opacity so that you can see the marsh layer below.

Figure 34.3 for reference.

Bobbi Doyle-Maher is a self-taught artist who lives in East Tennessee with her husband, three cats, and four dogs. Before stepping into the digital world, she was skilled with oil, acrylic, pastel, oil pastel, monotype, encaustic, and black & white photography. A few years ago, she began using digital image editors, such as Adobe Photoshop, MetaCreations Painter (now known as Procreate Painter 7), and Right-Hemisphere Deep Paint. Over time, she found herself spending more time painting digitally than with traditional paints. After purchasing a digital camera and a film scanner, she began to create digital paintings by using digital photos. Her digital paint studio includes a PC, a Nikon Coolscan IV film scanner, a Wacom pen tablet, and an Epson 2000P printer to make archival prints. More of her artwork may be viewed on her Web site at www.rabbitwillight.com.

■ Choose **Edit** ➢ **Transform** ➢ **Scale** to get a bounding box around the **egret** image.

■ To change the height and width proportionally, press **Shift** while clicking and dragging the upper-left corner handle of the bounding box to resize the image, or click the **Link** icon in the **Options** bar between the **W** and **H** fields.

■ Click inside the bounding box, to position the image; then, press **Shift** and click and drag one of the corner handles to size the image once again until the egret is sized and is located approximately, as shown in **Figure 34.5**. If the **Link** icon is on, you would not need to press **Shift**.

Note that a small portion of the egret's wing has been clipped in the original photo, so the egret layer ought to be positioned all the way to the right edge of the **marsh-before.tif** image.

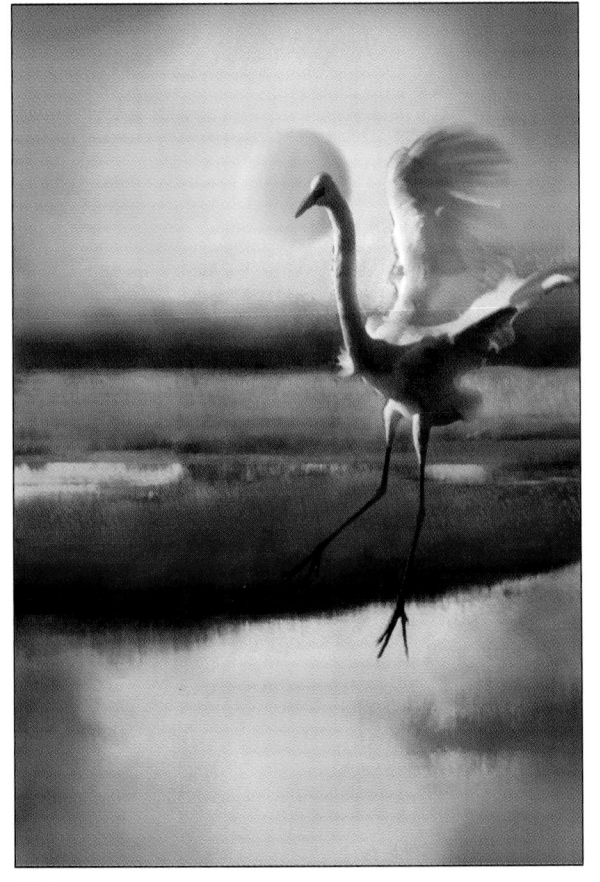

34·3

34·4

34·5

Alternatively, you can type 85 in the W and H boxes in the Move tool Options bar (as shown in **Figure 34.6**) to set both width and height to 85%. You can then either click the image using the Move tool to drag it to the correct position or type 1488.5 px in the X box and 478.8 px in the Y box to precisely position the egret.

- Press **Enter** to set the image location and size.

STEP 4: CROP IMAGE

- Click the **Crop** tool (**C**) in the **Tools** palette. Delete any values in the **Height** and **Width** boxes in the **Options** bar by clicking the **Clear** button in the **Options** bar. Click just outside the bottom lower-right corner of the image and drag the **Crop** tool marquee up and to the left until you have selected a portion of the image, as shown in **Figure 34.7**.
- Press **Enter** to crop the image. Don't worry about the line that appears at the bottom of the image as you'll shortly mask it away!

STEP 5: MASK EGRET

In this step, you create a mask layer to mask out the entire image in the egret layer except the egret. While you need to paint carefully when creating the mask, you do not need to be too precise. I would also recommend that you always use the soft round brushes and not the hard round brushes. The soft edges make it much easier for you to get the North Carolina egret to blend well into the Florida marsh!

- Click the **egret** layer in the **Layers** palette to make it the active layer — it is now highlighted.
- In the **Layers** palette, set **Opacity** to **60%**.

- Choose **Layer** ➤ **Add Layer Mask** ➤ **Reveal All** to create a new mask layer.
- Click the **Default Foreground Background Colors** icon at the lower left of the **Background/ Foreground Colors** box in the **Tools** palette. Then click the two-headed arrow icon to set **Foreground** to **Black** and **Background** to **White**.
- Click the **Brush** tool (**B**) in the **Tools** palette.
- Click the **Brush Preset Picker** box (the second box from the left in the **Options** bar) and select the **Soft Round 300 Pixels** brush.

34.7

34.6

If you don't see a **Soft Round 300 Pixel** brush, click the menu button on the **Brush Preset Picker** palette and select **Reset Brushes** to get the default brush set.

■ Check in the **Options** bar to make sure that **Mode** is set to **Normal**. Set **Opacity** to **88%** and leave **Flow** set to **100%**.

You can now begin painting the mask. As you paint on the layer mask with black, the painted area of the egret layer is hidden. Painting with white removes any black paint, hence the *egret* area is once again revealed. When you paint, click often so that you can use the Undo feature to undo any brushstrokes that were not placed correctly, without losing too much of your work.

Start off with the Soft Round 300 Pixels brush and then move to increasingly smaller brushes, such as the 200, 100, 45, 21, and 9 pixel brushes. Remember to take advantage of the Full Screen Mode; press F, F, and Tab to get an entire uncluttered screen of the image. Move the image around by pressing the Spacebar to get the Hand tool; then, click and drag the image where you want it. To zoom in, press Z to get the Zoom tool. Click an area and drag the selection marquee around the area that you want to view. To view the entire image, press Ctrl+0. To view at 100%, press Alt+Ctrl+0. If you decide that you painted out an area that should not have been painted, toggle to white by clicking the double-headed arrow icon to change Foreground to White. Then toggle it again to continue painting out the parts of the egret image you do not want to be visible. If needed, you can also change the Opacity setting in the Layers palette to make the egret more or less visible. Remember, your mask ought not to be too perfect as this is to be a loose painting — not a precise photograph.

■ Begin painting out the entire image except the egret by using the **Brush** tool and an appropriate brush size. After you are done, your image should look similar to the one shown in **Figure 34.8**. This may take you ten minutes or more.

■ I suggest that you now save your file as you have completed a considerable amount of work that you likely won't want to repeat. Choose **File** ➢ **Save As** (**Ctrl+Shift+S**) to get the **File Save** dialog box.

■ Type **egret-step6** in the **Name** box. Click in the **Format** box and select **Photoshop**. In the **Save Options** box, make sure that **Layers** is checked to ensure that the layers will be saved too!

STEP 6: CREATE NEW BACKGROUND LAYER

■ Click the **Background** layer in the **Layers** palette and drag it onto the **New Layer** icon at the bottom of the **Layers** palette to create a new layer named **Background copy**.

■ Click the **Hide Layer** icon (the eye icon in the left-most column in the **Layers** palette) to hide the **egret** layer and its layer mask.

34.8

STEP 7: CREATE SUN

- If the **Background copy** layer in the **Layers** palette is not highlighted, click it to make it the active layer.
- Click the **Square Marquee** tool in the **Tools** palette until you get a pop-up menu; choose **Elliptical Marquee** tool.

34.9

34.10

- **Shift+click** to create a circle approximately the size of the sun shown in **Figure 34.9**. Click inside the circle to place it, as shown in **Figure 34.9**. You may want to click once on the **Show Layer** icon next to the **egret** layer to make the egret visible. The location of the sun relative to the egret's head is important. Click inside the circle marquee and drag it where it ought to be. Then, click the **Hide Layer** icon next to the **egret** layer to once again hide the egret.
- To make a soft-edge around the sun, choose **Select** ➢ **Feather** (**Alt+Ctrl+D**) to get the **Feather Selection** dialog box shown in **Figure 34.10**. Set **Feather Radius** to **9 pixels**. Click **OK** to feather the selection.
- Just in case you later need to select the sun or everything but the sun, choose **Select** ➢ **Save Selection** to get the **Save Selection** dialog box. Type **sun** in the **Name** box and click **OK** to save your selection.
- Choose **Select** ➢ **Inverse** (**Shift+Ctrl+I**) to invert the selection as we want to paint the glow around the sun.
- Click the **Brush** tool (**B**) in the **Tools** palette.
- Pick **Pastel Yellow Orange** from the **Swatches** palette. If the palette is not already visible, choose **Window** ➢ **Swatches** to get the **Swatches Palette** shown in **Figure 34.11**. If your **Swatches** palette does not match the one in **Figure 34.11**, you may need to reset the palette by clicking the menu button in the **Swatches** palette and choosing **Reset Swatches** from the pop-up menu. You then are asked: **Replace current color swatches with the default colors?** Click **OK** to reset the **Swatches** palette.
- Select the **Pastel Yellow Orange** color by clicking that color in the **Swatches** palette. If you are not sure which color box is the correct color, slowly move your cursor over the colors and the name of each color displays. Or, you can set the **Swatches** palette to **Small List** mode by clicking on the menu button and selecting **Small List**. All the swatch names will then be visible.

■ Click the **Brush Preset Picker** in the **Options** bar to select the **Soft Round 300 Pixels** brush. Set **Opacity** to **24%**.

■ Begin painting lightly over the entire image by using a lighter touch on the ground and trees. This color helps to add a warm orange sunset glow.

■ Select **Light Cyan** from the **Swatches** palette.

■ Click the **Brush Preset Picker** in the **Options** bar to select the **Soft Round 200 Pixels** brush.

■ Paint **Light Cyan** in the water at the bottom of the image and then add some more to the top of the image in the sky area.

■ Alternate between using **Pure Yellow** and **Light Yellow** to paint around the sun and the reflection of the sun in the water. This is easy to do if you set **Pure Yellow** as the **Foreground** color and **Light Yellow** as the **Background** color and press **X** to exchange between them.

■ Choose **Select** ➢ **Inverse** (**Shift+Ctrl+I**) to select just the sun. Paint inside the selection by using **Pastel Yellow Orange**, **Light Yellow**, **Pure Yellow Orange**, **Pastel Cyan**, and **White**. Paint the yellows and oranges in the center and to the right. Keep the blue on the left. Add a small bit of **White** as a highlight to the sun to complete it.

■ Choose **Select** ➢ **Inverse** (**Shift+Ctrl+I**) to invert the selection.

34.11

■ Click the **Brush Preset Picker** in the **Options** bar. Click the menu button to get a pop-up menu. Choose **Natural Brushes 2** and then click **OK** to replace the current brushes with the new brushes.

■ Click the **Brush Preset Picker** in the **Options** bar and pick **Pastel Dark 118 Pixels**. Mode should be set to **Normal** and **Opacity** should be set to **30%**.

■ Paint light areas around the sun **Pastel Yellow Orange**, **Light Yellow Orange**, and **Light Yellow**.

■ Paint sky and water areas that are blue with **Light Cyan**.

■ Paint foreground grass with **Dark Red Orange**, and then use **Darker Warm Brown** and **85% Gray** for the bottom of the grass.

■ Paint distant grass **Pure Yellow Green**, **Dark Yellow Green**, **Pure Yellow Orange**, and end with some more **Pure Yellow Green**.

■ Paint distant tree lines with **Light Violet** and **Pure Violet**.

■ Paint the bottom of the nearest tree line with a **Dark Blue** and **85% Gray**.

One of the keys to creating a successful digital painting when painting over a digital photograph is to use many layers of paint. Like with natural media, more layers with different colors and strokes add richness and depth to the color which helps to remove the *photograph* look. In this next step, use the same colors as before, but this time use varying brush sizes and a low opacity.

■ Click the **Brush Preset Picker** in the **Options** bar and then click the menu button to get a pop-up menu. Choose **Reset Brushes** and click **OK** to get the default brush set.

■ Using the **Soft Round 300 Pixels** brush and the **200** and **100** sized brushes with **Opacity** set to **24%**, paint over areas to soften them. Use similar colors to what you used when you painted them before.

■ Choose **Select** ➢ **Deselect** (**Ctrl+D**).

STEP 8: PAINT EGRET LAYER

- Click the **egret** layer thumbnail (not the mask layer icon) in the **Layers** palette to make the egret viewable. Lightly paint the right side of the wing so that it blends into the sky.
- Using the **Zoom** tool, zoom in and lightly paint the right side of the wing so that it blends into the sky.
- Paint **Light Orange** and **Light Yellow** on the wings, neck, and top of the head by using different brush sizes as needed. These colors should be very light and add just a *hint* of color.

STEP 9: FLATTEN IMAGE AND BLEND

- Choose **Layer** ➢ **Flatten Image** to merge all the layers and the layer mask.
- Choose **Image** ➢ **Apply Image** to get the **Apply Image** dialog box shown in **Figure 34.12**.

One of the ways you can build up density and color saturation is to duplicate a layer and then blend the two layers together by using one of the blend modes, such as Multiply. The Apply Image feature works exactly the same as if you duplicated layers and then blended them with a blend mode, except you can do all this in one easy step, with one layer, and consume far less memory.

- Click the **Blending** box to get a pop-up menu. Choose **Multiply**. The image then looks unacceptably dark. You can lighten the effect by reducing the **Opacity %**. Try setting **Opacity** to **40%**; click **OK** to apply the settings.

STEP 10: MAKE FINAL IMAGE ADJUSTMENTS

The image is nearly complete. At this point you can change hue and saturation by using the Hue/Saturation command, you can adjust overall tonal range with Curves or Levels, or apply any other effects to complete the image as you'd like it.

- Add brush stroke effects by choosing **Filter** ➢ **Artistic** ➢ **Dry Brush** to get the **Dry Brush** dialog box shown in **Figure 34.13**. Set **Brush Size**

34.12

34.13

to **2**, **Brush Detail** to **8**, and **Texture** to **1**. Click **OK** to apply the effects.

■ If you would like to tone down the brush effects, you can choose **Edit** ➤ **Fade Brush Tool** (**Shift+Ctrl+F**) to get the **Fade** dialog box shown in **Figure 34.14**. Reduce the **Opacity** to **40%** and leave **Mode** set to **Normal**. Click **OK** to apply the settings.

■ As the intent is to get an overall orange sunset glow, select the **Soft Round 300 Pixels brush**. Click the **Swatches** palette to select **Pastel Yellow Orange** and also use **Light Yellow Orange** later. Set **Opacity** in **Options** bar to **15%**; paint over areas to soften them.

■ If there are any brushstrokes that need blending, use the **Clone Stamp** tool to remove them.

■ Make slight adjustments to levels to increase contrast to suit your own taste.

There you have it! A digital painting created from two digital photos! While there were lots of steps and many colors were used, this was not actually a painting as there were no detailed brush strokes required. If you want to, you can go back and pick different brushes and actually paint this image with brush strokes — rather than soft colors that blend with the background photos.

34.14

CREATIVE USE OF FILTERS AND COMMANDS

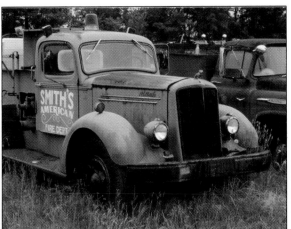

35.1

© 2002 Gregory Georges

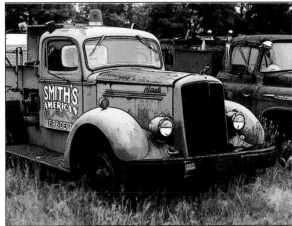

35.2

© 2002 Gregory Georges

The digital photo of the two firetrucks was taken with a hand-held digital camera on an overcast day — the perfect light for taking shots of subjects such as this one. What you may or may not know is that this image of a pair of old rusty fire trucks is an excellent image for trying all kinds of Photoshop 7 filters techniques. You'll enjoy working with it, I'm sure.

Unlike most techniques in this book where the goal is to make a cool image, our goal in this one is to edit the image in a number of ways to show you how you can get more out of Photoshop 7 filters. We take a few steps, and then stop to look at the results, and then take a few more and again look at the results, and so on. At the end of the technique, you ought to be on a longer journey of your own to explore the limitless power of Photoshop 7 with these tips as your guide.

In a couple of the earlier techniques in this book, you saw how you can improve the results of specific filters by doing some pre- and postprocessing of an image. In this technique, you discover that you can further modify the effects of filters by

- Blending layers (either with itself by using the Apply Image command or with another layer)
- Using masks
- Applying filters to a single channel
- Using the Fade command
- Changing blend opacity levels
- Mixing filters or commands

STEP 1: OPEN FILE

- Choose **File** ➢ **Open** (**Ctrl+O**) to display the **Open** dialog box. Double-click the **\35** folder to open it and then click the **firetrucks-before.jpg** file to select it. Click **Open** to open the file.

STEP 2: APPLY CUTOUT FILTER

If you just want a good clean graphic image, then the Cutout filter has to be one of the best. The Cutout filter has three settings and you can often get better results by preprocessing the image, that is, running another command or two on it first, so that the Cutout filter results in a better image.

If you increase the contrast of an image before applying the Cutout filter, you will have better control over the level of detail that you have in an image. For the purposes of this technique, assume that we want a sharp, high contrast image with strong colors.

- To increase contrast, choose **Image** ➢ **Adjustments** ➢ **Curves** (**Ctrl +M**) to get the **Curves** dialog box.

- Click the **Set White Point** eye dropper (it is the third eye dropper in the bottom-right corner of the **Curves** dialog box). Click once inside the nearly white lettering on the side of the Smith's truck to set the **White** point.
- Do the same thing with the **Set Black Point** eye dropper (the first eye dropper on the left), but make sure to click inside a part of the image where you think it should be the blackest, such as inside the front left wheel well where it is all shadow. After you click, you should notice that the darks (or blacks) get slightly blacker, which is good.

35.3

- Click **OK** to apply the settings. The image now has much more contrast.
- Choose **Filter** ➢ **Artistic** ➢ **Cutout** to get the **Cutout** dialog box shown in **Figure 35.3**. To meet our initial objectives, set **No. of Levels** to **8** to maximize the number of colors. Set **Edge Simplicity** to **0** as we want detail, not simplified edges. Set **Edge Fidelity** to **3** to maximize the edge detail. Click **OK** to apply the filter.
- You can take a vast number of good postprocessing steps with this image. Try bumping up color saturation by choosing **Image** ➢ **Adjustment** ➢ **Hue/Saturation (Ctrl+U)** dialog box. Set **Hue** to **+15**, **Saturation** to **+40**, and **Lightness** to **0**. Click **OK** to apply the settings and to get an image such as the one shown in **Figure 35.4**.
- Create a duplicate layer by choosing **Layer** ➢ **Duplicate Layer**. You now have two layers in the **Layers** palette and the top layer should be highlighted.

35·4

STEP 3: USE QUICK MASK

No doubt about it — the easiest and most frequently used filter effect for those new to any of the Photoshop family of products is the Poster Edges filter. If you use it, odds are good someone will look at your work and say, "Oh, you used the Poster Edges filter!" If you don't mind this — and I sometimes don't because I admit to liking the Poster Edges filter as there are times and places where it is okay to use it. You can use this filter to make some wonderful inkjet prints when a fine-art paper is used. In spite of what I just said, go ahead and use it.

- As we want to apply the **Poster Edges filter** on the **Background**, click once in the thumbnail in the **Background** in the **Layers** palette to set it as the active layer.
- Click the **Hide Layer** icon in the left column of the **Background copy** layer to hide that layer.

One of the problems with the Poster Edges filter is that some images (such as this one) need to have different settings applied to different parts of the image. The solution is to use the wonderful and quick to use Quick Mask. Using the Quick Mask, you can apply the optimal settings to each part of the image. In this image, we want to use one setting for the trucks, as they are smooth, and a second setting for areas covered by grass and tree leaves, as they have lots of edges and shadows.

The Quick Mask is as its sounds — a mask that you can create quickly. After you turn on the quick mask, anything that you paint with black is masked, while everything that is not painted is not masked. When it is turned on, you paint the mask. When you turn it off, it automatically creates a selection for you from the mask you painted, thereby allowing you to affect only the areas that were not masked.

■ To edit in **Quick Mask Mode** click the **Quick Mask Mode** button (**Q**), which is near the bottom of the **Tools** palette, as shown in **Figure 35.5**. Before painting, make sure that the **Foreground** color is **Black** by clicking the **Set Default Foreground** and **Background Colors** (**D**) icon, which is located just to the bottom of the **Foreground** and **Background** color boxes in the **Tools** palette.

■ Select the **Brush** tool (**B**) by clicking it in the **Tools** palette.

■ Click the **Brush Preset Picker** box (the second brush box from the left) in the **Options** palette to select an appropriate brush. I suggest selecting the

Soft Round 300 Pixels brush by clicking it in the **Brush** palette shown in **Figure 35.6**. The **Options** bar should now show **Mode** as **Normal**, **Opacity** as **100%**, and **Flow** as **100%**. As you click and drag your cursor, paint with a red color, much like a rubylith — the default color of the mask. Keep clicking and dragging until you paint all of the leaves and the grass. After you are done, your mask should look similar to the one shown in **Figure 35.7**.

■ To turn off **Quick Mask** mode and once again edit in **Standard Mode**, click the **Standard Mode** button in the **Tools** palette. You now see a selection marquee showing you where want to apply the **Poster Edges** filter.

■ Choose **Filter ➢ Artistic ➢ Poster Edges** to get the **Poster Edges** dialog box shown in **Figure 35.8**. If you click inside the image preview box inside the **Poster Edges** dialog box, the cursor turns into the **Hand** tool. You can now click and drag the image to pick an area where you can best judge the settings. As we are going to set the filter

35.5

35.6

for the truck, click and drag until you can view the Mack emblem on the side of the hood.

Assuming that we are in agreement that we want a nice level of posterization with medium heavy lines, try the settings of **4**, **3**, and **6** respectively for **Edge Thickness**, **Edge Intensity**, and **Posterization**. Click **OK** to apply the settings.

■ Invert the selection by choosing **Select** ➢ **Inverse** (**Shift+Ctrl+I**).

■ Choose **Filter** ➢ **Artistic** ➢ **Poster Edges** to get the **Poster Edges** dialog box. Click inside the image preview box and drag the image until you see the bottom-left corner of the image. Try setting **Edge Thickness**, **Edge Intensity,** and **Posterization** to 0, 0, and 5 respectively.

■ Click **OK** to apply the settings, which makes the areas covered with grass and leaves have similar characteristics as the portion of the image where there are fire trucks.

■ If the **Poster Edges** effect is too strong for you, you can fade the effect by choosing **Edit** ➢ **Fade Poster Edges** (**Shift+Ctrl+F**) to get the **Fade** dialog box shown in **Figure 35.9**. Not only can you adjust the *fade factor* by adjusting **Opacity**, but you can also change the blend mode! Using the

Preview feature, you can see the changes in the image as you make them. After you are done experimenting, click **Cancel** as I just wanted to show you how the **Fade** command works — not actually use it.

35.8

35.7

35.9

■ Choose **Select** ➤ **Deselect** (**Ctrl+D**) to remove the selection marquee.

■ To further enhance the filter you just applied, choose **Image** ➤ **Adjustments** ➤ **Levels** (**Ctrl+L**) to get the **Levels** dialog box. Set **Input Levels** to **20**, **1.00**, and **235** respectively, and then click **OK**.

STEP 4: BLEND LAYERS

In the Background layer, we now have an image created with the all-too-common Poster Edges filter. On the Background copy layer, we have an image created with the Cutout filter. Now blend them to get a hybrid that keeps most people guessing as to how it was done.

■ Click the **Background copy** layer in the **Layers** palette to make it the active layer. Click the **Blend Mode** box and choose **Lighten** as the **blend** mode. Reduce **Opacity** to about **60%**.

The image now looks entirely different. Try other blend modes and vary the Opacity setting. By doing this, you get a good idea of the vast number of combinations that you can get. After you find a blend mode that you like, you can get the exact effect you want by adjusting the Opacity. Should you want, you can even add a third or fourth layer and another filter or two to the stacked layers.

STEP 5: APPLY FILTER TO JUST ONE CHANNEL

In this step, you look at how layers can be used to modify filter effects.

■ Choose **Layer** ➤ **Flatten Image**.

In Technique 11, you'll learn how you can apply filters to remove grain in an image by only applying them to one channel — the channel that shows the most grain. For this example, we are going to do something similar. We apply a filter to a single channel.

■ If the **Channels** palette is not displayed, choose **Window** ➤ **Channels** to get the **Channels** palette shown in **Figure 35.10**. At this point, all the channels are highlighted, meaning that any edits that you do are done to all three channels. To edit just the **Red** channel, click the **Hide Layer** icon in the left column of all layers except the red layer.

■ Choose **Image** ➤ **Adjustments** ➤ **Posterize** to get the **Posterize** dialog box shown in **Figure 35.11**. Set **Levels** to **4** and click **OK**.

■ To view all channels, click the **RGB** thumbnail in the **Channels** palette. The effect of this step is to posterize just the red colors in the trucks and to make them even more posterized.

Remember you can use the History palette to easily step back and forth between steps to view differences in effects. For example, you can click back one step to see what your image looked like before applying a filter to just the Red channel. Then click to the last step to once again see the effect of the filter. Be aware if you run another command or filter after having looked at a past history state, all future history from that state forward will go away. You do have one chance to get it

35.10

back, as you can select Undo (Ctrl + Z) once to get back the old history.

The final image is probably not one you want to print out, but with these tips, you are on your way to being a master of using filters. Use these tips as *starter* ideas for coming up with your own ideas on how you can get the most from Photoshop filters. Before going on to the next technique, see if you can create a cool looking image or two of the two firetrucks. Then check the gallery on this book's companion Web site to see if your images are substantially different from those in the gallery at `www.reallyusefulpage.com/ 50ps7/techniquesfiretrucks.htm`. If they are, please e-mail a small JPEG file to `ggeorges@ reallyusefulpage.com`. I'd like to display your work in the gallery to show how different users use the same tool differently. Please make sure that the longest side of the image is 400 pixels and that it is a JPEG file.

This technique concludes this chapter. In the next chapter, we'll use some of the best plug-ins on the market to edit more digital photos.

35.11

CHAPTER **7**

USING PLUG-INS TO ADD IMPACT TO YOUR PHOTOS

I n this chapter, we look at nine plug-ins that can either make your tasks easier and quicker to do or can do them better than you can do with the features found in Photoshop 7.

Several plug-ins covered make it a snap to complete basic image correction. Grain Surgery does an excellent job of removing the dreaded digital noise from images. Convert to B&W Pro makes it easy and fun to make black and white images from color images. You discover how to transform a digital photo into a painterly image by using buZZ.Pro 2.0 and how to use a pen tablet to selectively paint photographic effects on your digital photos. The last technique covers a few special effects plug-ins that can be useful to photographers.

Before you begin each of these techniques, you should download a trial version of the appropriate plug-in. As vendors continuously update their products and make updates available on the Internet, a Web page has been created on this book's companion Web page which provides a list of current "clickable" links to take you to the most current software.

USING IMAGE CORRECTION PLUG-INS

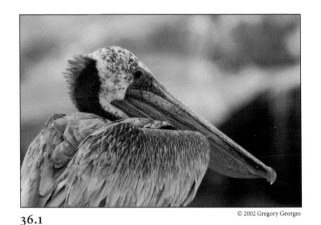

36.1

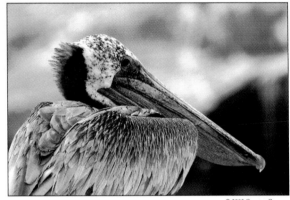

36.2

ABOUT THE IMAGE

Watchful Pelican Canon EOS D30 digital camera mounted on a tripod, 300mm f/2.8 IS with 2X tele-extender (960mm effective focal length), ISO 100, Fine image setting, 2160 x 1440 pixels, 1.1MB .jpg file

Not long after getting into digital photography and learning how to edit digital photos, most photographers begin wishing that there were a better and faster way to make basic image corrections. No matter how digital photos are created, they almost always are in need of basic image correction — just as are most photos that have been taken with a film camera. While Photoshop 7 offers a most powerful assortment of image corrections tools, it takes skill and time (sometimes too much time) to correctly use them.

While admitting upfront that no instant *perfect image* correction software exists — a couple of plug-ins can do some pretty amazing corrections — on most (but, not all) digital photos. Pictographic International Corporation's iCorrect Professional 3.0 plug-in (www.picto.com) is one *very* useful tool — well I guess I'll say what I feel — one exceptionally useful tool! I've gotten to the point when viewing images, I just about always view them after applying the iCorrect Professional 3.0 filter to get a

good idea how they ought to look. Sometimes the corrections are so good that I don't worry about doing anything else to the image. In this technique, you take a quick look at iCorrect Professional and two other useful plug-ins as well.

A downloadable trial version of iCorrect Professional 3.0 is available at `www.picto.com`, or you may visit `www.reallyusefulpage.com\50ps7\plug-ins.htm` to get a clickable link to the download page and read any notes and updates about this and many other Photoshop 7 compatible plug-ins.

STEP 1: OPEN FILE

■ After installing the **iCorrect Professional 3.0** plug-in, choose **File** ➢ **Open** (**Ctrl+O**) to display the **Open** dialog box. Double-click the **/36** folder to open it and then click the **pelican-before.jpg** file to select it. Click **Open** to open the file.
■ Choose **Filter** ➢ **Pictographics** ➢ **iCorrect Professional** to get the dialog box shown in **Figure 36.3**.
■ After loading **iCorrect Professional 3.0**, the initial settings are the settings used the last time the plug-in was used; they are not automatically selected settings for the current image. To adjust

the brightness and contrast of the pelican image, click in the box next to **Auto Black Point** as there is black in the image. Do the same for the **Auto White Point**, as the image has an almost pure white. This should improve the image.
■ As the image is too dark, click once on the **More** button under **Brightness**. Then click again to lighten the image even more. Each time you click the **Less** and **More** buttons, the **Brightness** increases or decreases by **10** levels. If you want to change the settings in single increments, press the **Alt** key while clicking the **Less** or **More** buttons. Try setting **Brightness** to **+ 20**.
■ The **Less** and **More** buttons under **Contrast** work the same as the **Brightness** buttons. Click once on **More** to increase contrast to **+10**. Then press **Alt** and click **Less** three times to set **Contrast** to **+7**. As **Contrast** increases, so does posterization, so that less is good in this case.
■ After **Brightness** and **Contrast** have been adjusted, color correction can be done by using **Memory Colors**. Click in the **Memory Colors** box to get a pop-up menu showing: **Neutrals**, **Foliage**, **Skin**, and **Sky**; select **Neutrals**. These default settings are for correcting colors of specific parts of an image as suggested by their names. In this image, we only have neutral colors — the black and white tones. Click once in the white area on the pelican's head in the image shown inside the iCorrect Professional dialog box and you should see an instant color change — for the better. The California Brown Pelican now looks much browner as the yellow-green tint has left the image! Now click in the darkest black areas, too. If, when clicking, you get a strange color, you can undo the bad correction by clicking the **Undo** button and trying again.

If this image were to have some green plants or trees, and a blue sky, you could further correct the colors by selecting **Foliage**; then click in the green areas, and then click **Sky** and click in the sky to complete the color correction. But, because those

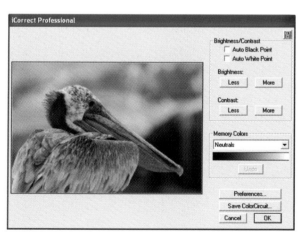

36.3

colors do not exist in this image, corrections to this image have been completed.

Before applying the settings to the image, you should know about two other valuable features.

■ Click the **Preferences** button to get the iCorrect Professional **Preferences** dialog box shown in **Figure 36.4**. This dialog box allows you to set the initial **Auto Strength** of the **Brightness** and **Contrast** settings shown in the main dialog box. It also lets you define more memory settings. For example, I shoot lots of night college lacrosse games, so I have created memory settings for photos taken at night on a specific lacrosse field. After shooting photos of a game, I can use these settings to get the colors that I want every time with just a click or two of the mouse button.

■ Click **Cancel** to return to the main dialog box. You find the other valuable feature in this dialog box at the bottom of the dialog box, which is the **Save ColorCircuit** button. If you save specific settings using this feature, you can use an additional program that comes with iCorrect Professional 3.0 to batch process an entire folder of photos by using your pre-defined settings.

■ Click **OK** to apply the settings. After applying a small amount of sharpening, the image looks more like the original scene and similar to the one shown in **Figure 36.5**.

If you use iCorrect Professional 3.0 and you like it, but want even more control over you images, then you are in luck — as the Pictographics iCorrect Edit Lab 2.0 is a similar, but much more feature-rich, plug-in. **Figure 36.6** shows the iCorrect Edit Lab 2.0 dialog box. Notice the four tabs for choosing four different sets of controls.

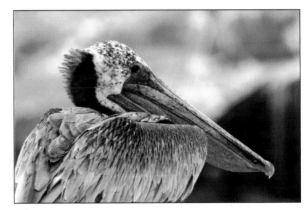

36.5

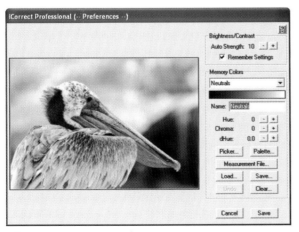

36.4

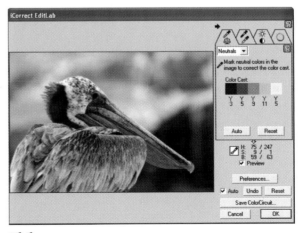

36.6

USING APPLIED SCIENCE FICTION'S DIGITAL SHO

Having either iCorrect Professional 3.0 or iCorrect Edit Lab 2.0 available to correct images will undoubtedly help you dramatically improve most images — quickly. However, both of these products make global changes to the entire image and yet, many images have *problem* areas that need a different set of adjustments from the rest of the image. One particularly common problem is if one or more parts of an image are under-exposed relative to the rest of the image. So, take a look at a quick solution to this kind of problem image. Applied Science Fiction, the makers of the Digital Ice technology found in some of the leading scanners, created Digital SHO to automatically optimize contrast and exposure. It is an excellent tool to fix problems caused by blacklit subjects or when important details are hidden in shadow, such as is the case with the lily photo we will use now. When the photo was taken, the entire lily and the surrounding area was entirely in shadow, and because the exposure was set to show detail in the flower itself, the darker areas of the photo show little detail. The goal is to keep the detail in the lily, make more of the detail in darker areas show, while making sure that no color cast is introduced.

To learn more about Digital SHO and to get a free downloadable trial version, visit: `www.picto. com` or `www.reallyusefulpage.com\50ps7\ plug-ins.htm` to get a clickable link to the Applied Science Fiction Web page and read any notes and updates about this and many other Photoshop 7 compatible plug-ins.

STEP 1: OPEN FILE

■ After installing the **Digital SHO** plug-in, choose **File ➤ Open** (**Ctrl+O**) to display the **Open** dialog box. Double-click the **/36** folder to open it and then click the **lily-before.jpg** file to select it. Click **Open** to open the image shown in **Figure 36.7**.

■ Choose **Filter ➤ Applied Science Fiction ➤ Digital SHO** to get the dialog box shown in **Figure 36.8**. It is a simple dialog box that conceals some rather clever mathematical algorithms. Drag the preview box to an area where you want to look for improvement in the shadows. In this case, the default settings for **Shadow Brightness** seem OK. If you make lots of changes in the **Shadow Brightness** setting, you may need more color saturation. To increase color saturation click and drag the **Color Intensity** slider.

Now click **OK** to apply the settings. The image shown in **Figure 36.9** shows the results of using Digital SHO and Pictograph's iCorrect Professional 3.0.

36.7

Applied Science Fiction offers a second *smart* plug-in called Digital ROC, which automatically restores color quality to digital images. It uses a proprietary algorithm that analyzes the color gradients to determine the optimum tonal curve for each color channel to remove the color cast from faded images and effects of tungsten and fluorescent lighting. It also adds density and contrast to black and white pictures. If you restore old photos, this is a plug-in that you will enjoy using as it can save you a tremendous amount of time, providing it works on the image that you need to fix. An important point to make about all of these *auto fix* plug-ins is that they can do a wonderful job on some images and a not so good job on others.

36.9

36.8

The Digital ROC dialog box is shown in **Figure 36.10**. After clicking OK, you can see the instant improvements that were made to the original photo shown in **Figure 36.11** and the final photo shown in **Figure 36.12**.

iCorrect Professional 3.0, iCorrect Edit Lab 2.0, Digital SHO, and Digital ROC are advanced Photoshop 7 compatible plug-ins that can help you get more done and get it done quicker. They can also be invaluable to those who use Photoshop 7 but do not have the experience to successfully use Photoshop 7 tools to accomplish the necessary tasks. I encourage you to download these plug-ins and try them on many of the *before* images found on this book's Companion CD-ROM and on you own images. You will then be able to make a good decision as to whether or not they are worth purchasing, as some plug-ins are costly unless they save you lots of time and effort.

36.10

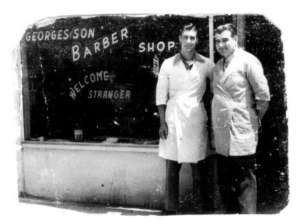

36.11

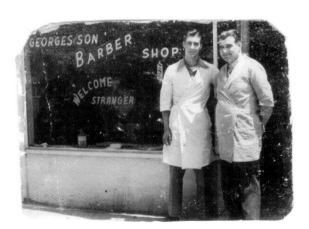

36.12

USING GRAIN SURGERY TO REMOVE DIGITAL NOISE

37.1

© 2002 Gregory Georges

37.2

© 2002 Gregory Georges

ABOUT THE IMAGE

Great Horned Owl Canon EOS D30, f/2.8 300mm IS, ISO 800, f/3.2 @ 1/125, 16-bit RAW setting, 1440 x 2160 pixels converted to 9.3MB 8-bit .tif, iCorrect Professional and Photoshop 7 Levels have been applied

Unwanted digital noise (or grain) in a digital image can be a gigantic stumbling block to making a digital photo look as good as if the nasty stuff weren't there at all! Besides appearing as variegated spots of color in a color image, the noise usually becomes even more pronounced when the image undergoes necessary image sharpening.

In Technique 11, we looked at several ways to remove the digital noise found in the photo of a great horned owl that was taken with an ISO 800 setting. In the end, the noise was simply diminished by applying the Gaussian Blur filter to the areas where it showed the most. Removing noise without also removing important fine detail and ultimately ending up with a loss of image sharpness in an image is very, very challenging when using the tools found in Photoshop 7. Thankfully, several software vendors have created excellent noise-reduction plug-ins that are able to remove a remarkable amount of grain from a wide variety of digital images.

Two of the more advanced and capable noise-removing plug-ins are Grain Surgery by Visual Infinity (www.visinf.com) and Quantum Mechanic Pro by Camera Bits (www.camerabits.com). Both vendors offer several versions of their products. Depending on the variety and type of digital images that you edit, one or both of these products ought to work for your intended use. For this technique, we use Grain Surgery for no other reason than one had to be selected and it works extremely well without much fussing with the parameters, plus I like the fact that it also can be used to match or add grain.

To learn more about Grain Surgery and to get a free downloadable trial version, visit www.visinf.com or www.reallyusefulpage.com\50ps7\plug-ins.htm to get a clickable link to the Visual Infinity Web page and read any notes and updates about this and many other Photoshop 7 compatible plug-ins.

STEP 1: OPEN FILE

■ After installing the **Grain Surgery** plug-in, choose **File** ➢ **Open** (**Ctrl+O**) to display the **Open** dialog box. Double-click the **\37** folder to open it and then click the **owl-before.tif** file to select it. Click **Open** to open the file.

STEP 2: RUN GRAIN SURGERY PLUG-IN

■ Choose **Filter** ➢ **Grain Surgery** ➢ **Remove Grain** to get the dialog box shown in **Figure 37.3**. If the preview windows does not show at **100%**, then click the + button just below and to the left of the preview image until the image is shown at **100%**. Click in the image and drag it up toward the left until you can see the grain to the left of the owl and yet still be able to see the highlights in the owl's left eye and the fine feathers on its ears. This view makes it easier to view the tradeoff between noise reduction and image sharpness.

■ Click once in the preview image to see the difference between the *before* image and the image created by the current settings. Amazingly, you find a good balance between lessened grain and retained image sharpness at the initial settings.

One of the attributes that I like most about this grain-reduction filter is that it offers many different parameters which allow complete control; yet, the default is totally automatic and rarely do adjustments to the default settings result in better grain-reduction. Mostly, changes are made to suit individual tastes.

■ An increase in **Noise Reduction** reduces image sharpness — so a **100%** setting is just right. Changes in **Degraining Passes**, **Noise Model**, and **Degraining Mode** all result in poorer results, so leave them set to **3**, **Multiplicative**, and **Single Channel** respectively.

To the left of the preview box are buttons to take snapshots and to create a split-screen view in the preview box; both of these features are to make it easier for you to compare different settings. There are also R, G, B, and I buttons that allow you to look an individual color channels. Finally, as successful sharpening of an image with digital noise is so dependent on the grain (or lack of grain), Grain Surgery lets you apply Unsharp Mask settings while viewing the effects in the preview image.

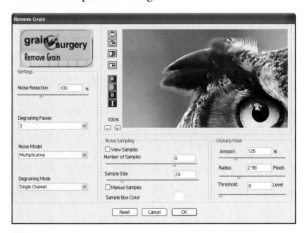

37.3

- Try setting **Amount** to **175%**, **Radius** to **1.0**, and **Threshold** to **3**. These settings favor adding some sharpness to the image over nearly complete removal of the noise.

Click **OK** to apply the grain removal settings while sharpening the image at the same time with **Unsharp Mask**. Your image should now look similar to the one shown in **Figure 37.4**.

Now compare the results of using the Grain Surgery plug-in with the results from Technique 11. The image produced using Grain Surgery should look sharper, without sharpened noise on the owl. While the background may look smoother in the image

created in Technique 11, it is overly smooth relative to the part of the image showing the owl. Minimizing noise in an image is important and I find that there is no substitute Photoshop 7 process or filter that minimizes grain as well as these two specialty plug-ins.

Figure 37.5 shows the Quantum Mechanic Pro dialog box. Once again, I highly recommend that you download trial versions of these and other noise-reduction plug-ins to see how they work on your images. It is my opinion that digital camera vendors will build noise-reduction features into their cameras. Canon's EOS 1D is an excellent example of this trend. While it does not completely remove digital noise, it does a very good job of making it less noticeable even when shooting at the 1600 or 3200 ISO settings. In the meantime, these tools will give you the results that you want.

Noise-reduction plug-ins can require some experimentation to get the best results and so they can be quite time-consuming. However, once you find a range of good settings for certain types of images, the process of removing noise can be a short and simple task. If you want your images to look good, my recommendation is to get one of these two plug-ins — you'll never get the results you can get with these plug-ins by using the standard Photoshop 7 tools — period.

37.4

37.5

CONVERTING COLOR TO B&W USING CONVERT TO B&W PRO

38.1 © 2002 Gregory Georges

38.2 © 2002 Gregory Georges

I n Technique 14, four different approaches to converting a color image to a black and white image were discussed. In each case, only Photoshop 7 filters and commands were used to make the conversions. While one or more of these approaches can be used on any image to make a wonderful black and white image, finding the optimal settings to get the image you want takes time and considerable experimentation — and comparing one setting to another is difficult.

In contrast, several Photoshop 7 plug-ins have been specifically designed for converting color to black and white; they not only make it easier to compare different settings, but some of them even mimic the processes of conventional black and white photography. One of my very favorite plug-ins is The Imaging Factory's Convert to B&W Pro plug-in.

To learn more about Convert to B&W Pro and to get a free downloadable trial version, visit www.theimagingfactory.com or www.really usefulpage.com\50ps7\plug-ins.htm to get a clickable link to The Imaging Factory Web page and read any notes and updates about this and many other Photoshop 7 compatible plug-ins.

247

STEP 1: OPEN FILE

■ After installing the **Convert to B&W Pro** plug-in, choose **File ➢ Open** (Ctrl+O) to display the **Open** dialog box. Double-click the **\38** folder to open it and then click the **iris-before.tif** file to select it. Click **Open** to open the file.

This close-up photo of an iris is a good photo to use to learn about the Convert to B&W Pro plug-in settings as the image has a considerable area that has very subtle tonal changes (the top white part of the iris) and other parts of the image have yellow, green, purple, and maroon colors, just about all colors except for blue or cyan.

STEP 2: RUN CONVERT TO B&W PRO PLUG-IN

■ Choose **Filter ➢ Digital Imaging Tools ➢ Convert to B&W Pro** to get the plug-in dialog box shown in **Figure 38.3**.

Getting the *right* settings for this image with this plug-in is strictly a matter of aesthetics — what you like will be the *right* setting for you. For this image, look at finding a setting that shows detail in the bottom part of the flower, but offers excellent contrast in the entire image. Also, see if you can pick settings that

38.3

maximize blacks, while making sure that you can still see detail in all parts of the image, especially in the dark parts of the flower at the bottom of the image.

■ Click the **Pre Filter Color** check box to turn prefiltering on if a check mark is not already there. Click in the **Pre Filter Color** box to select a filter color from the pop-up menu. Your choices are: **Red**, **Orange**, **Yellow**, **Green**, **Cyan**, **Blue**, and **Magenta**. Using these filters is similar to using color lens filters; they help to increase image contrast and differentiate colors with the same gray values. Click down to select each color in sequence to see which ones meet your objectives. **Figure 38.4** shows a series of images for all of the pre-set color settings, plus the original color image. Besides being able to select from the presets, you can select any one of 360 colors across the color range, plus adjust the color saturation from 0 to 100% by using the **Pre Filter Color** sliders.

■ Click in the **Pre Filter Color** box and select **Blue**.

■ Click the **Color Response** check box if a check mark is not already there. Click in the **Color Response** box to get a pop-up menu giving you a choice of **Linear**, **Photoshop**, **Agfa PAN APX**, **Ilford DELTA**, **Ilford FP4**, **Kodak T-MAX**, and **Kodak TRI-X**. These settings are supposed to determine the relationship between colors of the original image and the shades of gray on the final image as they might occur when using specific brands of film.

Once again, I suggest that you experiment to see which setting best meets our objectives. Select **Kodak TRI-X**. If you are not happy with any of the preset **Color Response** settings, you can adjust the ten sliders to create your own color response.

■ Click the **Tonal Response** check box if a check mark is not already there. Click in the **Tonal Response** box to get a pop-up menu giving you a choice of **Linear** or a custom setting; click **Linear**. In the **Tonal Response** area, you can use sliders to adjust **Neg. Exp. Exposure** and **Multigrade**. You

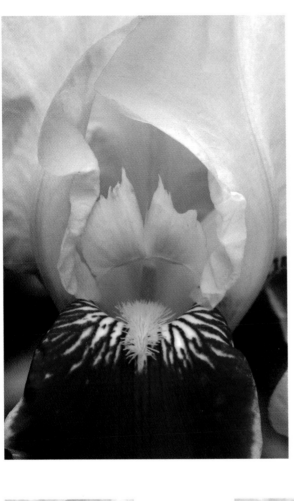

Red

Orange

Yellow

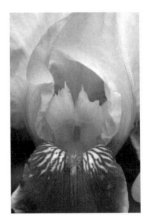

Green

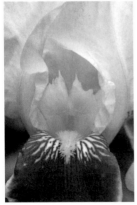

Cyan

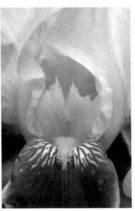

Blue

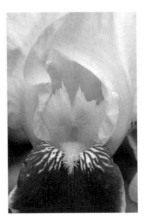

Magenta

38.4

should try each of these sliders, especially the **Multigrade** slider as it mimics the multigrade exposure system developed by Ilford.

After experimenting with the **Tonal Response** sliders, check in the **Tonal Response** box to once again select **Linear** to restore the default settings.

■ The last area in the Convert To B&W Pro dialog box is for tinting or toning with colors. Click the **Sepia Tone Color** check box if a check mark is not already there. Click in the **Sepia Tone Color** box to get a pop-up menu giving you a choice of **Blue** or **Tobacco**; click **Tobacco** to get an image, such as the one shown in **Figure 38.5**. If you don't like either of the preset tones, you can select any color you want by clicking in the color box, then you can also select the intensity of the color as well. Clicking **Tint** tints your image, thereby leaving the whites a pure white. Clicking **Tone** tones the entire image including the white areas so that there are no pure whites.

■ Click in the **Sepia Tone Color** box to switch off toning. The final image shown in **Figure 38.6** was created with the settings shown in **Figure 38.7**.

While several other good color-to-b&w conversion plug-ins are available, Convert to B&W Pro offers

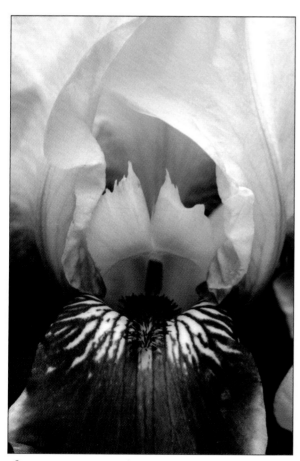

38.5

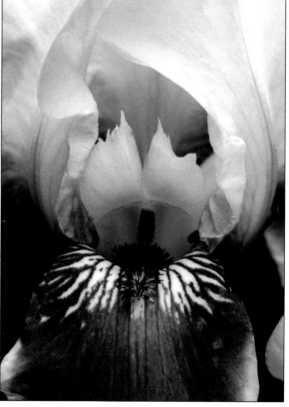

38.6

more user-selectable settings than any other plug-in that I know about, it can be applied to 48-bit RGB files, and the three RGB channels are used to create one B&W channel. In addition, the plug-in calculates 64-bits per channel where possible. This means that minute detail available in the original color file can be made visible in the resulting B&W file as accurately as is possible. If you edit 16-bit per channel images such as the RAW image files taken by many digital cameras — you will love the results of this plug-in. My bet is that you won't want to convert color images to black and white images without this plug-in after you use it a few times.

38.7

CREATING ARTWORK
WITH BUZZ.PRO 2.0

39.1

© 2002 Gregory Georges

39.2

© 2002 Gregory Georges

Before I began using an image editor, I enjoyed airbrush and watercolor painting. Because of that background, I have always wanted to be able to transform digital photos into images that look like a *painting* without having to apply lots of brushstrokes. Very early on, I learned that to create a successful digital painting, most digital photos need to be simplified; that is, many of the finer details need to be removed or simplified. Then those simplified areas need to once again be simplified, only this time just in terms of color, as brushstrokes are usually painted with a single color. Finally, those stroke-like marks need additional effects, such as texture, softness, or thickness to make an image look like a painting.

The Segmentis Limited buZZ.Pro 2.0 is a plug-in that offers 19 different effects that do exactly what is needed to create a variety of painting effects. The filters range from very powerful simplifiers, to blurs, screens, lines, and more. Each of these effects can be loaded into a stack; some of the effects allow further settings to be made. After some experimentation, buZZ.Pro 2.0

can be used to create many different painted effects. In this technique, you transform a photo of a farm house into a painting by using buZZ.Pro 2.0.

STEP 1: OPEN FILE

■ Choose **File** ➤ **Open** (**Ctrl+O**) to display the **Open** dialog box. Double-click the **/39** folder to open it and then click the **framhouse-before.tif** file to select it. Click **Open** to open the file.

STEP 2: LOAD BUZZ.PRO 2.0 PLUG-IN

A downloadable trial version of buZZ.Pro 2.0 is available at www.fo2pix.com, or you may visit www.reallyusefulpage.com\50ps7\plug-ins.htm to get a clickable link to the download page and to learn more about many other Photoshop 7 compatible plug-ins.

■ After installing **buZZ.Pro 2.0**, choose **Filter** ➤ **buzzPro** ➤ **buzz.Stack** to get the two interdependent dialog boxes shown in **Figure 39.3** and **Figure 39.4**.

■ To begin the simplification process, click **Simplifier Two** in the **Available Effects** box in the **Custom** dialog box to select it; click the **Add** button to add the effect to the **Current Stack**. The **buzz.Pro 2** preview dialog box should now look similar to the one shown in **Figure 39.5**. Click in the preview image to drag the image to the left corner of the roof.

39.4

39.3

39.5

■ Slide the **Remove Large** and **Add-back Small** sliders all the way to the left. Begin sliding the **Remove Large** slider toward the right until the preview image is simplified as much as you want. Try using a setting of **96**.

To add back some of the important small detail, slide the **Add-back Small** slider toward the right. A setting of **5** is a good setting to use.

■ Click in the preview image once again and drag the image around to view the effects on the important parts of the image. Make sure the settings that you choose are good settings for the roof, the eaves, the orange daylilies, and the white flowers in the foreground.

■ To add contrast click **Bright/Contrast** in the **Available Effects** box in the **Custom** dialog box; click **Add>** to add that filter to the **Current Stack**. The **Custom** dialog box should now look like the one shown in **Figure 39.6** and the **buzz.Pro 2** dialog box should look like the one shown in **Figure 39.7**. Slide the **Brightness** slider to the right to get a setting of **15**. Slide the **Contrast** slider to the right until it shows **40**. These settings increase the brightness and contrast levels of the image. Click **OK** to apply the settings.

39.6

STEP 3: MAKE FINAL ADJUSTMENTS

■ After making a few additional adjustments with **Levels** and **Hue/Saturation** to suit my taste, the image looks like the one shown in **Figure 39.8**. Now, try making your own adjustments by using **Levels** and **Hue/Saturation** to suit your tastes.

■ To add the final touch, use the **Photoshop 7 Text** tool to add a signature.

39.7

Because of the way that buZZ.Pro 2.0 simplifies images; it can be used to create very large high-quality images. **Figure 39.9** shows an image of some mountains in Sedona, Arizona, that were taken with a Nikon 950 digital camera. The original image was a mere 1600 x 1200 pixels. Using the Photoshop 7 Image Size command, the image was increased to 3840 x 2880 pixels — a 31.6MB image, which when printed at 240 dpi makes an excellent 16" x 12" print.

Besides creating painted effects, buZZ.Pro 2.0 can also be used to create various line or ink drawings.

Stacking the 19 different filters in different combinations and in different orders allows you more flexibility than you need. Some experimentation is required, but with some time, you can create some very nice effects. When you get a combination of filters that you like, you can save them as a Stack so that they can be easily applied again. You can also use one of the 16 preset Stacks that come with the software.

Segmentis offers several other products similar to buZZ.Pro 2.0. You may learn more about them on their Web site at `www.fo2pix.com`.

39.8

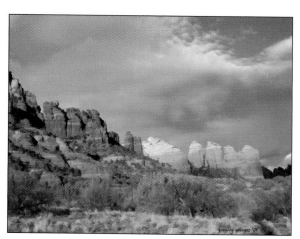

39.9

USING A PEN TABLET
AND PENPALETTE 1.0

40.1

© 2002 Peter Balazsky

40.2

© 2002 Peter Balazsky

ABOUT THE IMAGE

Peach Gloss Lips and a Tear Nikon 8008s film camera mounted on a tripod, 105mm Nikon lens, Scotch-Chrome-CS-1000 slide film, ISO 1000, f/8 @1/125, 2,048 x 3,075 pixel Kodak Photo-CD file was edited and reduced to 1,200 x 1,500 pixels, 5.4Mb .tif

Wacom, the pen tablet maker, and Nik Multimedia, Inc., a maker of special effects filters, teamed up to create penPalette — a wonderful set of photographic effects which can be selectively applied to any image with a Wacom pen tablet. In this technique, you will work with one of Peter Balazsy's superb portraits. After first converting the color image to a black and white image, you will increase contrast in selected parts of the image, apply a color tone to the image, and paint some color onto the lips.

To complete this technique, you must have penPalette installed and one of the Wacom pen tablets. Unfortunately, no trial versions are available for the penPalette. However, if you already have a Wacom tablet, you may qualify for a free penPalette or you may purchase one from the Nik Multimedia Web site at: www.nikmultimedia.com.

If you want to try the Nik Multimedia filters, you can download trial versions from their Web page and they all work well with an ordinary mouse if

257

you don't have a pen tablet. As for me, I'm hooked on using a 6" x 8" Intuos 2 Graphics Tablet. It is a tool that you will want to have if you plan on using Photoshop 7's new brushes and if you frequently find yourself painting on layer masks as shown frequently in the techniques in this book. Yes, you can live without a pen tablet by using a mouse, but if you try one — you'll want one, as it is the best tool I know to get you dodging and burning better than any traditional darkroom printer!

STEP 1: OPEN FILE

■ Choose **File** ➢ **Open** (**Ctrl+O**) to display the **Open** dialog box. Double-click the **/40** folder to open it and then click the **face-before.tif** file to select it. Click **Open** to open the file.

STEP 2: LOAD PENTABLET 1.0

■ To load penTablet 1.0 choose **File** ➢ **Automate** ➢ **penTablet 1.0** to get the **penPalette** dialog box shown in **Figure 40.3**.

STEP 3: CONVERT TO BLACK AND WHITE

■ To convert the color image to a black and white image, click the **BW filter** button in the **penPalette** dialog box to get the **B/W Conversion** filter dialog box shown in **Figure 40.4**. Try setting **Brightness** to **100%**, **Filter Strength** to **50%**, and **Spectrum** to **255**. Click **OK** to create the effect.
■ You now have the choice of using the **Brush** tool (**B**) to paint the entire image, or you can click on the **Fill** button in the **Editing Functions** area of the **penPalette** dialog box to convert the entire image to a black and white image. Then, click the **Apply** button in the **penPalette** dialog box to apply the effect to the image.

40.3

STEP 4: TONE IMAGE

■ To add a soft warm tone to the image, click on the **Warm** filter button in the **penPalette** to get the **Warm Tone** filter dialog box shown in **Figure 40.5**. Move the **Filter Opacity** slider to **65%** and click **OK**. Once again, you could use the **Brush** tool (**B**) and selectively paint the part of the image that you want to tone; however, as the intent is to tone the entire image, click the **Fill** button in the **Editing Functions** area of the **penPalette** dialog box to tone the entire image. Click **Apply** to apply the tone to the image.

STEP 5: SELECTIVE INCREASE CONTRAST

■ Now we will use the pen to increase the contrast in just part of the image. Click the **Contrast Only** button in the **penPalette** dialog box to get the **Contrast Only** filter dialog box shown in **Figure 40.6**. Using the sliders set **Contrast** to **130%** and **Darken** to **120%**, click **OK** to apply the settings.

■ Select the **Brush** tool (**B**) and then click in the **Brush Preset Picker** to get the **Brush** palette. If the palette does not look like the one shown in **Figure 40.7**, click the menu button in the upper-right corner of the palette to get a pop-up menu; choose **Reset Brushes**. Select the **Soft Round 300 Pixels** brush by clicking it in the palette.

40.5

40.4

40.6

■ You can now begin selectively painting with the pen tablet areas where you want to increase contrast. I suggest simply painting down the middle of the face and all over the blouse. This will improve the image significantly. Once the image is as you want, click on the **Apply** button in the **penPalette** to apply the filter to the selected areas.

STEP 6: COLOR LIPS

■ The final step is to add a small amount of color to the image. Click the **Colorize** button in the

penPalette to get the **Colorize** filter dialog box shown in **Figure 40.8**. Click in the **Filter Color** box to get the **Color Picker** dialog box shown in **Figure 40.9**. Type **182** in the **R** box, **104** in the **G** box, and **104** in the **B** box to select a suitable peach colored gloss lipstick color; click **OK** to return to the **Colorize** filter dialog box. Set the **Opacity Filter** to **75%**. Click **OK**.

■ Click in **Brush Preset Picker** box in the **Options** bar to select the **Soft Round 17 Pixels** brush. Now carefully paint the red color the lips. Once the lips have been painted click the **Apply** button in the **penPalette** to apply the filter effects.

40.7

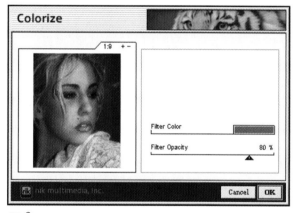

40.8

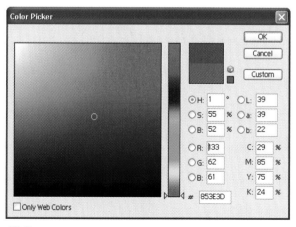

40.9

If you are not happy with the color of your painting, you can click the **Discard** button and start all over. Close the **penPalette** by clicking on the **Close** icon in the upper-right corner of the dialog box. Your image should now look similar to the one shown in **Figure 40.10**.

You can learn more about Peter Balazsy and his wonderful work in the profile at the end of Technique 22.

40.10

USING SPECIAL EFFECTS PLUG-INS

41.1

© 2002 Gregory Georges

Plug-ins are software modules that *plug-in* to Photoshop 7 and ImageReady 7 in such a way that they are as easily accessible as any of the standard Photoshop or ImageReady features. After plug-ins are installed, most of them show up at the bottom of the Filters menu. Unlike most of the plug-ins covered earlier in this chapter, many of these are specialty plug-ins that may not appeal to everyone. But, if you are in need of the effects they create, these plug-ins can be useful and they will certainly save you time. **Figure 41.1** shows a few digital effects that were created with the plug-ins covered in this technique.

Most of these plug-ins are available as downloadable trial versions. You can either check on the vendor's Web page, or visit www.reallyusefulpage. com\50ps7\plug-ins.htm to get a clickable link to the download page and read any updates about these and many other plug-ins.

263

SPECIAL EFFECT 1: MIRROR PARTS OF AN IMAGE

One of my all-time favorite special effects plug-in is the Xaos Tools (www.xaostools.com) Terrazzo 2.0. Designed to act like a digital kaleidoscope, it can also be used to merely mirror an image or part of an image. The image of a mountain range in Sedona, Arizona, taken with a Nikon 950 digital camera, and shown in **Figure 41.2**, was transformed into the photo shown in **Figure 41.3** with Terrazzo 2.0.

To give the image a painterly look and to enable the small 1600 x 1200 pixel image to be enlarged enough to make a 14" x 10.5" print, the image was first enlarged with the Photoshop 7 Image Size. The Fo2Pix buZZ.Pro 2.0 was then used to give it the painterly look and to smooth out the pixelization that occurred when the image was enlarged. After duplicating the background layer, the Photoshop 7 Magnetic Lasso tool was used to quickly select the sky and clouds. The Terrazzo 2.0 plug-in was then used to mirror the selected portion of the image. **Figure 41.4** shows the Terrazzo 2.0 dialog box and the settings that were used. The image was then flattened.

Terrazzo 2.0 is a fascinating plug-in that can be used to create all kinds of unusual and cool images. Try using it on flowers, trees, or other natural elements that do not have the perfect symmetry that this plug-in can create. If you thought that the magical tree in Technique 30 could be created using Terrazzo 2.0 — you are correct. A little cloning in parts of an image can hide some of the perfection that would otherwise make the image too perfect to be believable.

SPECIAL EFFECT 2: ENHANCE COLORS AND ADD WARMTH

If you are a traditional photographer who enjoys using filters when you shoot photos, then you'll love the digital versions that can be found in nik Multimedia's (www.nikmultimedia.com) nik Color EfexPro! Complete Collection, which has a total of fifty-five photographic filters for enhancing or stylizing any

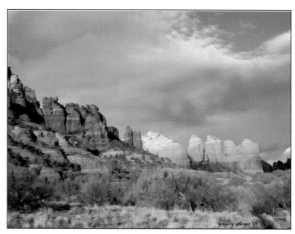

41.2

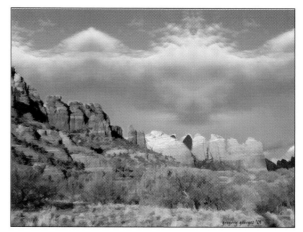

41.3

41.4

photo. The names of some of the filters are shown on the menu shown in **Figure 41.5**.

41.5

41.6

41.7

41.8

The dairy farm photo shown in **Figure 41.6** was changed into the one shown in **Figure 41.7** by applying two filters, making a minor adjustment with Levels, and then applying the Unsharp Mask.

Figure 41.8 shows the dialog box for the Brilliance/Warmth filter, which was used to strengthen the golden glow of sunset. Sliders control both Brilliance and Warmth. To increase the saturation of the blue sky, the Graduated 201h (Sky Blue) filter was used. **Figure 41.9** shows the dialog box for that filter. This filter offers four sliders that allow control over the rotation

of the horizon, the opacity of the blue filter, where the blue color begins to blend, and the strength of the blend. This gives you far more control than you have with traditional filters that fit on camera lenses.

SPECIAL EFFECT 3: CREATE SELECTIVE FOCUS

Trying to adjust your camera to get the desired depth-of-field to focus attention on a specific part of an image requires considerable skill, the right lens, the right film or ISO speed, the right amount of light — plus, a bit of luck, too. Andromeda Software, Inc. (www.andromeda.com) offers VariFocus — a plug-in that allows you to digitally focus/defocus features in your image with incredible control.

Figure 41.10 shows the VariFocus dialog box with the settings that were used to turn the image shown in **Figure 41.11** into the photo shown in **Figure 41.12**. Besides being able to adjust where the blur is located, you can also select different patterns for the blur, and adjust the level of the blur as well. Using this plug-in is not only much quicker than if you were to create gradations on a layer mask, but it also gives you much more control over the effect, and you can see the results instantly.

41.10

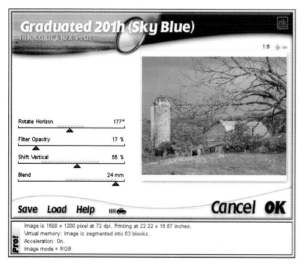

41.9

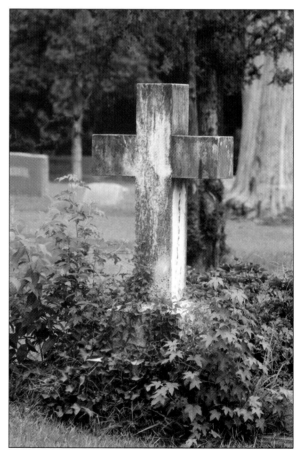

41.11

SPECIAL EFFECT 4: ADD REALISTIC FILM GRAIN OR A MEZZOTINT PATTERN

This book offers several techniques to remove digital noise or grain from an image. However, you may have times where grain is very desirable. Photoshop 7 has several filters that can be used to add grain to an image, such as Noise and Grain. However, those filters are vastly less sophisticated than the grain producing plug-in, Grain Surgery by Visual Infinity (www.visinf.com).

Grain Surgery not only removes grain, but it can create grain in both black and white images as well as color, and it can match grain from one image and place a similar grain in another image. This means that, for example, you could cut out a butterfly with little grain from one image, place it in a grainy image, and then use Grain Surgery to add a matched grain in the butterfly. Or, you can use Grain Surgery to just add grain to an image, such as the iris image shown in **Figure 41.13**. After first converting the image to black and white by using Convert to B&W Pro, Grain Surgery was used to add a *Kodak TRI-X Pan 400 BW* grain. The results are shown in **Figure 41.14**. **Figure 41.15** shows the Grain Surgery — Add Grain dialog box.

If you want to add something more sophisticated than film grain to an image, the Andromeda Software (www.andromeda.com) Screens plug-in converts gray-scale images into a wide variety of different line

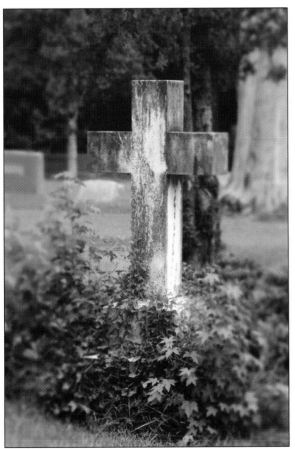

49.12

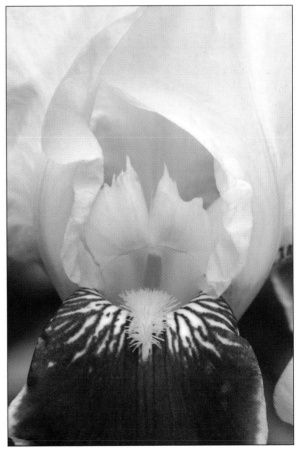

41.13

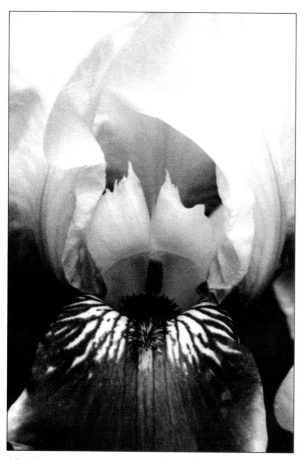

41.14

art screens, such as mezzotints, sharp contrast mezzo grams, mezzo blends, ellipses, lines, circles, spokes, waves, or any blended combination.

Figure 41.16 shows an image of an old pocketwatch. After converting the image to black and white, the Screens plug-in was used to apply a mezzotint which resulted in the image shown in **Figure 41.17**. **Figure 41.18** shows the controls that you have over the Screens effects.

SPECIAL EFFECT 5: CHANGE SELECTED COLORS

If you were to give a one to ten rating for cleverness in creating useful plug-ins, the Digital Light & Color

41.16

41.15

(www.colormechanic.com) Color Mechanic Pro would be about a 12.5! Color Mechanic Pro is a selective color correction plug-in that enables you to change one or more colors in an image without changing other colors and without the hassle of selecting the parts of the image that you want to change. You can both change the hue and saturation of selected colors, while at the same time lighten or darken them, too.

This tool is definitely the one to use to change sky colors, skin tones, clothing colors, and just about everything else. As a quick example, change the purple iris shown in **Figure 41.19** to the red iris shown in

41.18

41.17

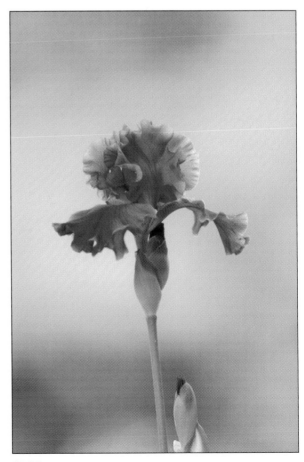

41.19

Figure 41.20. **Figure 41.21** shows the Color Mechanic Pro dialog box. To change colors in the flower, just click in the image and then drag the control point in the color cube to the desired color. If you find yourself changing colors in an image often, this is one plug-in you should download and try out. This plug-in is one I use often. If you get a copy, try re-coloring the image of the North Carolina farm house found in Technique 39. Modifying colors in the image created with buZZ.Pro 2.0 will make it look even more like a painting.

SPECIAL EFFECT 6: CREATING EDGE EFFECTS AND OTHER SPECIAL EFFECTS

Most photographers either love or hate edge effects. If you are prone to using them on a Web page, a brochure, or other printed materials, Auto F/X Software (`www.autofx.com`) offers two excellent products for such purposes. DreamSuite Series 1 has 18 unique visual effects for type, graphics, and photographs. The effects include: 35mm Frame, Chisel, Crackle, Crease, Cubism, Deckle, Dimension X, Focus,

41.21

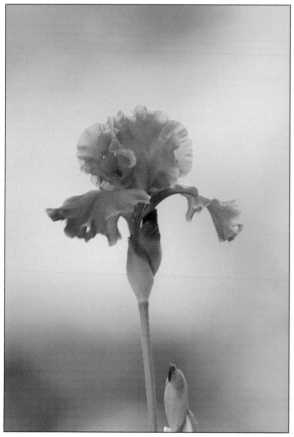

41.20

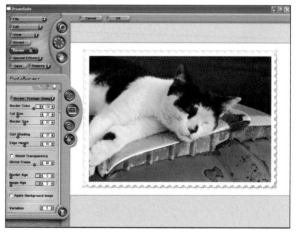

41.22

Hot Stamp, Instamatic, Liquid Metal, Metal Mixer, PhotoBorder, PhotoDepth, PhotoTone, Putty, Ripple, and Tape. **Figure 41.22** shows the DreamSuite dialog box and **Figure 41.23** shows the results of the 35mm Frame, Instamatic, and PhotoBorder effects applied to an image of a cat napping on the hood of an old rusty car.

The second product is Photographic Edges 5.0, which lets you have complete control over edges, montages, vignettes, and frames. The software comes on three CD-ROMs and includes 17 volumes of effects containing more than 10,000 edges, 1,000 Matte Textures, and 200 light tiles. **Figure 41.24** shows the Photographic Edges 5.0 dialog box. **Figure 41.25** shows a photo of an owl with a single edge effect applied.

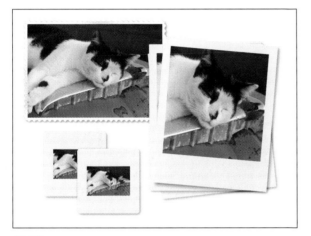

41.23

41.24

41.25

CHAPTER 8

MAKING PHOTOGRAPHIC PRINTS

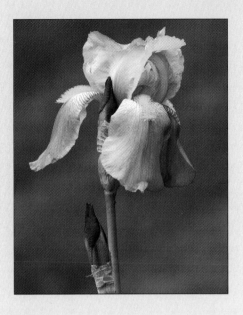

In this chapter, you discover how you can turn those digital images into a variety of photographic prints to suit your needs, whether they are of the "one-hour" style or fine-art prints suitable to be hung in a gallery or museum. First, you read how to place a print on a page with a caption, create a "school photo" style print with multiple images, and automatically generate a page of thumbnails that can be used for image cataloging purposes. Technique 43 covers myths, realities, and techniques you'll want to know about when you need to increase the size of an image to make a large print. Technique 44 covers step-by-step instructions on how to use an ICC profile with an Epson 1280 printer to get the best possible print. Technique 45 tells you what you need to know to get reasonably priced, yet high-quality Fuji Frontier prints made. If you want the convenience of uploading and ordering prints online, Technique 46 shows you some important steps and tips on how to get prints made by using the Shutterfly online printing service. The final technique covers steps to take to get the ultimate photographic print — a Lightjet 5000 print from Calypso, Inc.

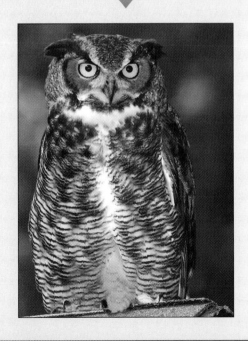

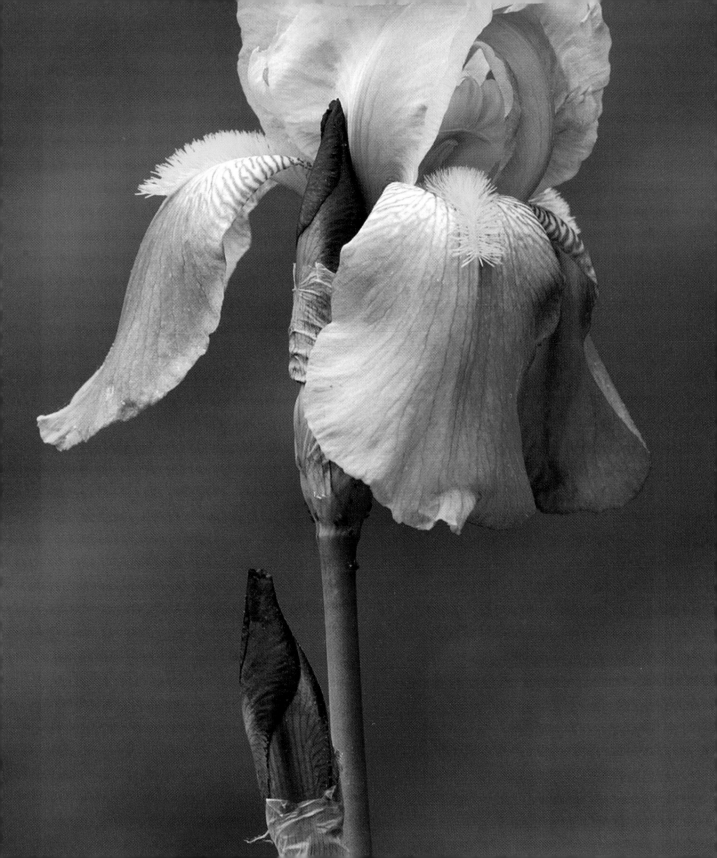

USING PRINT PREVIEW, PICTURE PACKAGE, AND CONTACT SHEET II

42.1

© 2002 Gregory Georges

42.2

© 2002 Gregory Georges

I f you want to control exactly where to place a digital image on a printed page and you want to add a caption, use the Photoshop 7 Print Preview feature. While there are plenty of page layout applications available to create a printed page exactly as you want it, you may still want to use Photoshop 7 due to its excellent color management capabilities, if your layout requirements are relatively simple. Print Preview is particularly useful for creating simple portfolio pages, as you read in this technique.

If you want to print more than one copy of an image to a page, the Photoshop 7 Picture Package feature may meet your requirements. To get a traditional-style contact sheet showing thumbnails of all the images in a folder (or subfolders), use the Photoshop 7 Contact II feature. In this technique, you look at all three of these useful features.

The objective of the next five steps is to create a print that can be used as portfolio page. A 5" x 7" image is placed 1" from the top and 1" from the right side of the page and a caption is placed below the image.

STEP 1: OPEN FILE

■ Choose **File ➢ Open** (**Ctrl+O**) to display the **Open** dialog box. Double-click the **/42** folder to open it and then click the **owl-before.tif** file to select it. Click **Open** to open the file.

STEP 2: ADD CAPTION

■ To add a caption to the printed page, you must first enter the caption into the image file by choosing **File ➢ File Info**, type the caption in the **Caption** box, and then save the file. To learn more about adding information to a file, read Technique 13. The file that you open in Step 1 already has a caption entered into the file, so you can proceed to Step 3.

STEP 3: RUN PRINT PREVIEW

■ Choose **File ➢ Print with Preview** (**Ctrl+P**) to get the **Print** dialog box shown in **Figure 42.3**. To position the image, click in the **Top** box and type **1**; make sure **inches** is shown to the right. Then click in the **Left** box and type **2.5**; once again, make sure **inches** is shown in the box to the right. You now positioned the image 1" from the top and the right side of the page, as shown in the preview window in the **Print** dialog box.

■ To add the caption already contained in the image file, you need to place a check mark in the box next to **Caption**. If a check mark is not next to **Show More Options** in the middle of the dialog box, click in the box to show more options. Make sure **Output** is shown as the **Options** type. Click in the box next to **Caption** to place a check mark if one is not already there.

While the Print dialog box is open, it is worthwhile to note that you may want to use a couple of other

useful features. Background enables you to select a background color. Border lets you set the size of a border should you want to print one around the image. Clicking next to Corner Crop Marks causes the Print feature to print small marks on each of the four corners of the image. These marks are very useful if you need to accurately cut an image from a page and the image has a white or very light-colored background. You can also place a check mark in the Labels box if you want to add Labels (for example, file names, dates, and so on) to the printed page.

STEP 4: SET PAGE SIZE AND SELECT PRINTER

■ To select page size and print orientation, click the **Page Setup** button to get the **Page Setup** dialog box where you can change the settings. To select the printer and printer settings, click the **Printer** button at the bottom of the **Page Setup**

42.3

dialog box to get the **Page Setup** dialog box. Click in the printer **Name** box to choose the printer. To change printer settings, click the **Properties** box in the **Page Setup** dialog box. After all the settings are made, click **OK** in the **Page Setup** dialog box. Then, click **OK** in the **Page Setup** dialog box.

STEP 5: PRINT PAGE

■ You are now ready to print the page. Click the **Print** button to get the **Print** dialog box. The correct printer should show as it was selected in the prior step. Click **OK** to begin printing.

USING PICTURE PACKAGE

If you want to place more than one image on a single page, use the Photoshop 7 Picture Package feature to automatically size and place multiple photos on a page, such as the traditional "school photo package" pages.

■ Choose **File** ➢ **Automate** ➢ **Picture Package** to get the dialog box shown in **Figure 42.4**. If you were to select **one 5" x 7" print and four 2.5" x 3.5" prints** from the **Layout** box in the **Document** area, you would get a printed page such as the one shown in **Figure 42.5**. You can even add a caption, file name, or copyright information on each photo by using the options shown in the **Label** area of the **Picture Package** dialog box.

42.4

42.5

USING CONTACT SHEET II

While we are on the topic of printing multiple images on a page, the Contact Sheet II feature should be mentioned. Contact Sheet II is a Photoshop 7 feature that allows you to print small *contact images* or thumbnail prints of every image in a folder (or even sub-folders) along with the file name. **Figure 42.6** shows the Contact Sheet II dialog box and **Figure 42.7** shows a printed page. These contact thumbnail sheets make excellent indexes for image archives either in printed form or as an image saved digitally.

42.6

42.7

INCREASING IMAGE SIZE
TO MAKE LARGE PRINTS

43.1

© 2002 Gregory Georges

43.2

© 2002 Gregory Georges

ABOUT THE IMAGE

Dragon Fly Canon EOS D30 digital camera, 300mm f/2.8 IS with 24mm extension tube, ISO 100, 16-bits per channel RAW image setting, f/7.1 @ 1/160, 18.7MB 2160 x 1440 pixel .crw file has been edited and cropped to a 1800 x 1440 pixels 8-bits per channel, 7.8MB .tif

When using a film, flatbed, or drum scanner to scan film or photographic prints, getting large enough digital image files is usually not a problem. However, as more photographers begin routinely using 2-, 3-, 5-, and now 6-megapixel digital cameras, which are currently the common and affordable sizes — getting a large enough image to make high-quality 8" x 10"s, 11" x 14"s, 16" x 20"s, or even larger prints is often a problem.

The problem of increasing image size while retaining image quality is one of the most challenging unsolved mathematical problems facing those involved in digital imaging research. Being able to get a large high-quality image from a small image file would reduce the time it takes to process images (see Technique 17), would allow images to be transferred online and between devices more quickly and with less bandwidth, and would help to minimize storage requirements. So, if there were a good solution today, we'd all be enjoying it and the inventor would have plenty of money to enjoy!

So, the multi-million-dollar question is: How do you increase the size of an image without suffering from image degradation? There are many answers (and opinions) to that question and in *my* opinion, each *good* answer always starts with "it depends." How far you can *res-up* an image *depends* on a number of image characteristics and how critical it is to have a sharp, in-focus image instead of one with the dreaded (or sometimes desirable) pixelization or softness that comes from adding pixels in places where there were previously no pixels.

While there are many rules or recommendations about when and how to use different techniques to increase the size of an image, I recommend that you learn about three different approaches and then experiment to get the results you want. Without question, many of the new digital SLRs and prosumer-level digital cameras have greatly changed my view of how far you can up-sample an image. Many digital cameras create totally grainless digital photos. If a digital picture is in focus and grainless, it can be enlarged much more than a scanned image that contains digital noise (the equivalent of film grain). Soft blurred digital photo can also have a remarkable smoothness to it that allows such a photo to be increased many times its original size.

One other factor that can limit how large an image can be increased is how much the image needs to be sharpened. In Technique 12, the point was made that an image should not be sharpened until it has been sized for its intended use. The process of up-sampling an image will at some point create visible pixelization; sharpening an image with moderate pixelization can result in a wholly unsatisfactory image. Likewise, upsampling an image that has already been sharpened can cause an even nastier problem — upsampled sharpening! Remember that you can't actually sharpen an image; you can only increase the perception that an image is sharp by creating more contrast along the *edges* of an image and this increase in contrast normally does not up-sample well.

Presently, digital photographers can take any one of three different approaches to increasing image size. These approaches are:

1. Use one of the several available image *resolution-upping* plug-ins, such as Lizard Tech's Genuine Fractals. Many digital imaging experts have argued for years over the merits of the leading *resolution-upping* plug-ins with no real definitive agreement that you can get better results using one of the plug-ins than you can when using the Photoshop 7 Bicubic Interpolation method, which can be found in the Image Resize command — *for original images that are under 20MB in size*. Few question the decided benefits of using these plug-ins for increasing larger original files (20MB or larger) to poster size or even larger when the *res'd-up* prints are to be viewed from a distance. However, the consensus view is that these plug-ins are not as useful as one would like them to be when increasing an original digital camera image file size when using up to a 6-megapixel digital camera to make large prints in the 11" x 14", 16" x 20", or even larger sizes.

2. Allow printer hardware to increase image resolution when printing. Depending on the printer model and its image interpolation capabilities, and the characteristics of a given photo, some printers can do a very good job at modestly increasing image size. Specifically, the Lightjet 5000 printer has such capabilities and it is widely accepted opinion that the Lightjet 5000's hardware interpolation does a better job of increasing image size than the Photoshop Bicubic interpolation or any currently available plug-ins. How much a file can be increased in size by various printers is once again subject to the characteristics of a given image and the acceptance level of image softness.

3. Use the Photoshop 7 Image Size command. Never underestimate what it can do!

Okay — enough talk; time to increase the size of the digital photo of the dragonfly by 300%. To illustrate some of the points made previously, this photo was chosen for enlargement because it will readily show softness if it is increased too much and because it needs sharpening to make the wings look their best. As you further increase image size, sharpening has a tendency to worsen the negative effects of up-sampling an image.

STEP 1: OPEN FILE

■ Choose **File ➢ Open (Ctrl+O)** to display the **Open** dialog box. Double-click the **/43** folder to open it and then click the **dragonfly.tif** file to select it. Click **Open** to open the file.

STEP 2: INCREASE IMAGE SIZE WITH IMAGE SIZE

■ Choose **Image ➢ Image Size** to get the **Image Size** dialog box shown in **Figure 43.3**. To increase the image size 300%, make sure there is a check mark next to **Constrain Proportions** and type **22.5** in the **Width** box with **inches** set as the increment.

Many digital photographers routinely increase image sizes by using the Image Size command but they increase the image size in steps believing that multiple steps will result in a better image. To decide if you want to use this time-consuming tip, open the compare300percent.psd file in the /43 folder. Looking at the Layers palette, you find three layers. The top layer is an image that was enlarged 300% with Genuine Fractals 2.0. The middle layer is an image that was increased 300% by using the Photoshop 7 Image Size command in six small steps, instead of all at once such as the image shown in the bottom layer. Click the eye icon in each layer to switch between layers to compare the effects of the three different image-sizing approaches.

After comparing these three layers, *for this image*, I've concluded that Genuine Fractals 2.0 did not produce good results. The difference between the *six-step* and *all at once* approaches is very minimal. If there is a difference, I believe that the *six-step* approach created a noticeable increase in digital noise in the soft blurred areas, which may or may not become more noticeable after the image has been sharpened. Again, I stress these ideas hold true for this image — not necessarily all other images.

Another not so widely practiced tip, but one that some image editors use often is to up-sample an image larger than it needs to be. Then, they sharpen the image and down-sample the image to the desired size to get results that they think are better. I have not enjoyed beneficial results with this approach on the images that I've tried it on — but it may work for you and your images, so try it if you have the time.

■ Click **OK** to increase image size by **300%**.

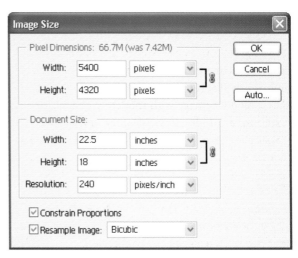

43·3

STEP 3: SHARPEN IMAGE

Now — and only after the image has been sized to its final size should you sharpen the image, as shown in Technique 12. If you are picky about the quality of your images, you should now print an image to make any decisions about whether the image was enlarged or sharpened too much. While making decisions about how a print will look by looking at a monitor is easy, looking at a print will make the best decisions.

Next time you need to increase the size of an image, remember: It *depends*, experiment, and don't judge the effects of up-sampling or sharpening by looking at your monitor if you are printing the image — print it — then judge the results.

USING AN ICC PROFILE WHEN PRINTING WITH AN EPSON 880/1280 PRINTER

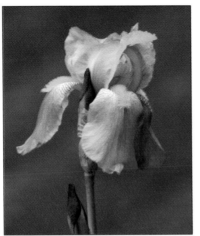

44.1

© 2002 Gregory Georges

44.2

© 2002 Gregory Georges

For me — to a very great extent — photography is the print! No matter what subject I shoot, what kind of camera I use, what image editor or plug-in I use, or what fancy editing techniques I apply, if the print is no good — neither is the rest of the process I used to create it. Consequently, the printer is a very important part of photography for me, and probably for you, too. For this reason, I will be bold and speak my opinion. At the time this book went to press, the Epson Stylus Photo 880/1280 printers were arguably the best photographic printers on the market that cost less than a $1,000. These printers were the best in terms of image quality and print longevity when used with the correct inks and media.

My expectations are, that by the time you read this book, the just-announced Epson Stylus Photo 2200P pigmented inkjet printer will be even better — but different and so you may still want a 880/1280 printer — or maybe one of each! To get the best results from these printers or other photographic printers, you need to have an ICC color profile for a specific ink and media combination. Epson recently introduced their most highly touted media — new ColorLife photo quality paper. They have also used some of the finest color profiling tools available to create an ICC profile for the inks and the ColorLife paper. In this technique, you find out how to print by using the ColorLife ICC profile and the ColorLife paper to make excellent prints.

STEP 1: DOWNLOAD AND INSTALL COLORLIFE PHOTO PAPER COLOR PROFILE

■ If the Epson **1280 ColorLife 2880 2** color profile is not already installed on your computer, you can get the profile and download instructions for various operating systems on the Epson Web site. To find out if the correct profile has been installed, choose **File ➢ Print with Preview** to get the **Print with Preview** box shown in **Figure 44.2**.
If there is not a check mark in the box next to **Show More Options**, click in the box to display more options.
Click in the **Options Type** box to select **Color Management** if it is not already selected.
Click in the **Profile** box in the **Print Space** area to get a pop-up menu such as the one shown in **Figure 44.3**. Scroll up or down as needed to determine if a profile is named **Epson 1280 ColorLife 2880 2**. If you find it, click it to select it and then click **Done**. If you do not have the correct profile, click **Done** and then carefully select and download the most recent ColorLife Photo Paper profile for your printer and operating system from the Epson Web page on the downloads and support page. Or, you may type in the following Web address to get to the page, too. `support.epson.com/hardware/printer/inkjet/pho890/index.html`. After downloading the files, follow the directions contained in the download files and in the installation program to install the profile and repeat this step to select the profile.

STEP 2: OPEN FILE TO PRINT

■ Choose **File ➢ Open** (**Ctrl+O**) to display the **Open** dialog box. Double-click the **/44** folder to open it and then click the **iris.tif** file to select it. Click **Open** to open the file.

STEP 3: SIZE IMAGE

■ Choose **Image ➢ Image Size** to get the **Image Size** dialog box, as shown in **Figure 44.4**. Click in the box next to **Constrain Proportions** if a check mark is not already there. Type **240** in the **Resolution** box. **240DPI** is a good minimum DPI setting to use for the Epson 880/1280 printers. Type **10** in the **Height** box and the **Pixel Dimensions** at the top of the image now shows that the image is **11MB** and that it was **11.6MB**. This adjustment is good, for we down-sampled the image slightly to make an excellent 6.688" x 10" print. If you want a full 8" x 10" print, you first have to crop the image and then increase the image size to make the width be 8". Click **OK** to size the image.

STEP 4: SET CORRECT PRINTER SETTINGS

At this point, you have merely set the Print Preview option to the correct color profile. However, if you don't set Photoshop to print with that profile, you won't get the intended results.

44·3

■ Choose **File ➤ Print** (**Alt+Ctrl+P**) to get the
Print dialog box. Make sure that the **Name** box
shows the correct printer, **Epson Stylus Photo
1280** (or 880). Click **Properties** to get the **Epson
Stylus Photo 1280** (880) **Properties** dialog box
shown in **Figure 44.5**.

Click in the **Media** type and select **Photo Quality
Glossy Film!** If you are thinking why this media
when we are using ColorLife media? Well, because
the instruction created by Epson that came with
the profile said to use that profile and it works!
The engineers that created the profile may not
have had the ColorLife media type when they cre-
ated the ColorLife profile — anyway it works well
so I suggest that you use it.

Now click **Custom** in the **Mode** area and then
click the **Advanced** box to get the **Advanced** dia-
log box shown in **Figure 44.6**. The next step is
very important. Click **No Color Adjustment** in
the **Color Management** area. This turns off the
Photoshop 7 color management feature and
specified that the print is to be made with the
ColorLife profile that we selected in the **Print
with Preview** dialog box in Step 1.

44.5

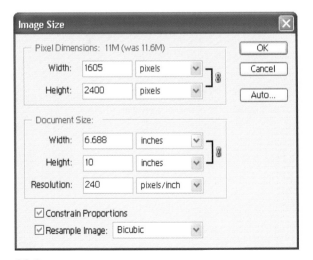

44.4

44.6

Clicking in the **Print Quality** box, you get a pop-up menu that gives you three choices: **Photo – 720dpi, Photo – 1440 dpi,** or **Super Photo 2880 dpi**; click **Super Photo 2880 dpi** to get the best possible print. Printing an 8" x 10" print with this setting takes a long time! To get nearly equal results, select the **Photo –1440 dpi** setting.

Click **OK** to return to the **Epson Stylus Photo 1280 Properties** dialog box. To get a preview of the print, click in the box next to **Print Preview** if a check mark is not already there. I always make sure to check this option, for it can save a piece of paper and some ink if you have settings that aren't what you want them to be.

Click the **Paper** tab if you want to print the image in the center of the page. Click in the box next to **Centered** in the **Printable Area** and the image centers on the paper.

Click **OK** to return to the **Print** dialog box.

Click **Print** to get the **Print Preview** dialog box, as shown in **Figure 47.7**. Do not judge the color of the print by the color of the image in the preview box. Why the colors are always wrong is a mystery to many of us. Just use the preview box to see that the image is approximately the size you want it and that it is placed on the page as you want it.

Click **Print** to begin printing the image.

The steps used in this technique to make a print using an ICC profile apply to most of the Epson printers and to most of their papers. Sadly, not all of the profiles that you can download from the Epson Web site are as accurate as the one for the ColorLife media. To get better profiles, you can make them yourself (this can take lots of time, maybe too much, and considerable money for the necessary tools) or you can buy profiles.

Getting the best results from Epson 880/1280 printers or any photographic quality inkjet printers can be challenging. If you are not getting the results you want, then consult one or more of the following resources:

Mitch Leben's Epson Printer e-mail group, which has hundreds of experienced Epson printer users who are willing to answer questions and offer tips. You can subscribe by visiting `www.leben.com/lists/epson-inkjet`.

Alan Womack's FAQ (Frequently Asked Questions) Web page, which is based upon postings made to the Epson Printer e-mail group mentioned previously. You find the FAQ Web page at `home.att.net/~arwomack01`.

Ian Lyon's Computer Darkroom offers lots of useful information for digital photographers including a tutorial on using ICC profiles that has links to an Epson Australia Web site where more Epson media profiles may be downloaded. You find this site at `www.computer-darkroom.com`.

Mastering Digital Printing: Photographer's and Artist's Guide to Digital Output, by Harald Johnson.

44.7

GETTING FUJI FRONTIER PRINTS MADE

45.1 © 2002 Mark McIntyre

45.2 © 2002 Mark McIntyre

ABOUT THE IMAGE

Driving Through the Lane and on to #1 Canon EOS 1D digital camera, 200mm f/2.8 (260mm effective focal distance), ISO 200, Fine image setting, f/5.6 @ 1/500, 1648 x 2364 pixels, 2.0MB .jpg

If you like to get your photos processed at a nearby one-hour photo lab and you now want quick turn-around on inexpensive prints made from images that you have on a CD-ROM or other digital image storage media, you should look for a nearby photo lab that has one of the Fuji Frontier printers. An increasing number of one-hour labs and independent film labs are using these printers, which are high capacity machines that can produce prints from conventional films, digital still cameras, and computer manipulated images. Fuji Frontier printers may be found at some drug stores that process film, discount stores, such as Costco, some of the Wolf camera stores, and so on. Taking the time to find one nearby can be worthwhile as prints made from a Fuji Frontier printer are generally excellent value. Typical prices at discount stores are: 4" x 6" $0.40, 5" x 7" $2.50, 8" x 10" $5.00, and 10" x 15" $13.00.

The objective of this example is to make an 8" x 10" print of the excellent NCAA basketball photo that was taken by Mark McIntyre during a game between NC State and the soon-to-be 2002 NCAA basketball champions — Maryland.

STEP 1: OPEN FILE

■ Choose **File ➢ Open** (**Ctrl+O**) to display the **Open** dialog box. Double-click the **/45** folder to open it and then click **basketball-before.jpg** to select it. Click **Open** to open the file.

STEP 2: CROP AND SIZE IMAGE

Fuji Frontier printers automatically crop images to fit within standard photo sizes. If you want to make a print that does not have the same width to height proportions as one of the standard size prints, you must add more canvas by using the Photoshop 7 Image ➢ Canvas Size command. However, before using the Canvas Size command, set the background color to any color other than white so that when you add more canvas it will have some color to it — then when the print is made, cut the color background off.

■ To crop the image to the proportions of an 8" x 10" print, click the **Crop** tool (**C**) in the **Tools** palette. Type **8 in** in the **Width** box, **10 in** in the **Height** box, and delete any values in the **Resolution** box in the **Options** bar.

■ Choose **View ➢ Fit on Screen** (**Ctrl+0**) and click the maximize icon in the upper-right corner of the image window if the document window is not already maximized. Click just outside the bottom-right corner of the image and drag the **Crop** marquee up and to the left to include as much of

the image as possible. Click the check mark in the **Options** bar or press **Enter** to crop the image.

■ The image is now **1648 x 2060** pixels, which is **205 DPI** for an 8" x 10" print. To view this information choose **Image ➢ Image Size** to get the **Image Size** dialog box. Click **Cancel** to close the dialog box.

When getting prints made with a Fuji Frontier printer, you generally get a better print if you do not up-sample the image — just crop it and let the Fuji Frontier size it.

STEP 3: SHARPEN IMAGE

■ The image can now be sharpened. As selecting **Unsharp Mask** settings when viewing an image at **100%** is best, choose **View ➢ Actual Pixels** (**Ctrl+0**). Choose **Filter ➢ Sharpen ➢ Unsharp Mask** to get the **Unsharp Mask** dialog box shown in **Figure 45.3**. Try setting **Amount** to **175%**, **Radius** to **1.0**, and **Threshold** to **1**. Click **OK** to sharpen the image.

STEP 4: SAVE FILE AND WRITE TO CD-ROM

Fuji Frontier printers only accept JPEG files, so make sure you save your file as a JPEG.

■ You can now save your file by choosing **File ➢ Save As** (**Ctrl+Shift+S**) to get the **File Save** dialog box. After selecting an appropriate folder,

MARK MCINTYRE
Mark McIntyre has been shooting sports photos since the late 1970s. He has shot basketball, baseball, bowling, field hockey, football, fencing, golf, lacrosse,

rugby, track and field, soccer — and the Olympics. Over the years, he has been the official photographer for Penn State, Temple, NC State, and Wake Forest's basketball teams, and his photos have been

type a name in the **File Name** box so you don't save it to the original file. Click in the **Format** box and select **JPEG** if it is not already selected. Click **OK** to get the **JPEG Options** dialog box, as shown in **Figure 45.4**. Type **12** in the **Quality** box or slide the slider all the way to the right to get to **12**. Using this setting, you will get the highest quality .jpg file that is possible. Click **OK** to save the file.

Your file is now ready to be written to a CD-ROM or other removable storage media and to be taken to a local photo lab where there is a Fuji Frontier printer. You may save yourself some time by calling the photo lab before visiting to learn more about what storage media is acceptable to the lab, available print sizes, turn-around time, and additional ordering information.

45.3

45.4

printed in many newspapers and most of the major sports magazines, including *Sports Illustrated*. The inset photo shows Mark shooting an ACC game from the best place on the court using two hand-held cameras and customized remote controls for two other stationary cameras, which allows him to get great photos of key plays anywhere on the court. Mark McIntyre may be contacted by telephone at: (336) 545-4450.

USING SHUTTERFLY'S ONLINE PRINTING SERVICE

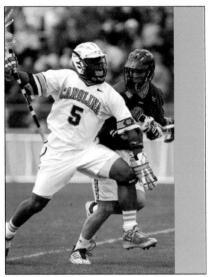

46.1

© 2002 Gregory Georges

46.2

© 2002 Gregory Georges

ABOUT THE IMAGE

UNC's Tim Gosier Playing Against Virginia Canon EOS 1D digital camera, 300mm f/2.8 IS with 1.4 tele-extender (546mm effective focal length), ISO 200, Fine image quality setting, f/4.0 @ 1/800, image has been edited and resized, 1920 x 2400 pixels, 3.0MB .jpg

I n this technique, you find out how to order Fuji Frontier prints online by using Shutterfly's online photo-finishing service. Shutterfly was selected as the service to use for this technique for three important reasons. First, the user-interface of the Shutterfly SmartUpload application is excellent — it allows you to get your work done quickly. Second, Shutterfly uses Fuji Frontier printers, which are some of the best high-volume printers on the market today. Finally, Shutterfly has an option that allows you to turn off all their *intelligent processing* features so that your prints may be printed as you intended to have them printed — rather than being further manipulated for color, contrast, and image sharpness.

Shutterfly's online service is excellent for getting *one-hour*-style prints made from your digital camera. Those that do event photography, such as sports photographers, can also use it. While I offer strong praise for the Shutterfly service and for Fuji Frontier printers, please be aware that this is a low-cost high-volume service. Do not expect to get the same results that you will get with premium photo-printing services, such as those offered by Calypso, Inc., which you will read about in the next technique.

Shutterfly uses state-of-the-art Fuji Frontier digital printers designed for professional photofinishers. These printers expose Fuji's Crystal Archive photographic paper by using red, green, and blue lasers to produce the sharpest prints available. The exposed photographic paper is chemically processed in the same way as in traditional photo labs.

At the time this book went to press, the cost for printing photos at Shutterfly was: $0.49 for a 4" x 6", $0.99 for a 5" x 7", and $3.99 for an 8" x 10". Besides offering online photo printing services, Shutterfly also offers a large assortment of photo objects and additional photography services including their innovative Snapbook. To learn more about Shutterfly and their offering, visit `www.shutterfly.com`.

Anyone with an Internet connection can use the Shutterfly online services; however, having a fast Internet connection, such as a DSL line or cable modem enables you to upload your images much faster than slower Internet services. If you have a slow connection, you may want to consider lowering the quality setting when saving your files as JPEG files.

STEP 1: COLLECT THE IMAGES YOU WANT TO PRINT IN A FOLDER

Technique 45 discussed how to prepare your images to be printed on a Fuji Frontier printer. Follow these same steps when preparing images to be uploaded to the Shutterfly service, which this technique covers. After you edit your images, collect all of the images that you want to print in a folder or folders specifically for uploading to Shutterfly so that the uploading process can be easy. As you have an option to print the file name on the back of each photo, you may want to consider renaming the files with names, places, dates, or other identifying text. For this technique, we use a lacrosse photo that has had extra canvas added to keep the print from being cropped.

STEP 2: DOWNLOAD AND INSTALL SHUTTERFLY'S SMARTUPLOAD APPLICATION

You have several ways to upload images to Shutterfly. If you plan on using the service often, I recommend that you use the Shutterfly SmartUpload application because it makes the upload and ordering process easy.

■ To download the **Shutterfly SmartUpload** application, you must first sign up for the service. There is no charge to sign up on the Shutterfly Web site at `www.shutterfly.com`. If you have already signed up, click **Members sign in**. After you sign in, click **Add Pictures** and then click **SmartUpload software** to get a Web page where you can select your operating system; then click **Download** to download the **SmartUpload** application.

■ After the install file has been downloaded, click it to install **SmartUpload**.

STEP 3: RUN SMARTUPLOAD

■ After launching **SmartUpload**, locate the folder that contains the images that you want to print in the *Explorer-like* window on the left side of the application window. The SmartUpload application

46.3

window looks similar to the one shown in **Figure 46.3**.

■ Click the lacrosse photo to highlight it and to select it to be uploaded.

■ Click the **Upload** button or choose **Upload ➢ Upload to Shutterfly** (**Ctrl+U**) to get a sign-in dialog box.

■ If you have not previously signed up for the service, click the **Sign Up!** button and answer the questions. Otherwise, click **Sign In** to get the **Choose Album**. You are then given the choice of creating a new album or using an existing album. To make a new **Album**, type in the name of the album in the **New Album** box and click **Upload**. You then get an **Upload** progress dialog box that shows how many pictures that you have selected to upload and an estimate of how long it will take to upload your pictures.

■ After your images have uploaded, a dialog box appears asking if you want to view your pictures at Shutterfly; click **Yes** to view your images on a Web page similar to the one shown in **Figure 46.4**.

Shutterfly has created and uses a proprietary image processing system called VividPics. VividPics reads the metadata (embedded information/EXIF data) in an image file to see if it can identify what kind of

digital camera was used and what settings were used so that Shutterfly printers can make the prints with the best sharpness, clarity, and consistency of color. If you upload unedited photos straight from a digital camera, VividPics can read this metadata and use it to make better photos than you would get from a system that does not have a similar kind of feature. However, if you have spent time editing your images with an image editor such as Photoshop 7 and then you save the file — not only will you loose the metadata, but you probably do not want the VividPics feature to make more corrections to your already corrected images. In this case, you should turn the VividPics feature off.

■ To turn off **VividPics**, you first must select the photo or photos that you do not want VividPics to further enhance. To do so, click the box below the lacrosse photo. Then, click the **Enhance** button at the top of the Web page. Toward the right side of the new Web page, you find four tabs; click **Effects**. Scroll all the way down to the bottom of the page and you see a box next to **Do not apply any automatic corrections to my pictures**, as shown in **Figure 46.5**. Click in the box to turn off VividPics.

■ To specify order details, scroll back to the top of the Web page and click **Order Prints**. Click the

46.4

46.5

46.6

Order Prints button on the right side of the Web page to get a Web page similar to the one shown in **Figure 46.6**. Here you can indicate how many prints you want made in each of the four available sizes for each image. You can even see how the image will be cropped when selecting different sizes by clicking **Preview**.

■ After specifying the quantity of each size you want to print, continue with the ordering process by clicking the **Select Recipients** button to specify the address where the photos are to be sent. After selecting a mailing address, continue on to **Checkout** to complete your order.

Ordering dozens or even hundreds of photos is just as easy as ordering a single photo, as shown in this example, which makes the Shutterfly service a good choice for event photographers.

GETTING LIGHTJET 5000 PRINTS FROM CALYPSO INC.

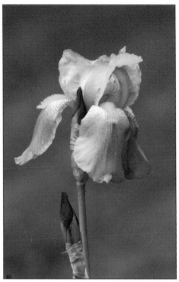

47.1

© 2002 Gregory Georges

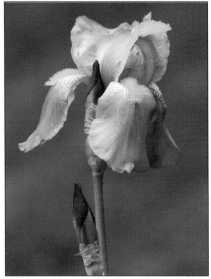

47.2

© 2002 Gregory Georges

ABOUT THE IMAGE

Purple & Yellow Iris on Green Canon EOS 1D digital camera on tripod, 300mm f/2.8 IS with 25mm extension tube, ISO 200, RAW image quality setting, f/8.0 @ 1/25, 1648 x 2464 pixels, slightly edited and converted to 8-bits per channel, 12.2MB .tif

I f you want the ultimate print made from one of your image files — then you want a Lightjet 5000 print made on Fuji Crystal Archive photographic paper. These continuous tone photographs are known for their rich blacks, print permanence, and excellent color range. Such prints are the preferred prints of many artists and professional photographers all over the world.

While there are over 400 sites worldwide that have Lightjet printers, only some of those sites keep their printers properly color-managed so that you get consistent prints that match the images on your monitor. Calypso Inc. (www.calypsoinc.com), in Santa Clara, California, is one company that I recommend due to the efforts they take to provide you with color-managed prints. Their focus is on nature, landscape, wild life, fine art, and travel markets and they have a list of customers that includes many of the finest photographers in the world.

To get prints made at Calypso, you can either upload image files to their FTP site or you can write the image files to a CD-ROM and send them via

mail or a courier service. Calypso also offers two different pricing plans. The *preferred* pricing plan is for images that have been prepped, color-managed, and profiled directly to the Calypso Lightjet 5000. In this case you take all the responsibility for color management. Or, you can pay more and have them do some of the work for you and they will be responsible for color-management. Please visit the Calypso Web site and read Calypso's Guide to Color Management on the Lightjet 5000.

This technique covers the steps you need to take, to enjoy the *preferred* pricing plan. In this technique, you take a Canon EOS D30 digital camera photo of an iris and follow steps to size the image and sharpen it so that it can be used to make an 11" x 14" Lightjet 5000 glossy print at Calypso, Inc.

STEP 1: DOWNLOAD CALYPSO'S LIGHTJET 5000 ICC COLOR PROFILE

In order to get a print from Calypso that matches the image on your screen, you *must* have a properly calibrated monitor and the color of your image file *must* be converted to the appropriate ICC color profile for the media you want. To learn more about how to calibrate your monitor using Adobe Gamma, read Technique 5.

■ To get Calypso's Lightjet 5000 ICC color profile, go to `www.calypsoinc.com`. In the left frame, click **Colorsync Profiles**. In the frame on the right, you find both **PC** and **Mac** profiles. Click the appropriate profile to begin downloading a ZIP file containing three color profiles; one for gloss, matte, and super-gloss paper. Additional files may be added when new media becomes available

and on occasion, new profiles are substituted for those listed here.

■ After the files have been unzipped, they need to be copied to the appropriate directory for your operating system. If you are using Windows XP, use Windows Explorer to locate and open the folder where the unzipped files were saved. Press **Ctrl** while clicking each of the three files to select them all. Right-click on one of the files to get a pop-up menu; choose **Install Profiles**. Windows XP automatically installs the color profiles for you. If you are running another operating system, the color profiles need to be copied into the appropriate folder. For Windows 95, 98, and ME, use the `Windows\System\Color` folder, for Windows NT 4.0 and 2000 use the `Windows\System32\Color` folder, for Windows XP use the `C:\windows\system32\spool\drivers\color` folder, for Mac OS 8-9 use the `System Folder: Color Sync Profiles (ColorSync 2.5)` folder, and for Mac OS X use the `Home/Library/ColorSync/Profiles` folder.

STEP 2: OPEN FILE TO BE PRINTED

■ Choose **File ➢ Open** (**Ctrl+O**) to display the **Open** dialog box. Double-click the **/47** folder to open it and then click **iris.tif** to select it. Click **Open** to open the file.

To order prints from Calypso, the file must be either a Photoshop `.psd` file or a `.tif` file and starting with an Adobe RGB 1988 profile is best if you have a

choice. As the `iris.tif` file is already tagged as Adobe RGB 1988 and it is a `.tif` file, the file is ready for the next step.

STEP 3: CROP AND SIZE IMAGE

■ To crop the image to the proportions of an 11" x 14" print, click the **Crop** tool (**C**) in the **Tools** palette. Type **11 in** in the **Width** box, **14 in** in the **Height** box, and **150** in the **Resolution** box in the **Options** bar.

Entering 150 in the Resolution box resizes the image to the Lightjet 5000's minimum recommended dpi setting and after the Crop command is applied, the image is up-sampled as well as cropped.

■ Choose **View** ➢ **Fit on Screen** (**Ctrl+0**) and click the maximize icon in the upper-right corner or the image window if the document window is not already maximized. Click just outside the bottom-right corner of the image and drag the **Crop** marquee up and to the left to include as much of the image as possible.

■ To move the **Crop** marquee up to include more space above the iris, press the **up-arrow** to move up one pixel at a time or press **Shift** and the **up-arrow** to move the selection marquee up **10 pixels** at a time.

■ After you select the part of the image that you want, click the check mark in the **Options** bar or press **Enter** to crop the image *and* to resize it as well.

■ The image should now be **1650 x 2100** pixels, which is **150 DPI** for an 11" x 14" print. To view this information, choose **Image** ➢ **Image Size** to get the **Image Size** dialog box. Click **Cancel** to close the dialog box.

STEP 4: SHARPEN IMAGE

■ As the image is now sized for the intended output size, you can now sharpen it. As it is best to select **Unsharp Mask** settings when viewing an image at **100%**, choose **View** ➢ **Actual Pixels** (**Alt+Ctrl+0**). Choose **Filter** ➢ **Sharpen** ➢ **Unsharp Mask** to get the **Unsharp Mask** dialog box shown in **Figure 47.3**. Try setting **Amount** to **250%**, **Radius** to **.3**, and **Threshold** to **0**. Click **OK** to sharpen the image.

47.3

STEP 5: CONVERT PROFILE TO CALYPSO LIGHTJET 5000 COLOR PROFILE

■ To convert color to the Calypso Lightjet 5000 color profile that was downloaded in Step 1, choose **Image ➢ Mode ➢ Convert to Profile** to get the **Convert to Profile** dialog box shown in **Figure 47.4**. Click in the **Profile** box to get a pop-up menu. You find three profiles named starting with "**CILJ5**"; these are the three Calypso Lightjet files. Select **CILJ5FujiCDGloss_3_27_01** to select the glossy media profile.
Make sure **Engine** is set to **Adobe (ACE)** and that **Intent** is set to **Perceptual. Use Black Point Compensation** and **Use Dither** should both be switched off.

■ Click **OK** to convert the profile.

STEP 6: SAVE FILE AND SEND OR UPLOAD TO CALYPSO

■ You can now save your file by choosing **File ➢ Save As** (**Ctrl+Shift+S**) to get the **File Save** dialog box. After selecting an appropriate folder, type a name in the **File Name** box so that you don't save it over the original file. Make sure that the **ICC Profile** box is checked in the **Color** area — it should show the **CILJ5FujiCDGloss_3_27_01** profile that you selected earlier. Also make sure you are not saving layers. Click **OK** to save the file.

Your file is now ready to be written to a CD-ROM or other removable storage media and be sent to Calypso or be uploaded to the Calypso FTP Web site. Please visit the Calypso Web site to learn more about what storage media is acceptable to Calypso, about getting an FTP site set up for your image files, and additional ordering information. Also, feel free to e-mail Michael Chambers at Calypso to ask questions and to request that an FTP account be set up for your use. His e-mail is m_chambers@calypso inc.com.

To get more recommendations and tips on how to get Lightjet 5000 prints, visit the book's Companion Web page at www.reallyusefulpage.com\ 50ps7.

47.4

CHAPTER **9**

CREATING AN
ONLINE GALLERY

I f you edit digital images and you want to share your work on the Internet, then this chapter has three useful techniques that you ought to find to be both valuable and fun. The first technique shows you how you can create a Web photo gallery using the Photoshop 7's Web Photo Gallery feature. The next technique shows you how to create an animation by using digital photos. Such animations can be used on Web pages or for other digital presentations on a computer or shared on a CD-ROM. Finally, the chapter and the book finishes by showing you how to create an image map. If you don't now what an image map is or how it can be used — you surely must read this technique. The image map helps you create viewer-friendly navigation between Web pages and it can be used to creatively display your photography.

b&w

birds

digital art

sports

wildlife

FORD F-100

autos

landscapes

animations

CREATING AN ONLINE GALLERY

48.1

© 2002 Gregory Georges

48.2

© 2002 Gregory Georges

One significant benefit of using digital photos is that they can easily be shared online. As more and more people have regular access to the Internet, displaying your photographs online makes them available to a large worldwide audience. Photoshop 7 makes it remarkably easy to create an online photo gallery — most of the repetitive and tedious tasks are all automated when you use the Web Photo Gallery feature. Although Web page designs are limited to 11 pre-formatted styles, the use of any HTML editor, such as Dreamweaver or HomeSite by Macromedia, or FrontPage by Microsoft makes it possible for you to modify the style sheets or the completed HTML pages to meet your own requirements.

In this technique, you use Web Photo Gallery to create an online gallery for the set of 12 black and white raptor photos shown in **Figure 48.1**. If you have ever created a gallery such as this one manually, you'll love this feature as it automatically resizes and optimizes each image, creates thumbnails, and creates HTML code that even includes a title and caption for each photo found in image files, plus all the necessary links to make the gallery complete.

STEP 1: VIEW COMPLETED GALLERY

Before you start creating the Web gallery, you may want to take a quick look at the completed gallery so that you can understand more about the many options that are available when using the Photoshop 7 Web Photo Gallery Feature.

■ Assuming that you copied the contents of the Companion CD-ROM to your hard drive as recommended in the Introduction, you find the Web gallery in the **\48\gallery** folder. Using Windows Explorer, double-click the **\48\gallery** to open it, and then double-click the file **index.htm** to view the completed Web gallery. The gallery should now be viewable in your default Web browser, as shown in **Figure 48.3**.

The Photoshop 7 Web Photo Gallery style that was used includes a frame (the independently scrolling box with thumbnails at the bottom of the browser) and it displays textual information found in each image file, such as title, caption, credits, and so forth. The style also displays a clickable e-mail address, which automatically launches the default e-mail client. As you go through this technique, you discover how these user-definable items were automatically placed on the Web page.

Before you run Web Photo Gallery, you must first collect all the images that you want to use and put them in a separate folder. If you want to display textual information about each image, such as title, caption, or even a purchase price, you need to add this information to each image file before running Web Photo Gallery. To read more about how this is done and how to automate the entry of this kind of information, read Technique 13. Technique 3 is another useful technique to use if you want to quickly size, optimize, frame, or add text to each photo.

One other useful technique to use when creating Web photo galleries is Technique 7. This technique includes a Photoshop 7 action that automates the entire process of correcting and enhancing a digital photo for use on a Web page. This action can be modified to meet your specific requirements and it can even include the image sizing and framing action found in Technique 3.

Alternatively, if you don't need or want to enhance your images and display textual information about them, you can use the features in Web Photo Gallery to automatically resize your photos when the Web pages are created as shown in this technique.

48.3

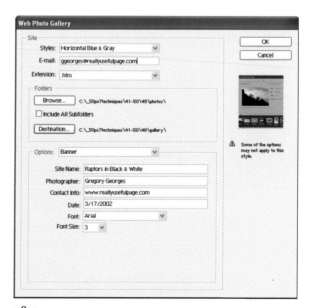

48.4

STEP 2: RUN WEB PHOTO GALLERY

- Choose **File** ➢ **Automate** ➢ **Web Photo Gallery** to get the dialog box shown in **Figure 48.4**.
- Click in the **Styles** box to get a pop-up menu listing 11 different Web page styles. If you click any one of these styles, a small thumbnail image displays on the right side of the dialog box. This thumbnail shows how the completed Web page looks. So that textual information from the image files can be displayed, choose **Horizontal Blue & Gray** after clicking in the **Styles** dialog box.
- If you want to display a clickable e-mail address, click in the **E-mail** box and type an e-mail address. This address shows in the upper-left-hand corner of the Web page.

In the **Folders** area in the **Web Photo Gallery** dialog box, you specify the folder where to store your original images and a folder where you want to place all the gallery images, thumbnails, and HTML pages.

- Assuming that you copied the files from the Companion CD-ROM as recommended in the

Introduction, click the **Browse** button to get the **Browse For Folder** dialog box shown in **Figure 48.5**. Click in the **\48\photos** folder and click **OK**. You have now set the source folder.
- To set the folder where to save the images, thumbnails, and HTML files, click the **Destination** button to get the **Browse For Folder** dialog box. After finding and clicking the **\48** folder, click the **\gallery folder**. Click **OK** to set the folder as the destination folder.

STEP 3: SELECT OPTIONS

- Click in the **Options** box to get a pop-up menu listing the five different sets of user selectable options. Click **Banner** to get the banner options shown in **Figure 48.6.**
- The text in the **Site Name** field becomes the title of the Web page. For this Web page, type **Raptors in Black & White**. If you want, you can type in the photographer's name and contact information; these fields can also be automatically placed on the Web pages when using *some* of the styles, but not all of them. The current date is automatically entered. Besides changing the date, you can also change the font and the font size.

48.5

48.6

■ Click in the **Options** box in the **Web Photo Gallery** dialog box to get a pop-up menu; click **Large Images** to get the image options shown in **Figure 48.7**. Large images are the images displayed in the center of the Web page. If your images are already properly sized and optimized for a Web page, you can click in the box next to **Resize Images** to turn that feature off. However, it is a good idea to leave resizing on with the proper values set as it will ensure that all the images are the correct size. As the raptor images we are using are larger than we want, make sure a check mark is in the box next to **Resize Images**. Click in the box next to **Resize Images** and select **Small**. Assuming the **Constrain** box is set to **Both**, all of the images will resize so that the longest side is **250** pixels.

■ Set **JPEG Quality** to **Medium**.

■ If you want to place a border around each image, set **Border Size** to the desired border size in pixels.

■ Place a check mark in all of the boxes to the right of **Titles Use**. This turns on all those fields so that they are automatically placed on the Web pages when they are created. This information is taken from each image file. If an image file does

not have the needed information, you can enter it (or change it) by opening a file, choose **File ➤ File Info**, and then type in the relevant information. You can learn more about this capability in Technique 13.

■ Click in the **Options** box in the **Web Photo Gallery** dialog box to get a pop-up menu; click **Thumbnails** to get the thumbnail image options shown in **Figure 48.8**. These options are similar to those in the **Large Images** section, except they give you control over how the thumbnail images are displayed. Set **Size** to **Small** and click **Filename** in the **Titles Use** area. This causes the file name to be placed under each of the thumbnail images.

■ Click in the **Options** box to get a pop-up menu; click **Custom Colors** to get the custom color options shown in **Figure 48.9**. These options allow you to pick your own colors for background, banner, text, and links. This particular style does not use these options, so no changes are needed.

■ Click in the **Options** box in the **Web Photo Gallery** dialog box to get a pop-up menu; click **Security** to get the security options shown in **Figure 48.10**. To protect each of the images with

48.7

48.8

copyright text, click in the **Content** box and select **Custom Text**.

■ Click in the **Custom Text** box and press **Alt+0169** to insert the copyright symbol and then type the year and a name. Leave **Font** set to **Arial** and **Font Size** set to **10 pt**. Click in the **Color** box and choose **White** to select white text, which contrasts with the mostly black, black and white raptor photos. Click in the **Position** box and select **Bottom Left**.

■ Click **OK** to begin creating the photo gallery. As the Web pages are being created, you see all the images that are loaded, edited, and closed, showing you the incredibly tedious and time-consuming task it has saved you from! Once the Web page has been completed, the new home Web page should be loaded and displayed in your default Web browser. It should look similar to the one shown in **Figure 48.2**.

STEP 4: CUSTOMIZING THE WEB GALLERY

The Photoshop 7 Web Photo Gallery feature has done a tremendous amount of work for you, but you may not want your gallery to look like it was created with a standard Photoshop 7 style template. Or, you may not like the colors, or the location of the large image, or one of a vast number of other possible details — and that is okay.

You have three ways to customize Web pages created by the Web Photo Gallery feature. You can either use an HTML editor to edit each of the HTML pages so that they are exactly as you want, or you can copy the Photoshop 7 Web Photo Gallery style folder and rename it — then edit the style templates and run Web Photo Gallery. This approach lets you use your own customized template any time that you want with no additional HTML editing being required. Or, you can create your own HTML pages using an HTML editor, such as FrontPage or Dreamweaver and use all the thumbnails and images automatically created with Web Photo Gallery.

You can find out more about customizing Web Photo Gallery style sheets by reading the Photoshop 7 Help and the documentation that comes with Photoshop 7.

48.9

48.10

CREATING ANIMATIONS USING DIGITAL PHOTOS

49.1

49.2

ABOUT THE IMAGE

Seeing Through the Fall Colors Canon EOS D30 digital camera mounted on a tripod, 100mm f/2.8 macro with circular polarizer, ISO 100, Fine image setting, 1/8 @ f/2.8, images have been edited and resized to be 214 x 320 pixel .jpegs (41Kb and 49Kbs)

Figure 49.1 shows two photos that were taken with a Canon EOS D30 digital camera and a circular polarizer on a 100mm lens. The photo on the left shows the results of rotating the circular polarizer so that all reflections were removed from the surface of the water. Without the surface reflections, it was possible to see all the way to the bottom of the stream. The second photo shows the results of rotating the circular polarizer so that the reflections were maximized.

The goal of this technique is to create an animation for a Web page that shows what it looks like when the circular polarizer is rotated. To accomplish this seemingly difficult objective, the images will be combined into one image as separate layers; then Opacity will be varied on the top layer and the animation will be created by using the Tween feature in ImageReady.

49·3

49·4

STEP 1: OPEN FILES AND COMBINE THEM INTO ONE FILE

Completing this technique is possible by using only ImageReady, the Adobe Photoshop 7 companion *Web image tool*. However, as its tight integration with Photoshop 7 offers so many benefits to those with computers that have sufficient resources to run both applications simultaneously, we use both applications. If your PC struggles to load and run both applications, close Photoshop 7 and just run and use ImageReady 7. ImageReady uses substantially the same menu commands and shortcuts as Photoshop.

■ Choose **File** ➤ **Open** (**Ctrl+O**) to display the **Open** dialog box. Double-click the **/49** folder to open it. Press **Ctrl** while clicking the **water1-before.jpg** and **water2-before.jpg** files to select them both; click **Open** to open both files in Photoshop 7.

■ To create a layer containing the **water1-before.jpg** image in the **water2-before.jpg** image, click the **water1-before** image to make it the active image. Click the **Move** tool (**V**) in the **Tools** palette. Press **Shift** while clicking in the **water1-before** image and drag the cursor onto the **water2-before** image. When you release the mouse button, the **water2-before** image now has a second layer and it is the **water1-before** image. The **Layers** palette should now look like the one shown in **Figure 49.3**.

Alternatively, you can click the **water1-before. jpg** image to make it the active image and then press Shift while clicking the image's thumbnail in the Layers palette and dragging it onto the **water2-before.jpg** image. In both cases, pressing Shift forces the new image to locate precisely in the center of the image where it is dragged.

■ Click the **Close** button in the upper-right corner of the **water1-before** image to close it, as the image is no longer needed.

STEP 2: SEND IMAGE TO IMAGEREADY 7

■ The image is now ready to be edited with ImageReady 7. To open ImageReady (if it is not already open) while sending the two-layered version of the **water2-before** image, click the **Jump to Image Ready** button (**Ctrl**+**Shift**+**M**), which is at the bottom of the Photoshop 7 **Tools** palette, as shown in **Figure 49.4**.

■ You should now see the **water2-before** image in the ImageReady 7 workspace. As you are to use quite a few palettes, I suggest that you arrange the palettes in their default positions (if they are not already there) by choosing **Windows** ➢ **Workspace** ➢ **Reset Palette Locations**. The ImageReady workspace should now look similar to the one shown in **Figure 49.5**.

STEP 3: CREATE ANIMATION

To create an animation, you now need to carefully define the first and last image and apply the Tween command to automatically create all the transitional states in between — that is it — it is that simple! As we want the beginning of the image to look as if no polarizer was used (the image with the rich fall colors), we set it as the first image. Then we create a second image in the Animation palette and carefully set it to look like the image where the circular polarizer's full capability of removing reflective light has been used (the image showing the bottom of the shallow stream).

■ Click the **menu button** in the upper-right corner of the **Animation** palette to get a pop-up menu; click **New Frame** to create a second frame in the **Animation** palette, which should now look like the one shown in **Figure 49.6**. The second animation cell is now highlighted indicating that it is the active cell. The **Layers** palette now reflects the settings for the active cell, as does the **water2-before** image.

49.5

49.6

49.7

49.8

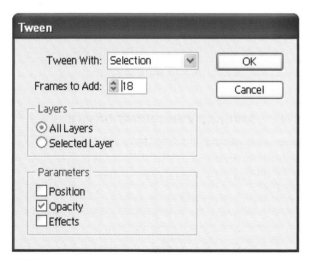

49.9

■ Click the **eye icon** to the left of the **Layer 1** layer in the **Layers** palette to hide that layer. The **Layers** palette should now look like the one shown in **Figure 49.7**. This now changes the look of the second cell in the **Animation** palette to look like the image where the bottom of the stream may be seen.

■ Press **Shift** and click cell **1** in the **Animation** palette to select both cells. Click the bottom of either cell to get a pop-up menu giving you options of setting the amount of time each cell is displayed; click **0.2** to set each cell to display two-tenths of a second.

■ With both cells still highlighted, click the **menu** button in the upper-right corner of the **Animation** palette to get the pop-up menu shown in **Figure 49.8**. Click **Tween** to get the **Tween** dialog box shown in **Figure 49.9**. This dialog box allows you to set the characteristics of the tween effect — the way the images are made *between* each cell.

■ Click in the **Frames to Add** box and type **18**, which results in a total of 20 cells — the starting and ending cells, plus 18 *tweened* cells. **All Layers** should be checked in the **Layers** area. In the **Parameters** area, only **Opacity** should be checked. Click **OK** to begin the tweening process.

■ The **Animation** palette should now look like the one shown in **Figure 49.10**. To see the entire animation, you have to use the scroll bar at the bottom of the **Animation** palette.

■ At the bottom-left corner of the **Animation** palette, there is a **Looping Option** setting box; click it to get a pop-up menu. Then click **Once** to have the animation play a single time without looping.

■ To view the **Animation**, click the **Play** button in the **Animation** palette — the button with a single triangle on it. You now see the 20-cell animation play in the **water2-before** image window. Pretty cool, don't you think?

■ Covering the details of Web images is way beyond the scope of this book, but you should be aware that ImageReady is doing some pretty

49.10

sophisticated manipulation of the images based upon defaults or your chosen settings. Take a quick look at the **Optimize** palette. Click in the **Settings** box to view the many options that are available. As animations must be GIF files and as we want the best quality of animation for our stream image animation, select **GIF 128 Dithered**. The **Optimize** palette should now look similar to the one shown in **Figure 49.11**.

■ To find out how large the image has become, look at the bottom of the water2-before.jpg document window. You see that the entire 20-cell GIF image is 556.3 Kbs. While that is small, for what is essentially a file of 20 images, the file is too large to download from a Web page and just fine to use as a CD-ROM–based image. To make it smaller, you can change GIF settings, make the image smaller, or tween with fewer than 20 cells.

49.11

Admittedly, this animation is very simple and we avoided looking at the many other features that allow you to further control how the animation displays. But, this example gives you a good idea of what can be done with animations. Well-thought-out animations can enhance Web pages, but they also can repeat too often, be too distracting, and ultimately lower user experience if you have not used them appropriately.

You may now want to consider other ways that you can use animations. How about having a moon float up toward the top and off a late evening photo as if it were rising in the sky? Or, you can create an animation where the sky gets darker and darker until it is almost totally black as it does each evening as the sun sets. Taking this concept to reality takes less than two minutes by using ImageReady 7. After creating the first and last cell, I reduced Lightness by using Hue/Saturation and then tweened 28 new cells to create the GIF image named `sunset-in-the-forest.gif` from the saturated image created in Technique 9. The file can be found in the \49 folder. View this image by dragging it onto an open Web browser. The image loops three times. What animation do you want to create?

STEP 4: SAVE AND VIEW ANIMATION FILE

■ To optimize and save the newly created animation, choose **File** ➢ **Save Optimized As** (**Ctrl+Shift+Alt+S**) to get the **Save Optimized** dialog box. After selecting a folder where you want to store the image (I suggest using the **\49** folder if you followed the recommendations made in the Introduction on copying images from the Companion CD-ROM), click **Save** to save the file.

■ To view the animation, open up a Web browser; then using Windows Explorer, find and then click and drag the **water2-before.gif** file onto the open Web browser, as shown in **Figure 49.2**. As soon as it displays, the animation begins to play. As we set the looping option to once, it plays once. To view it again, click the Web browser's **Refresh** or **Reload** button to play it again.

STEP 5: RETURN TO PHOTOSHOP 7

■ You can now close ImageReady, or you can click the **Jump** button at the bottom of ImageReady's **Tools** palette to return to Photoshop 7.

CREATING AN IMAGE MAP

50.1

50.2

ABOUT THE IMAGE

Photo Gallery Navigation Page 640 x 480 pixel .jpg 50KB .jpg file

No doubt about it — this is an exceedingly useful technique for anyone interested in creating an online photo gallery — even if you don't know what an image map is! If you want a simple Web site navigation page, then consider creating an image map with thumbnail-size versions of your photos. You won't need to create buttons, navigation bars, or need to have one of those text menu navigation bars like those that are created by so many Web page creation tools.

The navigation image shown in **Figure 50.1** was created by dragging and dropping thumbnail images onto a black background — it was then saved as an optimized JPEG that is small in size and can quickly download even when using a slow Internet connection. In this technique, you discover how to create a link to a Web page for each of the thumbnail photos that ought to be linked to another Web page. Adobe ImageReady 7 is all you need to complete the work.

50.3

50.4

STEP 1: OPEN FILE

- Launch ImageReady 7.
- Choose **File ➢ Open** (**Ctrl+O**) to display the **Open** dialog box. Double-click the **/50** folder to open it and then click the **link-graphic.jpg** file to select it. Click **Open** to open the file.
- To reset all of the ImageReady 7 palettes, choose **Window ➢ Workspace ➢ Reset Palette Locations**. The ImageReady 7 workspace now looks similar to the one shown in **Figure 50.3**.

STEP 2: CREATE SLICES

- Click the **Slice** tool (**K**) in the **ImageReady Tools** palette, which is shown in **Figure 50.4**.
- If the image is not zoomed to **100%**, choose **View ➢ Actual Size** (**Ctrl+Alt+0**); viewing the full-size image makes it easier to use the **Slice** tool.
- Using the **Slice** tool (K), click the upper-left corner of the black and white thumbnail image and drag the selection marquee box down and to the right until you surround the entire image, as shown in **Figure 50.5**. If your selection marquee is not

50.5

perfect, you can click one of the selection handles and drag the marquee to where it ought to be to make it perfect! You have now created your first slice and the image should now look like the one shown in **Figure 50.6**.

■ As you may have guessed, you now need to do the same thing to each of the other images that need to be linked. To make some of your later work easier, I suggest that you create slices for all the images in a sequential clockwise fashion. Do not be concerned that other slices are being created (meaning that the numbers for the slices increase faster than you select thumbnail images), as these *automatic* extra slices are necessary; but, you don't need to be concerned about them. You can tell the difference in what you created and what ImageReady created; user slices are indicted by solid lines, and the automatically created slices are indicated by dotted lines.

■ After you create all the slices for the thumbnails that need links, your image should look like the one shown in **Figure 50.7**.

STEP 3: CREATE LINK FOR EACH SLICE

Now that you created slices for all the thumbnails that need links to other Web pages, you need to type in the URL for each link. You have two easy ways to do this. You can either open the Rollovers palette (**Figure 50.8**) and then sequentially click each thumbnail to select a slice, or you can click the Slice tool in the Tools palette and wait until you get a pop-up menu, and then click Slice Selection tool. Using the Slice Select tool, you can then click each thumbnail in the image to select a slice. In either case, the goal is to sequentially select each image that needs to be linked, and then type in the appropriate URL in the Slice palette.

■ Using the **Slice Select** tool (to select it click it in the **Tools** palette and wait for a pop-up menu and then select **Slice Select** tool), click the black & white image to select it.
■ If the **Slice** palette is not open, choose **Window ➤ Slice** to get the **Slice** palette shown in **Figure 50.9**. Type **linked-page.htm** in the **URL** box. A Web page called **linked-page.htm** is in the **\50** folder. This process allows you to test your links and see how easy it is to create image slices.

50.6

50.7

50.8

■ Select each slice in a clockwise fashion. To make it easy to enter **linked-page.htm** in the **URL** box in the **Slice** palette, you can click the **down-arrow** at the right side of the **URL** box and select it from the list of recently used URLs — how easy can it be. Plus if you type the link correctly the first time, you won't make an error. Life is good! Continue on until you have linked all the slices.

You're now done. Just save the image and the ImageReady-created HTML code and you're ready to test it in a Web browser.

STEP 4: SAVE IMAGE AND HTML CODE

■ Click **File ➢ Save Optimized As** (**Ctrl+Shift+ Alt+S**) to get the **Save Optimized As** dialog box shown in **Figure 50.10**.

■ Assuming that you followed the recommendations in the Introduction about copying the contents of the Companion CD-ROM, select the **\50** folder. If you did not follow these recommendations, you need to make sure that you copy the file **linked-page.htm** from the **\50** folder on the companion CD-ROM to the same folder you select to save the image and HTML files. This file allows you to test each link.

50.9

- Click in the **Save as type** box and select **HTML and Images**. The **File Name** box must now show **link-graphic.html**.
- Click **Save** to save the image and create the HTML page.

STEP 5: VIEW IMAGE AND TEST LINKS

- Using Windows Explorer, open the **\50** folder and double-click the **link-graphic.html** to load it in your default Web browser. If you use Microsoft Internet Explorer, your Web browser should look similar to the one shown in **Figure 50.11**.
- As you move your cursor across any of the thumbnail images that have been linked, the cursor changes to a hand cursor indicating a clickable link is there. Click a linked thumbnail and you are taken to **linked-page.htm** where you can click to return to the **link-graphic.html** page. If you created and linked all the slices correctly, you should be able to click each image that is associated with a text title and get **linked-page.htm**.

While we have done all of this work in ImageReady 7, getting the same results by using just Photoshop 7 is also possible. Photoshop 7 offers considerably fewer features for creating Web graphics than does ImageReady 7 so that is why we used ImageReady. As you gain experience with ImageReady 7, it will be your choice for Web image creation. Should you want to try completing this technique in Photoshop, you need to enter the URL in the Slice Options dialog box shown in **Figure 50.12**. To access this dialog box, click the Slice Options box that you find in the Options bar after you select the Slice Select tool in the Tools palette.

My hope is that you have learned how to create image maps and that you will create one for your own Web photo gallery. If you do, and you'd like to share your work with other readers of this book and visitors to the companion Web page, then, please send an e-mail with a link to `ggeorges@ reallyusefulpage.com`.

You have now reached the end of the last technique and the end of the book. I hope you have enjoyed the techniques and the digital photos that you used to

50.10

50.11

complete the techniques. If you have any questions about these techniques, ideas for new techniques, comments about how one or more of them may be improved, or you have some work you would like to share on the Companion Web page, please send me an e-mail — I would enjoy hearing from you. I may be reached at ggeorges@reallyusefulpage. com. Good-luck on your images and may the light be with you!

50.12

APPENDIX A
WHAT'S ON THE CD-ROM

This appendix provides you with information on the contents of the CD that accompanies this book. For the latest and greatest information, please refer to the ReadMe file located at the root of the CD. Here is what you will find:

- System Requirements
- Using the CD with Windows
- Using the CD with Mac OS
- What's on the CD
- Troubleshooting

SYSTEM REQUIREMENTS

Make sure that your computer meets the minimum system requirements listed in this section. If your computer doesn't match up to most of these requirements, you may have a problem using the contents of the CD.

FOR WINDOWS 98, WINDOWS 2000 (WITH SP2 OR LATER), WINDOWS NT4 (WITH SP 6A OR LATER), WINDOWS ME, OR WINDOWS XP:

- Intel Pentium III or 4 processor
- At least 128MB of RAM (192MB recommended)
- 280MB of available hard-disk space
- A CD-ROM drive
- An 800 x 600 color monitor with 16-bit color or greater video card

FOR MACINTOSH:

- Power PC processor (G3, G4)
- Mac OS 9.1 or later
- At least 128MB of total RAM installed on your computer (192MB recommended)
- 320MB of available hard-disk space
- An 800 x 600 color monitor with 16-bit color or greater video card

CD-ROM INSTALLATION INSTRUCTIONS

To install a particular piece of software, open its folder with My Computer or Internet Explorer. What you do next depends on what you find in the software's folder:

1. First, look for a ReadMe.txt file or a .doc or .htm document. If this is present, it should contain installation instructions and other useful information.

2. If the folder contains an executable (.exe) file, this is usually an installation program. Often it will be called Setup.exe or Install.exe, but in some cases the filename reflects an abbreviated version of the software's name and version number. Run the .exe file to start the installation process.

WHAT'S ON THE CD

The following sections provide a summary of the software and other materials you'll find on the CD.

50 TECHNIQUES

All the techniques from the book, including code listings and samples, are on the CD in the folder named "Techniques."

■ Over 50 full-sized, original "before" photos for completing each of the fifty step-by-step techniques and 50 "after" images showing the final results.

Most of the "before" images are digital photos created with professional digital SLR cameras and quality lenses. A few images are made with high-end film scanners. The "after" images are compressed JPEG files so that all the images, plus the Photoshop 7.0 trial software, can fit on a single CD-ROM.

■ Internet browser-based slide show featuring "before" and "after" images. To run the show, use Windows Explorer to locate the folder **/show**. Double-click **index.htm** to run the slide show in your Internet browser. You can view this slide show online at `www.reallyusefulpage.com/50ps7/show`.

APPLICATIONS

The following applications are on the CD:

■ 30-day full-featured, trial version of Adobe Photoshop 7.

■ Free Adobe Acrobat Reader for viewing the book

Shareware programs are fully functional, trial versions of copyrighted programs. If you like particular programs, register with their authors for a nominal fee and receive licenses, enhanced versions, and technical support. *Freeware programs* are copyrighted games, applications, and utilities that are free for personal use. Unlike shareware, these programs do not require a fee or provide technical support. *GNU software* is governed by its own license, which is included inside the folder of the GNU product. See the GNU license for more details.

Trial, demo, or evaluation versions are usually limited either by time or functionality (such as being unable to save projects). Some trial versions are very sensitive to system date changes. If you alter your computer's date, the programs will "time out" and will no longer be functional.

EBOOK VERSION OF *50 FAST PHOTOSHOP 7 TECHNIQUES*

The complete text of this book is on the CD in Adobe's Portable Document Format (PDF). You can read and search through the file with the Adobe Acrobat Reader (also included on the CD).

TROUBLESHOOTING

If you have difficulty installing or using any of the materials on the companion CD, try the following solutions:

- **Turn off any anti-virus software that you may have running.** Installers sometimes mimic virus activity and can make your computer incorrectly believe that it is being infected by a virus. (Be sure to turn the anti-virus software back on later.)
- **Close all running programs.** The more programs you're running, the less memory is available to other programs. Installers also typically update files and programs; if you keep other programs running, installation may not work properly.
- **Reference the ReadMe:** Please refer to the ReadMe file located at the root of the CD-ROM for the latest product information at the time of publication.

If you still have trouble with the CD, please call the Customer Care phone number: (800) 762-2974. Outside the United States, call 1 (317) 572-3994. You can also contact Wiley Customer Care by e-mail at `techsupdum@wiley.com`. Wiley will provide technical support only for installation and other general quality control items; for technical support on the applications themselves, consult the program's vendor or author.

APPENDIX B

COMPANION WEB SITE

A companion Web site has been created especially for this book at: `www.reallyusefulpage.com/50ps7`. What is on the site?

- Updates and corrections to this book
- Readers' Photo Gallery – View the work of other readers and share your best work too! If you have created an outstanding image that you would like to share with others, please e-mail a .jpg file version to `curator@ reallyusefulpage.com`. Make sure that the images that you e-mail fit within a 640 x 640 pixel space and that together they are under 75KB. Future editions of this book may contain images submitted to this gallery. Permission will be requested and credit will be given to those who submit images.
- A really useful list of online photography and image-editing resources, including Photoshop plug-ins
- FAQ (Frequently Asked Questions) section for getting answers to common questions
- Recommended book reading list to further your skills
- List of online galleries that you might like to visit

JOIN AN ONLINE FORUM

The author of this book has created and hosts an online forum at Yahoo! Groups for readers of his books, as well as anyone else that has an interest in digital photo editing. To join, visit: `http://groups.yahoo.com/group/ digital-photo-editing`.

Subscribe to the e-mail service to participate. You can post images and share tips and techniques with other readers of this book. There will even be an occasional online chat session to which you will be invited.

CONTACT THE AUTHOR

Gregory Georges, the author of this book, welcomes comments from readers. He may be contacted by e-mail at: `ggeorges@reallyusefulpage.com`, or occasionally on ICQ using pager # 8706892. His Web site is: `www. reallyusefulpage.com`. While he reads all e-mail, the heavy volume makes it impossible to respond to all messages.

INDEX

ABOUT THE AUTHOR

Gregory Georges has been an active photographer for more than 25 years. He has had a long-lasting passion for photography as an art form and enjoys capturing fun and important events. His favorite photographic subjects include flowers, wildlife, sporting events, old buildings, and birds. Gregory has been a longtime user of computers both personally and professionally ever since his first computer class in 1969 and now uses an entirely digital work-flow for his photography — from initial image capture, to image editing, and digital printing.

He is the author of *50 Fast Digital Photo Techniques*, and *Digital Camera Solutions*; both are best-selling books on digital cameras and digital image editing. He is a contributing writer for *Shutterbug* and *eDigital Photo* magazines, and he provides photographs to a growing list of Web sites and commercial clients. His Web site, www. reallyusefulpage.com is a *really useful page* for learning more about how to get the most from new digital technologies.

COLOPHON

This book was produced electronically in Indianapolis, Indiana. Microsoft Word 97 was used for word processing; design and layout were produced using QuarkXPress 4.11 and Adobe Photoshop 5.5 on Power Macintosh computers. The typeface families used are: Chicago Laser, Minion, Myriad, Myriad Multiple Master, Prestige Elite, Symbol, Trajan, and Zapf Dingbats.

Acquisitions Editor: Michael Roney

Project Editor: Amanda Peterson

Technical Editor: Marc Pawliger, Dennis Short

Copy Editor: Jerelind Charles

Editorial Manager: Rev Mengle

Permissions Editor: Laura Moss

Production Coordinator: Dale White

Cover Art: Gregory Georges

Quality Control Technicians: Andy Hollandbeck, Susan Moritz, Linda Quigley, Charles Spencer

Production: Melanie DesJardins, Joyce Haughey, LeAndra Johnson, Gabriele McCann, Laurie Petrone, Betty Schulte

Proofreading: Vicki Broyles

Indexing: Becky Hornyak